Penguin Classics of World Art

The Complete Paintings of Manet

Edouard Manet was born on 23 January 1832 into a wealthy bourgeois family. He was educated at the Collège Rollin, where he met Antonin Proust, who was to become a life-long friend. His family reluctantly allowed him to study under Couture (1850–56), but Manet was strongly opposed to the historical style of painting and in 1858 his career as an artistic rebel began with *Le Buveur d'Absinthe*. Between 1853 and 1856 he travelled in Italy, Holland, Germany and Austria. In 1860 he met Berthe Morisot, who was to exercise a considerable influence upon him. At the end of that year he began to paint *La Musique aux Tuileries*, which was acclaimed by his friends, among whom was Baudelaire. Manet longed for official recognition, and it is ironic that he became, as Degas said, 'more notorious than Garibaldi'. His work was frequently rejected by the Salon and when hung was ill received by public and critics alike. In 1863, *Déjeuner sur l'Herbe* appeared at the first *Salon des Refusés*, where it caused an uproar, and two years later further uproar ensued when *Olympia* was exhibited at the Galerie Martinet. Though he was associated with the Impressionists, and in some respects can be considered a founder of the movement, Manet refused to exhibit with them. From 1876 he began to suffer from locomotor ataxy, which progressively worsened, causing him considerable pain. In 1881 he was created Chevalier de la Légion d'Honneur. On 14 April 1883, gangrene set into his left leg and surgeons decided to amputate; on 30 April he died.

In a foreword to his exhibition of 1867 Manet wrote, 'Monsieur Manet has always recognized talent where he has met it; he has had no pretensions to overthrow old methods of painting or to create new ones. He has simply tried to be himself and no one else.' Yet painting was never the same after Manet. His work in its choice of subject, its realism and immediacy, and its brilliant technique exploded the traditional view. As his friend and champion Zola said, 'He departed for the unknown every time he placed his white canvas on the easel.'

The Complete Paintings of

Manet

Introduction by **Phoebe Pool**

Notes and catalogue by **Sandra Orienti**

Penguin Books

Penguin Books Ltd, Harmondsworth, Middlesex, England
Viking Penguin Inc., 40 West 23rd Street, New York, New York 10010, U.S.A.
Penguin Books Australia Ltd, Ringwood, Victoria, Australia
Penguin Books Canada Ltd, 2801 John Street, Markham, Ontario, Canada L3R 1B4
Penguin Books (N.Z.) Ltd, 182–190 Wairau Road, Auckland 10, New Zealand

First published by Rizzoli Editore 1967
This translation first published in Great Britain by Weidenfeld & Nicolson 1970
Published in Penguin Books 1985

Photographic sources

Color plates: Art Institute of Chicago; Blauel, Munich;
Conzett and Huber, Zurich; Fogg Art Museum,
Cambridge, Mass; Giraudon, Paris; Held, Ecublens;
Kleinhempel, Hamburg; Messiaen, Tournai; Metropolitan
Museum, New York; Museum of Fine Arts, Boston;
National Gallery, Washington, D.C.; Schopplein, San
Francisco; Società Scala, Florence; Staatliche Museen,
Berlin; Vaering, Oslo.
Black and white illustrations: Art Institute of Chicago;
Nelson Atkins Museum of Fine Arts, Kansas City, Mo.;
Baltimore Museum of Art; Brenwasser, New York;
Brooklyn Museum; Bryn Mawr College, Bryn Mawr,
Penn.; California Palace of the Legion of Honor, San
Francisco; Cauvin, Paris; Cincinnati Art Museum,
Cincinnati; City Art Museum, Saint Louis; Cleveland
Museum of Art, Cleveland; Fogg Art Museum, Cambridge,
Mass; Held, Ecublens; Hill-Stead Museum, Farmington,
Conn.; Horowitz, New York; Isabella Stewart Gardner
Museum, Boston; John G. Johnson Collection,
Philadelphia Museum of Art; Knoedler, New York; Leeser,
New York; Mellon, Upperville, Va. and Washington;
Mengis, Shelburne, Vt.; Metropolitan Museum, New York;
Museum of Art, Providence; Museum of Fine Arts, Boston;
National Gallery, Washington, D.C.; Norton Simon
Foundation, Fullerton, Calif.; Outerbridge, Farmington,
Conn.; Paley, New York; Philadelphia Museum of Art;
Phillips Collection, Washington, D.C.; Photo Les Beaux-Arts,
Paris; Pollitzer, Garden City Park, New York; Rizzoli
Archives, Milan; Rogers, New York; Ryan, New York;
Schiff, New York; Smith College Museum of Art,
Northampton, Mass.; Stralem, New York; Tannhauser,
Berlin; Tannhauser, New York; Toledo Museum of Art,
Toledo, Ohio; University of Kansas, Museum of Art,
Lawrence; Walters Art Gallery, Baltimore; Wyatt,
Philadelphia; Yale University Art Gallery, New Haven.

Introduction

Manet refreshed art by confronting his own times with neither stale dogma nor too stifling a hatred of tradition. His friend Zola said that 'he departed for the unknown every time he placed his white canvas on the easel'. This admirably suggests Manet's instinctive and spontaneous way of painting, his wish to transmit a new and personal impression from what was immediately before his eyes, his constant obliterations and fresh beginnings. But if he sought the unknown in this sense, in his painting tactics he was not much concerned with the infinite and unfathomable beyond everyday social life, the mystery evoked by Van Gogh's *Starry Sky* and by other painters and poets of the later 'Symbolist' generation. For Manet was in some ways the heir of Courbet and would have agreed with the famous manifestoes of 1855 and 1867 that 'Painting is essentially a concrete art and can only consist in the representation of real and existing things. An object which is abstract, invisible, non-existent is not within the realm of painting'. He was also of course the friend of Baudelaire, and like him was sometimes able to distil in his art the exact and peculiar flavor of contemporary Paris.

Manet was rarely dull as a human being or as an artist. He was lively and likeable 'by nature as a social and political animal' and well suited, except in his sensitivity, to be the rallying point for new ways of painting. It was ironical that one so little resigned to social exile, as Gauguin and Van Gogh were perforce resigned, should become as Degas said, 'more notorious than Garibaldi' and be gaped at as a monster by the customs official at Hendaye. The common description of the Impressionists in the '70s as *la bande à Manet* was not entirely wrong. While his detractors were bewailing his lack of spirituality and his plagiarisms from the Spanish and Venetian masters, Manet extracted from these very borrowings a pungent novelty of style and content which was greatly to affect such artistic giants as Cézanne, Degas, Monet, Renoir and Matisse.

Assuming, for purposes of discussion, that Manet's new style and subject matter can be artificially separated, it is still hard to decide which of the two most enraged the general public of the day. To us, Manet's use of color in the '60s often seems subtle, almost discreet, relying as he frequently did on blacks, grays and delicate browns. But the twentieth century has been conditioned to accept the brilliance of late Monet and Renoir, the high key of Matisse, the Fauves and other heirs of Vincent Van Gogh. (Vincent maintained to his brother that the painter of the future would be a colorist and, by his example, helped to make the prophecy come true.) In the 1860s, however, as Manet's friend and artistic executor Duret pointed out, the *Salon public* was accustomed to 'opaque shades and dead tones'. In spite of some precedents in the work of Delacroix, it was believed that a number of bright colors should not be put side by side without chiaroscuro, shadowy transitions or modulations to soften the abruptness of the contrasts. But Manet, painting on an unfamiliar white canvas, often deliberately juxtaposed clear acid tones – sharp green, bright peach or pale Davidian yellow – with his blacks and dark grays.

Manet was often blamed (and sometimes praised) for what was then considered his exceptional luminosity; in 1863 the comparatively cool *Déjeuner sur l'Herbe* (Plates IV–V) seemed an enormous blotch of color to which the word *bariolage* (a disparate mass of colors) was scathingly applied. There were rumors that even Delacroix had said that the harsh colors pierced the eye like a saw. If one compares *Le Déjeuner* with the more shadowy outdoor scenes of Courbet, it is easier to understand what was felt. Manet was happiest painting subjects which were flattened out by a strong light from behind his own head. In this way he could avoid elaborate modeling and surround his objects with a dark contour. (*Olympia*, *The Fifer*, and later, the portrait of Clémenceau, all shown here in color, are good examples of this technique). Courbet, with his greater feeling for density and substance, is said to have complained of the *Olympia*: 'It's flat; there is no modeling; you would imagine she was the Queen of Spades in a pack of cards, coming out of her bath'. But Cézanne who, in his old age at least, declared that 'Nature for us men is more depth than surface', appears not to have felt this drawback; in the late '60s many of his still-lifes and other works, such as *The Tannhäuser Overture*, reveal a strong influence from Manet.

Apart from the comparative brightness and luminosity of his colors, Manet's paintings have lately been considered the first of the modern works 'by virtue of the frankness with which they declare the surface on which they are painted'. Clement Greenberg, the American critic and champion of

Abstract Expressionism, points out that 'The Impressionists, following Manet, abjured underpainting and glazing, to leave the eye under no doubt as to the fact that the colors used were made of real paint that came from pots and tubes'. This was not, of course, the practice of Ingres or David, who made a smooth illusionistic surface, concealing the traces of the brush.

In another respect, painting after Manet could never be the same again. He may be described as a complex man 'born', as Matisse said, 'to simplify art'. If one passes from a room full of eighteenth-century or Romantic painting to one containing works by Manet and his followers, one is forcibly struck by the concise and summary quality of the later painting. This may owe something to the decline of the meticulous and detailed miniature painting and to the rise of rapid lithographic and watercolor techniques. Nor, of course, could the Impressionists have indulged in minute details, since they wished to capture the immediate and changing effects of a particular season and light. But we know that the concision of Manet and his friends was a product far more of deliberate artistic choice than of accident.

It is clear from Manet's early paintings that, like his friend Degas, he grew up during the aftermath of the Romantic Movement and reacted very strongly against the sprawling details and garrulous trimmings of the Romantics. In this he was characteristic of his generation. In 1861 even the great Victor Hugo was censured by the critics for the Gothic details and fussy repetitions in his new book *Les Misérables*. Antonin Proust's memoirs of his friend Manet, although not published until after the painter's death, are convincing on this point: 'He often used to say to me, "I loathe all that is unnecessary in painting, but the difficulty is how to see what is necessary . . . who will show us the way to make painting simple and clear, who will get rid of all these trimmings?"' If one compares Manet's portraits of Berthe Morisot or Degas' *Place de la Concorde* with a *fête champêtre* of Watteau, or a genre scene by Meissonier, or a historical picture by the fasionable Gérome, it becomes easier to grasp what Manet meant.

The cult of impersonality and a distaste for rhetoric, melodrama and autobiographical indiscretion, are other signs of Manet, the Post-Romantic *flâneur* and dandy. Much has been made of his social position and the fact that Manet was brought up in the exclusive world of the higher magistracy. But the search for objectivity in painting is surely connected less with birth, or even temperament, than with the semi-scientific atmosphere of the day and with the reaction from Romantic posturing and the noisy propaganda which surrounded Courbet and his circle at the Brasseur Andler; (it was the socialist writings of Courbet's friend Proudhon which provoked Zola's retort: 'The artist is not at anyone's service and we refuse to enter yours'.). The same so-called patrician reticence was shared not only by Degas, who *was* born of cultured upper-middle class parents, but also by Renoir and Monet, who were sons of the people. The casual, undramatic poses in contemporary photographs may also have strengthened this predisposition.

However it arose, Manet's so-called impersonality has infuriated critics in both the nineteenth and twentieth centuries. In 1868 the critic Thoré-Bürger complained that 'Manet's real vice is a sort of pantheism which values a head no more than a supper; which sometimes even gives a greater importance to a bouquet of flowers than to the face of a woman'. It is true that the wonderful painting of the sheets in *Olympia* and the still-lifes in *Le Déjeuner sur l'Herbe* and *The Bar at the Folies-Bergère* almost, but I think not quite, steal the picture from the respective figures. The contemporary critics and public very much disliked this impassivity, or what Alan Bowness has well called 'the alienating stare' of Olympia and the woman bather. It probably seemed more repulsive to them than did the nudity.

Some years ago, Professor Meyer Schapiro pointed out that it is unwise to confuse the cool, impersonal tone of Manet and Degas with an indifference to subject-matter. In the '60s both these artists were obviously very much interested in the content of their painting and here, too, Duret was justified in considering Manet as 'one of the real inventors'. Of course his interest in *le beau moderne* and the world around him was not in the least exceptional (Baudelaire had been championing modernity since his *Salon de 1846*; Théophile Gautier, and even Manet's master Couture, had both suggested that, for example, trains and railway stations were possible subjects for serious art). But even though scholars such as Sandblad have disinterred eighteenth-century prints and graphic works by Daumier and Guys, which were probably sources for *La Musique aux Tuileries*, this picture still remains one of the most original paintings of the nineteenth century. It is like a superb report on the daily life of Manet's own friends and rises far above the journalism of Constantin Guys, who was deified by Baudelaire as *Le Peintre de la vie moderne. La Musique* has often been criticized for its lack of compositional unity, but surely this crammed informality, this lack of central accent, is both deliberate and highly successful. As Zola wrote in 1867, 'His attitude towards figure painting is like the academic attitude to still-life. What I mean is that he groups

figures more or less fortuitously'.

When Manet was being coaxed by his fellow-students at Couture's to complete some bold improvisation, he would apparently retort: 'What? Do you take me for a history painter?' In 1867 Zola, no doubt briefed by Manet, also declared: 'This artist paints neither history nor his soul.' Nevertheless, on occasion, Manet *was* a history painter and a highly original and forcible one. It is true that he did not share the current mania for druids or Roman gladiators, but he tried instead, as Courbet had already tried, to paint episodes from the history of his own day. It seems to have been clearer to his contemporaries than to posterity that Manet was a consistent left-wing republican; later writers have sometimes been unaccountably confused by Manet's liking for fashionable parties and his distaste for obvious political propaganda in art. His decision to paint the execution of the Emperor Maximilian and to show the firing squad in *French* uniform, to indicate *French* responsibility, cannot have been accidental or naïve, although it was partly the result of documentation from newspapers. The decision of the authorities to suppress the lithograph of the execution shows that *they* were not in any doubt. During the Commune of 1871, Manet, with Courbet and Daumier, was elected to the *Fédération des Artistes de Paris* and his vivid barricade scenes surely reflect disgust at the cruelty of the advancing army. Earlier, in *The Kearsarge and the Alabama*, he had depicted a naval encounter of the American Civil War, but Manet treated it very coolly in comparison with the rhetorical drama once thought suitable for the sagas of Napoleon I. Manet also painted the Republican hero Gambetta, and Rochefort, a Communard journalist escaping by boat from a penal colony; and for all these pictures he undertook documentation worthy of his novelist friends.

In the present century Manet's detractors have generally concentrated their fury on his ambivalent relations with the Impressionists. Even Degas considered that his refusal to exhibit with them in 1874 showed that he was 'more vain than intelligent'. But Monet, Renoir and Sisley recognized that they owed him far more than the money and support which he supplied when they were destitute. Manet's bright, blond colors and his elimination of half-tones, by exploding the traditional view that a painting must proceed by intermediate stages from dark to light, set free the Impressionists to paint in whatever colors they chose. The Impressionists were also indebted to Manet as the new *Peintre de la vie moderne*; *Musique aux Tuileries* and *Déjeuner sur l'Herbe* were the forerunners of *Le Moulin de la Galette, Skating in the Bois de Boulogne*

and other works in which Renoir transferred the glamor of Titian's Venice or Watteau's Cythera to the middle-class amusements of his own day. And Monet and Berthe Morisot benefited too. When Zola wrote that 'to represent life-sized figures in a landscape is every painter's dream', he was speaking of the situation as it was *after* Manet's *Déjeuner sur l'Herbe*, which was the principal source of, amongst other things, Monet's pictures *Women in a Garden* and *Mme Monet on a Garden Bench*, as well as Bazille's *Woman in a Pink Dress* and Berthe Morisot's outdoor scenes.

It was poetic justice that Manet's art was itself to be invigorated and renewed, after a period of comparative sterility, by these younger painters who had already learned so much from him. In the '20s, when Impressionism became a term of abuse, some critics denied that Manet's painting had ever been influenced by this loose and unclassical style. It is true that Manet was never principally a painter of landscape or reflected light, that he never gave up local colors or black and that the majority of his works were executed in the studio, even if from drawings made on the spot. But a comparison of such a flat, poster-like work as *The Fifer* of 1865–6 with the far more airy and atmospheric *Game of Croquet* (1873), *Monet in his floating Studio* (1874) or *The Grand Canal, Venice* (1874), shows the distance which he had traveled. Manet learned much from his charming and congenial friend Berthe Morisot, and also from working side by side at Argenteuil with Renoir and Monet. Roger Fry's idea that Manet's 'Impressionism' was a deplorable aberration can scarcely be sustained in face of *The River at Argenteuil*, or *The Roadmenders in the Rue de Berne*.

Courbet said that 'The real artists are those who pick up the age exactly at the point to which it had been carried by preceding times'. According to this definition, few painters have been more 'real artists' than were Courbet himself, and afterwards Manet; their discoveries almost persuade one to believe in a continuous if mythical progress of the arts, like the 'Why' view of history. Ill-informed contemporaries confused the works of Courbet and Manet. Rossetti in a letter of 1864 declared: 'There is a man called Manet (in those studios where I was taken by Fantin), where pictures are for the most part mere scrawls. Courbet, *the head of it* is not much better.' The young Renoir, more instinctively professional, disagreed. The technical novelties outlined above are all summarized in his alleged remark: 'Courbet was still the tradition but Manet was the new generation of painting.' It matters little if Renoir did not in fact really say this in words, for he made it abundantly clear in his pictures.

PHOEBE POOL

An outline of the artist's critical history

The greatest advantage which Manet enjoyed was the support of three of the greatest writers of the day: Baudelaire, Zola and Mallarmé. Baudelaire, who clung to Manet with the curious prehensile diligence of the poet, was not, in spite of the previous remarks, perfectly 'up-to-date' with the painter's work and was rather inclined to drive him in the direction of his own interests. This applied particularly to his interest in things Spanish and this, according to A. Proust and Tabarant, caused Manet to waste much of his time, almost as if the painter's interest had been practically solely motivated by exotic ideas and not, in a more profound way, by his prolonged study of great Spanish painting. Baudelaire wrote little on Manet, and their correspondence reveals more of the man than of the artist. But he was always quick to defend Manet and to correct unstintingly the unjust shafts of the critics. Zola, by contrast, entered the lists with gusto, writing what appeared to be the wholly balanced pleading of a counsel for the defense, but vehement, nevertheless, and partisan in favor of the accused. But at the same time, he too tended to speak in his own defense and to draw Manet towards the 'naturalistic' approach, revealing a 'reading' of it which was as impassioned as it was partial, so that sometimes it seems that his own certainty of the truth may not have been entirely free from momentary fluctuations. In the relationship between Manet and Mallarmé, neither of the two tried to win the other over to his own cause or to force the direction or the significance of what the other was seeking. The eager collaboration seems to have been full of affectionate respect and mutual amazement: 'You poets,' Manet wrote to him, 'you are frightening and it is often impossible to understand your fantasies.'

After Manet died, his work began to be understood, warily at first, but with an ever-increasing and conscious clarity of judgment. It is significant that, of the painter's friends, it was not the writers nor the influential men, but Monet and his circle, who started the subscription for *Olympia*. The admission of this work to the Louvre was a mark, not of the blessing of official recognition, but of the universal quality of Manet's work.

Manet, a Spaniard in Paris, associated in some obscure manner with the tradition of Goya, had exhibited at the Salon of 1861 a *Joueur de Guitare* which, it must be said, caused a considerable sensation. It was brutal, but it was frank, and there was in this violent sketch the promise of a vigorous talent. Two years have passed by since then, and Manet has entered, with his instinctive courage, into the realms of the impossible. We absolutely refuse to follow him there. All sense of form is lost in his great portraits of women, and notably in that of the *Chanteuse*, where, with an oddity that troubles us deeply, the eyebrows have deserted their usual horizontal position and are placed vertically down the side of the nose, like two shadowy commas. There is nothing there but the discordant clash of tones of black and white. The effect is pale, hard and sinister. On other occasions, when Manet is in a happy mood, he paints *La Musique aux Tuileries*, *Le Ballet Espagnol* or *Lola de Valence*, that is to say, pictures which reveal in him an abounding vigor; but which, with their medley of red, blue, yellow and black, are but caricatures of the colors and not the colors themselves. To sum up, such art may well be extremely honest, but it is not sound, and we can feel under no obligation to plead Manet's cause before the Exhibition jury.
PAUL MANTZ in *Gazette des Beaux-Arts*, 1863

M. Manet has the qualities of a magician – luminous effects and flamboyant tones, which echo Velasquez and Goya, his favorite models. It is of them that he thought when composing and painting his picture of the arena. In his second picture, *Les Anges au Tombeau du Christ*, it was another Spanish master, El Greco, whom he copied with an equal passion, doubtless as a form of sarcasm against the bashful lovers of timid and conventional painting. This dead Christ, seated like a normal person and seen full face, with his arms at his sides, is too terrible to behold. Perhaps he is beginning to come to life again under the wings of the two angels who are present. Oh! These curious wings from another world, colored with a blue of greater intensity than the uttermost depth of the sky! No bird on earth has such plumage. But perhaps these angels, these birds of heaven, really wear such colors, and the public has no right to laugh at them, for it has never seen angels. One must therefore no more argue about angels than about colors.

I agree, however, that this formidable Christ and these angels with wings of Prussian blue seem to mock the world, which says: 'One has never seen such a thing! What an error of judgment!' It was a very distinguished woman who expressed this criticism of Manet's poor Christ, exposed to the mockery of the Philistines of Paris. This is not to say that the whites of the shroud and the tones of the flesh are not rendered extremely truthfully in Manet's painting, and that the modeling of the arms and the foreshortening of the legs do not bring to mind some famous masters – Rubens in his *Christ Mort*, and in his *Christ à la Paille* in the Museum at Antwerp, and even certain Christs of Annibale Carracci in his more unrestrained and imposing moments. The likeness is remarkable. However, Manet's *Christ* most resembles El Greco, the pupil of Titian, and the teacher of Luis Tristan, who became in his turn the teacher of Velasquez.

We have dwelt enough on these eccentricities which conceal a true painter whose works will perhaps one day be highly praised. Let us remember the early days of Eugène Delacroix, his triumph at the Universal Exhibition of 1855, and the way in which his works sold – after his death! TH. THORÉ-BÜRGER, in *Indépendance belge*, 1864

Dear Sir,

I do not know if you remember me and our former discussions. So many years have gone by so quickly. I read of your writings very diligently, and I would like to thank you for the pleasure you have given in coming to the defense of my friend Edouard Manet, and doing him a little justice. However, there are a few small things to be corrected in the opinions which you expressed.

Manet, whom people consider wild and hot-tempered, is really a very loyal and very simple man, doing whatever he can to be reasonable, but unfortunately affected by romanticism from his very birth.

The word *pastiche* is not fair. M. Manet has never seen the works of Goya, nor the works of El Greco, neither has he ever seen the Pourtalès gallery. That may seem unbelievable to you, but in fact it is true.

I too have been amazed and taken aback by these curious coincidences.

Manet, at the time when we were in control of that marvelous Spanish museum (which the stupid French Republic with its excessive respect for property gave back to the House of Orléans), was a child and was serving on board a ship. People have spoken to him so much about his imitations of Goya, that he is now trying to see some of Goya's works.

It is true that he has seen some Velasquez, I don't know where. You have your doubts of what I am saying? You doubt that such extraordinary geometrical parallels can happen in nature. Ah well! I myself am accused of copying Edgar Allen Poe!

Do you know why I have translated Poe so painstakingly? Because he is like me. The first time that I opened one of his books, I recognized with surprise and delight, not only subjects which I had dreamt of, but PHRASES thought of by me and written by him twenty years before.

Et nunc erudimini, vos qui judicatis! . . . Don't be annoyed, but keep a kindly remembrance of me in the back of your mind. Every time that you seek to do Manet a service, I shall be thankful to you.

I am taking this scrawl to Mr Berardi, for transmission to you. I shall have the courage, or rather the cynicism of my convictions. Quote my letter, or some part of it, I have told you the absolute truth. CH. BAUDELAIRE, letter to Thoré-Bürger, 7 May 1864

Strange works! All the dwarfs; one especially seated full face with his hands on his thighs: a supreme picture for a real connoisseur. His magnificent portraits: one would have to list them all: they are all masterpieces. A portrait of Charles V by Titian, which has a great reputation, doubtless well deserved, and which would certainly have impressed me under other circumstances, here seems to me to be wooden.

And Goya! The strangest after the master whom he imitated overmuch in the most servile sense of the word. Nevertheless he had very considerable spirit. Among his works at the museum are two fine equestrian portraits in the style of Velasquez, although considerably inferior. What I have seen of his work up to now has not pleased me very much. During my time here I must see the magnificent collection of his works at the home of the Duke of Ossuna.

I am disconsolate: the atmosphere is very heavy this morning, and I am afraid that the bullfight which should take place this evening and which I was going to give myself the pleasure of attending, may not take place. Till when? Tomorrow I go to Toledo. There I shall see the works of Greco and Goya which I have been told are well represented there.

Madrid is a pleasant city, full of diversions. The Prado is dotted with pretty girls, all in mantillas, which gives it a very original look. In the streets there are all sorts of costumes, and the toreadors, who themselves have a strange form of town wear. E. MANET, letter to Fantin-Latour, Madrid, 28 May 1865

Manet's place in the Louvre is marked like that of Courbet, and like that of any artist of a strong and original character. In other respects, there is not the slightest resemblance between Courbet and Manet, and these artists, if they are logical, must deny one another. It is just because they have nothing in common that they can each live their own personal life . . . One may perhaps laugh at the panegyrist as one has already laughed at the painter. One day we shall both of us be justified. There is one eternal truth which sustains me as a critic: it is that artistic temperaments alone live on and dominate the ages. It is impossible – impossible I tell you – that Manet will not have his day of triumph and will not obliterate the timid mediocrities who surround him. E. ZOLA, in *Evènement illustré*, 10 May 1866

I stand in front of the pictures of Edouard Manet as if standing before new accomplishments which I feel that I must explain and comment on.

What strikes me first in these pictures is a very sensitive precision in the relations of the tones with one another. Let me explain. Some pieces of fruit are resting on a table and stand out against a gray background; between the pieces of fruit, depending on whether they are nearer or further away, there are certain color values forming a whole range of tints. If you start in a higher key than normal, then you must stay in a higher scale throughout; and the opposite applies when you start in a lower key. It is that which is called, I think, the law of values. Among painters of the modern school I know only Corot, Courbet, and Edouard Manet who have consistently obeyed this law in their figure painting. Their work gains from it an outstanding clarity, great truthfulness and a most attractive look.

Edouard Manet usually starts in a higher key than that which is found in nature. His pictures are light and luminous, and have a consistent paleness. The light which falls is white and generous and lights the objects in a gentle fashion. None of the effects is in any way forced; the people and the countryside are bathed in a sort of warm limpidity which fills the whole canvas. What strikes me next is a necessary consequence of the strict observation of the law of values. The artist, face to face with whatever subject, lets himself be guided by his eyes which see the object in broad masses of color all subject to the other . . . The whole personality of this artist lies in the manner in which his eye is organized; he sees things in pale colors, and he sees them as masses.

What strikes me in the third place is a somewhat austere but nevertheless delightful charm. I am not speaking of the milk and roses charm of the heads of china dolls, I am speaking of a charm which is incisive and truly humane. . . .

9

The first impression which one of Edouard Manet's canvases produces is somewhat harsh. One is not used to seeing such straightforward and sincere interpretations of reality. Moreover, as I have said, there is a certain stiff elegance which surprises. To begin with, the eye only sees broad masses of color. Soon the objects become defined and take their place; after some seconds, the whole vigorous effect becomes apparent, and one enjoys the real pleasure of looking at this clear and serious painting, which renders nature with a gentle roughness, if I may be allowed to express myself thus. When one approaches the picture one sees that the method is more delicate than rough; the artist uses only a brush, and that very discreetly; there is no build-up of colors, but only a single coat. The methods of this bold artist, whom we have mocked, are extremely well founded, and if his works have a distinctive appearance, they owe it purely and simply to the personal way in which he perceives things and interprets them. E. ZOLA, *Edouard Manet, Etude biographique et critique*, 1867

Manet's painting never really does justice to the intrinsic qualities of novelty and forward looking, while Impressionism is almost entirely new, since it derives from a new perception of color, almost from a new use of the retina and of the sensory centers to which this changed retina is linked. Manet, on the other hand, is a great painter of large zones of color openly stated in light and dark, as seen by the Venetians, Velasquez and, so I am told, Goya, whose work I have not seen. Manet's many peacock-hues resemble Tiepolo, and under the seeming slovenliness of a house-painter's palette, may be seen the firm robust outlines of a great master of line. He is among the last of the great masters and stands on the threshold of the great masters of the future. D. MARTELLI, in *Fieramosca*, 1884

He has this cheerful bantering, in which contempt scarcely makes itself felt. He radiates happiness, a happiness which is infectious, as is his whole good humored philosophy.

I have always seen him thus. His spirit is infused with sunlight and I love him for it. G. DE NITTIS, *Notes et Souvenirs*, 1895

With Manet, his eye played so great a part that Paris had never known a stroller like him, and one whose perambulations had more purpose than most. As soon as winter arrived, and the fog blanketed the light from the morning onwards – to the point where all painting became impossible in the studio – we took ourselves out and went to the boulevards. There he sketched on a pad various trifles, a profile, a hat; in a word a transient impression. And when, on the following day, a companion said to him while thumbing through his notebook: 'You should finish that off' he was convulsed with laughter. 'You take me,' he said, 'for a historic painter'. 'Historic painter' was, in his mouth, the most deadly insult that one could address to an artist. A. PROUST, in *Revue Blanche*, 1 February 1897

This eye of Manet's whose beginnings stemmed from old city-bred traditions, this newly awakened eye, intent upon an object or upon people, pure and absorbed, captured by the humor of the situation, retained but lately that fresh immediacy of approach which enabled him in the sitting that followed to snap his fingers at the trials and tribulations of the twenty previous sessions. As for his hand, the clarity and facility of its impress could be felt, and explained the mysterious way in which the purity of his vision was transferred to it, so as to create a new and notably French masterpiece, vibrant, pale in tone, profound, now sharply defined, now shadowed by dark overtones. STÉPHANE MALLARMÉ, *Divagations*, 1898

When I returned to Paris in January 1882, my first visit was to Manet. He was then painting *Bar aux Folies-Bergère*, and the model, a pretty girl, was posing behind a table laden with food and drink. He recognized me at once, held out his hand and said: 'It is very tedious, and you must excuse me, but I have to remain seated. Sit down there.'

I took a chair behind him and watched him work. Manet, although he painted his pictures with a model, did not copy straight from nature; I had an awareness of his masterly simplifications. The head of his wife was the subject, but his copy was not obtained by any means that nature taught. Everything was intensified: the tones were clearer, the colors more vivid, and the values closer. The whole formed a soft pale harmony. Somebody came in. I recognized my childhood friend, Dr Albert Robin. We spoke of Chaplin. 'You know, he has a great deal of talent', said Manet, while painting with short brush strokes the gilt paper of a champagne bottle. 'A great deal of talent', he repeated. 'He understands a woman's smile; and that is something very rare. Yes, I know, there are those who pretend that his painting is too polished; they are mistaken; and what is more, his use of color is very well handled.'

Other people arrived, and Manet stopped painting and went and sat down on the divan against the right hand wall. It was then that I saw just how much his illness had affected him. He walked leaning on a stick and seemed to tremble. Nevertheless he remained cheerful and spoke of his coming recovery. I returned to see him during my stay. He told me things like the following: 'Conciseness in art is both a necessity and a source of elegance. A concise man makes one reflect; a verbose man is boring. Always amend things in the direction of conciseness – in a figure look for the main area of light and the main area of shade; the rest will come naturally; it is often something very little. And then, cultivate your memory, for nature will never give you anything else but information. It is like a guard rail which stops you lapsing into the banal – one must always remain the master and do whatever amuses. No humdrum tasks, no indeed, no humdrum tasks. Look, since you like that, go over there.' He indicated a door. I opened it and found myself in a store room, where there was piled up an enormous number of pictures! I saw *Le Linge, Olympia, Chez le Père Lathuille, Le Christ aux Anges, Argenteuil*. I was attracted by *Le Père Lathuille*, which was the best lit. This picture, which I had seen at the Salon of 1880, remained in my memory as the most astonishing representation of a Paris restaurant. I was in front of this canvas, dwelling on the mysterious charms of a picture of extreme subtlety, and I would have stayed there without moving for a great length of time, if Manet's voice had not called me. I left the room where those unappreciated masterpieces were piled up, and returned to him. I told him as best I could what

the experience of his paintings meant to me, and I had the pleasure of seeing appear in his eyes, whose brightness had not been dimmed by his illness, a look of emotion which remained one of the most precious memories of my life. G. JEANNIOT, in *La Grande Revue*, 10 August 1907

[1]Jeanniot no doubt meant to say *Christ aux Soldats*. *Le Christ aux Anges* was no longer at Manet's studio in 1882.

As soon as Manet crossed the Pyrenees, he thought about the ideas which the Japanese engravings had given him. And that is why, by a queer coincidence, but a chance which in my view was accidental, on his return from Madrid he seemed to say goodbye to Spain. Did he betray it? Not at all. He ceased almost completely to extol its sights, but he remained faithful to it in spirit, in that he continued by more penetrating means to work towards capturing on paper and canvas that vibrant expression of reality which the Spanish masters had themselves sought.

L. ROSENTHAL, *Manet aquafortiste et lithographe*, 1925

This witty city dweller, this man about town so susceptible to the attractions and the subtleties of the spirit of Paris, this conversationalist, forthright and yet sensitive, introduced into the French school of painting innovations which still give it life.

... and so the aspirations of Baudelaire in his *Salon de 1845*, and above all in his article on Constantin Guys in 1863, were confirmed and fulfilled by an art which did not limit itself to an impersonal and extremely rigid objectivity, but which was permeated by the tremors of a life of singular vigor, with a school of painting devoted to the spectacle of objects and beings, and the manners of the time; to the lively analysis of the contemporary scene; to its beauties, familiar or obscure; to its whims; to its refined amusements; to its indifference; to the poetic side of its *déshabillé*; to men and women who emerged from the gilt frames and the dim shadows of museums and passed by on the street or in a salon, and who were looked upon with a sort of ruthless charm rather than indulgence or sympathy.

H. FOCILLON, *La peinture au XIX et XX siècle*, 1928

Olympia shocks, evokes a holy terror, imposes herself upon us, and triumphs. She is a scandal, and yet an idol; a force, and the personification in public of the shameful secrets of society. Her head gives an impression of vacancy: a narrow band of black velvet separates it from the essential part of her being. The purity of a perfect line captures the essence of a model of impurity, whose very function demands an unquestioning and frank ignorance of any sense of shame. She is a carnal priestess, dedicated to absolute nakedness, who makes us ponder upon how much of primitive barbarism and ritual animalism is concealed and survives in the dress and activities of the prostitutes of the great cities.

This is perhaps why Realism is so closely associated with Manet. The Naturalists aimed at representing life and human affairs just as they are – a purpose and a program completely lacking in sophistication, but it seems to me that their positive value lies in their discovery (or rather their introduction) of poetry, and sometimes of the greatness to be found in certain objects or certain themes which until their time had been considered unworthy or insignificant.

... Emile Zola, with a fervor which, as was natural to him, easily graduated to violence, upheld then an artist very different from himself, whose force, sometimes brutal-seeming art, and boldness of vision stemmed nevertheless from a nature completely devoted to elegance, and completely infused with the spirit of that air of freedom which Paris still breathed. For all the doctrines and theories, Manet, a shrewd and sceptical Parisian, thought only of fine painting. P. VALÉRY, *Triomphe de Manet*, 1932

There is much argument over whether one should prefer the Manet of the earlier years, the admirer of the Spanish painters and Franz Hals, using a somber range of colors; whether, among the gray and black, should stand out a dominant note, sometimes of blue, sometimes of pink; or whether Manet did not really find his true means of expression until after his conversion to painting in bright colors under the influence of Claude Monet, the true creator of Impressionism. But these are pointless arguments. Manet borrowed very considerably: he borrowed from dead painters as well as from the living. It is a method which only stronger spirits can afford to use. They know that they are not compromising their originality. Whether he paints in somber or brilliant colors, whether he makes a quick sketch, whether he etches a copper-plate copy, whether he is carrying out a composition of many people or a single figure, a still-life or a landscape, Manet can be recognizable at the least touch, the least stroke, of his pencil. He makes his mark on everything that he does, and this mark is that of the painter who does not wish, as he said to his friend Proust, 'to paint what he sees', but he has a personal and very distinctive vision of nature, things and beings; he wants to achieve only the truth, and he cannot imagine anything outside the truth; but he gives the most humble objects which his hand depicts a flowing charm and innate distinction. To those works which are largely spontaneous, but which depend also on logic and reason, Manet wished, and this is not one of the least fascinating aspects of art, to impart the passion of the original impulse with all the supreme artistry which gives the appearance of ease. I say 'appears' because, in accordance with the classic rule, his very real talents enable him above all to make numerous experiments in various directions, in the course of a slow and patient build-up. There are numerous pieces of evidence which enable us to understand his methods, methods which demand the courage to which few painters have recourse. These painting sessions follow one another over a period of weeks and weeks; almost every evening the canvas is once again blank, and the painter has wiped everything out. It is this, perhaps, which explains how Manet's drawings are comparatively rare, and his personality is only half revealed in them, less completely in any case than in his etchings and lithographs. His drawings are, for the most part, quick outline sketches in which, however, the stroke of the pencil, summary as it is, is always outstandingly expressive.

In fact, Manet draws with his brush on canvas. Then he wipes it out and starts again, wipes it out afresh and starts again once more, so that the picture that we finally see represents the final stage of a number of successive attempts, in which the drawing which had a natural grandeur, played a fundamental role.

Manet understood instinctively that art, which is our most

certain weapon, and indeed the only one we have to conquer death, aims at the eternal. P. JAMOT, *Réalité ou poésie*, 1932

In Manet's youth, the factor which had a real bearing on the formation of his mind and which set him problems which he was to make indissolubly his own, was the encounter with Spanish art. Spain must have seemed to Manet not only an old country with excellent painting, but a real and living world, exotic and yet on the door-step, on which he could draw freely.

. . . Another fact linked him with Velasquez (rather than with 17th-century Holland) and this was an exclusively pictorial one: the liking for rapid and economical painting. Economy is an extremely ancient painting phenomenon: instinctively the most ancient painting is the most summary. But the archaic brevity, whether in a 5th-century vase or a 13th-century French mini-ature, should not be confused with brevity in the interests of truth, which is what we are dealing with here. Psychologically, they are very different. The first is a highly simplified image, remote from its perceptive sources, which has become a purely imaginative language. The second, on the other hand, is still linked to a whole combination of perceptions which have been organized, simplified and brought, still palpitating, to the clarity of an arabesque. G. CASTELFRANCO, *La Pittura moderna (1860–1930)*, 1934

Today, after half a century of ardent restitution, a certain impatience with Manet has now re-appeared. Nowadays, it is the *avant-garde* who take him to task, first for frequenting the museums and second for not placing himself decisively at the head of the first Impressionists. Everyone owes something to him but, as usual, they are weary of gratitude.

As I see it, at the outset Manet captured from the Italy of Tintoretto, the Spain of Velasquez and the Holland of Franz Hals, a delight in sumptuous color, simply to give it to the people of his day. E. RADIUS, *Quel matto di Manet*, 1945

It has been said that Manet did not know how to paint a single square inch of flesh, and that *Olympia* was drawn in steel wire: one forgets, however, that before wishing to 'draw' *Olympia*, or to paint flesh, he wanted to paint pictures.

The pink dressing gown in the picture of *Olympia*, and the blue material in *Déjeuner sur l'Herbe*, would seem to be patches of color and their substance is a pictorial substance, not a repre-sentation of materials. The picture, whose background had been a gap, now becomes a surface, and this surface becomes not only the right objective, but the only objective. The most supercilious sketches of Delacroix were, even so, dramatizations; what Manet undertakes in certain of his pictures, is a repre-sentation of the world. Now, if it had already happened that his style had attained that degree of autonomy which it was hence-forth to lay claim to, it had always been at the surface of a passion, of which painting was only the means of expression. 'The purpose for which the world was created was the produc-tion of a good book', said Mallarmé; how much better a purpose would be the restoration of the tradition of delight in painting. Then, the reconciliation of colors with each other, freed from tones of brown and coats of varnish, makes its specific impact. A. MALRAUX, *Psychologie de l'Art – Le Musée imaginaire*, 1947

When, in his youth, Manet read in Diderot's *Salons* that 'when a people's clothing is mean, art should leave costume alone', he exclaimed: 'What rubbish! One must belong to one's time and paint what one sees.' To be of his time, and to paint according to his emotions, was Manet's constant goal and he scandalized that bourgeoisie from which he sprang. A sophisticated spirit and a man of elegance, Manet was, perhaps, the first painter since the 16th-century Venetians to plunge into life and to transform it into pictures purified through poetry, listening to his emotions, and to his emotions alone: to emotions which put him in a state of grace vis-à-vis his subject, whether figure or landscape, so that he was able to capture it with outstanding freshness and elegance. With Manet fell all the traditional barriers between inspiration and realism; in other words, all the conventions put forward by the Romantics, the Neo-Classicists, the Naturalists and the Academics. In front of his subject he felt only the vibrations of an artist's emotions, which took on life in color, and in color which, as with the Venetians, was under-stood from a tonal point of view; that is to say, in its values of luminosity and not of chiaroscuro. So the modeling by means of chiaroscuro disappeared. The color zones are placed side by side in their freshness, with flowing brushstrokes, contained within an incisive and sensitive line. In what was therefore the coherent development of his painting career, Manet was creat-ing a new way of looking at things which was direct and aggres-sive, by means of which the image takes on the intensity of the unreal, caught in the fleeting impression. His pictorial form, increasingly flowing and 'abbreviated', as Signora Brizio notes, accentuates this magical intensity of the physical and spiritual moment which is caught as it develops.

If the recognition of the *classicism* of Manet's art is a certainty which has been acquired by his critics little by little, it is perhaps not yet brought fully to light, as Focillon (1928) devined, that the sincerer and more original part of Manet's personality was developed in the period in which the luminous atmosphere of *plein-air* heightened the timbre of his color; when, that is, he succeeded in expressing his sensitivity completely, far beyond all cultural demands.

It is in this most profound and burning sincerity that Manet's greater powers of innovation lie. R. PALLUCCHINI, *Gli Impressionisti alla XXIV Biennale di Venezia*, 1948

The delicacy of color-blending, the great mastery with which he harmonized the blacks, grays and white, enlivening them with strong but delicate touches which are both unexpected and enchanting, the ability to unite, in the technical process, a limpid warmth of line and values and an execution that was rich in character, all these rare endowments of the authentic painter . . . J. REWALD, *History of Impressionism*, 1949

Today we see, in the best of Manet's work, a perfect art, easy to understand and already familiar, and we marvel at the fight which he had to put up throughout his life to obtain recognition of his artistic worth, and at the dislike which continued after his death and which, even now, re-emerges sporadically. From this springs the doubt that our admiration is not enough for a critical understanding of Manet and it is necessary to return to the polemics which he aroused, in order to understand both the

aspects of his art; the lasting aspect which we enjoy today and the aspect governed by the times from which it came.

. . . Giorgione, Titian, Velasquez, Delacroix and Courbet all painted female nudes, some more and some less realistically. But they all had the precise intention of representing the beauty of the woman, in accordance with the age-old opinion which distinguished the beautiful woman from the rest. And even Goya, too, obeyed this convention. Manet, on the other hand, cared not a fig for it. Probably the nude study of Victorine Meurent was very much more beautiful than the one Manet painted in *Olympia*. This would seem most likely from *Déjeuner sur l'Herbe*. In *Olympia* the nude figure is four-square, in a pose adapted to relate the expanse of flesh to the surface, with neither modeling nor semi-modeling, as if it were rendered in flattened relief in which the mass of the raised material is thicker than it appears to be. This conception of the nude is fully consonant with the way of constructing all the other light areas of the picture . . . He sacrificed to this ideal all that femininity to which he was so sensitive in his worldly life. For its sake, he reduced his Victorine to something between an idol and a marionette. Beauty, truth, life, he absorbed everything in art . . . The originality of Manet consists really in the direction marked out by his way of conceiving and executing a painting, because the origin of that direction can only be found in himself.

Manet, in fact, did not create an ideology in painting as did Delacroix with *Le 28 juillet 1830* or Courbet with his *Casseurs de Pierres*. No ideology comes down from Manet. *Musique aux Tuileries* has been mentioned as one, and this was the ideology of modern life, already put forward by Courbet and with which, however, Manet did not persist . . . But if he did not invent an ideology, Manet did create figures which have come to be admired for themselves, because they exist and make their presence felt through their artistic life, parallel to the life of natural things, but not to be confused with them. The figures do not act, do not communicate any specific emotions or passions and thus, as has been observed, their eyes have no expressive function; their value consists in their existence as aesthetic life. . . .

His rebellion at the Academy was a rebellion of form, not of subject. He felt the necessity to consider line as a means of separation, rather than as a contour, to reduce chiaroscuro to its smallest terms and to disregard three-dimensional space. In this way, he obtained a strong sharpness of figures, a rich coloration, even in black, and an emergence of the figure (in relief, as it were) which was both more compelling and more externally presented, reduced to flattened relief and detached from the atmosphere. The three cardinal points upon which Manet's style turns are: sharpness of figures, rich and intense coloration arising from the elimination of chiaroscuro and composition in surfaces. L. VENTURI, *Da Manet a Lautrec*, 1950

Manet's crisis is a spiritual crisis. His style is the sequel, the consequence or the immediate effect of a state of moral incapacity for an inner life both harmonious and in accord with the relationship between a sentient being and the world around him. W. GEORGE, *Manet et la carence du spirituel*, 1950

. . . (Manet) was born in the age of Realism, the age of Courbet, that other splendid outcast. He took part in the fight for Realism, and he was the friend of Zola, his passionate defender . . . but his urge for pure painting already goes beyond Realism.

Zola, eager for justice, could feel for him because he saw in him a victim of bourgeois stupidity and hypocrisy, a fine genius treated as a pariah by society, but he did not realize, and could not realize, the strictly plastic nature of that quality in Manet which shocked society. To be sure, Manet, a contemporary of artistic Realism and literary Naturalism, was looking for truth, but what he was looking for even more was truth in painting. If he takes an interest in the various aspects of modern life, it is from contempt of conventional or academic subjects and, in a deeper sense, indifference to the subject itself. He paints the clothes of his period, but without the good-natured humor introduced by those on whom Baudelaire bestows the titles of painters of modern life, those who breathe life into the 'modern movement'. He paints modern clothes because it is these clothes which are before his eyes, and in the way that he would paint anything else. For anything can be the subject of painting; this idea leads him naturally to select in their entirety those elements which are nearest to hand and commonplace. J. CASSOU, *Manet*, 1954

(Manet) 'was the first', Matisse notes, 'to act instinctively, and so simplify the craft of painting . . . only expressing whatever made an immediate impact upon his senses'. When bourgeois values, conventional skills and academic functions were at the height of their power, he introduced, with impeccable charm, pure painting which had no other secret but its own clearness and self-discipline. J. LEYMARIE, *L'Impressionisme*, 1955

. . . Manet conveyed in painting, with a quick and almost aggressive sensitivity, those aspects of contemporary life which were of most interest to his elegant and acute spirit of a Parisian *boulevardier*. In this he differed from another great painter of modern life, who by comparison with him was in advance and, in a certain sense, more radical and weightier, almost a 'new Caravaggio'; Gustave Courbet. G. A. DELL'ACQUA, *Gli Impressionisti francesi*, 1955

In the history of art the name of Manet has a meaning of its own. Manet is not only a very great painter; he broke with those who went before him. He initiated the period in which we live, in harmony with the world as we know it today, but out of tune with the world in which he lived, and which he scandalized. Manet's painting brought about a sudden change – a sharp upset for which the word revolution would be fitting, did it not give rise to ambiguity. The change in the spiritual climate which his painting exemplifies differs, in essentials at least, from the changes of political history. G. BATAILLE, *Manet*, 1955

Whether his subject was taken from life or inspired by a picture in a museum, Manet always made his work his own. With few intellectual interests, and as an artist of directness and impulse, compositional inventiveness interested him but little. His inspiration turned to and was expressed in the newness of pictorial rendering. His method of presenting his subjects is a truly formal economy of line. Those great black marks which outline *Olympia* in irregular and interrupted line are, in themselves, a

summary and the result is to make the picture emerge strongly. Equally, *Le Fifre*, another of his most famous pictures, is boldly framed in gray with no indication of setting, and set firmly on the ground, though this is not, in fact, shown in clear material form.

For his indifference to the rhetoric of his subject, Manet has been called a pure painter, first of all by Zola and then by many of the major critics of the 19th century. To tell the truth, the definition was meant as a eulogy but has lent itself to ambiguity; as if so much painterly felicitiousness was accompanied by a slight and superficial quality of spirit. But this is not the point! Manet's way of feeling was brought to life with such immediacy in his painting that it is not possible to extract from it the cerebral and rhetorical residue which was so abundant in the majority of 19th-century artists, who were able to give the illusion of greater spiritual complexity. There is nothing of all this in Manet; there is nothing but the freshness of a lively and direct sensation. And there, impartial, but always in the foreground, was the inviolable Manet himself, with his way of reacting to things, his emotions which took him by surprise, his bold air, his easy boastfulness, which had their release – and this is what alone is worthwhile and makes them vivid – in his sensitivity to nuances and elegance. A. M. BRIZIO, *Ottocento-Novecento*, I, 1939

I knew him but for a short time, for he died when I was beginning to paint, but I was counseled by him, and I have the remembrance, a vivid one, of his charming manners and his urbanity with its tinge of irony, of his witty chaff and his charming face of a fair man growing gray. Dressed like a clubman, he leaned upon a cane, with a rubber tip, dragging his lame leg shortened by the amputation of the foot. Although he knew that he was very ill, he preserved a smiling serenity of demeanor, welcomed many friends in his studios in the Rue d'Amsterdam, where they repaired at about five o'clock in the afternoon, now that he was unable to walk along the boulevards.

. . . Manet used very fine white canvas without grain, and, seated in front of his subject, appears to have given the canvas a thin coating of oil which he wiped off before beginning to paint; the oil put on in such a way that every touch of his brush was as smooth as that of a water-color brush. The touch, once made, and barely joined to the next, the liquid, yet dense pigment, owing its solidity to the accuracy of the tone, that touch left as it was made, unctuous, plastic, firm, did not prevent the breathing of the canvas, for it did not close the pores of it. J. G. BLANCHE, translated by F. C. de Surnichrast, *Manet*, 1925

Monsieur Manet has been exhibiting or trying to exhibit his pictures since 1861.

This year he has decided to present to the public the whole of his work.

When he first showed in the Salon, Monsieur Manet received a good notice. But later, when he found that he was so often turned down by the jury, he realized that the first stage in an artist's career is a battle, which at least should be fought on equal terms, that is to say that the artist should be able to show the public what he has done . . . Without this opportunity, the painter would become too easily imprisoned in a circle from which there is no escape. He would be forced to make a pile of canvases or roll them up in an attic.

Official recognition, encouragements and rewards are in fact regarded as a hall-mark of talent; the public has been informed already what to admire and what to avoid, according to whether the works are accepted or rejected. On the other hand an artist is told that it is the public's spontaneous reaction to his pictures which makes them so unwelcome to the various selection committees. In these circumstances the artist has been advised to wait; but wait for what? Until there is no selection committee? He would be much better off if he could thrash the question out directly with the public. The artist today is not saying, 'Come and see some perfect pictures', but, 'Come and see some sincere ones'.

It is sincerity which gives to works of art a character which makes them appear an act of protest, when in fact the painter has only thought of rendering his own impressions.

Monsieur Manet has never wished to protest. On the contrary, the protest, entirely unexpected on his part, has been directed against himself; this is because there is a traditional way of teaching form, methods and manner of looking at a picture, and because those who have been brought up to believe in these principles will admit no others. It makes them childishly intolerant. Any works which do not conform to these formulas they regard as worthless; they not only provoke criticism, but hostility and even *active* hostility. To be able to exhibit is the vital concern, the *sine qua non* for the artist, because it happens that after looking at something for some while, one becomes familiar with what seemed before to be surprising, or if you will, shocking. Little by little it becomes understood and accepted. Time itself imperceptibly refines and softens the original hardness of a picture.

By exhibiting, an artist finds friends and allies in his struggle for recognition. Monsieur Manet has always recognized talent where he has met it; he had had no pretensions to overthrow old methods of painting or to create new ones. He had simply tried to be himself and no one else.

Further, Monsieur Manet has met with valuable encouragement and recognizes how, day by day, the opinion of men of real discernment is becoming more favorable. It only remains now for the artist to regain the goodwill of a public who have been taught to regard him as an enemy. MANET, foreword to the Exhibition of 1867

The paintings in color

List of plates

In the captions beneath each plate are given the actual measurements (width) of the painting in centimeters, or the measurements of the detail illustrated.

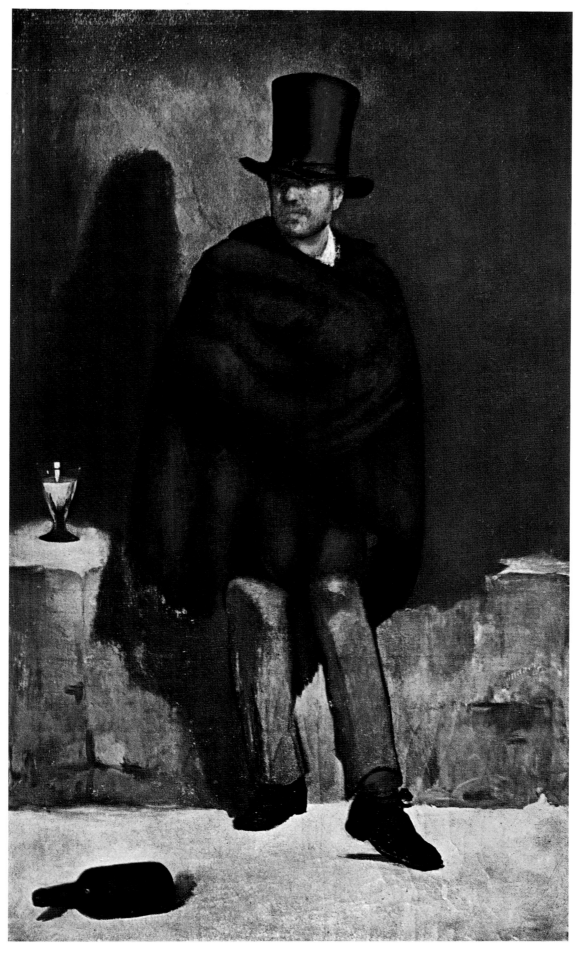

PLATE I THE ABSINTHE DRINKER Ny Carlsberg Glyptotek, Copenhagen
Whole (106 cm.)

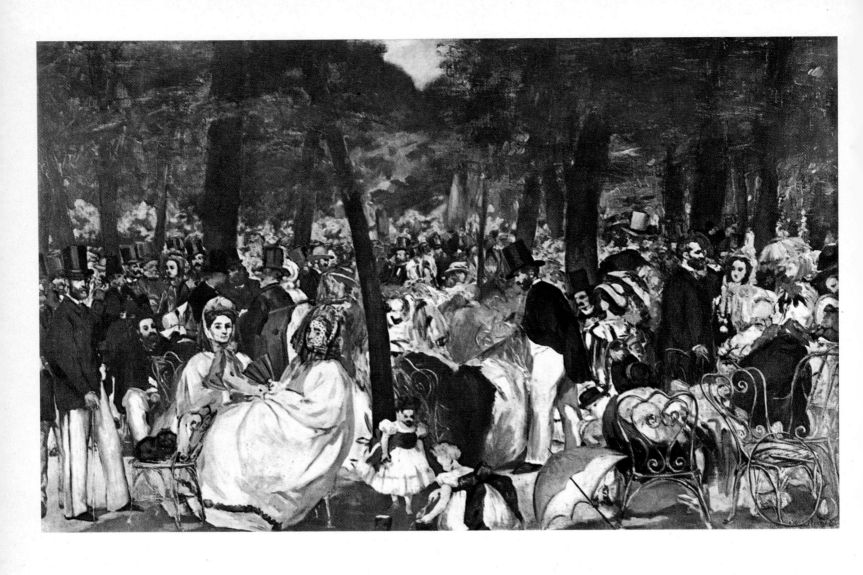

PLATE II MUSIC IN THE TUILERIES GARDENS National Gallery, London
Whole (119 cm.)

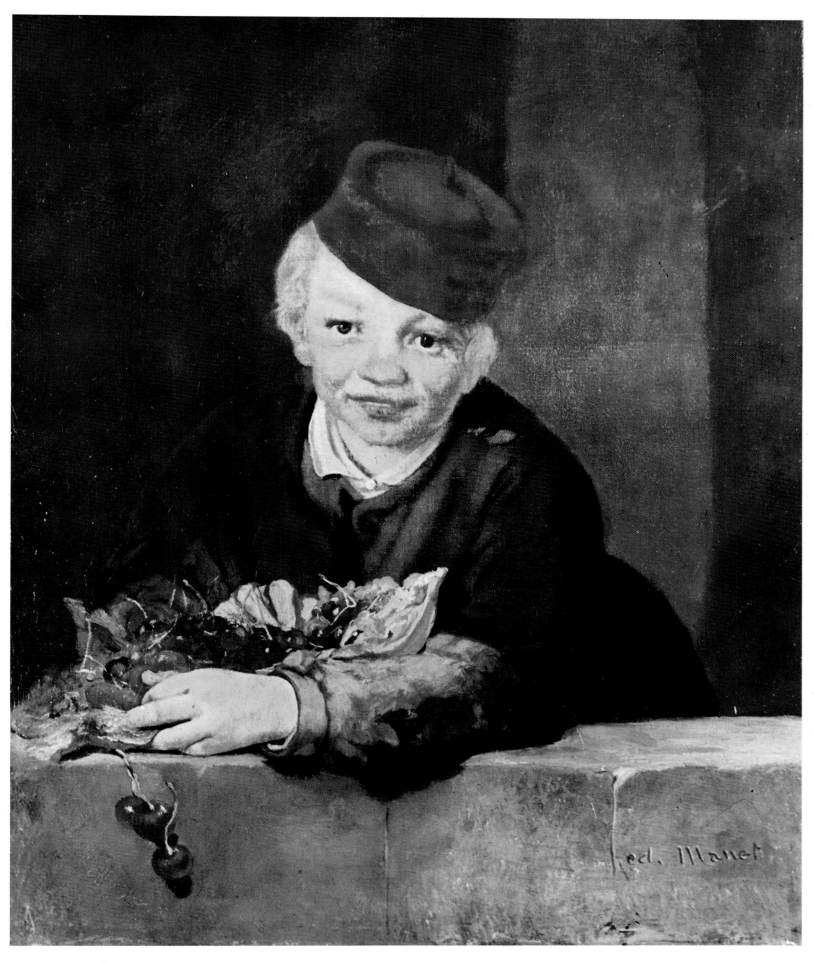

PLATE III THE BOY WITH THE CHERRIES Fundação Calouste Gulbenkian, Oeiras
Whole (55 cm.)

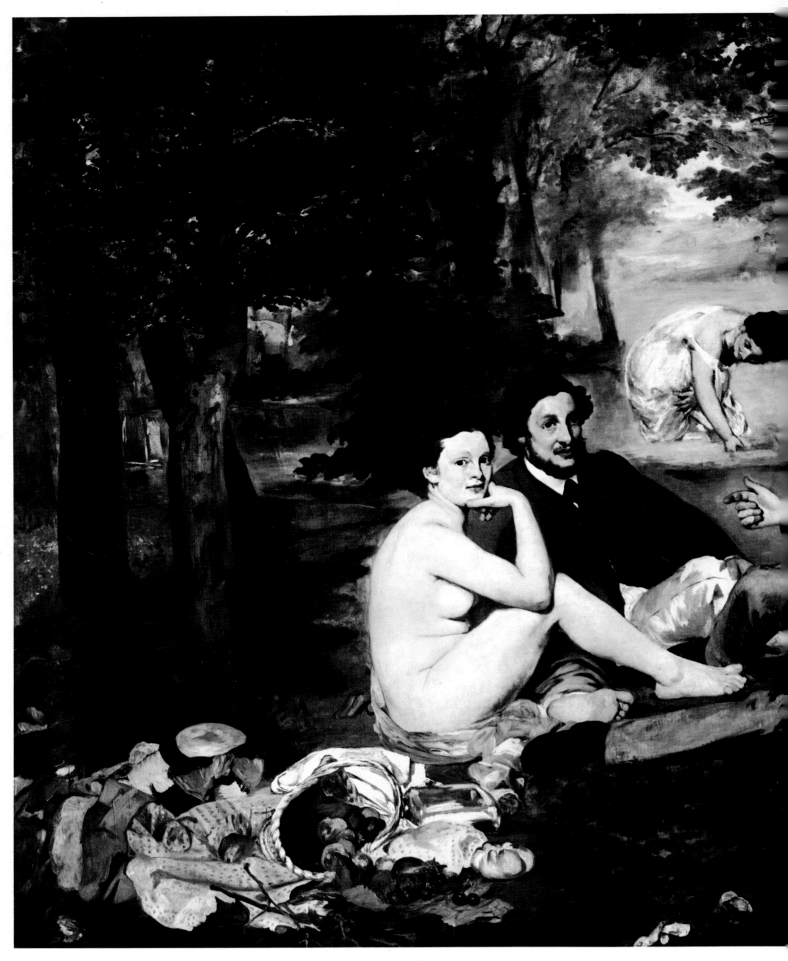

PLATES IV-V THE PICNIC Jeu de Paume, Louvre, Paris
Whole (264.5 cm.)

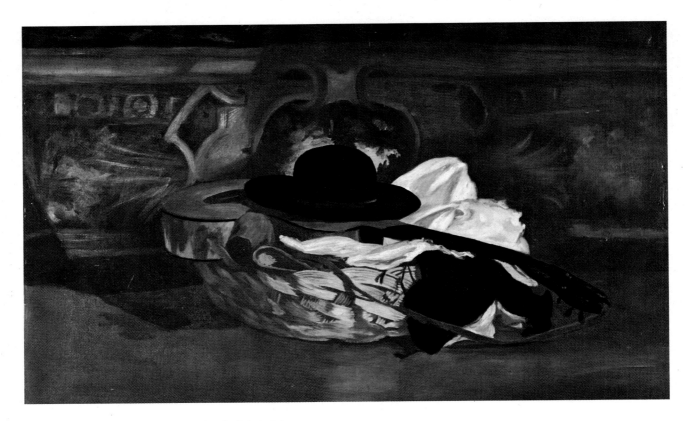

PLATE VI A STILL-LIFE, GUITAR AND SOMBRERO Musée Calvet, Avignon
Whole (121.5 cm.)

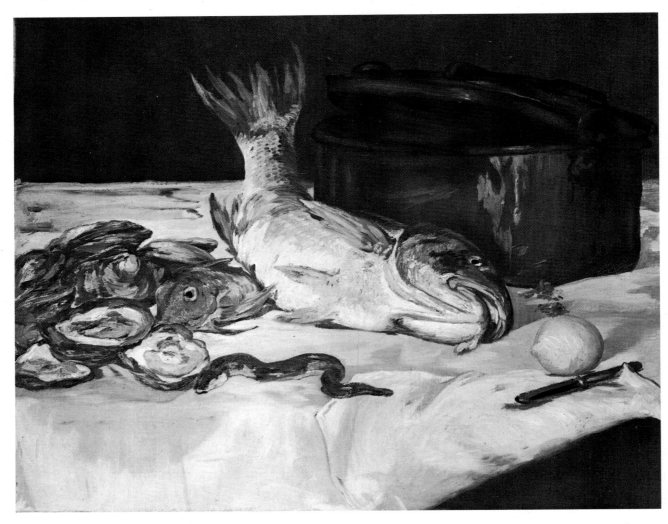

PLATE VI B STILL-LIFE, OYSTERS, EEL AND RED MULLET Art Institute, Chicago
Whole (92 cm.)

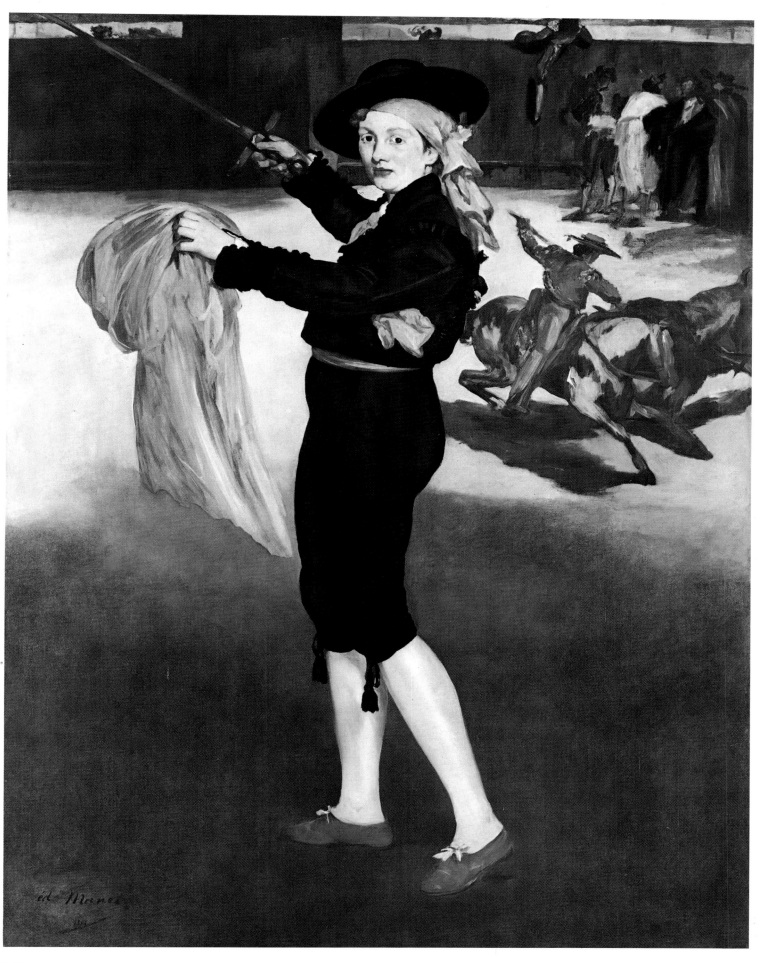

PLATE VII MLLE VICTORINE IN THE COSTUME OF AN ESPADA Metropolitan Museum, New York
Whole (129 cm.)

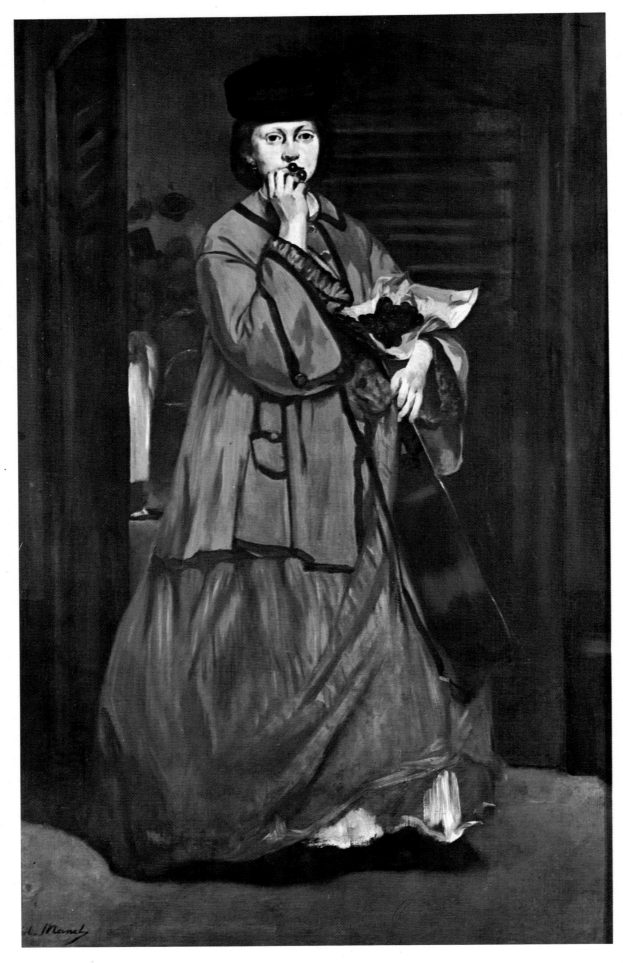

PLATE VIII THE STREET SINGER Museum of Fine Arts, Boston
Whole (109 cm.)

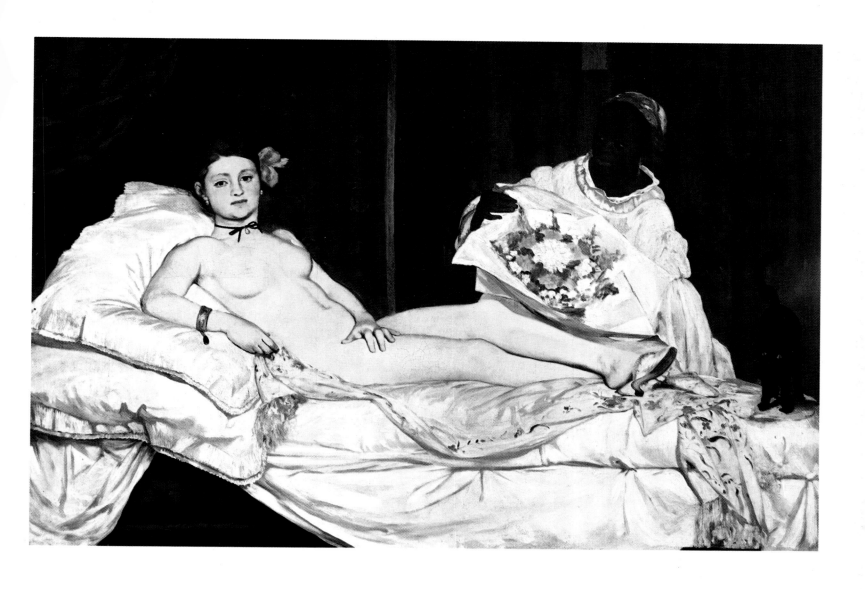

PLATE IX OLYMPIA Jeu de Paume, Louvre, Paris
Whole (190 cm.)

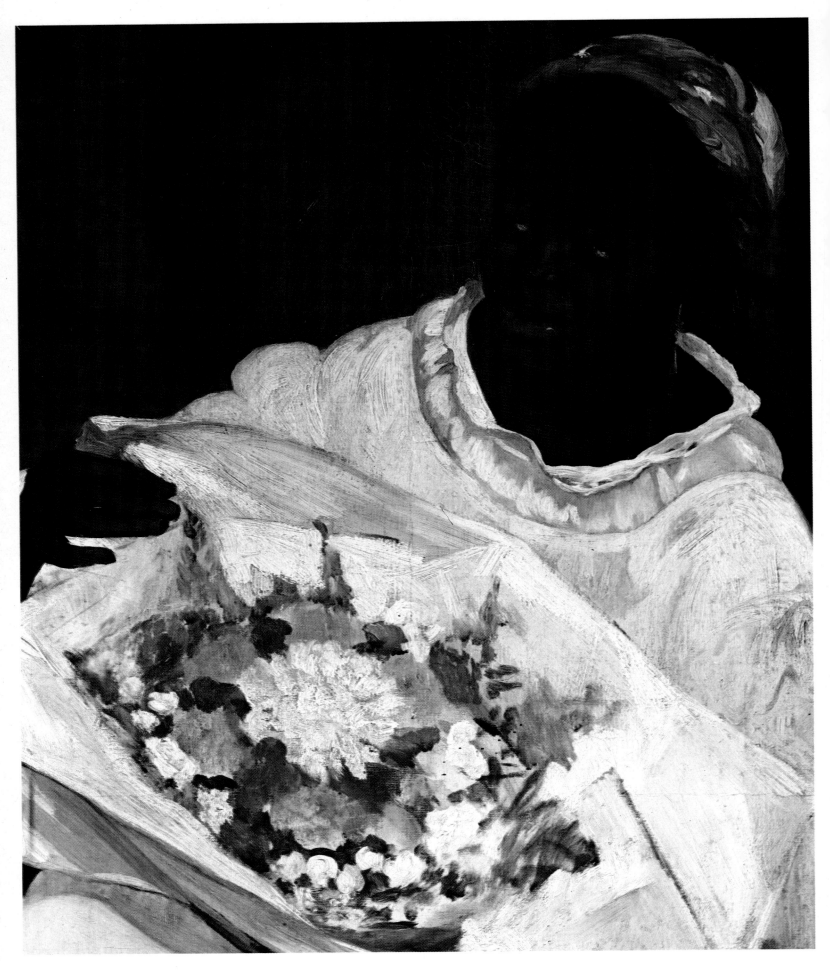

PLATE X OLYMPIA Jeu de Paume, Louvre, Paris
Detail (50 cm.)

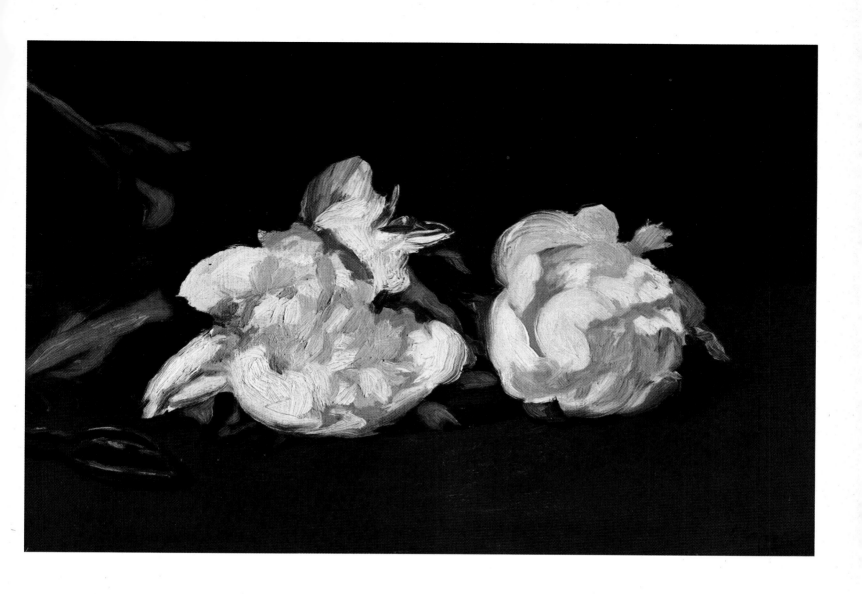

PLATE XI BRANCH OF WHITE PEONIES AND SECATEURS Jeu de Paume, Louvre, Paris
Whole (46 cm.)

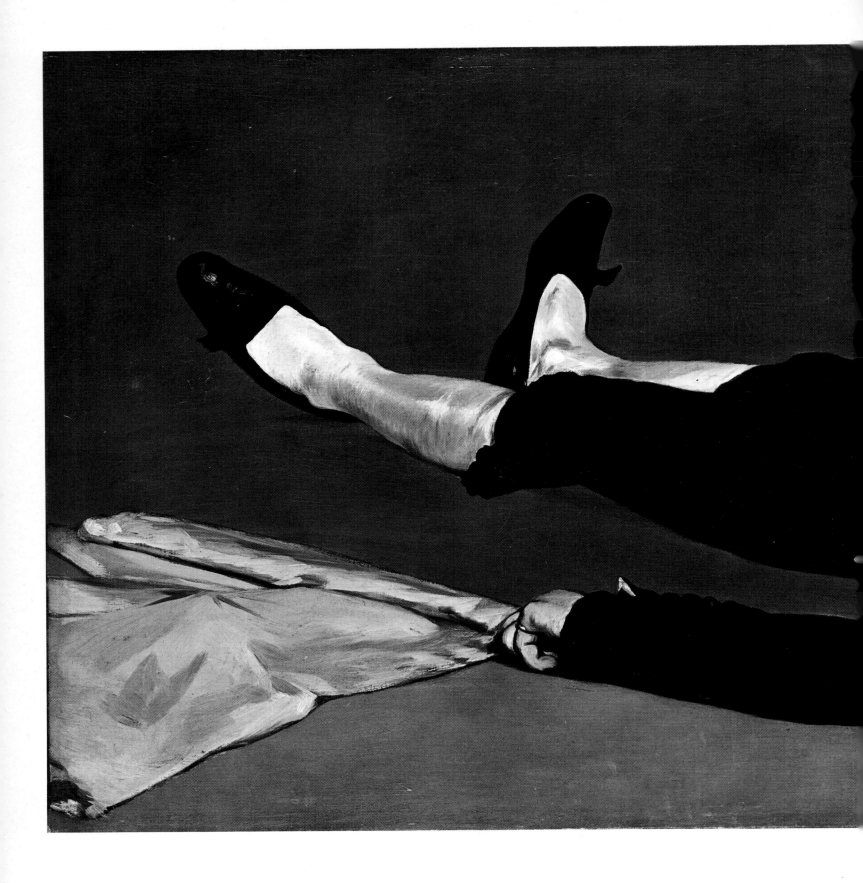

PLATES XII-XIII THE DEAD TOREADOR National Gallery of Art, Washington
Whole (154 cm.)

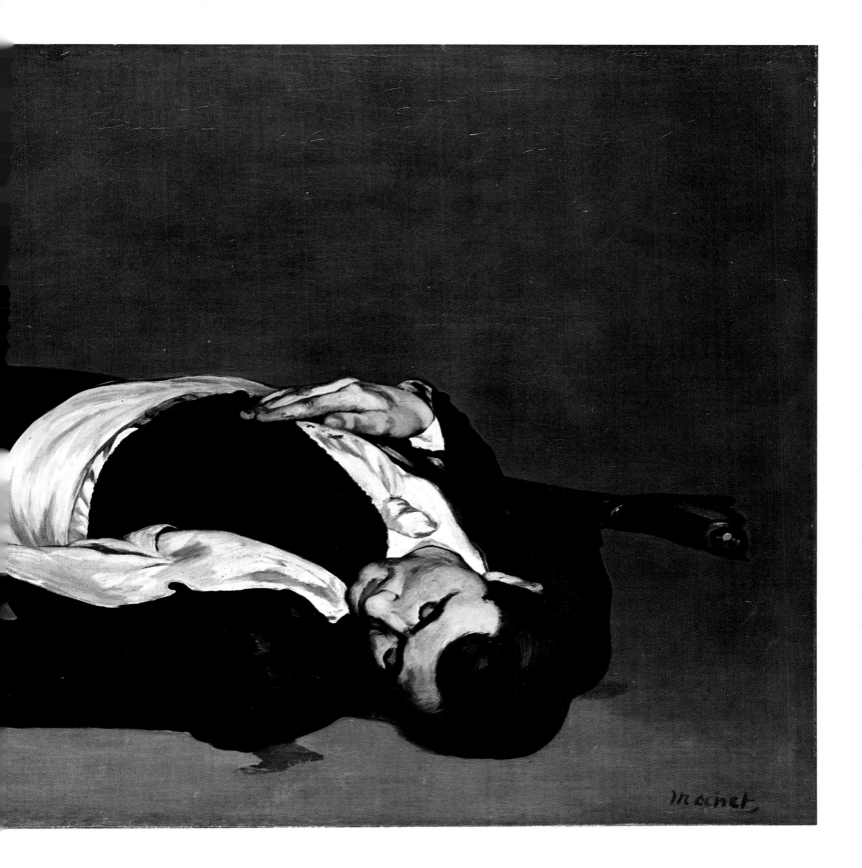

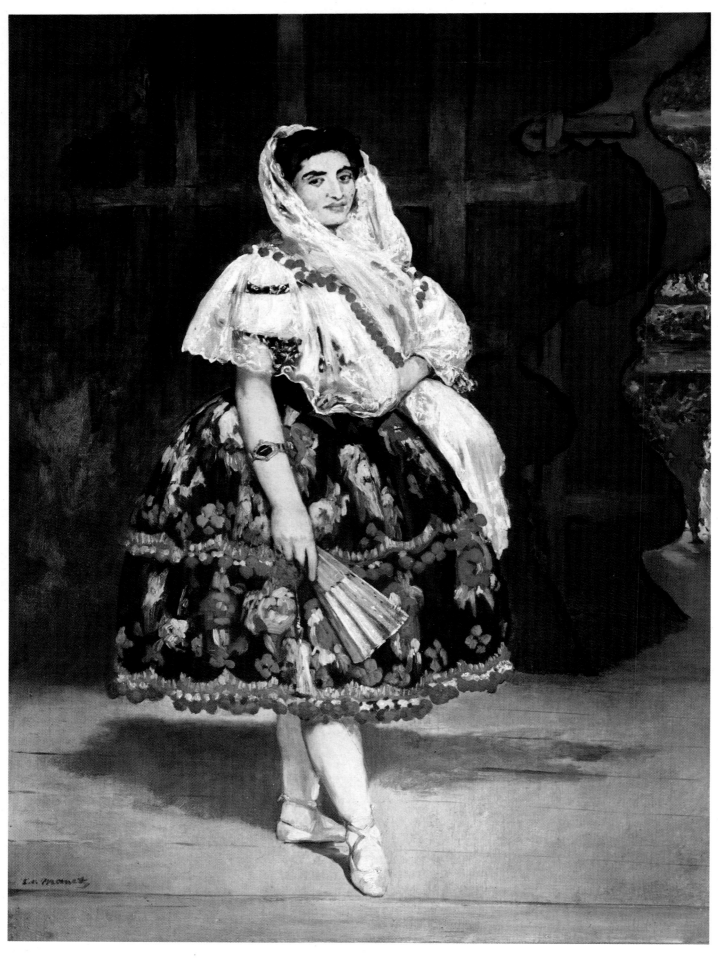

PLATE XIV LOLA DE VALENCE Jeu de Paume, Louvre, Paris
Whole (92 cm.)

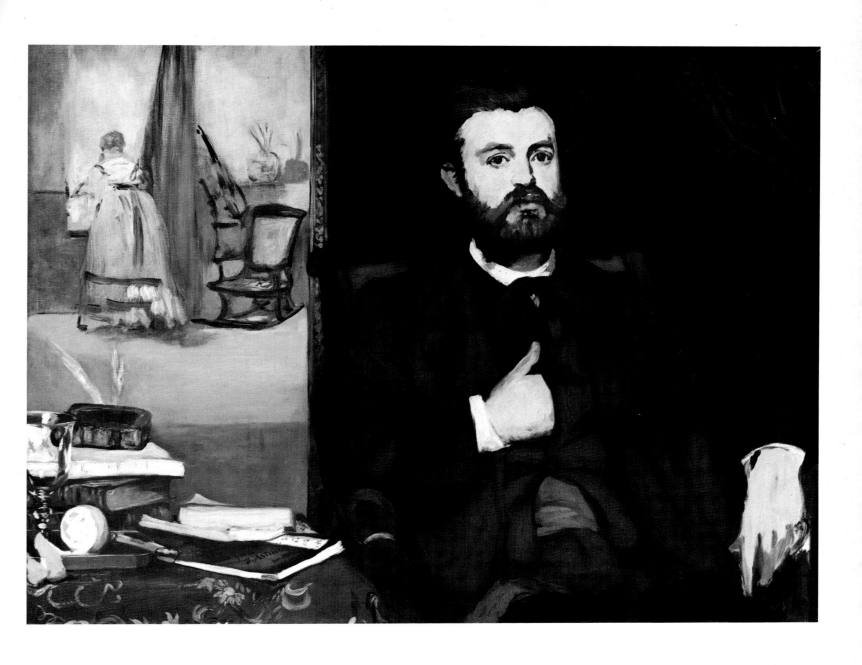

PLATE XV PORTRAIT OF ZACHARIE ASTRUC Kunsthalle, Bremen
Whole (116 cm.)

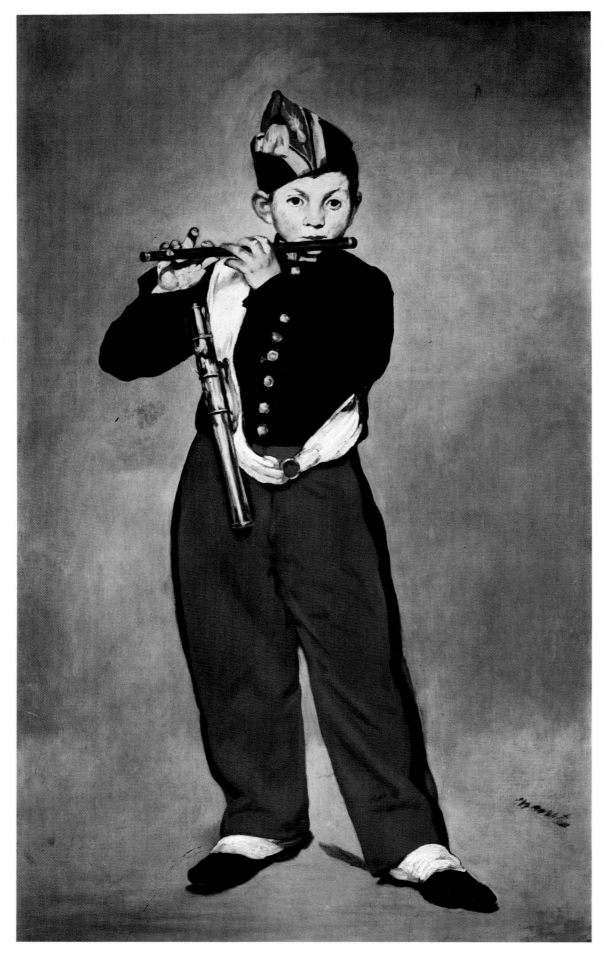

PLATE XVI THE FIFER Jeu de Paume, Louvre, Paris
Whole (97 cm.)

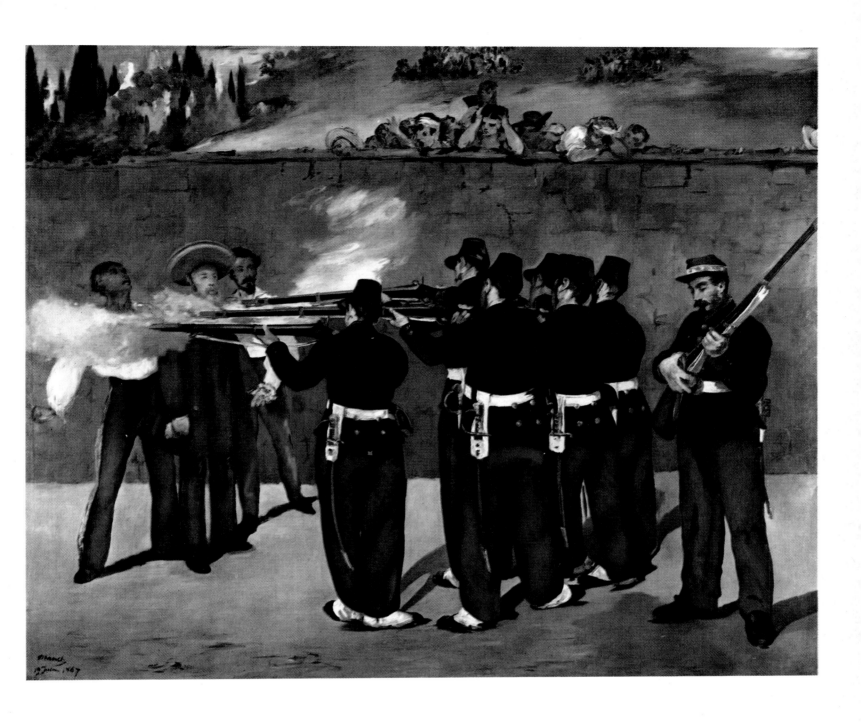

PLATE XVII THE EXECUTION OF MAXIMILIAN Kunsthalle, Mannheim
Whole (305 cm.)

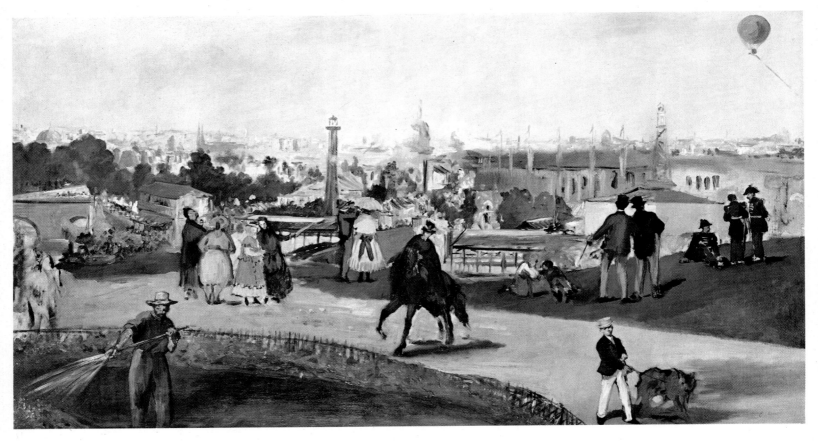

PLATE XVIII A VIEW OF THE INTERNATIONAL EXHIBITION, 1867 Nasjonalgalleriet, Oslo
Whole (196 cm.)

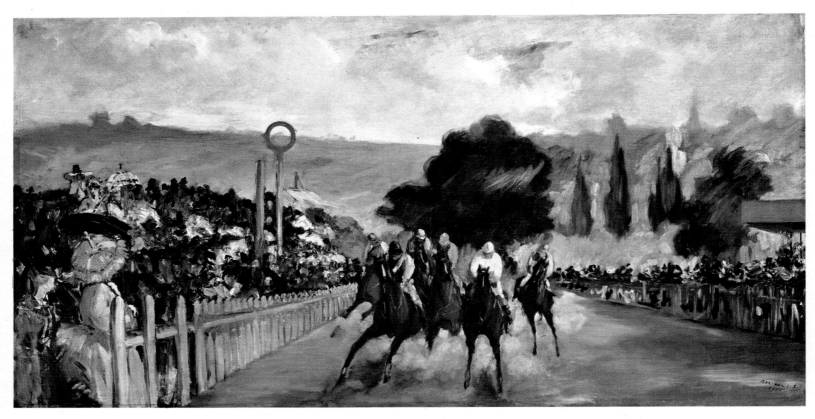

PLATE XVIII B RACING AT LONGCHAMP Art Institute, Chicago
Whole (84.5 cm.)

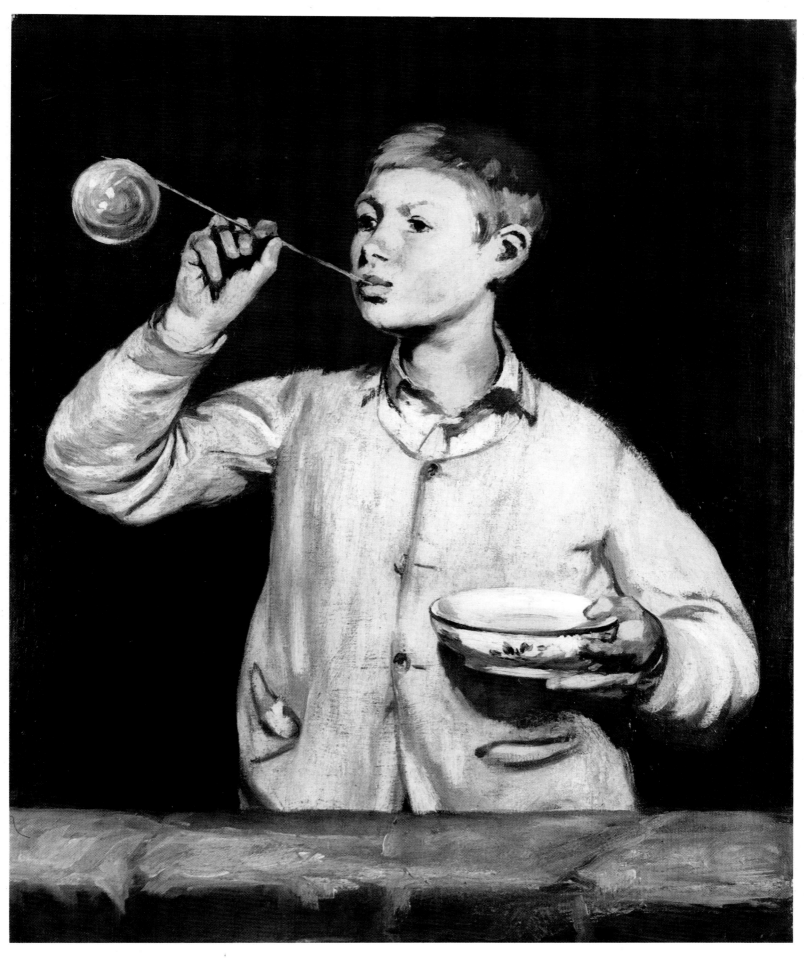

PLATE XIX BOY BLOWING SOAP BUBBLES Fundação Calouste Gulbenkian, Oeiras
Whole (82 cm.)

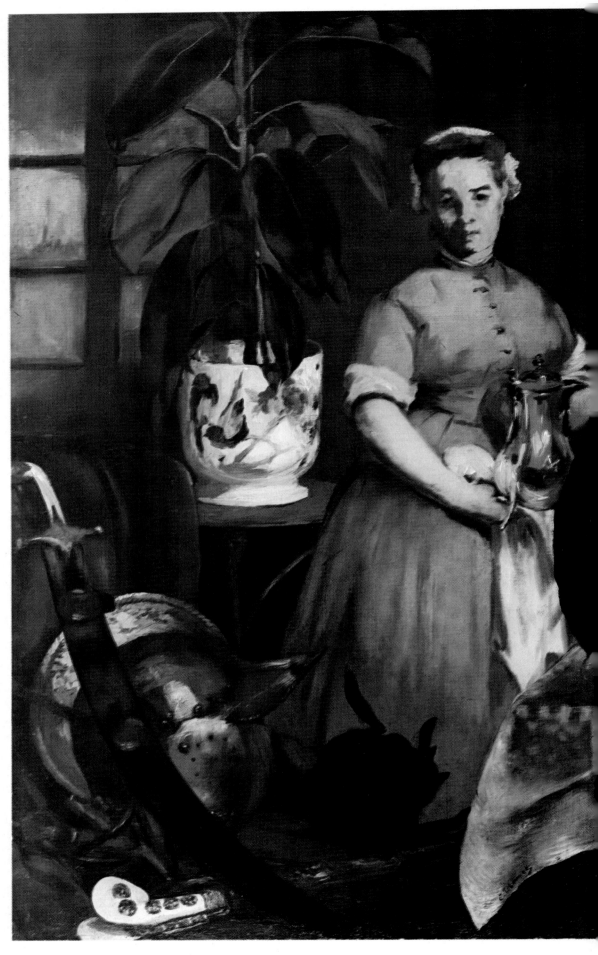

LUNCHEON IN THE STUDIO Neue Pinakothek, Munich
Whole (154 cm.)

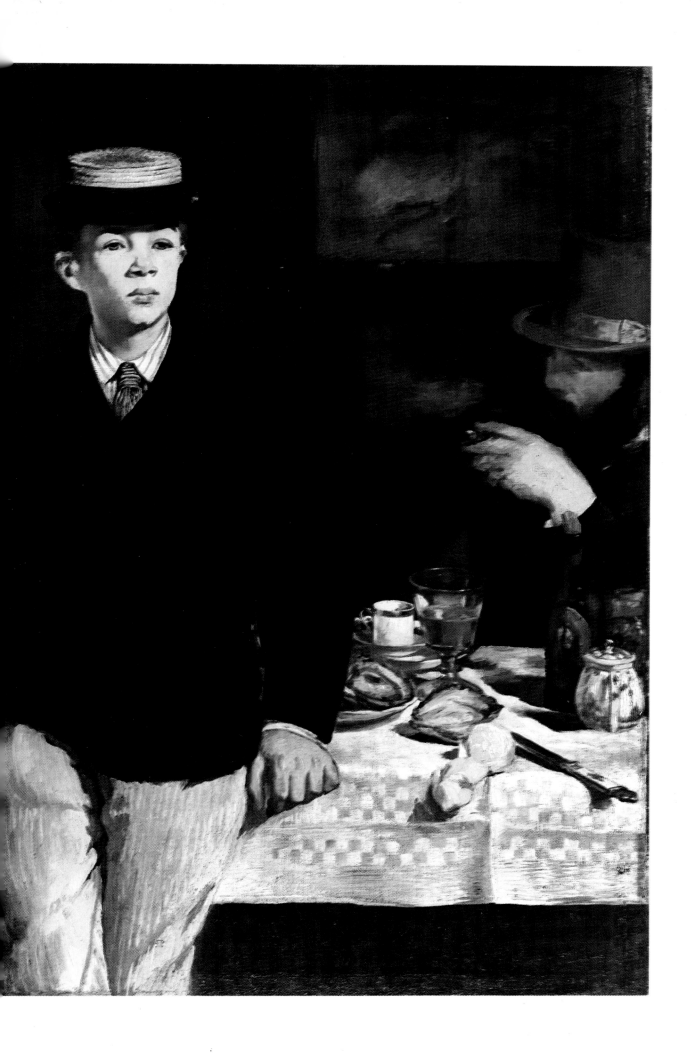

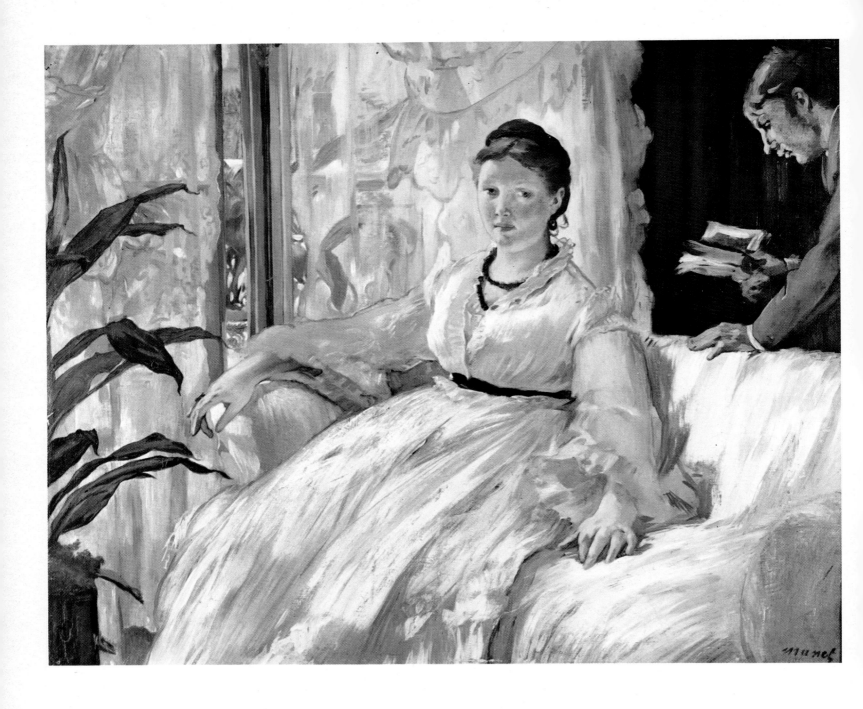

PLATE XXII READING Jeu de Paume, Louvre, Paris
Whole (73.5 cm.)

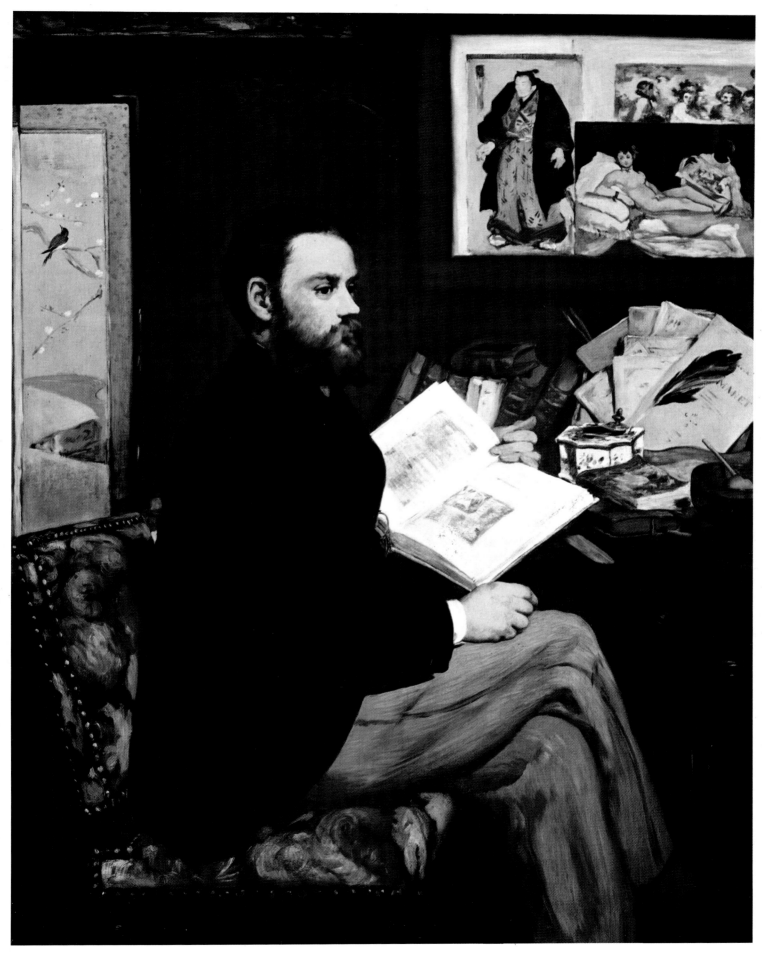

PLATE XXIII PORTRAIT OF EMILE ZOLA Jeu de Paume, Louvre, Paris
Whole (114 cm.)

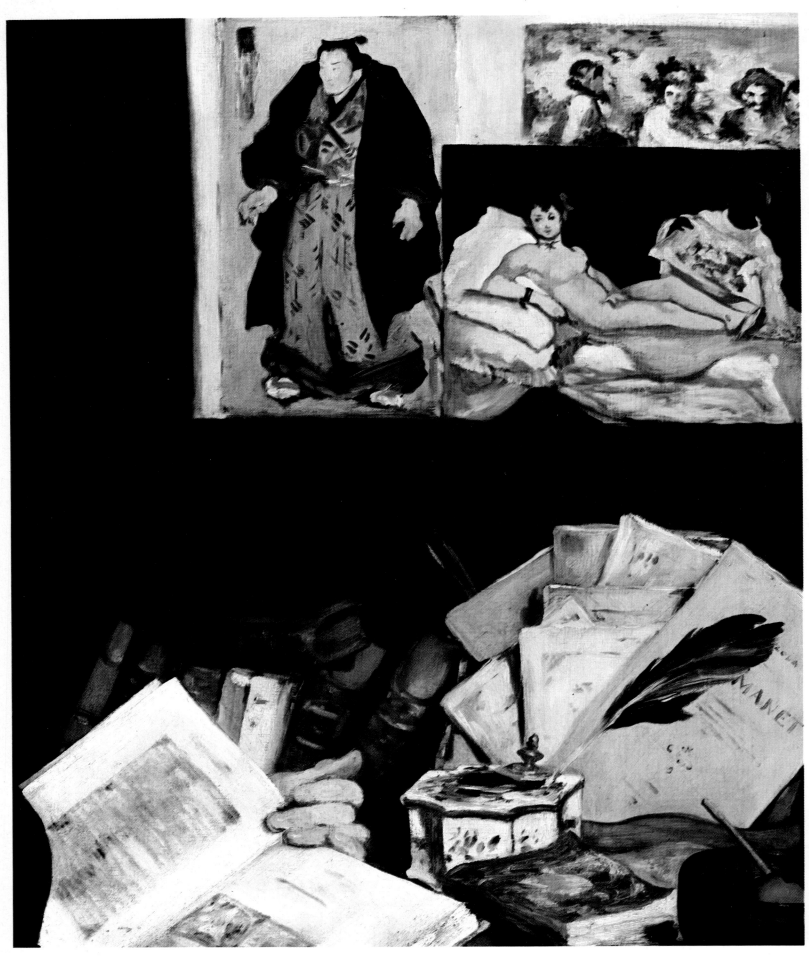

PLATE XXIV PORTRAIT OF EMILE ZOLA Jeu de Paume Louvre, Paris
Detail (58.5 cm.)

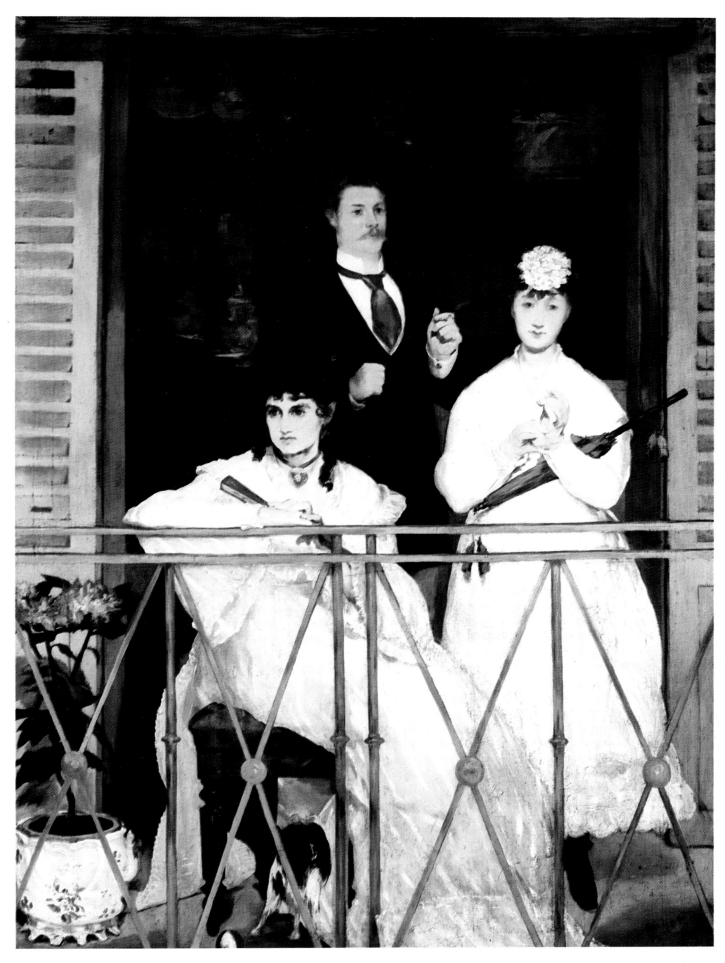

PLATE XXV THE BALCONY Jeu de Paume, Louvre, Paris
Whole (124.5 cm.)

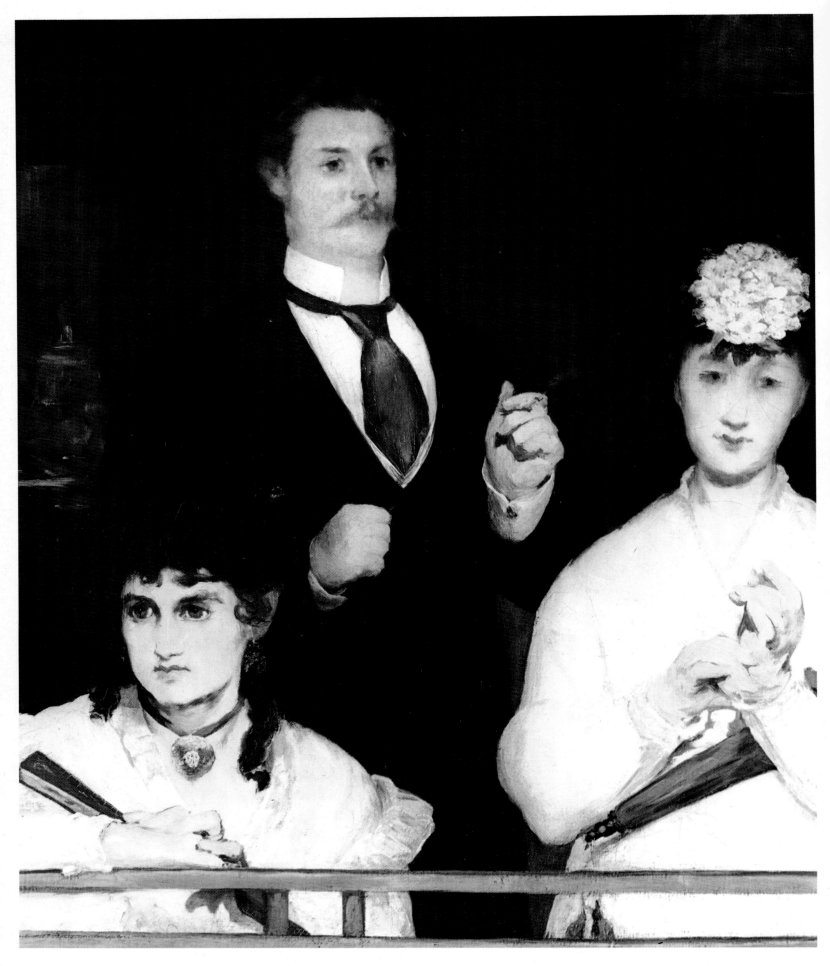

PLATE XXVI THE BALCONY Jeu de Paume, Louvre, Paris
Detail (65 cm.)

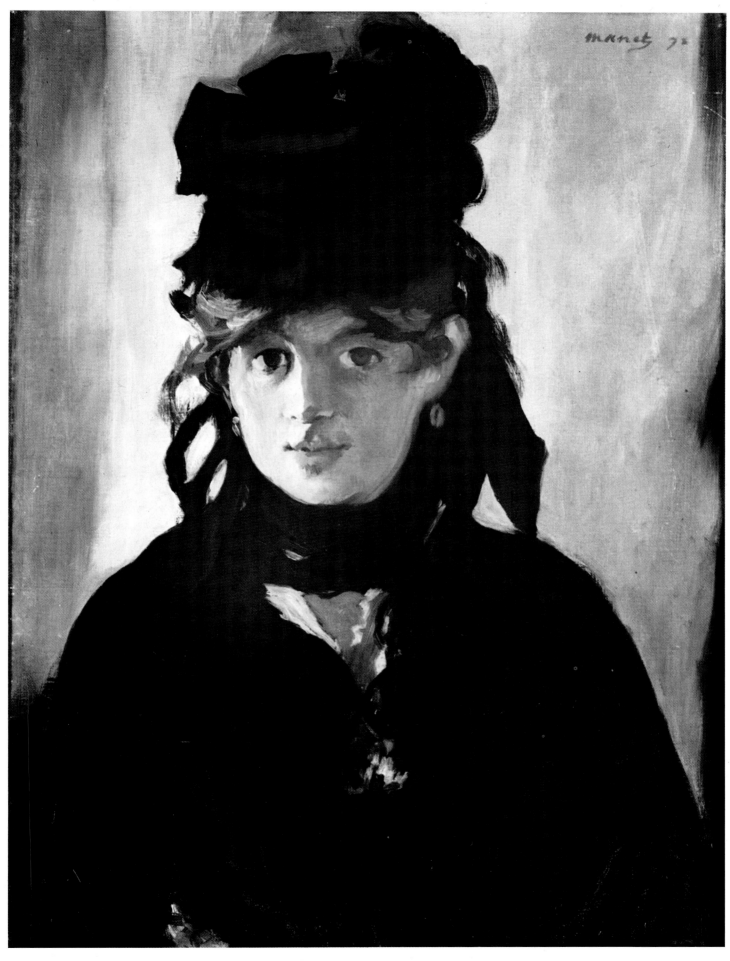

PLATE XXVII PORTRAIT OF BERTHE MORISOT Rouart Collection, Paris
Whole (38 cm.)

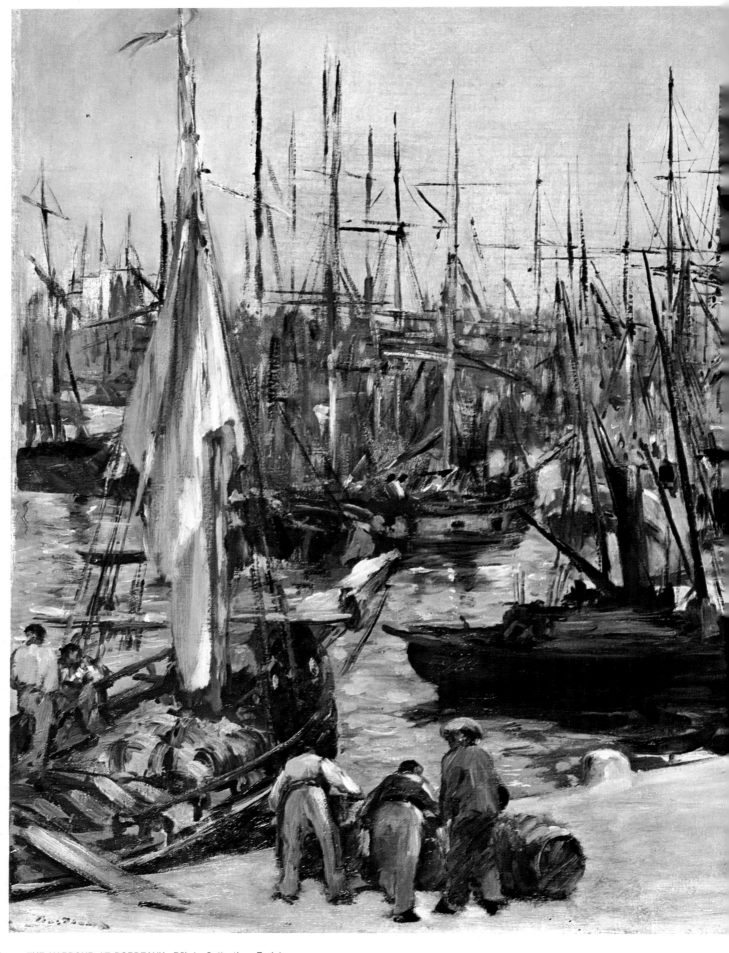

PLATES XXVIII-XXIX THE HARBOUR AT BORDEAUX Bührle Collection, Zurich
Whole (100 cm.)

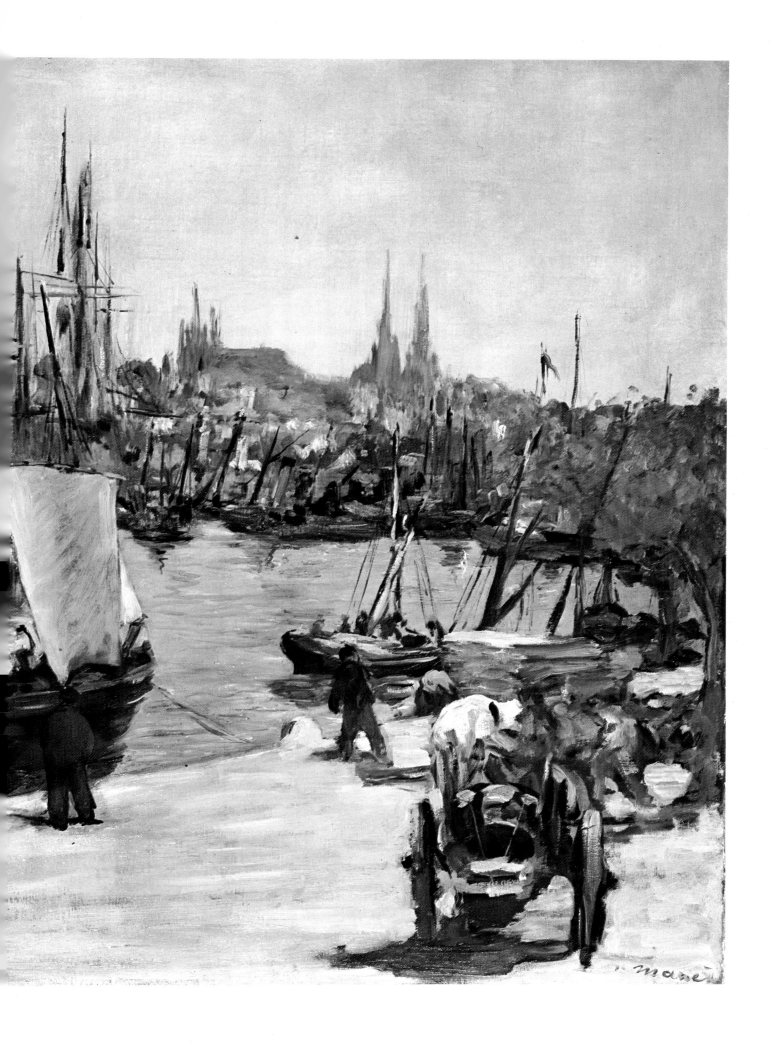

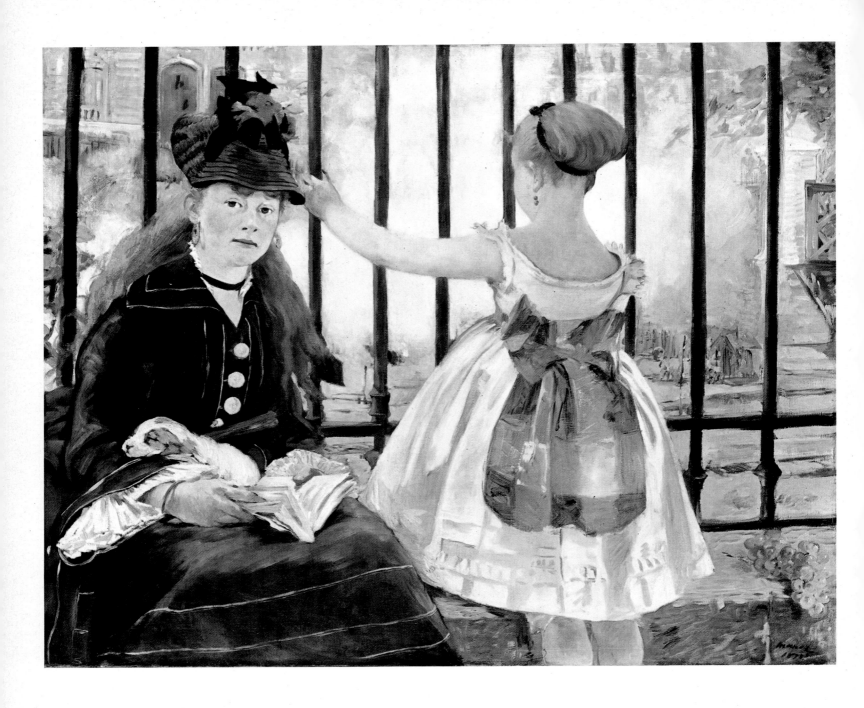

PLATE XXX THE RAILWAY National Gallery of Art, Washington
Whole (112 cm.)

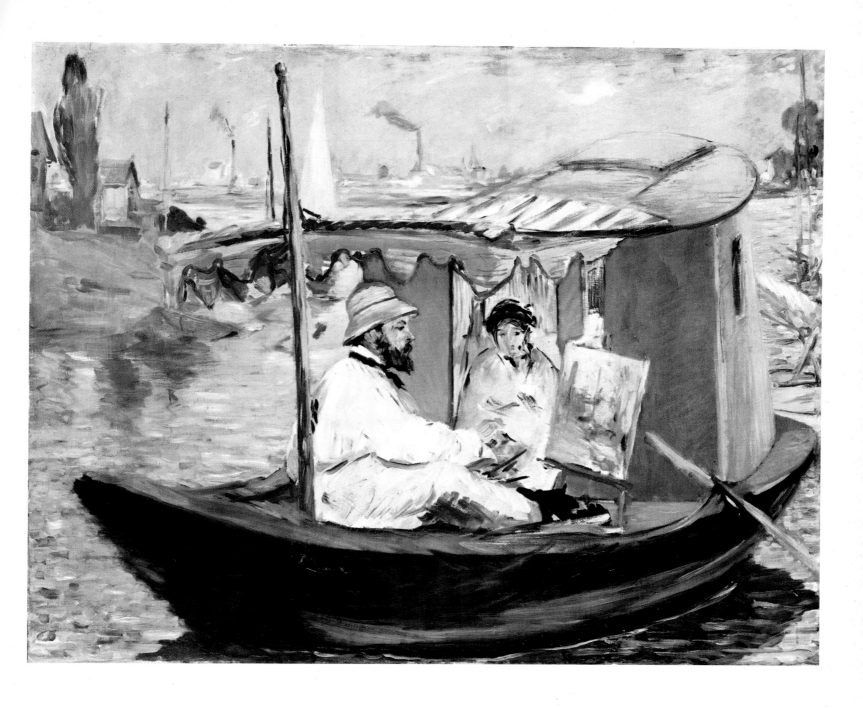

PLATE XXXI CLAUDE MONET IN HIS FLOATING STUDIO Neue Pinakothek, Munich
Whole (98 cm.)

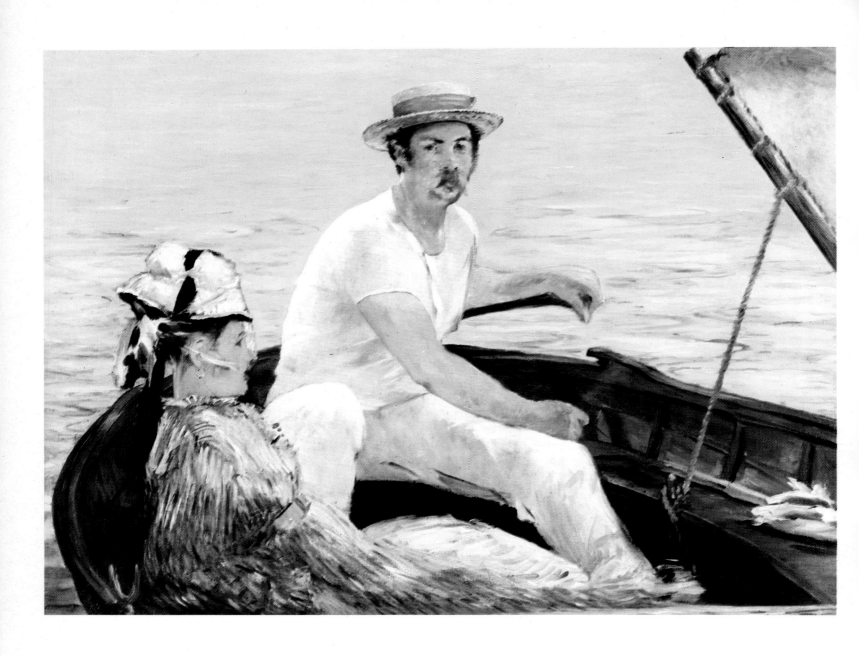

PLATE XXXII SAILING Metropolitan Museum, New York
Whole (130 cm.)

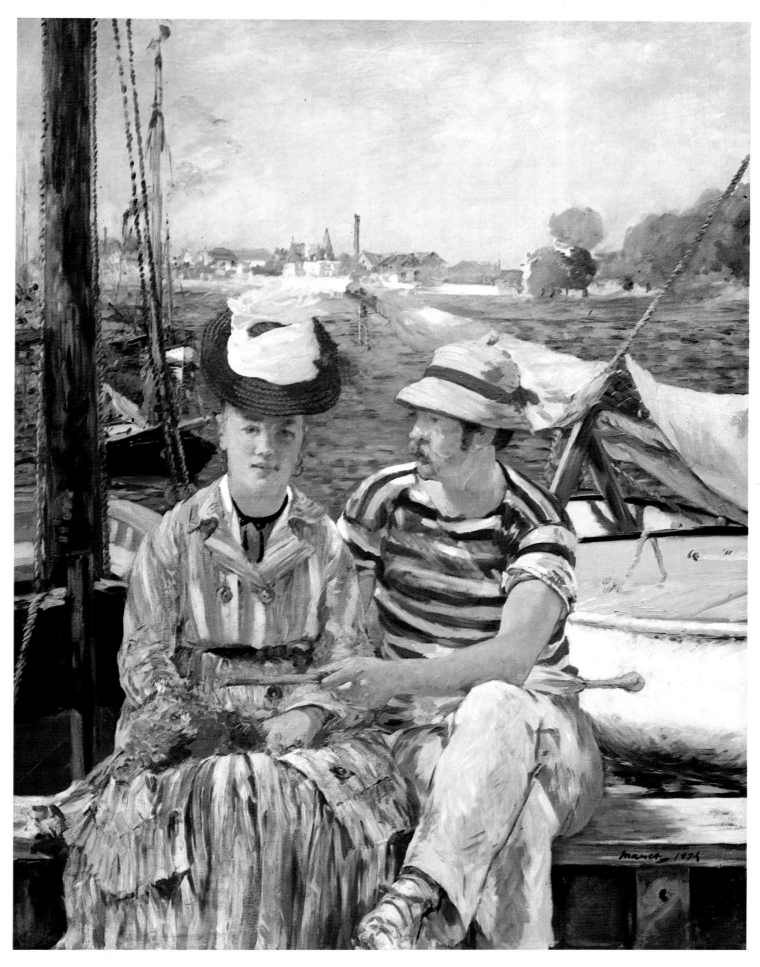

PLATE XXXIII ARGENTEUIL Musée des Beaux-Arts, Tournai
Whole (131 cm.)

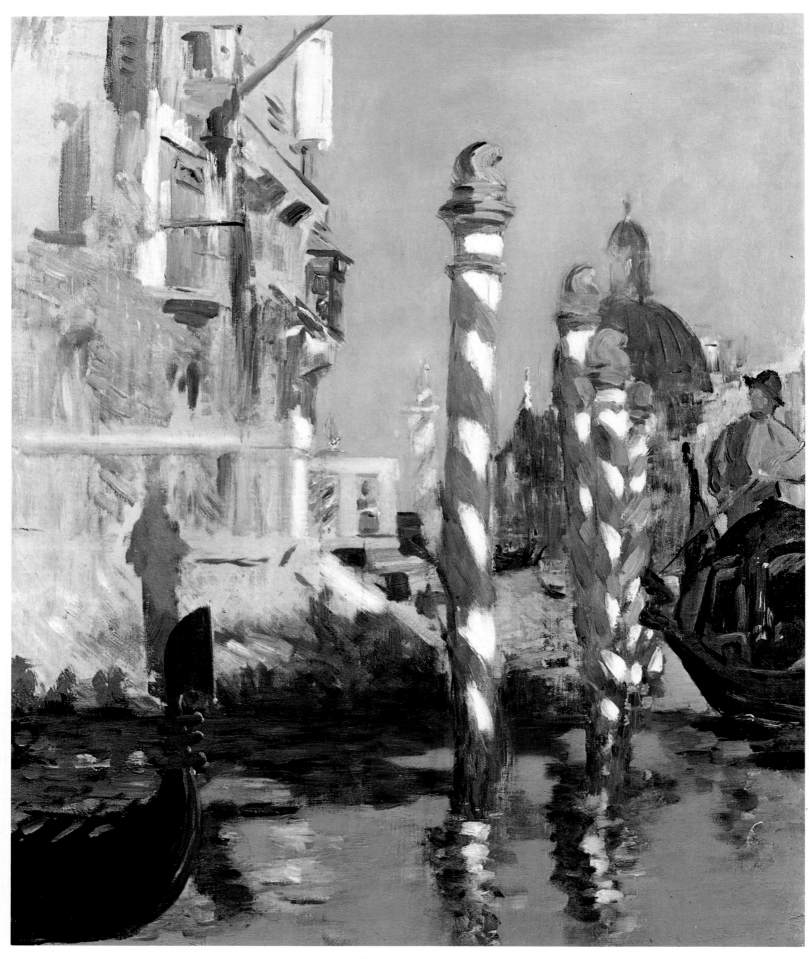

PLATE XXXIV THE GRAND CANAL, VENICE Provident Securities Company, San Francisco
Whole (48 cm.)

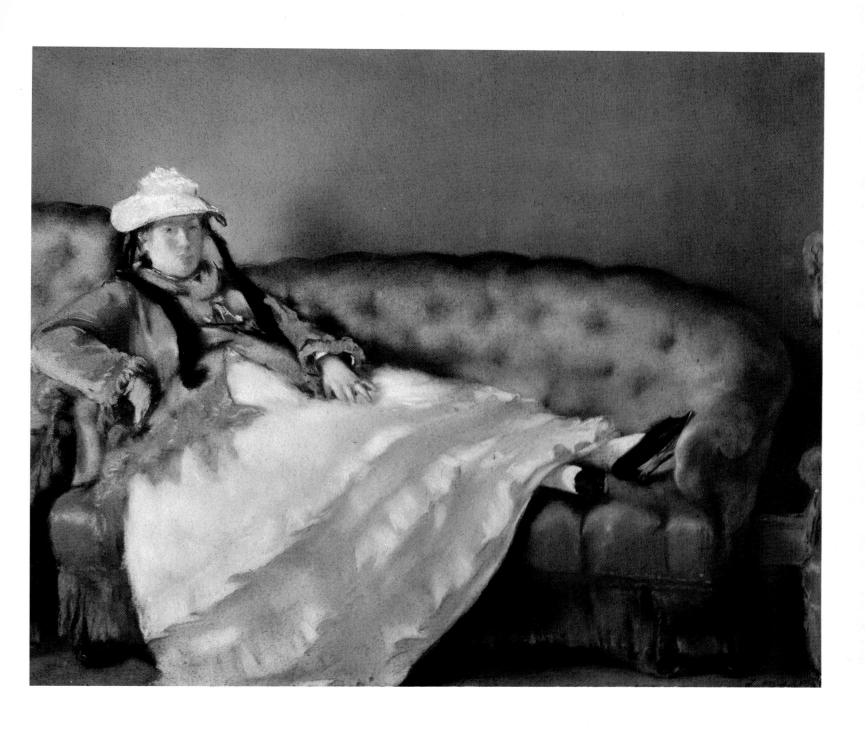

PLATE XXXV Mme EDOUARD MANET ON A BLUE SOFA Jeu de Paume, Louvre, Paris
Whole (61 cm.)

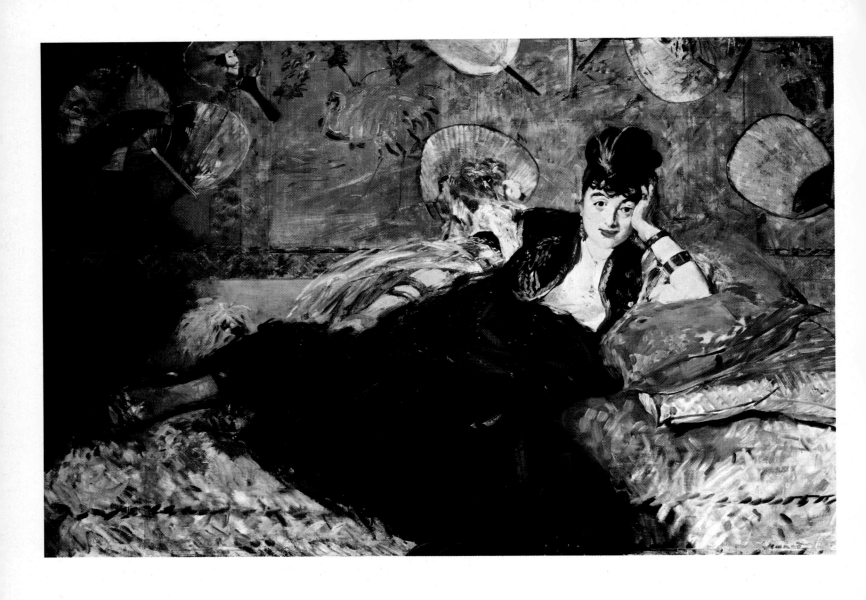

PLATE XXXVI THE LADY WITH THE FANS (NINA DE CALLIAS) Jeu de Paume, Louvre, Paris
Whole (166.5 cm.)

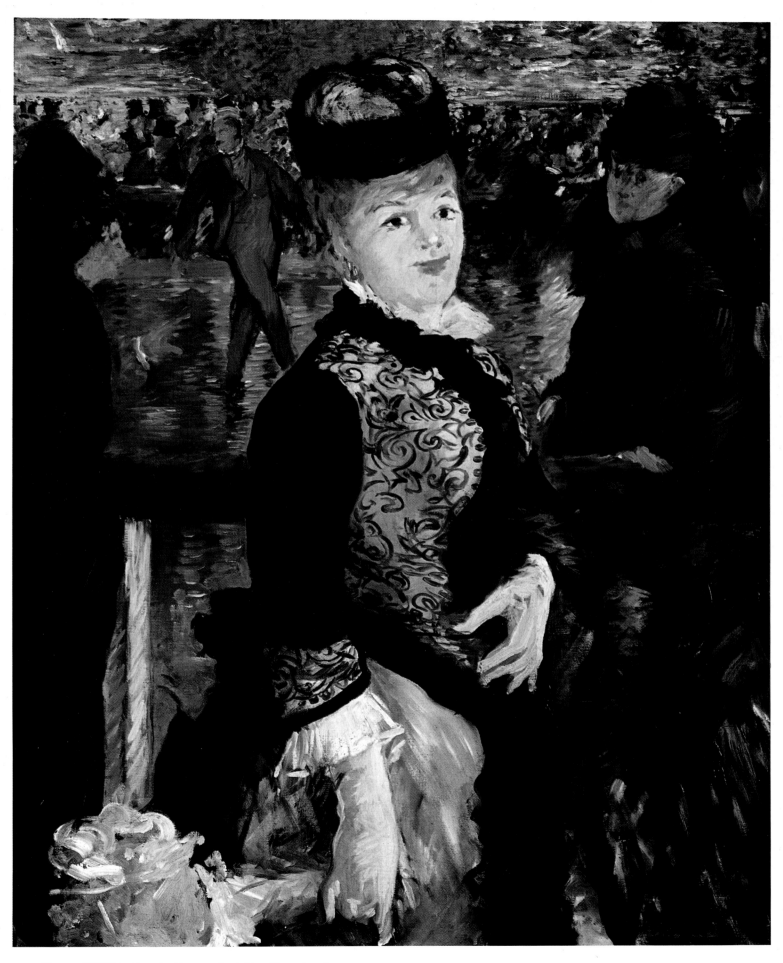

PLATE XXXVII SKATING Fogg Art Museum, Cambridge, Massachusetts
Whole (72 cm.)

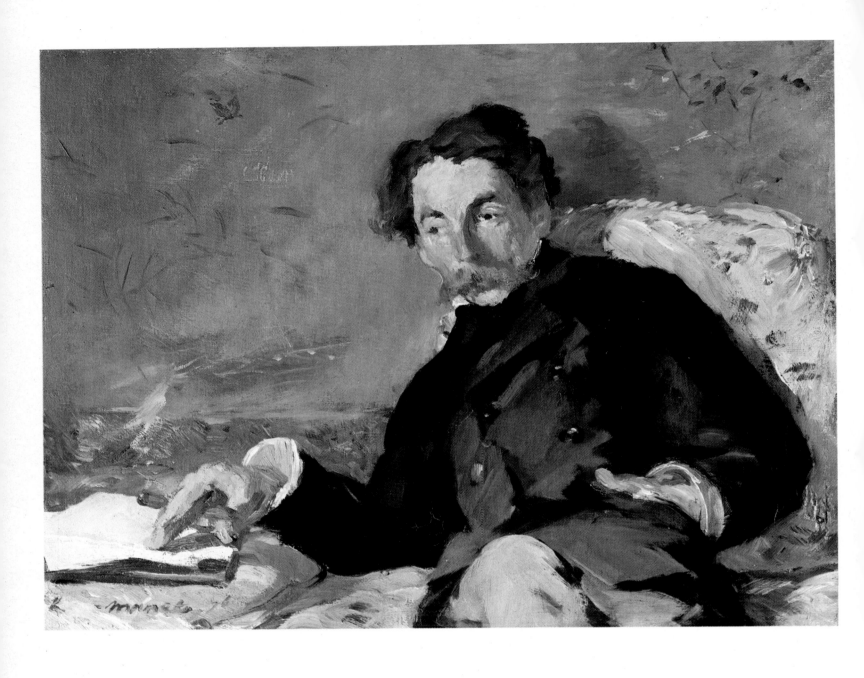

PLATE XXXVIII PORTRAIT OF STÉPHANE MALLARMÉ Jeu de Paume, Louvre, Paris
Whole (36 cm.)

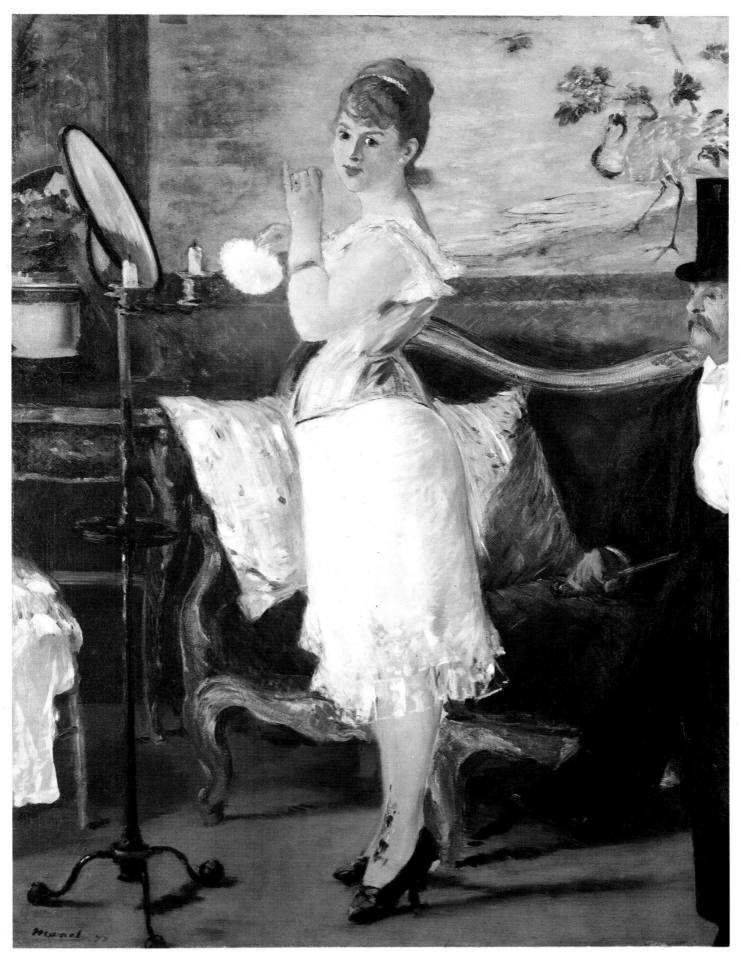

PLATE XXXIX NANA Kunsthalle, Hamburg
Whole (116 cm.)

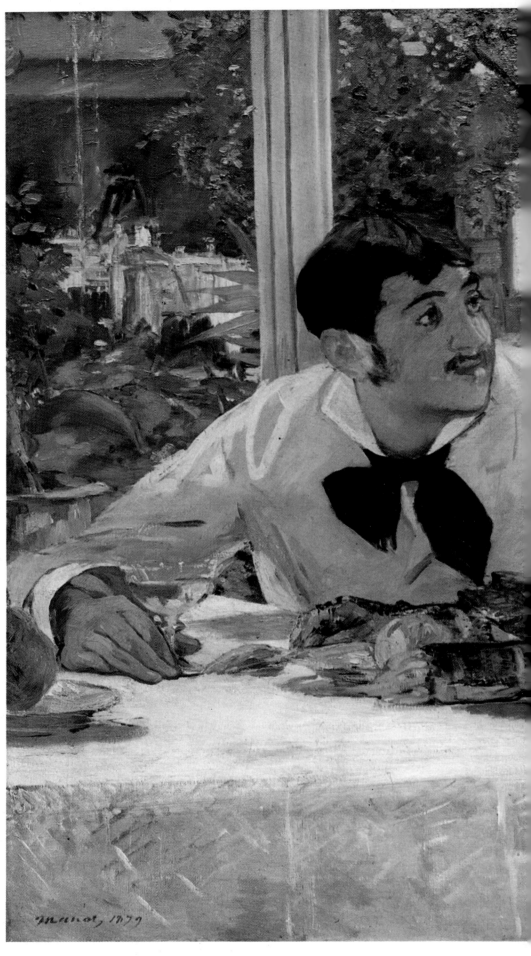

AT 'PÈRE LATHUILLE'S' Musée des Beaux-Arts, Tournai
Whole (112 cm.)

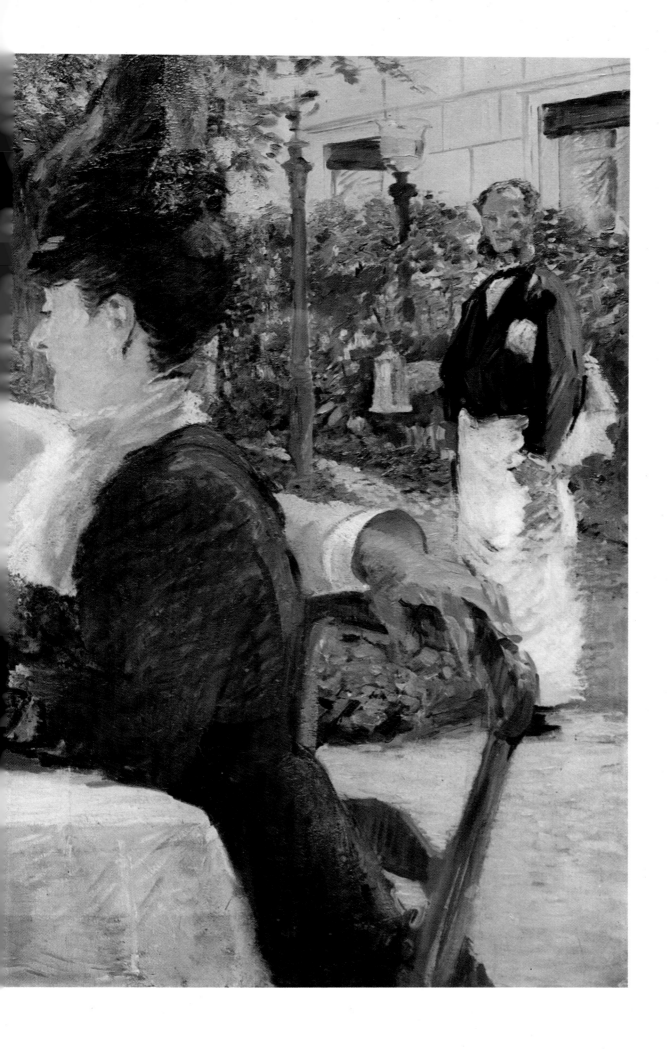

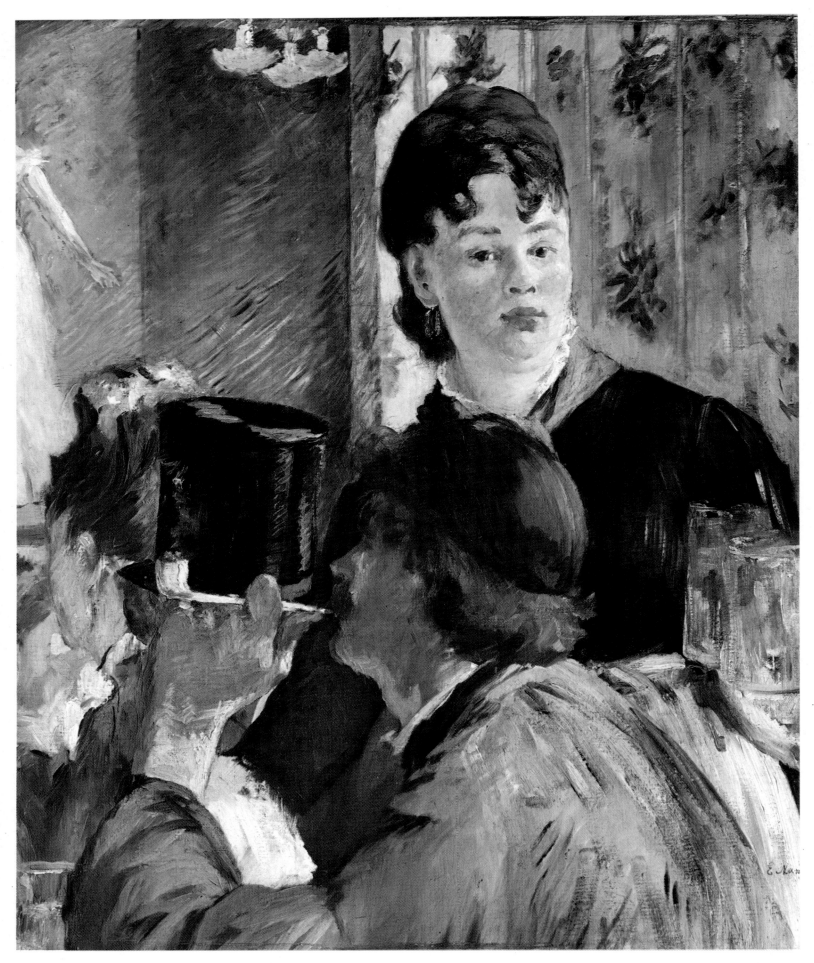

PLATE XLII THE WAITRESS Jeu de Paume, Louvre, Paris
Whole (65 cm.)

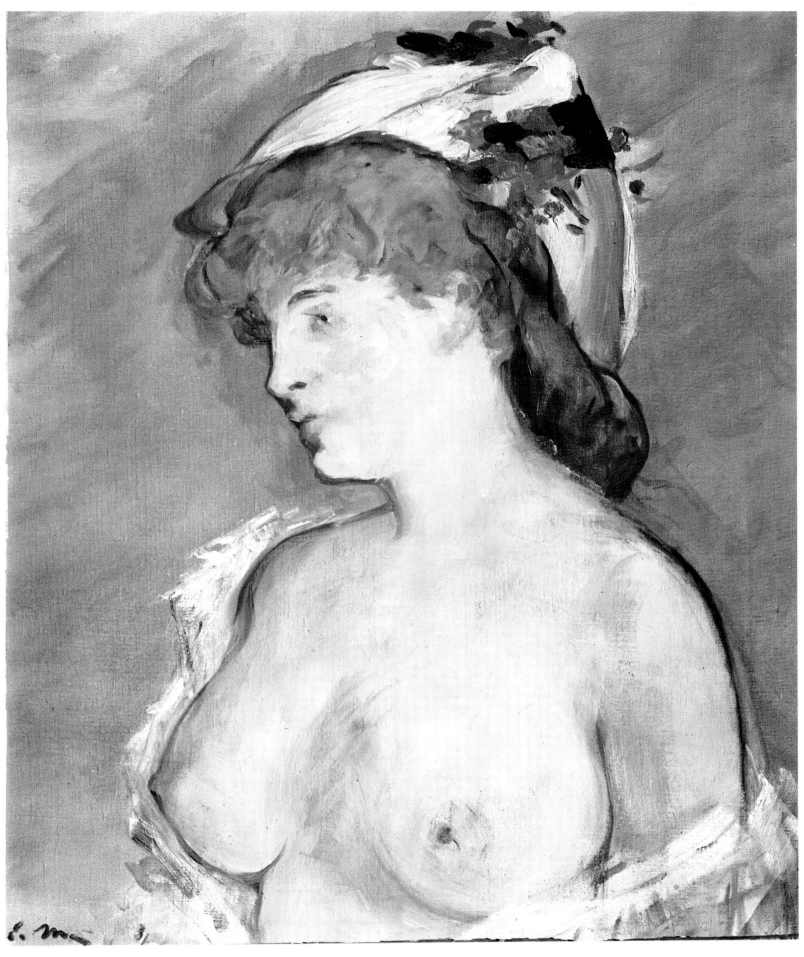

PLATE XLIII THE BLONDE WITH BARE BREASTS Jeu de Paume, Louvre, Paris
Whole (52 cm.)

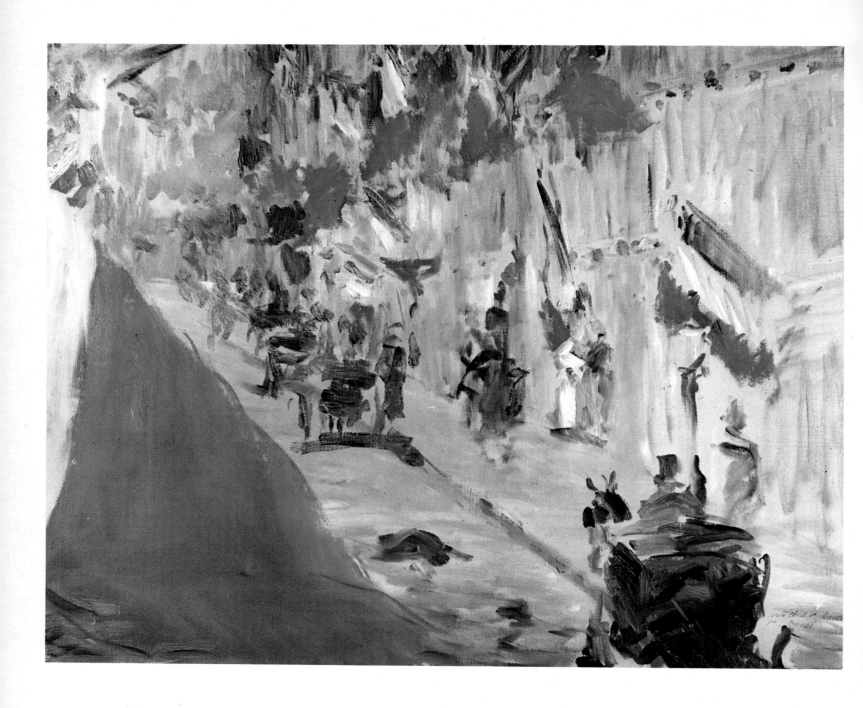

PLATE XLIV RUE MOSNIER DECKED WITH FLAGS Bürhle Collection, Zurich
Whole (81 cm.)

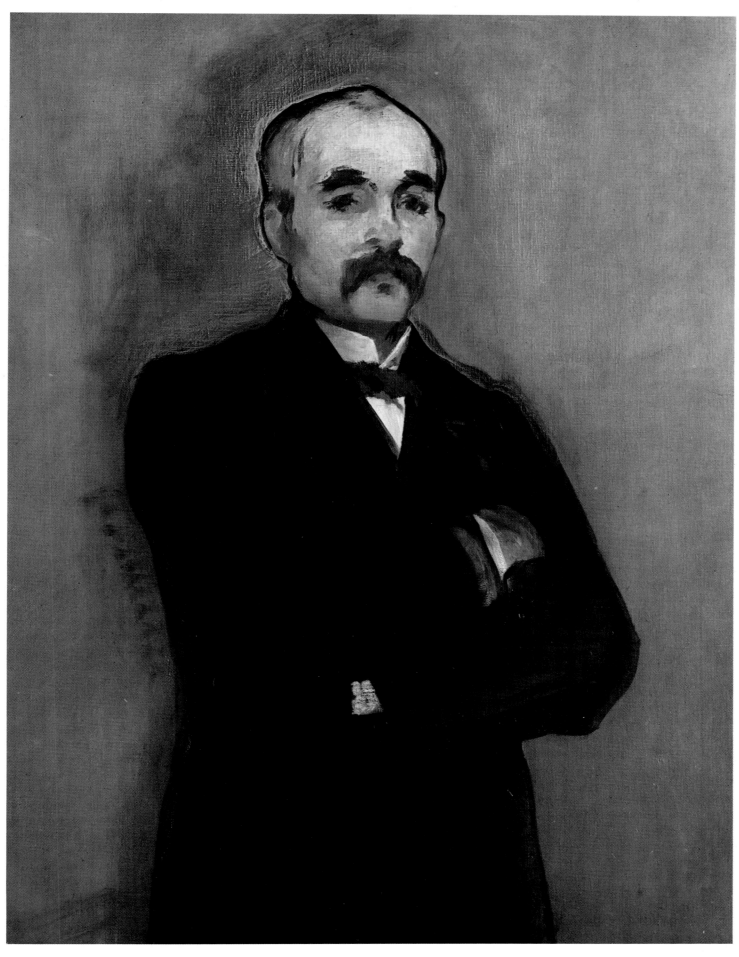

PLATE XLV PORTRAIT OF CLEMENCEAU Jeu de Paume, Louvre, Paris
Whole (74 cm.)

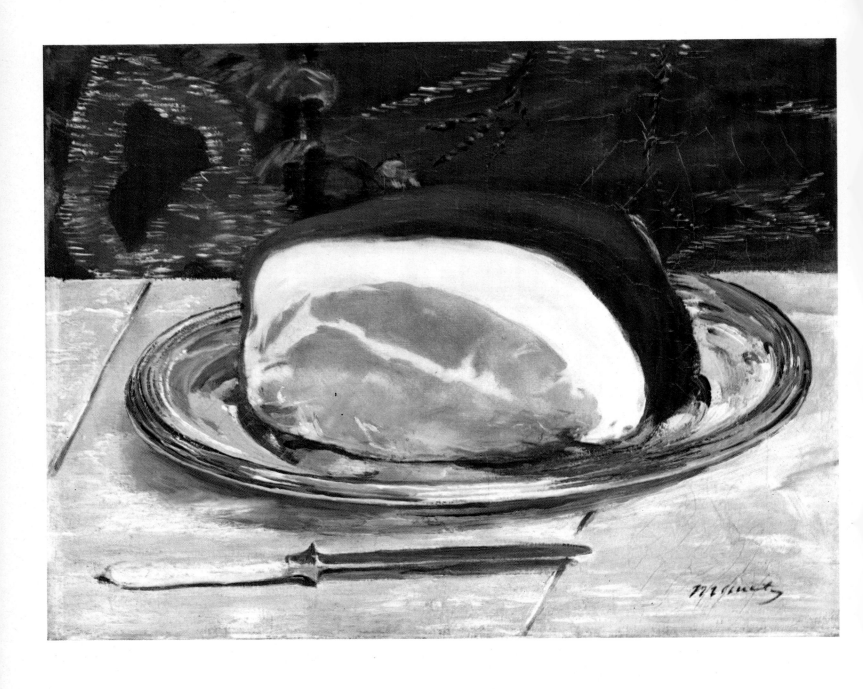

PLATE XLVI STILL-LIFE, WITH A HAM Art Gallery, Glasgow
Whole (42 cm.)

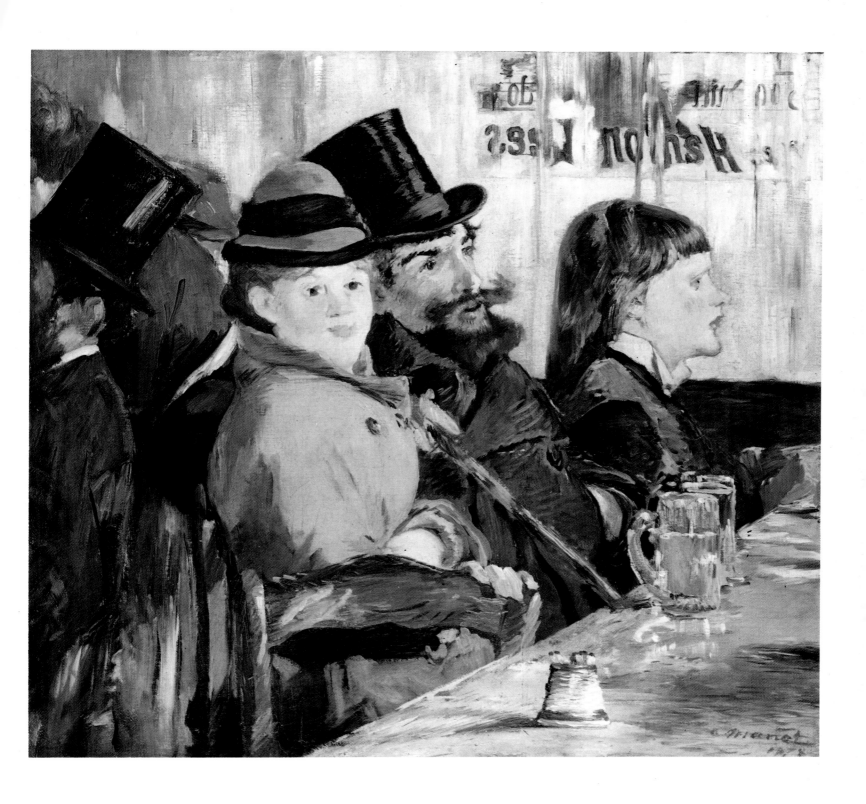

PLATE XLVII AT THE CAFÉ O. Reinhart Collection, Winterthur
Whole (83 cm.)

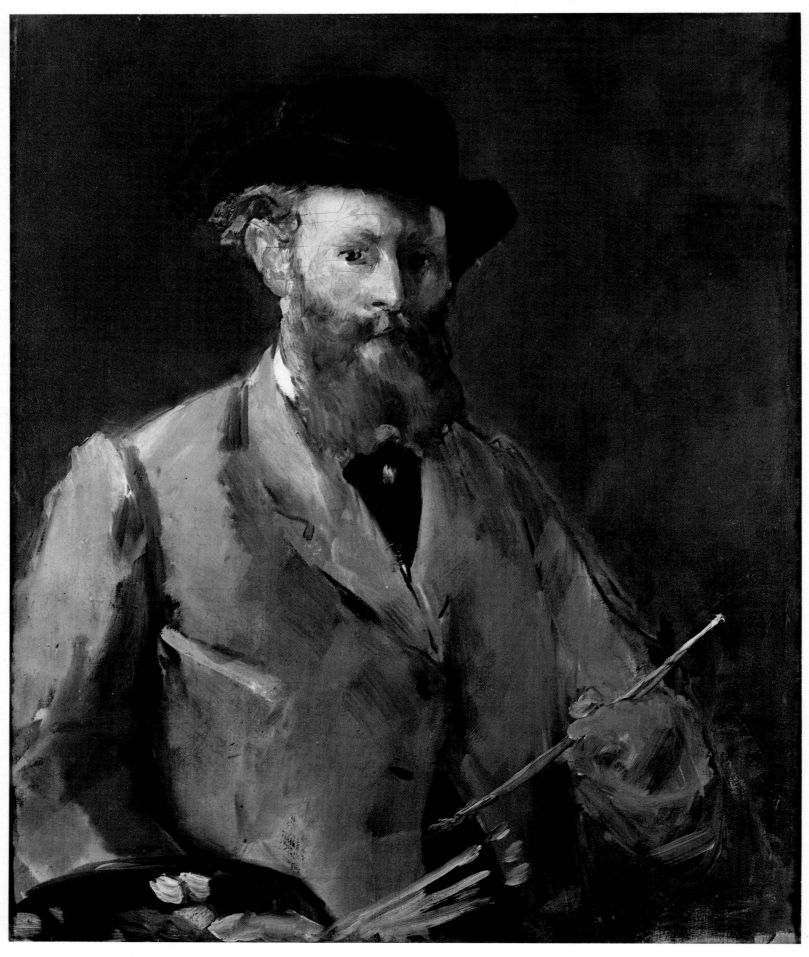

PLATE XLVIII SELF-PORTRAIT WITH PALETTE Private Collection, New York
Whole (67 cm.)

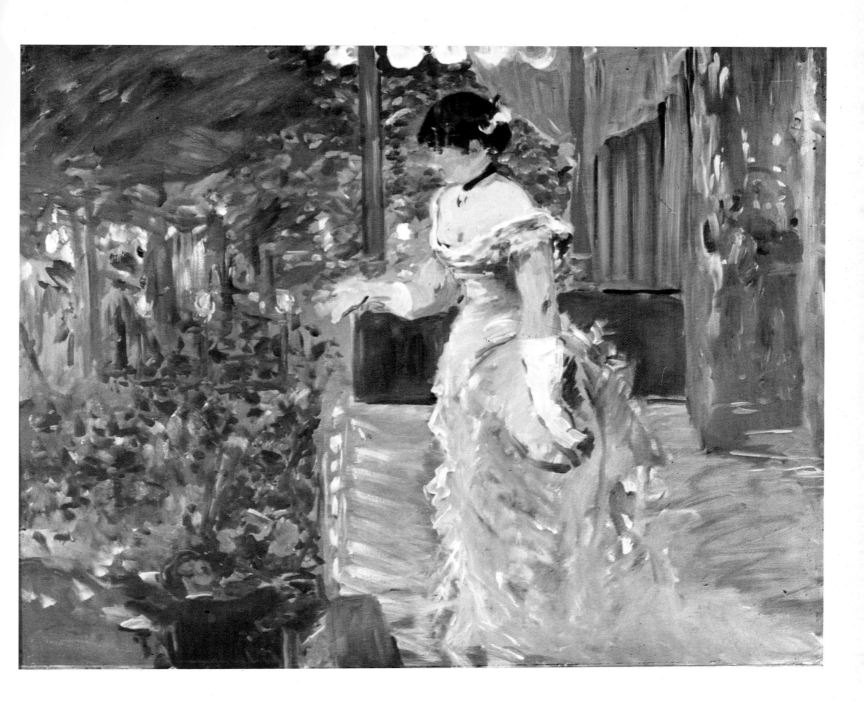

PLATE XLIX SINGER IN A CAFÉ-CONCERT Private Collection, Paris
Whole (93 cm.)

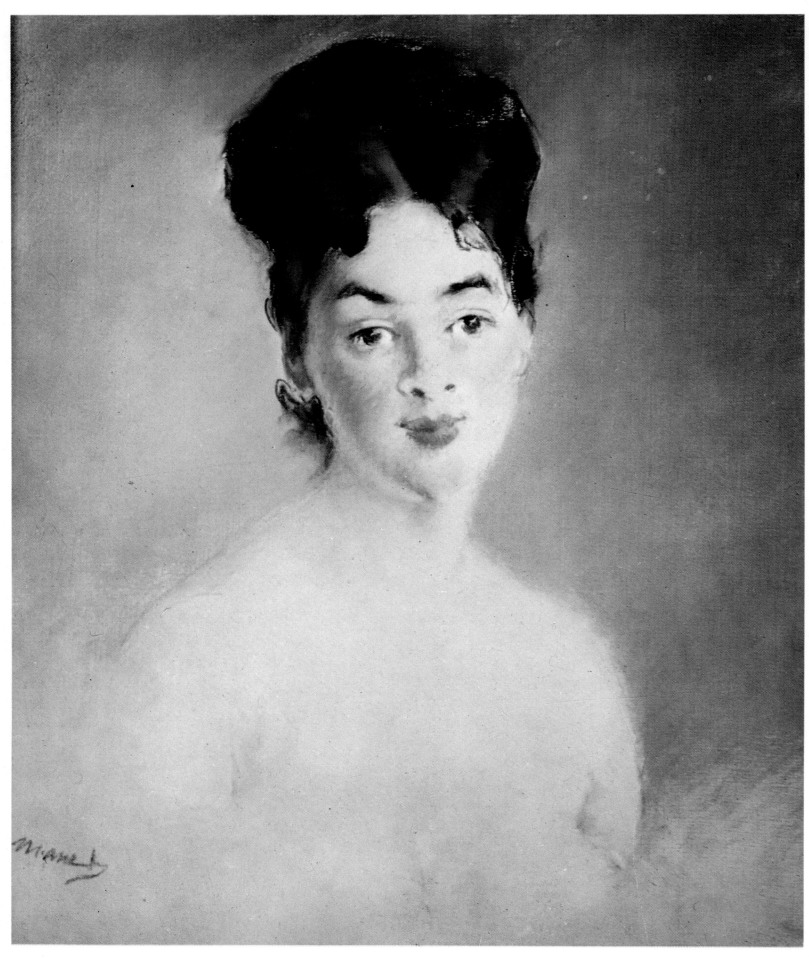

PLATE L HALF-LENGTH STUDY OF A NUDE WOMAN Jeu de Paume, Louvre, Paris
Whole (46.5 cm.)

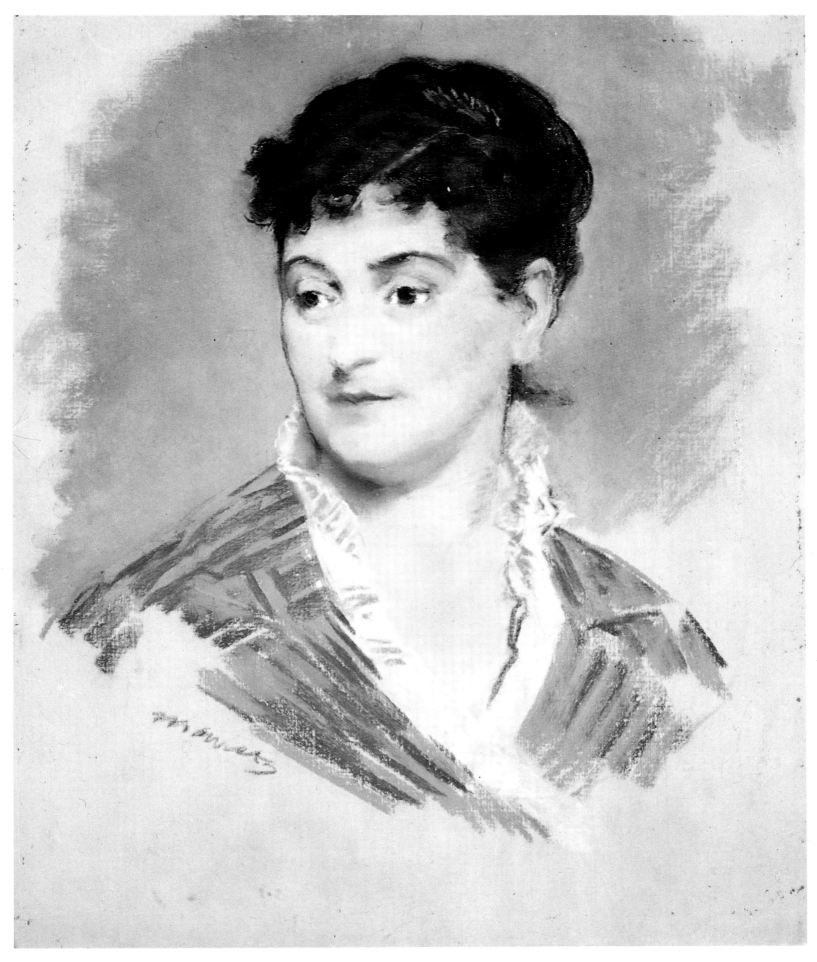

PLATE LI PORTRAIT OF Mme ZOLA Jeu de Paume, Louvre, Paris
Whole (46 cm.)

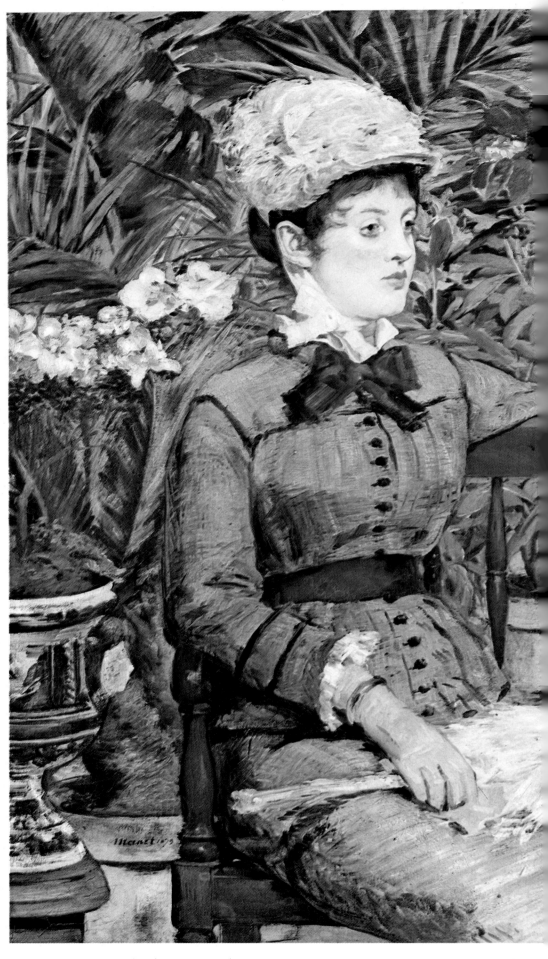

IN THE CONSERVATORY Staatliche Museen, Berlin
Whole (150 cm.)

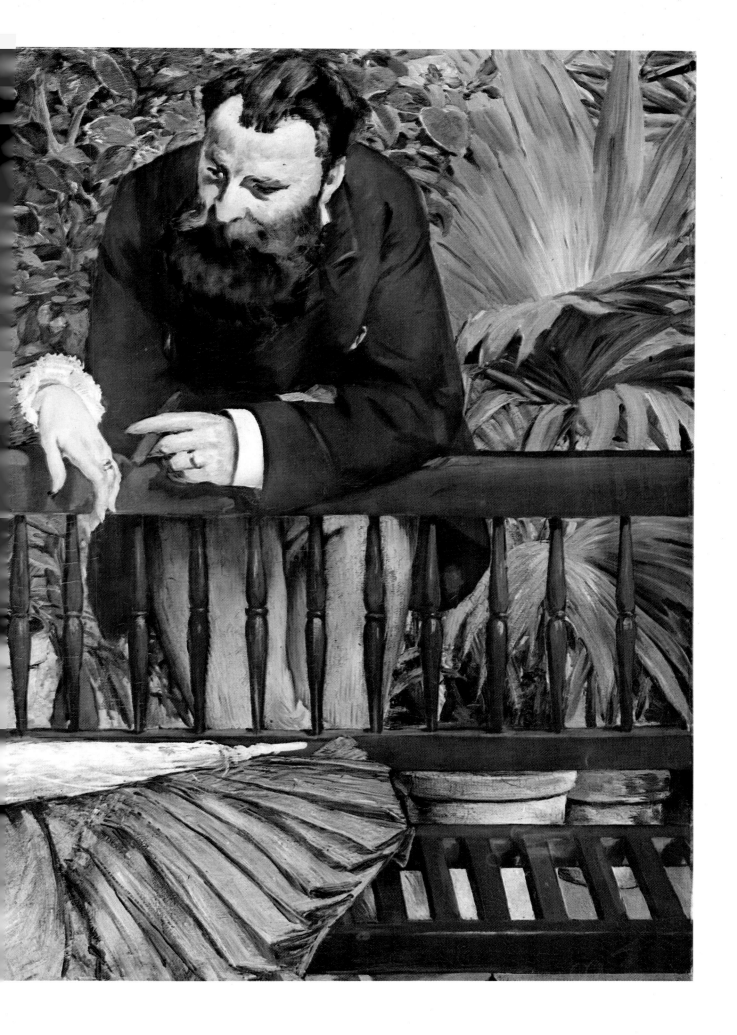

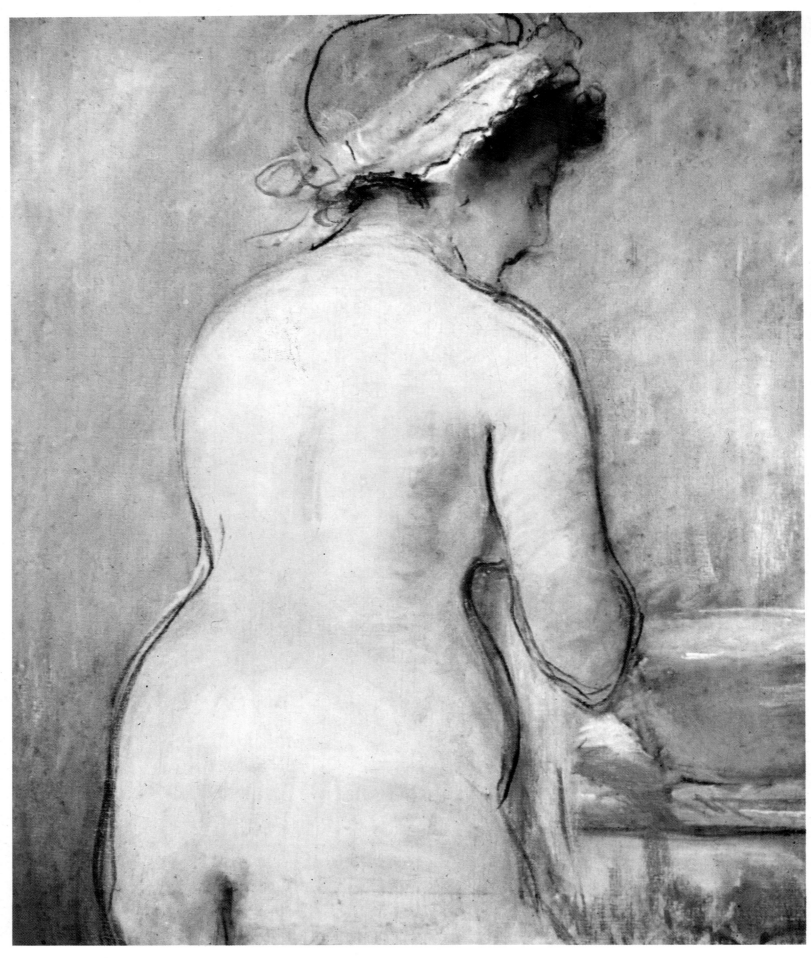

PLATE LIV NUDE Private Collection, Zurich
Whole (46 cm.)

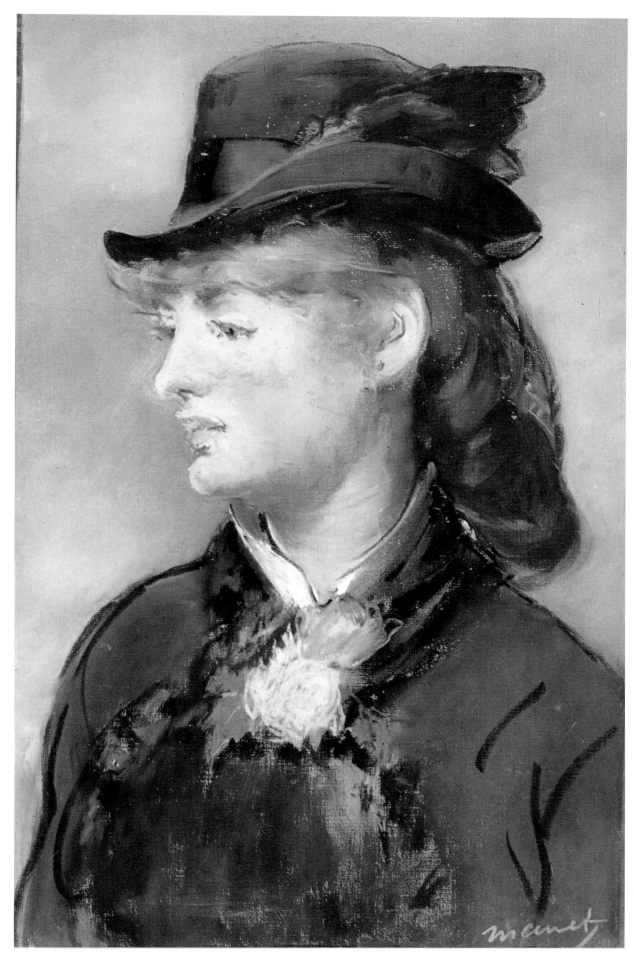

PLATE LV MODEL FROM THE 'BAR AT THE FOLIES-BERGÈRE' Musée des Beaux-Arts, Dijon
Whole (34 cm.)

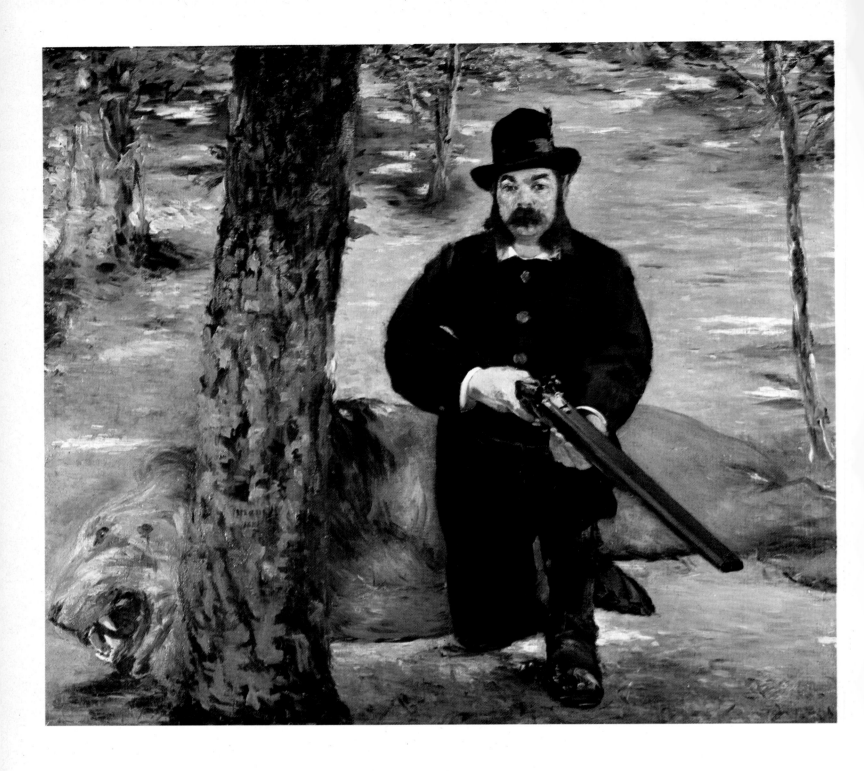

PLATE LVI PORTRAIT OF PERTUISET, THE LION HUNTER Museu de Arte, São Paulo
Whole (170 cm.)

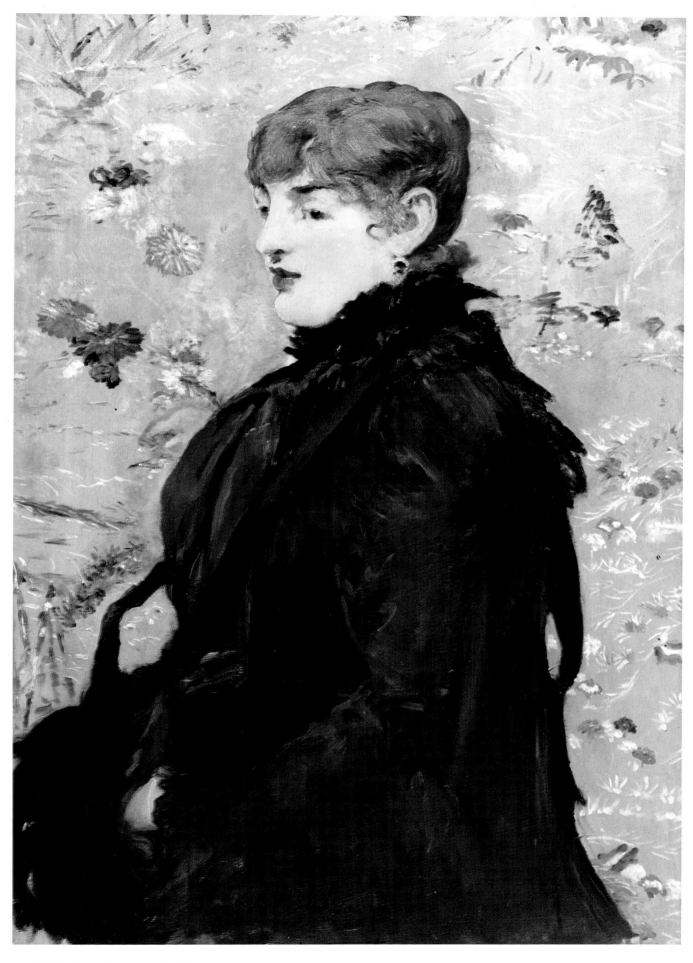

PLATE LVII AUTUMN Musée des Beaux-Arts, Nancy
Whole (51 cm.)

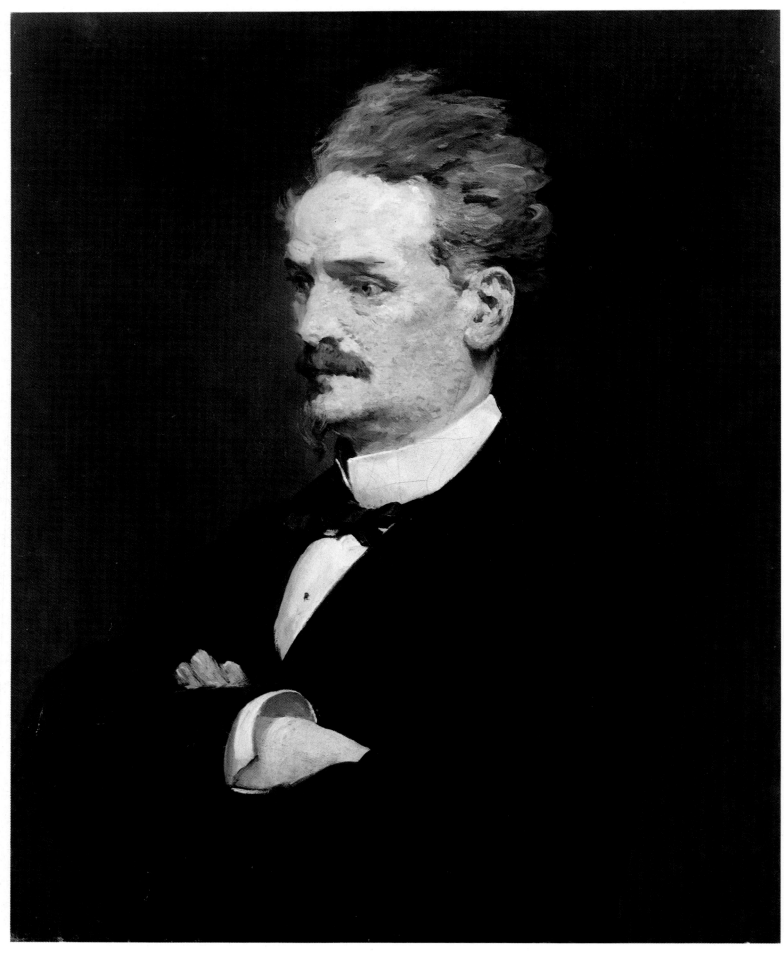

PLATE LVIII PORTRAIT OF HENRI ROCHEFORT Kunsthalle, Hamburg
Whole (66.5 cm.)

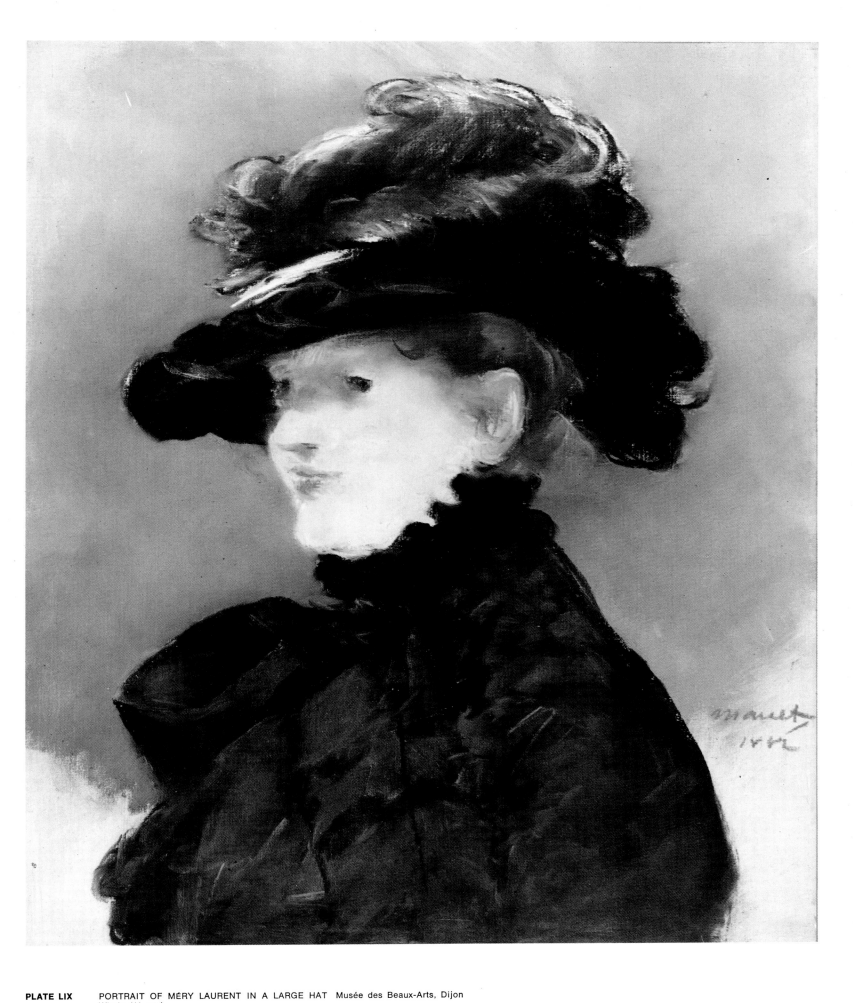

PLATE LIX PORTRAIT OF MÉRY LAURENT IN A LARGE HAT Musée des Beaux-Arts, Dijon
Whole (44 cm.)

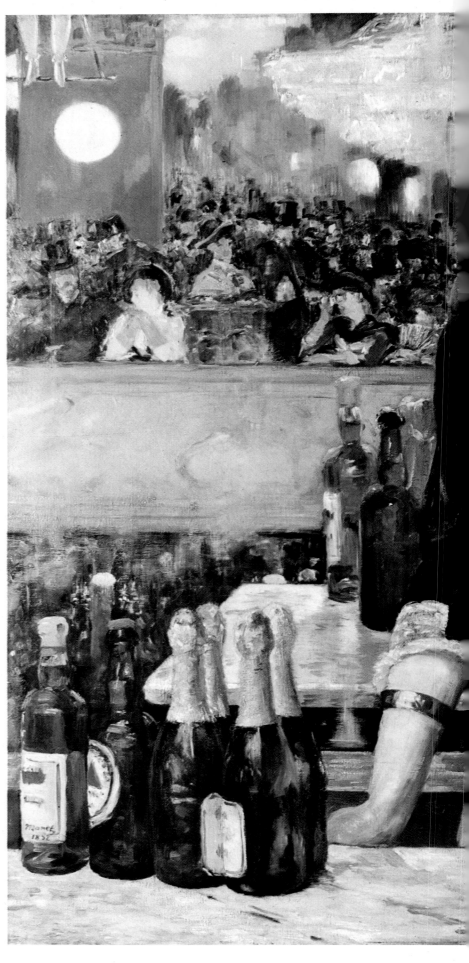

THE BAR AT THE FOLIES-BERGÈRE Home House Trustees, Courtauld Institute Gallery, London
Whole (130 cm.)

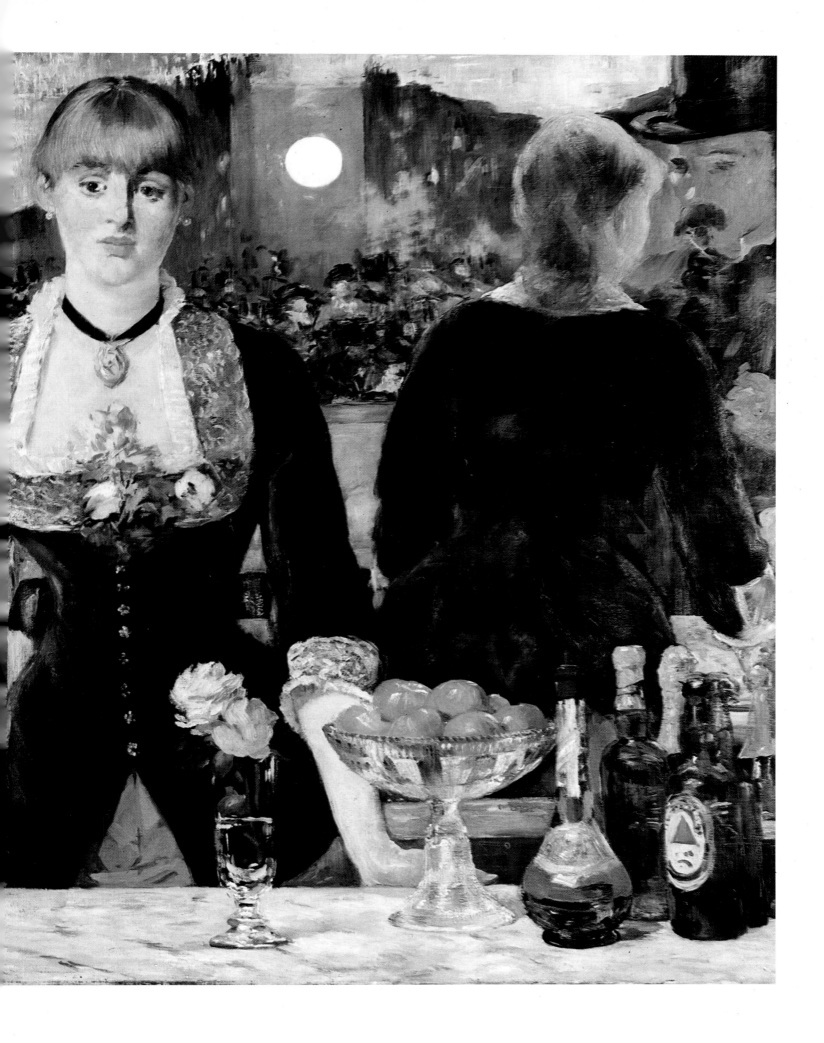

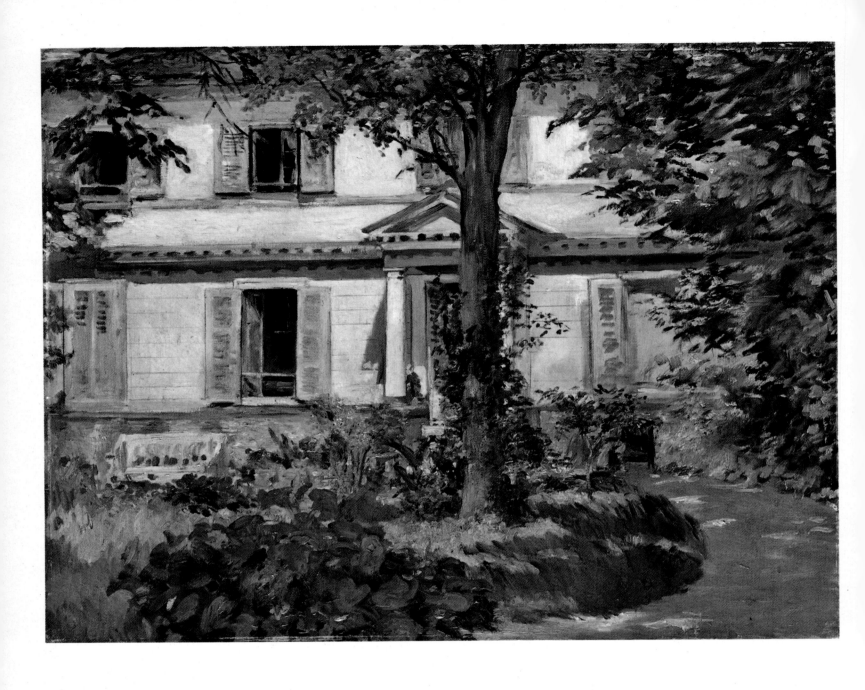

PLATE LXII THE HOUSE AT RUEIL Staatliche Museen, Berlin
Whole (92 cm.)

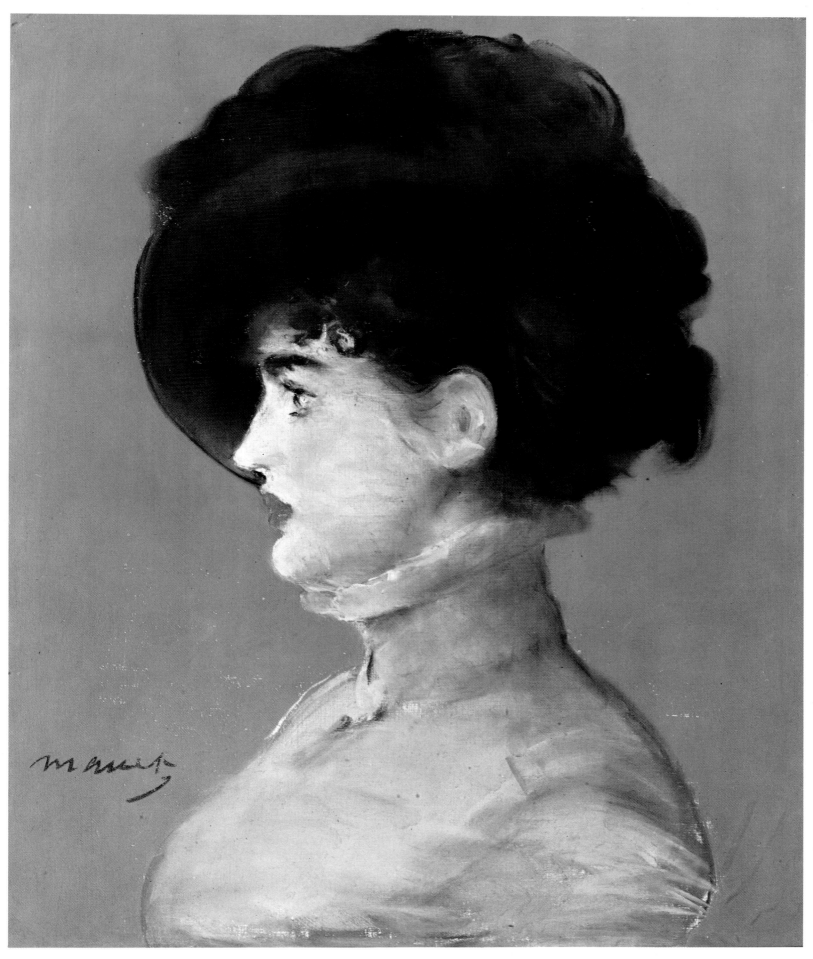

PLATE LXIII THE WOMAN WITH THE BLACK HAT, PORTRAIT OF IRMA BRUNNER, THE VIENNESE WOMAN Jeu de Paume, Louvre, Paris
Whole (46 cm.)

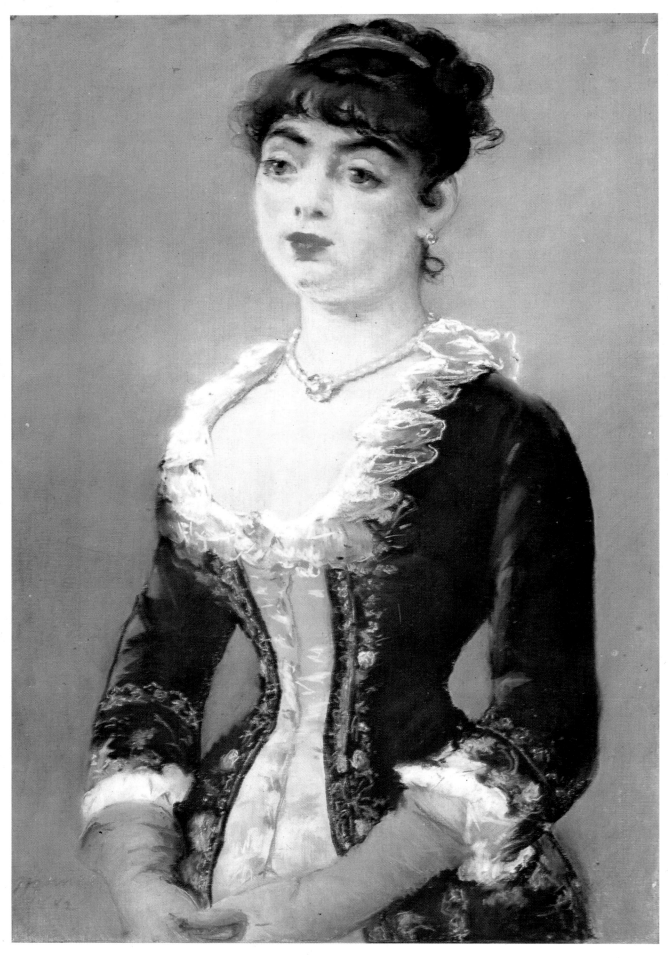

PLATE LXIV PORTRAIT OF Mme LÉVY National Gallery of Art, Washington
Whole (52 cm.)

The works

The present volume is the first of this series to be dedicated to a 'modern' artist. This term is taken to mean the masters of the nineteenth century onwards, about whom, for obvious reasons, sufficient written material has not gradually percolated to allow for a really reliable assessment. A similar attempt has been made to give catalogues for their works which are no less complete than those compiled for the 'classic' masters (i.e. those before the eighteenth century). However, since the critical and philological material available has not been worked out in detail from such advanced research, nor set in such conclusive historical perspective (also because too many works are still in reticent private hands), the bold affirmation of 'complete works', which has been used for the series so far, may not be considered legitimate. The possibility of recent finds, the need for close studies and the consequent probability of second thoughts are, in the case of the 'moderns' much greater, hence the prudent measure of changing the usual form of the title to that of 'paintings', which is precisely intended to put the reader on his guard when confronted with a catalogue situation which is still only too fluid. In this first instance (as will be the case for the other 'modern' artists to whom later monographs will be dedicated) such literature as is available has certainly not been overlooked; that is to say, not only the authoritative listings by Jamot and Wildenstein and by Tabarant, nor those which preceded them, but also any later publication up to the present day, which makes reference to Manet: monographs, general studies, catalogues from galleries, exhibitions, shows and sales, articles and so on. Nor has the direct examination and consideration of any accessible work been neglected, in order to check whether the validity of critical and exegetical conclusions and inductions, often mutually contradictory, could be sustained. It follows, therefore, that the catalogue is certainly a most careful one, but all the same, the foregoing reservations still apply.

The re-examination of Edouard Manet's output, through contacts with scholars and well-known collectors, has brought about not so much the addition of new 'pieces' to the known lists, as the expunging from them of a certain number the authenticity of which, for various reasons, has not seemed to be completely tenable. In this regard, our gratitude is particularly due to Daniel Wildenstein (who, with Denis Rouart, is editing a new critical catalogue of Manet's paintings and drawings) for bringing up to date the reliable datings and for the vast photographic documentation which he has so kindly provided. However, bearing in mind the authority and diffusion of the two earlier catalogues referred to, it was not thought possible to rule out completely from the list the works of dubious authenticity which they quote. These, therefore, are grouped into a separate list (page 121) together with those of the other works which, although housed in official collections, rightly arouse some suspicion. On the other hand, dubious copies and replicas are marked as such in the list containing their related originals. We shall be satisfied if, having thus recalled such paintings to the attention of the critics and devotees, we succeed, once and for all, in establishing their right to be cited in the *corpus* of the artist's work. Such though, as have been revealed as alien, even if accepted in authoritative writings on the painter, have been deliberately omitted.

Finally, since in the case of 'modern' artists it is not possible in general to speak of alterations made in the studio by assistants or collaborators and so on, we have reduced the graphic symbols concerning the degree of authenticity of individual paintings to just two – authenticated works and doubtful works. The present catalogue had to be cleansed of every doubt.

Key to symbols used

So that the essential elements of each work may be immediately obvious, the heading of each 'entry' includes a series of symbols after the number of the painting (which follows the most likely chronological order and to which reference is made whenever the work is quoted in the course of the book).
These symbols refer:
(1) to the execution of the work, i.e. its degree of authenticity
(2) to the technique and base material used
(3) to its whereabouts
(4) to the following further data : whether the work was signed and dated ; whether it is at present complete in all its parts; and whether it was finished. The other numbers included in the heading itself concern: on top, the size in centimetres of the painting (height and width) and, below, its dating. When this dating cannot be given with certainty, but is only approximate, it is preceded and/or followed by an asterisk*, according to whether the uncertainty concerns the period preceding or following the dating indicated, or both. All the information supplied reflects the opinion prevailing among modern art historians. Any noteworthy disagreements and further details are stated in the text.

Execution

 Authenticated work

 Doubtful work

Technique and materials

 Oils on canvas

 Oils on board

 Oils on paper

 Pastels on canvas

 Pastels on paper

Whereabouts

 Location open to the public

Private collection

Whereabouts unknown

 Lost work

Additional data

 Signed work

Dated work

Incomplete or fragmentary work

Unfinished work

If more than this is needed for any given work, the relative indications are grouped in the same symbol.
The signs ? * or A, placed by the symbol concerning the signature or atelier mark, indicate that these are: false or doubtful (?); were put on by Manet's widow (*) or in the atelier (A) on the occasion of the sale in 1884.

⊞ ⎫
⊗ ⎬ Indications given in the text
⊟ ⎭

Bibliography

Much information on the vast literature dedicated to Manet is given by J. Rewald (*History of Impressionism*, New York 1946, 1961 and 1973) and G. Bataille (*Manet*, Geneva 1955).

Among Manet's contemporaries who concerned themselves with his work should be noted particularly: Th. Gautier (*MU* (for this and other abbreviations, see below), 1861); E. Zola (*Mon Salon*, Paris 1886; *Edouard Manet, Étude biographique et critique*, Paris 1867 (also in *Mes Haines*, Paris 1902); *EL*, 10 May 1868); S. Mallarmé (*RE*, 10 April 1874; *AMR*, 30 September 1876; *Divagations*, Paris 1898); G. Jeanniot (*GR*, January 1882); A. Proust (*GBA*, 1882; *Edouard Manet, Souvenirs*, Paris 1913); C. R. Marx (*JA*, 11 January 1884); P. Mantz (*TE*, 16 January 1884); E. Bazire (*Manet*, Paris 1884); G. Moore (*Confessions of a Young Man*, London 1888); G. de Nittis (*Notes et Souvenirs*, Paris 1895); and Th. Duret (*Histoire d'Edouard Manet et de son œuvre*, Paris 1902 and 1926 (here abbreviated as D)).

For the biography, apart from the above-mentioned works by A. Proust, Bazire, Moore and de Nittis, the following are of particular importance: E. Moreau-Nélaton (*Manet raconté par lui-même*, Paris 1926 (here abbreviated as M-N)); J. Guiffrey (*Lettres illustrées d'Edouard Manet*, Paris 1929); A. Tabarant (*Une correspondance inédite d'Edouard Manet*, Paris 1935); P. Courthion (*Manet raconté par lui-même et par ses amis*, Geneva 1945); and H. Perruchot (*La vie de Manet*, Paris 1959).

We are indebted for the 'classic' catalogues to: A. Tabarant ((see also above) *Manet, Histoire catalographique*, Paris 1931 (here abbreviated as T 1931); *Manet et ses œuvres*, Paris 1947 (here abbreviated as T 1947)); P. Jamot, G. Wildenstein and M. L. Bataille (*Manet*, Paris 1932 (here abbreviated as J-W)); and D. Rouart and D. Wildenstein (*Edouard Manet, Catalogue Raisonné*, 2 vols, Lausanne and Paris 1975).

Other studies of varying interest have been published by: P. Jamot ((see also above) *BM*, 1926; *GBA*, 1927); L. Venturi (*LA*, 1929); C. V. Wheeler (*Manet, An Essay*, Washington 1930); C. Léger (*Manet*, Paris 1931); G. Bazin (*AA*, 1932); P. Valéry (*Le Triomphe de Manet* in the catalogue of the exhibition at the Orangerie, Paris 1932); E. Lambert (*GBA* 1933); J. Mesnil (*AR*, 1934);

M. Florisonne (*AA*, 1937; *Manet*, Munich 1947); J. N. Ebin (*GBA*, 1945); J. Thyis (*Manet et Baudelaire*, Algiers 1945); J. Rewald ((see also above) *Manet, Pastels*, Oxford 1947); B. Reifenberg (*Manet*, Berne 1947); J. Alazard (*Manet*, Lausanne 1948); J. Leymarie (*Manet et les impressionnistes au Musée du Louvre*, Paris 1951; *Edouard Manet*, Paris 1951); Fr. Mathey (*Introduction à Edouard Manet*, Paris 1949); D. Cooper (*Manet*, London 1949); J. C. Sloane (*AQ*, 1951); G. H. Hamilton (*Manet and his Critics*, New Haven and London 1954); N. G. Sandblad (*Manet*, Lund 1954); J. L. Vaudoyer (*Manet*, Paris 1955); J. Richardson (*E. Manet*, London 1958 (here abbreviated as R)); K. Martin (*E. Manet*, Basle 1958); J. Mathey (*Graphisme de Manet*, I, II and III, Paris 1961, 1963 and 1966 (with many dubious inclusions)); T. Reff (*BM*, 1962); P. Courthion ((see also above) *Edouard Manet*, New York 1962); J. C. Harris (*AB*, 1964 and 1966 (here abbreviated as H)); A. C. Hanson (*Manet and the Modern Tradition*, New Haven and London 1977); Metropolitan Museum, New York (*Manet*, catalogue of exhibition 1983–4); and T. J. Clark (*The Painting of Modern Life. Paris in the Art of Manet and his Followers*, London 1984). In addition, noteworthy contributions may be found in: *AA*, May 1952 (special edition with articles by C. R. Marx (see also above), J. E. Blanche, F. Fels, J. Guenne and P. Valéry (see also above)); *F*, 1932 (special edition with articles by A. Meier-Graefe (see also above), J. E. Blanche (see also above), E. Jaloux and M. Dormoy); *Edouard Manet 1832–1883*, catalogue by A. Coffin-Hanson for the exhibition at the Philadelphia Museum of Art (November to December 1966) and at the Art Institute of Chicago (January to February 1967) (here abbreviated as C-H).

For the graphic work the following should be noted: E. Moreau-Nélaton ((see also above) *Manet graveur et lithographe*, Paris 1906); H. Focillon (*GBA*, 1927); R. Rey (*Choix de 65 dessins de Manet*, Paris 1932); M. Guerin (*L'Oeuvre gravé de Manet*, Paris 1944); J. Harris (*Edouard Manet, Graphic Works: A Definitive Catalogue Raisonné*, New York 1970); J. Leymarie (*Gravures des Impressionnistes (Pissarro, Manet, Renoir, Cézanne, Sisley)*, Paris 1970); and A. W. de Leiris (*The Drawings of Edouard Manet*, Berkeley 1970).

List of abbreviations

A *The Arts*
AA *L'amour de l'Art*
AB *The Art Bulletin*
AIBA *Annuaire illustré des Beaux-Arts*
AMR *The Art Monthly Review*
AQ *The Art Quarterly*
AR *L'Art*
BM *The Burlington Magazine*
CA *Courrier artistique*
CH *Charivari*
CL *Constitutionnel*
CO *The Connoisseur*
EI *L'Evènement illustré*
EL *Electeur Libre*
F *Figaro*
FO *Formes*
GA *Le Gaullois*
GBA *Gazette des Beaux-Arts*
GR *La Grande Revue*
IB *Indépendance belge*

ILL *Illustration*
JA *Journal des Arts*
LA *L'Art*
MU *Moniteur universel*
ON *Opinion nationale*
PJ *Paris-Journal*
PR *La Presse*
R *Réforme*
RE: *La Renaissance artistique et littéraire*
RAAM *Revue de l'Art ancien et moderne*
RF *République française*
RP *Revue de Paris*
RXIX *Revue du XIXe siècle*
SI *Siècle*
SQ *Salon quotidien*
TE *Le Temps*
V *Voltaire*
VM *Vie moderne*

This monograph, compiled upon the criteria set out on a previous page, constitutes the fruits of the studies which the author carried out on Edouard Manet previously and not recently, even though it is only now being published.

Outline Biography

1832 Edouard Manet was born on 23 January at 5 Rue des Petits-Augustins (now Rue Bonaparte). His father, Auguste, was chief of staff at the Ministry of Justice and his mother, Eugénie-Désirée Fournier, the daughter of a diplomat in Stockholm.

1833 21 November, birth of Eugène, second son of the Manets.

1835 16 March, birth of third son, Gustave.

1838–45 Edouard Manet entered school at Vaugirard. Made his first attempts at drawing under the guidance of a maternal uncle, Edmond-Edouard Fournier. Shortly afterwards, in 1844, was registered as a boarder at the Collège Rollin, where he met Antonin Proust who was to become a life-long friend. His uncle Fournier often accompanied the boys on expeditions to the museums, where they made many copies, and encouraged them to attend the special drawing school attached to the college itself. However, as they often preferred to sketch the heads of their class-mates rather than the lay figures, they were suspended for a month.

1848 When Edouard's studies at the Collège Rollin came to an end, his father wanted him to study law, but he chose instead the career of a naval officer and put himself down for the July competitive examination. He failed, and as a preparation for the next attempt, he embarked on the transport steamer *Le Havre et Guadeloupe*.

1849 In April he was in Rio de Janeiro and, during the voyage, sketched portraits of his ship-board companions. In July he once again attempted the entrance examination for the Naval School, but was unequivocally rejected. His father agreed to his devoting himself to painting under Thomas Couture, whose *Romains de la décadence* had brought him great success at the 1847 Salon. During this period, the young Manet was receiving piano lessons from a Dutch girl, Suzanne Leenhoff.

1850 In January he started attending Couture's studio, where he remained for almost six years. Right from the start there were disputes between master and pupil, for the latter was so violently opposed to the historical style of painting that he wanted to leave the studio. However, his father insisted that he should stay.

1851 During the dramatic days of December, according to A. Proust, he made drawings identifying the corpses in Montmartre.

1852 On 29 January Suzanne Leenhoff gave birth to a son who was to bear the name Léon Koëlla Leenhoff. Although various biographers have cast doubts upon the fact, the child must have been Manet's son, though throughout his life Léon was represented as being Suzanne's younger brother. In June, Manet devoted himself to studying in the Paris museums. There followed further disagreements with Couture.

1853 In the autumn, he obtained his father's permission to undertake a tour of Italy. Although he was chiefly interested in Florence, he presumably also visited Rome.

1854 Renewed quarrels with Couture. This was possibly the year in which, with A. Proust, he went to see Delacroix to ask his permission to copy the latter's *Dante et Virgile à l'enfer* (4 in the Catalogue).

1856 Around Easter time, Manet left Couture's studio and set up one of his own in the Rue Lavoisier, together with Albert de Balleroy, a painter of hunting scenes. He traveled to Holland, staying at the Hague and Amsterdam; in Germany, staying at Dresden and Munich, from where he went on to Vienna and back to Italy again, to Florence, Rome and Venice.

1857 During a visit to the Louvre he made the acquaintance of Fantin-Latour, who became a good friend.

1858 Painted *Le Buveur d'Absinthe* (16). He showed the painting to Couture, who abused it; and this brought about the final break between the two men.

1859–60 Moved to another atelier at 58 Rue de la Victoire for a short time and then to the Rue de Douai, where he only stayed for eighteen months. Some of his paintings were inspired by the banks of the Seine and the Ile Saint-Ouen, one example being *La Pêche* (34). With the marriage (1860) of Napoleon III to Eugenia de Montijo, all things Spanish became the rage in Paris. At the Louvre, Edouard later met Berthe Morisot and her sister Edma, who were both talented painters. At the end of 1860, he began to paint *Musique aux Tuileries* (32), which was

completed at this new atelier was *Le Vieux musicien* (44). In this period he started engravings. He met Victorine Meurent, who agreed to model for him, and some of the painter's most famous works contain her likeness (45 etc). A Spanish troupe who were playing at the Hippodrome inspired *Ballet espagnol; Lola de Valence; Le ballerin Camprubi* etc. (47–9). During his frequent weekends at Gennevilliers, he planned *Déjeuner sur l'Herbe* (59). His father died on 25 September leaving him a substantial inheritance which, however, he was incapable of handling.

1863 In February and March he put fourteen paintings on show in the Galerie Louis Martinet and among them was *Musique aux Tuileries* (see 1860). He

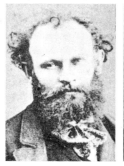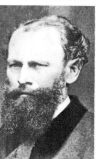

Photographs of Manet by Godet and Lochard. The first two were taken in about 1860, the third round about 1867 and the fourth in 1877.

acclaimed by his friends, among whom was Baudelaire.

1861 The Salon accepted *Le Chanteur espagnol*, which brought Manet the *'mention honorable'* and new friends such as Duranty and Degas, while exciting acid comments from Courbet's circle. In September he put *Le Gamin aux Cerises* and *Liseur* (19 and 36) on show in the Galerie Louis Martinet in Paris, and in October showed *Le Chanteur espagnol* again and *Le Garçon à l'épée* (37).

1862 Moved from the studio in the Rue de Douai to one at 8 Rue Guyot. The first picture

submitted to the Salon *Jeune homme en costume de 'majo'; Victorine en costume d' 'espada'* and *Déjeuner sur l'Herbe* (50, 51 and 59) but the hanging committee turned them down and on 15 March *Déjeuner* appeared at the first *Salon des Refusés*, where it caused an uproar. Thoré-Bürger's review provoked a sharp reply from Baudelaire (1864 – see Critical Outline). On 28 October in Holland, he married Suzanne Leenhoff. He began to frequent the Café Guerbois where he met, among others, the photographer Nadar and the painters De Nittis, Fantin-Latour, Bazille, Degas, Monet and possibly Pissaro.

1864 He did not consider it wise to submit to the Salon such a daring work as his recently painted *Olympia* (62). Instead he sent in his vast composition called *Corrida* (later taken to pieces – see 65 and 66) and *Le Christ aux Anges* (64) which were accepted. On 19 June, two American ships, *Keasarge* from the North, and *Alabama* from the South, fought a battle off Cherbourg. Manet depicted the encounter (67) and this painting was shown in the first fortnight of July at Cadart's, in Paris. He spent the summer with his family, dividing his time between the sea at Boulogne-sur-Mer, and the country, at Gennevilliers. In October he moved to 34 Boulevard des Batignolles. Meanwhile, the meetings at the Café Guerbois continued. ('What was called the *École des Batignolles* was the Guerbois and never anything else', maintains Tabarant.)

1865 In February he put some new works on show at the Galerie Martinet. He submitted *Jésus insulté* (89) and *Olympia* (see 1864) to the Salon, causing a further uproar. When the Salon closed, he took himself off for a fortnight to Boulogne-sur-Mer. At the end of August he left for Spain. The main stages of his journey were Burgos, Valladolid and Madrid, where he had a chance encounter with Théodore Duret, who was to remain a friend for many years.

1866 In February he made the acquaintance of Zola. He painted *Le Fifre* (105) which he submitted to the Salon along with *L'Acteur Tragique* (90). Both were turned down, and Manet decided to exhibit some works in his own studio. He remained in Paris for the summer.

1867 This was the year of the *Exposition Universelle*. Manet's works were excluded from the arts section, which spurred Zola to an impassioned defense. He spurned the Salon, too, though a portrait of him by Fantin-Latour was featured there. Instead, he organized a one-man show in the hut he had constructed in the Marquis de Pomereux' garden between Avenue Montaigne and Avenue de l'Alma (now Avenue George V). In order to carry out this work, Manet had to ask his mother for a loan of 18,305 francs. After several delays, the show was opened on 24 May.

Signatures in oil and pastel from various periods of Manet's life. Reading from top left they are from catalogue numbers, 49, 65, 78, 107, 174, 291, 317, 399 and 403. The first dates from 1862, the second and third from 1864, then 1866, 1873, 1879, 1880 and the last two from 1882.

From the left, a signature from a spurious work; signature added by Manet's widow (325); the initials of the atelier on 265 and the signature on a watercolor (T 1947, 582).

The admission fee was 50 centimes and the catalogue had an unsigned preface written by Manet himself in collaboration with Astruc. Eight years of work were represented here by fifty original pictures, three museum copies and three etchings. The public scoffed and the critics, Duret included, were harsh. Manet was shattered. However, he continued to work and June brought *Vue de l'Exposition Universelle*. At the beginning of August he may have been working on *L'Exécution de Maxmilien de Mexique* which the authorities refused to allow him to exhibit. In the middle of the summer, he went with his family to the sea at Boulogne-sur-Mer and Trouville, but, on 1 September the death of Baudelaire called him back to Paris. In November, Zola began sitting for his portrait (118).

1868 He continued working on the portrait of Zola (see **1867**) which was submitted to the Salon with *Femme au Perroquet* (103). In June, Manet's increasingly firm friendship with Duret found expression in a portrait of the writer (119). At Boulogne-sur-Mer, in the summer, he conceived the idea of the so-called *Déjeuner dans le Studio* (120). After his return to Paris he painted, among other things, *Le Balcon* (121).

1869 Alfred Stevens brought to Manet's studio a 20-year old painter, Eva Gonzalès, who was to be his only pupil. This new friendship aroused both artistic and womanly jealousy in Berthe Morisot, whom Manet had already painted many times (121 and others). *Déjeuner dans le Studio* and *Le Balcon* were admitted to the Salon. He hurried off to Boulogne-sur-Mer, where he made several paintings of the port (126–130). He made a brief trip to London and returned, very pleased with the welcome he had received from Legros and the art-lover Edwards.

1870 Long and laborious studies preceded the portrait of Eva Gonzalès (133). In February, the animosity which existed between the critic Duranty, an *habitué* of the Café Guerbois, and Manet, led to a duel on the morning of 23 February in the Forêt de Saint-Germain, and Duranty was slightly wounded. As well as the portrait of Mlle Gonzalès, Manet submitted *Leçon de Musique* (134) to the Salon. It was this same exhibition which, through the picture by Fantin-Latour, brought fame to the *Atelier aux Batignolles*. At the beginning of the summer, Manet was the guest for a few days of the De Nittis family at Saint-Germain-en-Laye (140). At the outbreak of hostilities between France and Prussia, he was called up (3 September) and evacuated his family to Oloron-Sainte-Marie in the Basses-Pyrénées. In December, Manet was a lieutenant under the command of the painter Meissonier, who was his colonel (141).

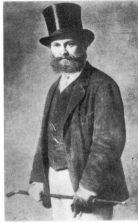

H. Fantin-Latour, Portrait of Manet *(painted in 1867 and shown at the Salon that year).*

1871 After the fall of Paris, on 12 February, Manet rejoined his family at Oloron-Sainte-Marie (142 and others). On 21 February he went to Bordeaux for a week (146) and then, on 1 March, to Arcachon where he rented a cottage for a month (147 and others). The insurrection in the capital made it impossible for the painter to return and he visited Royan, Rochefort, Saint-Nazaire and Molignen, where he stayed for a month. On 18 May he managed to return to Paris with his family. He found his atelier in the Rue Guyot half-ruined and heard that he had been elected to the Artists' Federation of the Commune. Meanwhile, street-fighting was still going on, and these events inspired the engravings of the *Guerre Civile*. At the end of August he went away with his family to Boulogne-sur-Mer and made a trip to Calais (151 and 152). He returned to Paris at the end of September.

1872 At the beginning of January, Durand-Ruel acquired a large number of Manet's works. As he had not worked a great deal at this time, Manet exhibited at the Salon an old picture which he borrowed back from Durand-Ruel, namely *Combat entre le Keasarge et l'Alabame* (see **1864**). Meanwhile he had had various alterations made in a new atelier at 4 Rue de Saint-Pétersbourg, opposite Rue Mosnier (now Rue de Berne). Berthe Morisot visited him and he painted some new portraits of her (155 and others). He sent works to two shows put on by the Society of French Artists of London. In August he traveled in Holland with his wife.

1873 He exhibited *Repos* and *Bon Bock* (131 and 165) at the Salon, and *Bon Bock* was highly successful. In the summer, he was at Berck-sur-Mer with his family and painted various seascapes (167 and others). Later, he painted *Chemin de Fer* (180). In the autumn, Marguerite de Conflans was to be seen at parties in the Manet house and the painter made several portraits of her (182 etc). It may have been during these weeks

that he began the studies for the portrait of Nina de Callias, who had once been Bazire's mistress and was then the mistress of Charles Cros (192). On 28 October the Opéra was destroyed by fire: Manet went there to collect sketch-notes and took up once more an old project of his, *Bal masqué à l'Opéra* (188).

1874 In January the portrait of Nina de Callias (see **1873**) was finished. He sent three canvases to the Salon: *Hirondelles; Bal masqué à l'Opéra;* and *Chemin de Fer* (169, 188 and 180) and a watercolor, *Polichinelle*. Only the latter and *Chemin de Fer* were accepted. Mallarmé, whom he had known, possibly, since the year before, published an article in *La Rennaissance* which spoke highly of Manet and a firm friendship grew up between the two men. Meanwhile, on 15 April, the famous exhibition of Impressionist works opened in a studio loaned by Nadar. Although he was invited to take part, Manet did not do so, since he considered that the Salon was the only suitable battleground for the artist. He spent the summer at Gennevilliers as the guest of his cousin, De Jouy, where he reveled in being surrounded by the affection of friends and colleagues, including Caillebotte, Rudolph Leenhoff, Suzanne's brother, and Monet. It is from this period that date *Argenteuil, En Bateau, Claude Monet dans son Studio flottant,* and *La Famille Monet au Jardin* (193, 194, 197 and 198). In the autumn came the last portrait of Berthe Morisot, who married Eugène Manet on 22 December, Manet did the illustrations for Mallarmé's translation of *The Raven* by Edgar Allan Poe.

1875 Although he had the right to send three pictures to the Salon, he only offered *Argenteuil* (see **1874**). He painted *L'Artiste* (201). He paid a short visit to Venice in the beginning of September (206 etc). From this year onwards, he and his friends and colleagues chose to transfer their meetings from the Café Guerbois (see 1863) to the *Nouvelle-Athènes*.

1876 The Salon turned down *L'Artiste* (see 1875) and *Le Linge* (208). Manet exhibited them in his own studio, along with other works, in a one-man-show which coincided with the second exhibition given by the Impressionists. In July he and his family spent two weeks as guests of the banker Hoschedé at Montgeron (217 etc). He began to experience a pain in his left foot, which he thought to be a passing injury but which was, in fact, the first symptom of locomotor ataxy. When he left Montgeron, he went to the seaside at Fécamp and on 2 September was back in the city again. Mallarmé was a frequent visitor to his studio, and during their meetings Manet painted the poet's portrait (224).

1877 He worked on his first 'naturalist' work, *Nana* (229), and began studies for his portrait of Faure as Hamlet (230)

which was shown at the Salon, although *Nana* was rejected. He began the portrait of the critic Albert Wolff (231), and this period also yielded the portrait of his friend A. Proust (232). During September and October he used other 'naturalist' themes, such as *Prune* and *Skating* (233 and 234).

1878 In order to avoid the hanging committee, he refused the opportunity of sending thirteen pictures to the *Exposition Universelle* and, similarly, turned down the chance of a one-man show which would have cost him even more than that of 1867. He kept away from the Salon, too — his atelier was to be his only gallery. At the beginning of July he had to leave his studio for another, at 77 Rue d'Amsterdam. Before leaving,

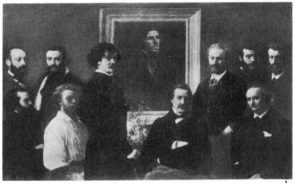

H. Fantin-Latour, Homage to Delacroix *(160 cm. by 250 cm.; 1864; Paris, Louvre). The group on the left of Delacroix's portrait includes Cordier, Legros and Whistler standing, and Duranty and Fantin-Latour seated. On the right are Manet, Bracquemond and De Balleroy standing, and Champfleury and Baudelaire seated.*

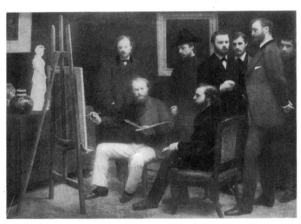

H. Fantin-Latour, L'atelier des Batignolles *(204 cm. by 273.5 cm.; 1870; Paris, Louvre). Behind Manet, who is holding a palette, are Otto Schlöderer and Renoir. To the right are Zola, Edmond Maître, Bazille and Monet, standing, and Zacharie Astruc, seated.*

Rue Mosnier on canvas (247 etc). He was unable to occupy the new studio until 1 April 1879 and until that date he used a conservatory-like studio lent to him by Count Otto Rosen, a painter of Swedish origin. He spent the summer at Gennevilliers, returning to Paris in September. He frequented the *brasseries* and *café-chantants* seeking ideas for various works (249 etc). In the autumn the Guillemets started posing for *Dans la Serre* (268).

1879 The Guillemets (see **1878**) and the painter's wife (269)

he worked very hard to capture finished posing for their portraits in Rosen's conservatory. After giving the matter considerable thought, Manet decided to send to the Salon, along with *Dans la Serre*, one of the best of the 1874 paintings, namely *En Bateau*. On 1 April he set himself up in his new studio in Rue d'Amsterdam. In the same month he wrote his famous letter to the prefect of the Seine *département* and to the President of the *Conseil Municipal de Paris*, outlining a project for a painted decoration for the new Hôtel de Ville on the theme of 'the stomach of Paris', but he received no reply. This year saw two self-portraits (274 and 275). Tormented again by pains in his left leg, he tried various cures and was

recommended to take the waters at Bellevue, but put off making a decision. He painted portraits of George Moore, *l'Anglais de Montmartre*, Rosita Mauri, an actress friend of A. Proust, and Charpentier's sister-in-law, the charming Isabelle Lemonnier (278, 279, 280 etc). In July Eva Gonzalès married the engraver Henri Guérard. In about the middle of September, Manet went to Bellevue with his wife to take the waters. He stayed six weeks and made the acquaintance of the singer Emilie Ambre whose portrait he

began, finishing it the following year (301). At the end of the year Emilie Ambre, who was leaving for a tour of America, persuaded Manet to entrust to her a new version of *L'Exécution de Maxmilien de Mexique* (166 C) so that she could have it exhibited in American cities. The exhibitions caused some stir and were rather unwise, since the singer turned them into a sort of carnival, and Manet was very upset.

1880 During January, he worked on a new portrait of Proust (303). Between 10 and 30 April, and coinciding with the fifth show by the Impressionists, he exhibited at *La Vie Moderne*. The twenty-five works and the catalogue illustrated with two lithographs attracted a large, though not always favorable, public. He sent the latest portrait of Proust and *Chez le Père Lathuille* (271) to the Salon. In June, Emilie Ambre, who had returned from America, leased a villa at Bellevue to Manet for the usual cure. During his three-month stay there he did a great deal of work (304) etc.

1881 At the beginning of the year he painted portraits of Pertuiset (341 and 343) and showed them at the Salon, obtaining the medal for second place, which put him *hors de concours* for future shows, causing an outcry in official circles. He conceived the idea of portraying the seasons with four beautiful female figures. He began with *Printemps*, using as his model the young actress Jeanne de Marsy (348). He rented a villa at Versailles and moved there with his family in the last week of June, but did not paint very much (349 etc). He made some drawings to illustrate *Annabel Lee*, which Mallarmé was translating along with other poems by Poe, which were to be published by Deman in Brussels in 1888 with the following dedication by Mallarmé: 'To the memory of Edouard Manet, these pages which we read together'. Not at all improved in health, he returned to Paris at the beginning of October. He began meeting his friends of the *Nouvelle-Athènes* again. He often went to the Folies-Bergère, which had opened in 1880, where he found inspiration for the two versions of the *Bar aux Folies-Bergère* and the two portraits of Suson (357 etc). The actress and *femme galante*, Méry Laurent, often went to his atelier and it was she who posed for the second of the seasons, *L'Automne* (372). Manet's health deteriorated but he was cheered by some good news: his friend A. Proust who for a short time was Ministre des Beaux-Arts in the Gambetta government, was successful in proposing his name and Manet was created Chevalier de la Légion d'Honneur.

1882 In May there was an Exhibition of Decorative Arts, with A. Proust as its President. Proust, however, had to try to steer a course amid the different temperaments of the people involved and allowed two of Manet's paintings to be excluded. Manet exhibited *Bar aux Folies-Bergère* and *Printemps* (see **1881**) at the Salon with great success. Some other portraits date from this period: of Méry Laurent, of Irma Brunner and of Hecht's small daughter (375, 385, 389 and others). From July to October he lived in a gloomy rented cottage at Rueil where he painted still-lifes, the garden and the house (390 etc), and entertained his friends. When he returned to the city, he had in mind a large composition of a military nature for which he sketched *Le Clairon* (407), but he later abandoned the idea.

1883 A little before 25 March, he was painting flowers again (417) and began a portrait of Méry Laurent's servant (418), which Suzanne was to find on the easel after his death. Soon it became impossible for him to co-ordinate his movements. He could no longer manage to get to the studio and, on 6 April took to his bed for good. A few days earlier he had written to the miniaturist, Defeuille, asking him to give him some lessons in the technique as he wanted to take it up. On 14 April gangrene set into his left leg and the surgical consultants decided to amputate. Visits to the patient were prohibited but his most faithful friends called in every day: the Abbé Hurel, Nadar, Chesneau, Burty, Fourcaud, J. de Biez and Mallarmé. On 30 April, Edouard Manet died. Manet's will, which had been drawn up on 30 September 1882, made his wife the sole heir and enjoined upon her to name as her own heir Léon Koëlla, 'who has looked after me most devotedly, and I think that my brothers will find these dispositions quite natural'.

1884 In January the critic Edmond Bazire published his *Manet*, which was illustrated by H. Guérard with reproductions of the painter's works. As a result of representations by A. Proust, the Ministre des Beaux-Arts allowed a posthumous showing of the collected works of Manet on the premises of the Ecole des Beaux-Arts. The exhibition included 116 oil paintings, 31 pastels, 20 water-colors and drawings, 12 lithographs and etchings. Between 5 and 29 January, 13,000 people paid to see the exhibition. Lochard photographed Manet's works when they were collected in the atelier. On 2 and 3 February, 169 of Manet's works were put on show at the Hôtel Drouot and the sale which followed (4 and 5 February) brought in the substantial sum of 116,637 francs. Gustave Manet died.

1886 Between 10 April and 25 May, Manet's works were shown in New York as part of a collection exhibited under the general title of 'Impressionists of Paris'.

1889 Fifteen pictures by Manet were shown at the *Exposition Universelle*. On 8 January, Sargent and Monet started a subscription fund to prevent *Olympia* from being acquired by an American collector and the sum of 19,415 francs was collected.

1890 Letter (7 February) from Claude Monet to the Ministre de l'Instruction Publique offering *Olympia* (see **1889**) to the nation. The work was not accepted for the Louvre and was placed, instead, in the Musée du Luxembourg.

1892 13 April, Eugène Manet died.

1893 Paintings by Manet were exhibited from 1 May to 9 October in Chicago in a show of works belonging to private American citizens.

1894 The painter Caillebotte died, leaving his collection of Impressionist works to the Musée du Luxembourg. The committee accepted Manet's *Angelina* and *Le Balcon* but turned down *La Partie de Croquet*. On 19 March, pictures by Manet from the Duret Collection were sold.

1895 March. Exposition of Paintings by Edouard Manet was put on in New York by the Durand-Ruel Gallery.

1896 26 March. Sale of the Chabrier Manets.

1900 Ten works by Manet were shown at the *Exposition Universelle* in Paris. Méry Laurent died on 26 November leaving to her heirs various oils and pastels by Manet.

Manet's tomb in the Passy cemetery, Paris. The bust is by F. Leenhoff.

1902 Duret published the first edition of his book on Manet.

1905 During January and February works by Manet were included in an exhibition of works by Impressionist painters at the Grafton Galleries, London. Thirty-one of the artist's works appeared in the Salon d'Automne in Paris between 18 October and 25 November.

1906 Manet's widow died on 8 March. Moreau-Nélaton presented to the Louvre five of the artist's works, among which was *Déjeuner sur l'herbe*, and published his book, *Manet, graveur et lithographe*. Twenty-five of Manet's oils and water-colors, belonging to the singer Faure, were exhibited at the Galerie Durand-Ruel and the same exhibition went on to Berlin and London during June.

1907 *Olympia* (see **1889**) was transferred to the Louvre as a result of representations to Clémenceau by Monet.

1910 An exhibition of thirty-five of Manet's oils and pastels from the Pellerin Collection was put on the Galerie Bernheim-Jeune in Paris and was later taken to the Moderne Galerie in Munich. On 8 November other works by Manet and by post-Impressionist painters appeared (until 15 January 1911) at the Grafton Galleries, London.

1912 Meier-Graefe published his monograph on Manet.

1913 A. Proust published *Edouard Manet, Souvenirs*. From 29 November to 13 December there was an exhibition entitled 'Paintings by Edouard Manet' at the Durand-Ruel Gallery in New York.

1914 Among the works in the Camondo Collection bequeathed to the Louvre were ten paintings by Manet.

1919 Manet engravings on show at the Grolier Club, New York.

1922 Show of Manet's paintings at the Ny Carlsberg Glyptothek in Copenhagen. Prints of others at the E. Weythe Gallery in New York.

1924 Jacques-Emile Blanche published his *Manet*. There was an exhibition of works by Manet,

Renoir and Morisot at the Carnegie Institute in Pittsburgh and at the Museum of Art in Cleveland.

1925 When Zola's widow died, the Louvre received three works by Manet: *Portrait de Zola; Portrait de Mme Zola* and the watercolor of *Le Christ Mort et Deux Anges,* which had already been bequeathed to the museum by the writer.

1926 E. Moreau-Nélaton published *Manet raconté par lui-même.*

1928 Exhibition of Manet's works in the Matthieson Gallery, Berlin and at the Galerie Bernheim-Jeune, Paris.

1932 Works by Manet formed part of an exhibition at Burlington House, London, called 'French Art 1200–1900'. Commemorative exhibition to mark the centenary of his birth in Paris (catalogue edited by C. Sterling, P. Valéry and P. Jamot). Another exhibition, this time of prints, at the Public Library, New York.

1933 Some of the artist's works were put on show at the Art Institute of Chicago (American Collections) and at the Museum of Art in Philadelphia (Manet and Renoir).

1937 An exhibition devoted to Manet was put on by the Wildenstein Gallery in New York. Some of his works also appeared in a Paris exhibition of *Chefs d'oeuvre de l'Art français*.

1938 Works were exhibited in the *Honderd Jaar Fransche Kunst* in Amsterdam.

1946 Masterpieces by Manet at the P. Rosenburg Gallery in New York.

1948 The Wildenstein Gallery in New York devoted another show to his work.

1952 Works by Manet appeared in the display of *Impressionistes et Romantiques français dans les Musées allemands* at the Orangerie in Paris.

1954 Some of the Manets belonging to the Louvre were shown at the Tate Gallery, London, and others in the exhibition of French Painting from Gérome to Gauguin at the Institute of Arts, Philadelphia.

1961 Manet exhibition at the Musée Cantini at Marseilles.

1962 A group of works by Manet and his school shown at the Museum of Art, Baltimore.

1964 Masterpieces of the Swiss collection *De Manet à Picasso* at the Beaulieu in Lausanne. Others of his works shown in Munich in the collection *Von David bis Cézanne.*

1965 Prints of the artist's works were brought together into a collection at the Bibliothèque Nationale in Paris. Paintings on show at the Wildenstein Gallery in New York.

1966 and **1967** Collection of 195 of his works exhibited at the Museum of Art in Philadelphia and at the Art Institute of Chicago.

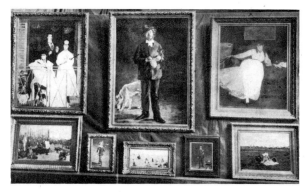

One of Godet's many photographs of the posthumous exhibition at the Ecole des Beaux-Arts, Paris, in 1884. The numbers of the works in the present volume are, from top left, 121, 201 and 131, then 146, a watercolor, Pulchinello, *130, 119 and 169.*

Catalogue of works

Born into a solid middle-class Parisian family, Edouard Manet was to preserve throughout his life some of the attitudes which were partly determined by these origins. In spite of this, he displayed, in the field of art, a free audacity, a modernity of outlook, an ironic broad-mindedness and, above all, a firmness in upholding the rationale of his own painting in the inimical atmosphere of the artistic society of his time, although he was capable of being cut to the quick, especially in the early years, by spiteful and superficial criticism. In following his artistic vocation, Manet went first through a rigorous training discipline, passing through all the vicissitudes which attended the beginnings of modern painting in all its aspects, starting with experiment and proceeding to the boldest of creative freedom. The choice of the Couture school was his father's, and there Manet suffered for six years. These years were far from peaceful because of the trouble caused by the polemics and innovations which he openly introduced into the atelier, where the hated pomposity of 'historical' painting was lauded and where the didactic methods could not have been very different from those which might have been fostered by David. Even as early as this, however, he was beginning to exercise those great faculties which struck Mallarmé. The hand was being trained in the still covertly academic conception of drawing, but the eye could not be satisfied with the affected *Romains de la Décadence* which, as recently as 1847, had brought Couture great acclaim. Then Manet rediscovered the museums, where he was particularly attracted to Venetian and Spanish works. It was upon these two great traditions (and especially the second) that he came to build up a palette which was capable of rendering a subject without recourse to shadow and detailed drawing. His two journeys, in 1853 and 1856 (the more important of which, as was usual, was the Italian one) were instigated by a need to rediscover the fountain-head of a stylistic education that was to

consilidate what he had already absorbed. Whether or not he had seen the Spanish paintings in the Pourtalès Collection in Paris — a matter which has been long and often in dispute — is of little relative significance, and it is quite feasible to give credence to the strange coincidence about which Baudelaire wrote. Manet's admiration was not so much for Goya, whose work he was to come to know better at a later time, as for Velasquez, from whom he harvested a store of inventive features, a sense of color and an obvious immediacy of composition.

Today, the works of his early youth are very few and far between, and it is not possible to enumerate more than two or three works by Manet as a boy and adolescent. When he was a sailor, the exotic enchanted him (one has only to read his letters from Rio) but its attraction faded, however, from these youthful journeys, was a love of the sea with its restless motion, its changing colors and its palpable yet unpredictable atmosphere.

During this same youthful period his approach to sacred subjects, while not a response to an inward need, was, nevertheless, a manifestation of his desire to break away from the confines of 'historical' painting. So it was with the heads and the portraits of friends and acquaintances, painted with a lively psychological penetration, which brought down upon him the scorn and wrath of his master. So it was with the pictures for which the model was Alexandre, whose *gamin* ways and melancholy, disillusioned look he captured, even though at times they became reminiscent of the *Petit Gilles* by Couture himself. These similarities, however, were less important than the chromatic innovations and the fresh approach to various passages, such as the hands, for example, which already point the way to a better Manet. But in these works and in *The Absinthe Drinker* (16) other influences are clearly recognizable, and appear also to some extent in his first, clamorous 'Spanish' work, *The Spanish Singer* (33). These

were the lesson which he recognized in, and accepted from Courbet the approach to reality; again, the somewhat bituminous shadows of Couture; and, already, the literary ghost of Baudelaire.

Indeed, by about 1858, Baudelaire's subtle power began to take hold of Manet and it is already visible in *The Absinthe Drinker*, although Baudelaire himself did not like the work. On the other hand, *Music in the Tuileries Gardens* (32) did please Manet's friends, including Baudelaire, who had been with him when he was making the preliminary studies. This famous work, although displaying some uncertainty in the fusing together of figures in the open air, was a fresh and unexpected breath of contemporary life. It could be said that the poet also helped to fan the painter's passion for Spain, which was far from unproductive. That feast of color, those beautiful women and the glittering costumes must have been curiously pleasing to Manet, especially as his favorite painters, the Spanish masters, had painted the life that was burgeoning around them, and after the homely theatricality of *The Spanish Ballet* (47), *Lola of Valencia* (48) seems to adumbrate these same features.

At the other extreme, *Le Déjeuner sur l'Herbe* (59), that 'scandalous' triumph of the Salon des Refusés, was a scandal just because of its two-fold modernity. It was a bourgeois and contemporary interpretation of a sixteenth-century theme and, at the same time, a highly impudent novelty in its concise presentation of the figures through the use of accentuated color delineation. Nor was *Olympia* (62) any less of a 'scandal'. Gone were the half-tones and chiaroscuro shading: the picture is rendered in flat colors and bold contrasts which render, by means of a contrapuntal use of color, a guileless theme whose precedents were the Venuses of Giorgione and Titian and, nearer home, the *Maja desnuda* of Goya. The compositional arrangement emerges in such a very simple and vivid form, in spite of the extreme flattening of the figures, that it offers, on the one hand a dematerialized and quintessential inlay of color and, on the other, a disturbing ordinariness. The rough contour line, which marks out the spaces without stopping to define the planes, was to return again in another work, *The Fifer* (105) which establishes a double attraction : that of the figure against the background and of the figure in relation to the person looking at it, through the bold evocation of volume balanced by relief.

With the journey to Spain in 1865, Manet came to recognize his cultural predilections and to place them in a very precisely defined area. However, he also drew from Japanese art just those aspects which seemed to him to be consistent with and related to his own interests,

namely the way of expressing shapes and positioning them in space, the clear-cut definition of figures and their chromatic positioning in their allotted area, and the boldness of setting which is, perhaps, not so very far removed from the passion for photography which he shared with Degas. This too derived from a desire to document and to achieve contemporaneity, and could be both ample and selective at one and the same time. It is in this sense that his attraction to some historic scenes can be understood — though this was history without trappings or moral overtones. The naval battle between *Keasarge* and *Alabama* (see 67) was not painted by one who prudently awaits the outcome, but is simply a spectacle, that of a battle at sea which brought back all the old nostalgia and enchanted him afresh. The same applies to the drawings, experimental sketches and paintings related to *The Execution of Maximilian of Mexico* (115 and 116) which bear witness not only to a kind of journalistic curiosity, but also to the drama of an event whose humanity comes less from emphasis than from the untrammeled simplicity by means of which every gesture has that unique fatefulness that can assail our ignorance.

For Manet, 'Impressionism' had a very special meaning, and he was well aware of this, with the result that he did not participate in the shows given by the group. He rejected certain articles in their faith that art could be redeemed from outside official positions and in painting as a happening in color. Monet's *plein-air* work interested Manet and it was not for nothing that he tried it out for himself. It was, perhaps, in 1864 that, with *Racing at Longchamps* (87) he succeeded in capturing, in the crowd of spectators, that swift feeling of figures in the vibrancy of light. He was confronted with the same problems in a more demanding way during the months which he spent at Gennevilliers and Argenteuil with Monet and Renoir. In Manet, however, neither the love for *plein-airisme* and the reactions of light on natural elements, nor the scrupulous attention to optical and parascientific precepts was exclusive. Lightening his palette and making his harmonies more vibrant and magnificent, he returned to the study of figures, seeking a synchronized relationship both between the figures themselves and between them and the natural setting. Thus it is that we have the figures of Monet and his family (197 and 198) and the dazzling *Argenteuil* and *Boating* (193 and 194), which are coherent and worked out in an entirely original language.

Although Manet started working on *Bon Bock* (165) he was still, however, in the same year passionately seeking a vital immediacy in his rendering of the masked crowd at the Opéra and picked each

character out with his brush solely by the use of color. The figures have spontaneity and he makes the groups dissolve and re-form with the naturalness of a man who looks at the contemporary scene with detachment. And the times seemed full of promise. Not only was there the gaiety of the *boulevards* and the *café-chantants*, but this was also the period of the train, for example, and Manet seems to see himself in the awe shown by the little girl gazing at the cloud of steam (180).

At this juncture, too, it is right that mention should be made of Zola. A link between the author of *L'Assommoir* and the painter has been spoken of in connection with *Nana* (229) but *The Plum* and *Skating* (233 and 234), too, may in some measure be considered as influence. However, it would not be difficult to find links for another chain leading from *Père Lathuille* (271) through the portrayals of the *café-concerts* and the *brasseries* (262 and others) to *Bar at the Folies-Bergère* (357), Manet's last great work where, in the sparkling colors used in the play of figures reflected in the mirror, in the unhurried and almost elusive tangibility of the shapes, in the joyful suspense, yet conscious of the sadness of the atmosphere, he commits to canvas the fruits of long experience, resulting from his love of things and from the new feeling attributed to beauty and to painting.

Of all the catalogues published up to the present time on Manet's work, one of the most comprehensive and reliable is that provided by the photographs which Lochard took in the artist's atelier after his death. These include photographs of paintings, even in sketch form — oils, pastels and watercolors — and drawings, etchings and lithographs, although authors differ on their number. Lochard's photographs were not exhaustive and other sources are the Durand-Ruel photographs and those of Duret. Moreover, a large photographic collection, once the property of Moreau-Nélaton, is preserved in the Cabinet de la Bibliothèque Nationale in Paris. One could be forgiven for thinking that, with these and other proofs, it would be relatively safe and easy to give accurate information about the authenticity of any work. If, however, we refer to the most illustrious cataloguers, we see that Jamot and Wildenstein use a different typographical mark to distinguish those works about which they harbor doubts, just as Tabarant avoided mentioning any which were not cited elsewhere. As far as the present work is concerned too, it was considered that it would be undesirable to allude to those works which are among those placed in doubt and whose exclusion from the authenticated *corpus* has been confirmed in such a way as to make it decisive (see also page 81).

Where Manet is concerned, the question of forgeries takes on a special aspect. Many of the crudest which have passed onto the market or into the hands of unwary collectors bear, as a reference, the period at Bellevue, where Manet spent the end of the summer of 1879 and the whole of the summer of 1880. Most of these forgeries, mainly female figures and still-lifes, bear the dates 1873, 1875 and 1877, usually the first, which makes the deception immediately obvious, not just because of the quality but also because of the impossible reference. In this connection, one of the most notorious and strange of these cases was revealed by Tabarant in an apparently unimpeachable museum in Stockholm and which, in the catalogue, bore the date and reference of the genuine painting in the Art Institute of Chicago, with a brash false signature; and a portrait of Courbet. Attributions just as unwise have been made about portraits of Zola which have blossomed in great numbers, whereas it is known and documented that Manet only painted the one in the Louvre.

Unfortunately, the imprudent circulation of these on the market and in private collections, especially provincial ones, was, to some extent, facilitated by the fact that, although Manet signed, or marked with the atelier seal, about half of his 'definitive' paintings (oils and pastels) he only rarely put his name or initials on watercolors or drawings. His widow, however, signed or put a seal on at least fifteen or so of the works and guaranteed the authenticity of a dozen. In addition, on perhaps twenty-five of the oils and water-colors, though authentic, there is a false signature.

Other unusual circumstances also played their part in the 'posthumous' vicissitudes of Manet's works and these are exemplified by the misfortunes of *Fishing* and *Portrait of Mme Manet in the Conservatory* (46 and 269). In these two cases, the existing replicas are certainly by Edouard Vibert, nephew of Manet's wife, Suzanne, and the son of Suzanne's sister, Marthe, who was herself the wife of a painter, Jules Vibert. Nothing can scotch the suspicion that, in addition to these replicas, which were probably not done with any evil intent, other similar pieces of handiwork may have come from this same Vibert who was endowed, among other things, with a considerable talent for imitation. Also, it should be added that, when Suzanne Manet died, much passed under the heading of *Succession de Madame Veuve Edouard Manet*, including, in addition to various paintings by the master himself, some by her brother-in-law Jules, the father of the imitator Edouard Vibert, and also by Suzanne's brother, Rudolph Leenhoff, who was also a painter. Among the large *corpus* of valueless

references, the palm must surely go to a work by Edouard Vibert, *Le Bouquet de l'Olympia*, which did the rounds of the antiquarians and small collectors. It is a close and detailed reproduction of the flowers in the famous picture and was, in its turn, imitated, as is demonstrated by other things of the kind which passed onto the market. Finally, some reference at least should be made to what O. Kurtz (*Forgers and Forgeries*, 1961) called the 'swindle of the Duret source'. Théodore Duret, whose precious photographs have already been mentioned, and whose study of Manet is referred to many times in the present catalogue, has the merit of being one of the first to admire the master and to buy his works. He sold his first collection in 1894, and the works in this collection enjoyed the very highest esteem. However, with the advancing years, Duret's critical faculties, as well as his memory, declined and, when he died, his surviving heritage consisted mostly of forgeries which had been passed off on him by swindlers. So, in spite of the efforts of the executors of his will, a good deal of spurious work is now found under the label of 'Duret source'.

Above, the word 'definitive' has been taken to apply to Manet's oils and pastels, with the underlying implication

3

that the watercolors, like the drawings, should be considered as 'preparatory'. Indeed, apart from exceptional cases – usually connected with illustrations or otherwise unconnected with paintings – this classification is acceptable, provided, of course that we think more of the event that moved the painter than of the resulting works, since no-one would dream of denying to a Manet folio the prestige of a fully autonomous and completed work. The limits of this study have been determined by these distinctions and it is restricted in scope to the 'paintings' of Manet, and therefore to the oils and pastels – just those 'definitive' works, in fact, upon which rests his most lasting fame.

The paintings are listed in their most likely chronological order which is, in any case, guided by the various, though not always consonant, stages of Manet's output. In addition to this, a critical order has been sought which distinguishes, and to some extent isolates, their creation, and where care has been taken to note the thematic identity and affinity which exists between different works, even though they are distinct one from another. This has been done by grouping them under a single numbered entry in which, although they are linked, they are dealt with separately, in individual descriptions marked by different letters of the alphabet. The heading of the entries – and therefore the letter A – has been reserved for the work in each 'group' which marks the end-product of that group. The others follow, in spite of the fact that they are mostly studies or earlier paintings, sketches and 'suppressed' experiments, since 'repetitions' are also given in replicas or copies which, nevertheless, add nothing to the completeness of the listed work. Thus the list mentions

418 'numbers'; if it had contained all the catalogued works, the number would have risen to 495. As far as the entries are concerned, wherever the only useful information about a painting is contained in the title and the data given in the heading, it was considered pointless to add to this with unnecessary comment.

Another timely warning concerns the whereabouts of the paintings. It may be said without fear of contradiction that the indications given here are the outcome of truly painstaking research. In many cases it has been the fruit of not inconsiderable efforts to identify an old 'home' – hence the addition of the adverb 'formerly' before a somewhat uncertain reference – while in not a few other cases, the anonymity of 'privately owned' might have been

order which is, in any case, guided by the various, though not always consonant, stages of Manet's output. In addition to this, a critical order has been sought which distinguishes, and to some extent isolates, their creation, and where care has been taken to note the thematic identity and affinity which exists between different works, even though they are distinct one from another. This has been done by grouping them under a single numbered entry in which, although they are linked, they are dealt with separately, in individual descriptions marked by different letters of the alphabet. The heading of the entries – and therefore the letter A – has been reserved for the work in each 'group' which marks the end-product of that group. The others follow, in spite of the fact that they are mostly studies or earlier paintings, sketches and 'suppressed' experiments, since 'repetitions' are also given in replicas or copies which, nevertheless, add nothing to the completeness of the listed work. Thus the list mentions

avoided, had the owners not refused consent. Finally, as for the photographic reproductions, they are almost complete in number and are unrivalled in either of the two 'classic' collected lists. The paintings for which there is no illustrative support are those few whose whereabouts have not been discovered. To justify their right to be included in this catalogue reliance in research has had to rest on the authority of documentary evidence or reproductions which were not fit to use.

4A 4B

1 ⊞ ⊛ 70×84 *1854* ▤ ⁝

Vierge au Lapin Blanc (Madonna of the White Rabbit) Mrs Beltram Smith Collection, New York
Copy of the celebrated painting by Titian in the Louvre. The largest of the five surviving versions, it was painted by Manet in the Louvre Museum in Paris.

2 ⊞ ⊛ 47×85 *1854* ▤ ⁝

La Vénus du Pardo (Venus of the Pardo) Rouart Collection, Paris
Copy of the Titian painting in the Louvre. In Manet's time it was known as *Jupiter et Antiope*.

3 ⊞ ⊛ 61×50 1854 ▤ ⁝

Autoportrait du Tintoret (Self-portrait of Tintoretto) Musée des Beaux-Arts, Dijon
Copy of the painting in the Louvre, with a reproduction of the original inscription. Manet gave it to his brother, Gustave, and it later passed into the hands of his other brother, Eugène. In its present location since 1898.

4 ⊞ ⊛ 36×43 1854? ▤ ⁝

Dante et Virgile à l'Enfer (Dante and Virgil in Hell) Musée des Beaux-Arts, Lyon
A This is the first of the two copies made by Manet of the painting by Delacroix, which was then in the Musée du Luxembourg.
B The other copy, which dates from the same period (oils on canvas, 33 cm. × 42 cm.; H. O. Havemeyer, Metropolitan Museum, New York) is a freer and more summary rendering and was probably executed with the intention of studying Delacroix' style from the point of view of color and composition. Wildenstein believes 4A to be the later copy.

5 ⊞ ⊛ 47×77 1855? ▤ ⁝

Les Petits Cavaliers (Réunion de Treize Personnes) The Little Gentlemen (Meeting of Thirteen People) Tryggve Sagan Collection, Oslo
Copy of a painting formerly attributed to Velasquez (Louvre, Paris). The inscription 'Manet, after Velasquez' may be seen on it. Tabarant suggests that it may have been painted in about 1855, while Richardson dates it around 1860.

5

6 ▦ ◑ 56×47 ▤ A ⦂ 1855-56

Portrait d'un Homme (A. Proust?) (Portrait of a Man) Formerly in the O. Federer Collection in Prague

7 ▦ ◑ 25×39 ▤ ⦂ 1856

Leçon d'Anatomie (The Anatomy Lesson) Private Collection, Paris
Copy of the painting by Rembrandt at the Mauritshuis in the Hague. Painted during the trip to Holland and given by Manet to Dr Siredey, the family physician.

8 ▦ ◑ 45×36 ▤ ⦂ 1856

Christ au Roseau (Christ with a Reed) Hugo Fleischhauner Collection, Stuttgart

9 ▦ ◑ 41×32 ▤ ⦂ 1856?

Tête d'un Jeune Homme (Head of a Young Man) Private Collection, Paris
Copy of a well-known painting by Filippino Lippi in the Uffizi in Florence, painted during the first or second visit to Italy. Once belonged to A. Proust and later to the baritone Faure.

10 ▦ ◑ 24×37 ▤ ⦂ 1856

La Vénus d'Urbino (The Venus of Urbino) Private Collection, Paris
Copy of the Titian painting in the Uffizi in Florence, made when he stayed there during his second tour of Italy. It reveals both Manet's interest in the Old Masters and his own independence of interpretation. Compare the background with that in *Portrait of Astruc* (70)

11 ▦ ◑ 50×40 ▤ ⦂ 1856*

Tête de Vieille Femme (Head of an Old Woman) Barclay Collection, New York

12 ▦ ◑ 63×50 ▤ ⦂ 1856*

Christ à la Houe (Le Christ Jardinier) Christ with a Hoe (Christ the Gardener) R. Werner Collection, Stuttgart
A Together with the work mentioned below, this was one of the studies for a *Noli me tangere* which Manet was planning to paint.
B The painting mentioned above (oils on canvas, 39 cm. × 32 cm.). Owned by Abbé Hurel in 1902.

13 ▦ ◑ 54×43 ▤ ? ⦂ ante 1858

Pont d'un Bateau (Deck of a Ship) National Art Gallery of Victoria, Melbourne

14 ▦ ◑ 92×65 ▤ ? ⦂ *1858*

Femme aux Chiens (Woman with Dogs) Private Collection, San Antonio, Texas

15 ▦ ◑ 41×32 ▤ ? ⦂ 1858?

Fumeur (Buveur) Smoker (Drinker) (1913) Macomber College, Boston, Massachusetts
Copy of the well-known painting by A. Brouwer in the Louvre.

11

16 (Plate I)

12A

12B

13

16 ▦ ◑ 181×106 ▤ ⦂ 1858-59

Le Buveur d'Absinthe (The Absinthe Drinker) Ny Carlsberg Glyptothek, Copenhagen
The model was an eccentric alcoholic named Collardet. The theme was suggested to the painter by some verses of

Baudelaire in his *Fleurs du Mal* at a time when he was chafing under scholarly teaching and the 'literary' style of painting. Manet sent the work to the 1859 Salon, but it was rejected by the hanging committee, of whom Delacroix may have been the only member in favor of it. The 'motif' was included in 44.

17 ▦ ◑ 55×46 ▤ ? ⦂ *1859*

Tête d'Homme (Man's Head) Formerly in the Gilles Cardin Collection, Paris

18 ▦ ◑ 54×30 ▤ ⦂ *1859*?

Arbres (Trees) Formerly in the Devillez Collection, Brussels
The annotation which Léon Koëlla put on the relevant photograph by Lochard: 'Study for *Déjeuner sur l'herbe*', and repeated by Jamot and Wildenstein, may be wrong (Tabarant). If it is correct, then the painting would be not earlier than 1863.

19 ▦ ◑ 65×55 ▤ ⦂ *1859*

Gamin aux Cerises (Boy with Cherries) Fundacao Calouste Gulbenkian, Oeiras
It would appear, from a note by Berthe Morisot (in J—W) that the model for this picture was a fifteen-year-old, Alexandre, who came from a very poor family and ran errands for Manet. One day the lad was overcome by despair and hanged himself in the painter's studio. This tragic event inspired Baudelaire's story *La Corde* (in *Le Spleen de Paris*). Berthe Morisot's daughter, Madame Rouart, records that the picture was sold at Durand-Ruel's after Manet's death. While still retaining scholastic elements, the work displays some felicitous features: the hand grasping the cherries, rendered with abundant delicacy and high-lighted here and there, is typical of Manet (Courthion). It was first shown at the Galerie Martinet in Paris between 1 and 30 September 1859.

20 ▦ ◑ 47×37 ▤ ⦂ 1859

Portrait de l'Abbé Hurel (Portrait of Abbé Hurel)
In its original form it measured 81 cm.×72 cm. (92×65, according to Duret): It was given to the sitter himself by Manet's widow.

21 ▦ ◑ 55×45 ▤ ⦂ 1858-60

Femme à la Cruche (Verseuse) (Woman with a Jug) Ordrupgaardsamlingen, Copenhagen

22 ▦ ◑ 19×17 ▤ ⦂ 1859-60

Gamin au Chevreau (Boy with a Kid) Private Collection, Paris

23 ▦ ◑ 79×92 ▤ ⦂ 1859-60

Étudiants de Salamanque (The Students of Salamanca) Museo Nacional de Bellas Artes, Buenos Aires
The story of the students searching for treasure was possibly inspired by Lesage's *Gil Blas*. The background landscape is in the immediate neighborhood of Paris.

14

15

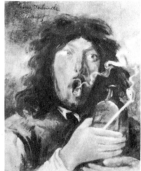

17

18

19 (Plate III)

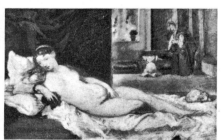

7

10

24 ⊞ ◕ 46×38 / 1860 ▤ ⦂
Velasquez dans le Studio (Scène d'atelier espagnol) Velasquez in the Studio (Scene in a Spanish atelier)
Lorenceau Property, Paris
A kind of tribute to the Spanish painter, with elements drawn from *Las Meniñas* in the Prado in Madrid (the portrait group of Velasquez) and from 5.

25 ⊞ ◕ 45×25 / 1860 ▤ ⦂
Cavaliers Espagnols et un Garçon avec un Plateau (Spanish Gentlemen and a Boy with a Tray)
Musée des Beaux-Arts, Lyon
Copy of a picture in the Louvre, formerly attributed to Velasquez.

26 ⊞ ◕ 62×50 / 1860 ▤ ⦂
Portrait d'un Homme (Le Chanteur Rubini? Paul Roudier?) Rijksmuseum Kröller-Müller, Otterlo

27 ⊞ ◕ 74×60 / 1860 ▤ ⦂
L'Italienne (The Italian Model)
A Cassat Collection, Philadelphia

28 ⊞ ◕ 110×90 / 1860 ▤ ⦂
Portrait des Parents du Peintre (Auguste Manet, et Madame) (Portrait of the Painter's Parents) Rouart Collection, Paris

29 ⊞ ◕ *1860* ▤ ⦂
L'Infante Maria Margarita (The Infanta Maria Margarita)
Copy of the Velasquez painting in the Louvre and known of through a watercolor which apparently succeeded the version in oils, itself lost.
J. Mathey (1963) notes a version in oils (33 cm. × 24.8 cm.; private collection, Paris) which he considered authentic.

30 ⊞ ◕ 92×72 / *1860* ▤ ⦂
Garçon au Chien (Boy with a Dog) Private Collection, Paris
According to Huyge, a reproduction of a Murillo in the Hermitage, Leningrad, inspired this oil-painting, but it is well known that Manet did not have much admiration for Murillo.

31 ⊞ ◕ 38×46 / *1860* ▤ ⦂
Enfants aux Tuileries (Children in the Tuileries Gardens)
Rhode Island School of Design, Providence, Rhode Island

32 ⊞ ◕ 76×119 / 1860 ▤ ⦂
Musique aux Tuileries (Music in the Tuileries Gardens) National Gallery, London
The fact that the date 1862 is in a different color from the signature may support the hypothesis that it was put there two years after the picture was painted, perhaps at the time of the exhibition in the Galerie Louis Martinet, in 1863. However, the question remains

20

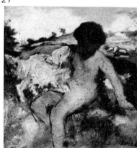

21

22

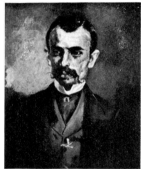

26

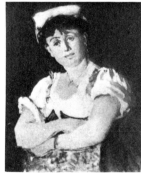

27

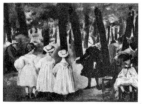

31

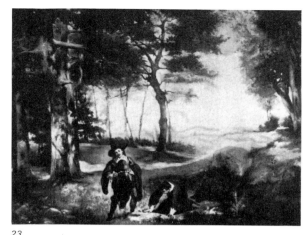

23

24

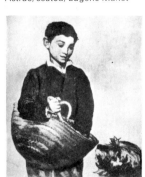

25

open since some scholars (J-W : T. 1947 etc.) date it 1860, while others (C-H: Rewald : R. etc.) date it as 1862. The famous article in which Baudelaire (F. 1863) set out his conception of the 'painter of modern life' certainly seems to bear close reference to this picture. It was the first in which Manet showed himself to be free from looking backwards at scholasticism and the museums, and in which he

brought the existence of *le tout-Paris* into focus. He may have been familiar with engravings by such artists as Delucourt, depicting Parisian life in the 1790s. The climate of 'modern life' is rendered with a direct contemporaneity, in the freshness of a particular moment of the day. On the left of the picture can be recognized the painter himself, with Balleroy, Zacharie Astruc, seated, Eugène Manet

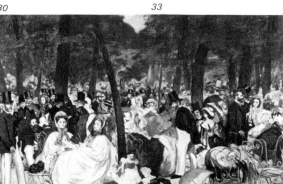

32 (Plate II)

and Offenbach. In the middle distance are Baudelaire, in profile, with Théophile Gautier and the writer Lord Taylor. Then again there are Champfleury, Lejosne, Fantin-Latour, Aurélien Scholl and the painter Monginot. The two ladies sitting on the left are Mme Loubens and the veiled Mme Lejosne. The reader should be warned, however, that scholars do not all agree on the identification of all those portrayed. This confusion probably arises from the presence of some unidentified persons. The work was exhibited in 1863 in the Galerie Martinet where it scandalized the clients. Zola was to recount later (R XIX 1867) that: 'an outraged art-lover went so far as to threaten violence if *Musique aux Tuileries* were left in the room any longer'. It was bought by Durand-Ruel (1872), and passed later into the hands of Faure, who lent it for the posthumous exhibition (1884) and to the Exposition Manet, Salon d'Automne (1905). It returned to the possession of Durand-Ruel in 1908, from whom it was bought by Sir Hugh Lane, who presented it to the National Gallery.

33 ⊞ ◕ 147×114 / 1860 ▤ ⦂
Chanteur Espagnol (The Spanish Singer) (Dated 1860) (Church Osborn) Metropolitan Museum, New York
It may be that, just when all Paris was talking about the famous Andalusian guitarist Huerta, a mediocre, clumsy and left-handed guitarist was posing for Manet (R.). On the other hand, Jamot and Wildenstein consider that the model may have been Jérôme Bosch, a well-known soloist with the Spanish troupe then playing at the Hippodrome. When it was exhibited at the 1861 Salon, it attracted the attention of some

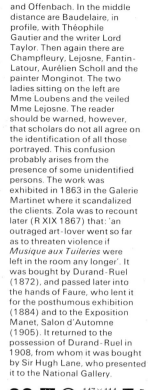

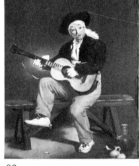

33

28

30

From Mathey (1963). See 29.

89

34

young artists, although it is surprising — as Richardson notes — that not one of the critics then grasped Manet's innovation, namely the renunciation of halftones which made the bold contrast of colors produce effects of outstanding clarity. However, the critics were warm in their reception of it and this is particularly true of Théophile Gautier who had just come back from a trip to Spain: 'Caramba! There's a *Guitarero* who doesn't come from the Opéra Comique ... There is a great deal of talent in this life-size figure, painted with a full brush in courageous strokes and really true color'. (MU 1861). Manet received the *mention honorable* of the Salon for this work.

34 ⊞ 🔾 77×123 1860-61 ▤ * ⦂

La Pêche (Autoportrait avec Suzanne et Pêcheurs: Ile Saint-Ouen) Fishing (Self-portrait with Suzanne and Fishermen: Ile Saint-Ouen). Signed Ed Manet in Mme Manet's hand Metropolitan Museum, New York
This is a fantasy, in which the couple, Manet and Suzanne Leenhoff, appear in seventeenth-century costume, and fishermen in a boat are moving about among the water weeds. Jamot and Wilderstein consider it to have a strong relationship with *La Pesca* by Annibale Carracci (Louvre, Paris) while Bazin notes the direct link with two pictures by Rubens, *Castle Grounds* (Kunsthistorisches Museum, Vienna) and *Landscape with Rainbow* (Louvre, Paris).
Tabarant mentions the existence of a duplicate which Mme Manet always kept and never showed to anyone. After she died, Léon Koëlla put it up for sale (1910) with an authentication by Duret who entered it in his catalogues between 1919 and 1926. However, Tabarant, supported by Durand-Ruel, Vollard and Joyant, believes that the second copy of *La Pêche* may have been made by Mme Manet's nephew, Edouard Vibert, the son of her sister, Marthe, when the original had to be given up.

35 ⊞ 🔾 146×114 1861 ▤ ⦂

Nymphe Surprise (The Startled Nymph) Museo Nacional de Bellas Artes, Buenos Aires
A This was the final

composition of the series which was probably begun the year before (see below). The nude figure of the woman seems to have been inspired by Rembrandt's *Susanna* in the Mauritshuis in the Hague.
B Oil-painting on board (35 cm. × 25 cm.) (Galerie Charpentier, Paris). This should, perhaps, be thought of as the first of the series. However, it is also considered (C-H) that it might have been connected with the first rough sketches for a theme to do with the finding of Moses. The painter's wife posed for this.
C Another version. (35 cm.× 46 cm.; Nasjonalgalleriet, Oslo; with false signature)
D A third version (35 cm.× 46 cm.; formerly in the Camentron Collection, Paris). All three are discussed in Burlington Magazine, November 1967.

36 ⊞ 🔾 98×80 1861 ▤ ⦂

Liseur (An Old Man Reading) (E. Davis) City Art Museum, Saint Louis
The model was Joseph Gall, a painter of animals, who had a studio close to Manet's. Moreau-Nélaton notes the influence of Velasquez in the head, hands and book.

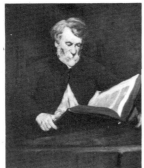

36

37 ⊞ 🔾 131×93,5 1861* ▤ ⦂

Garçon à l'épée (Boy with a Sword) Metropolitan Museum, New York
Léon Koëlla served as model for this picture which was highly thought of by Zola when it was exhibited at Martinet's. The sword came from the armor owned by the painter, Monginot. See Burlington Magazine, May 1962.
There is a replica (42 cm.× 31 cm.) on the market with a false signature. Jamot and Wilderstein consider its authenticity dubious and Tabarant rejects it entirely.

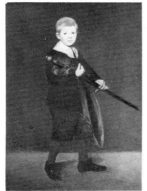

37

38 ⊞ 🔾 46×38 1861-62 ▤ ⦂

Pivoines dans un Bock (Peonies in a Glass Tankard, with Necklace) Private Collection, London

39 ⊞ ⊕ ante 1862? ▤ ⦂

Portrait d'Adèle (Portrait of Adèle)
Adèle was a friend of Baudelaire. It is known that Manet made a portrait of her

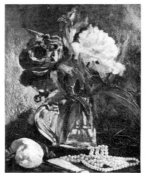

38

(T) in a painting which has never been found.

40 ⊞ 🔾 90×113 *1862 ▤ ⦂

Portrait de Jeanne Duval (Portrait of Jeanne Duval) Szépmüveszeti Muzeum, Budapest
The subject was Baudelaire's mistress, whom the poet abandoned when he moved to Brussels during the spring of 1862.

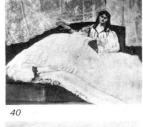

40

41 ⊞ 🔾 90,5×72,7 *1862? ▤ ⦂

Gitane à la Cigarette (Gypsy with a Cigarette) Archibald S. Alexander Collection, Bernardsville, New Jersey
Probably conceived as part of *Les Gitanes* in the early conception of the work (see 46). It is usually reckoned as dating from 1862, although Jamot and Wildenstein believed it to be from 1878.

42 ⊞ 🔾 92×73 *1862 ▤ ⦂

Gitane (Bohémienne) (Gypsy Woman) Formerly in the Bashkirtzeff Collection, Paris. Fragment of *Les Gitanes* (46). The place where the canvas was cut can be seen at the level of the knees.

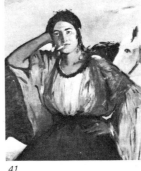

41

43 ⊞ 🔾 90×74 *1862 ▤ ⦂

Gitan (Bohémien) (Gypsy Man) Formerly in the Samson Collection, Paris
Fragment of *Les Gitanes* (46).

44 ⊞ 🔾 188×248 1862 ▤ ⦂

Le Vieux Musicien (The Old Musician) (Dale) National Gallery of Art, Washington
One of the most ambitious works conceived by Manet in 1862 (T 1947; Richardson). It perhaps derives from *The Topers* by Velasquez, by way of the engraving by Goya. The models were chosen from the ghetto near the Rue Guyot.

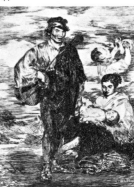

The Gypsies (engraving, 28.4 cm. × 20.6 cm.; first state; 1862; 'Manet sculpt') showing the whole composition, prior to being cut up, from which 46 was taken. There is also a watercolor of the Waterdrinker 17.9 × 13.5; 1861).

45 ⊞ 🔾 175×109 1862 ▤ ⦂

Chanteuse des Rues (The Street Singer) (Sears) Museum of Fine Arts, Boston
This is one of the first portraits of Victorine Meurent, Manet's favorite model until 1875. Light and lively, she is portrayed putting some cherries from a paper bag into her mouth. In Richardson's opinion, the clean, clear-cut figure is the first manifestation of Manet's interest in Japanese painting.

43

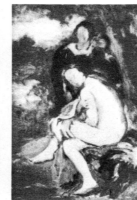

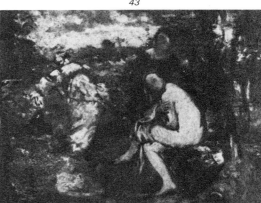

35A *35B* *35D*

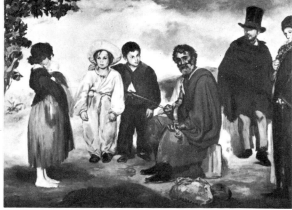

44

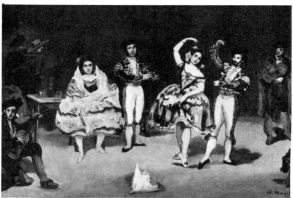

47

46 ⊞ ◒ 57×48 / 1862

Régalade (Guzzling)
MacCormick Collection, Chicago
One of the fragments taken by Manet from the large composition *Les Gitanes* (itself 190 cm. × 130 cm.). He was never satisfied with the large work and divided it into three sections after exhibiting it in his one-man show in 1867 (see 42 and 43). An etching is the sole remaining record of the complete work.

47 ⊞ ◒ 61×91 / 1862

Ballet Espagnol (Spanish Ballet) Phillips Gallery, Washington
Between 12 August and 2 November 1862, a Spanish dance company, under their manager and principal male dancer, Don Mariano Camprubi, gave performances at the Hippodrome in Paris, where they were very well received. Manet, who admired them greatly and was much taken by the exotic atmosphere, obtained Camprubi's permission for the troupe to pose for him on the three days of the week when there were no performances. Manet first took rough sketches and drawings and then painted a ballet scene from life. At the sides are two guitarists and, on the left, Lola de Valence, the principal female dancer, with the supporting male lead. On the right is Don Mariano Camprubi with the agile young dancer, Anita Montez, who sent Paris wild. The composition is spread across the stage and the immediacy of the different elements minimizes any sense of folklorist theatricality. However, Richardson remarks that 'the figures, though individually remarkable, are disproportionate and unsatisfactorily related to each

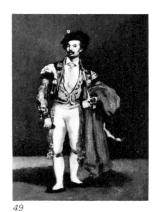

45 (Plate VIII)

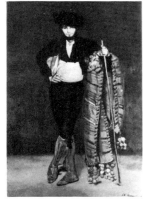

46

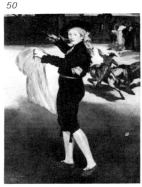

48 (Plate XIV)

other'. But this does not seem serious; any roughness of design corresponds with the painter's notions of freshness and 'naïveté'.

48 ⊞ ◒ 123×92 / 1862

Lola de Valence ('Lola of Valencia) Jeu de Paume, Louvre, Paris
Baudelaire wrote a quatrain expressly for this painting:
Entre tant de beautés que partout on peut voir,
Je comprends bien, amis, que le désir balance,
Mais on voit scintiller dans Lola de Valence
Le charme inattendu d'un bijou rose et noir.
My friends, I know desire to range among
The beauties that surround us; but the charm
Of Lola de Valence does all disarm
The unexpected charm of a red and black jewel.
Baudelaire wanted to have it put on the canvas itself, but it was placed on a label on the frame. It demonstrates the unconditional success which the work had among Manet's

friends. The dancer's pose (see 47) derives from Goya and from a lithograph by Daumier. Tabarant observed that the incantation, *bijou rose et noir* would have been better suited to the supporting female dancer of the Camprubi troupe, Anita Montez, rather than to Lola's heavy beauty. When the painting, along with thirteen others, was exhibited just before the 1863 Salon in the Galerie Martinet, the mood of critics and public alike was summed up in the following few lines by P. Mantz (GBA 1863) : 'When M. Manet is in a joyful mood, he paints *Musique aux Tuileries, Ballet Espagnol* or *Lola de Valence,* that is, pictures which reveal his generous fertile vigor, but which, in their medley of red, blue and yellow, are the caricature of color rather than color itself. In short, it may be a very faithful kind of art, but it is not sound and does not give us cause to plead M. Manet's case before the Exposition hanging committee'. The first owner of the work was Jean-Baptiste Faure, who bought it in 1873.

49 ⊞ ◒ 46×33 / 1862

Ballerin, Mariano Camprubi (The Dancer, Mariano Camprubi) Donald S. Stralem Collection, New York
The manager of the Spanish troupe (see 47) appears as he often did in the performances (C.-H.). Tabarant refers vaguely to a pendant to this, portraying Anita Montez (see 47) which may have gone to America.

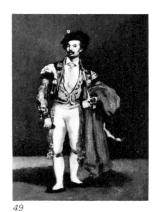

49

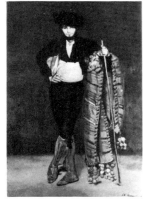

50

50 ⊞ ◒ 188×125 / 1862

Jeune Homme en Costume de 'Majo' (Young Man in 'Majo' Costume) (H. O. Havemeyer) Metropolitan Museum, New York
Manet's brother, Gustave, modeled for this in Andalusian costume. It was rejected by the 1863 Salon, and so appeared in the Salon des Refusés.

51 ⊞ ◒ 166×129 / 1862

Mlle Victorine en Costume d' 'Espada' (Mlle Victorine in 'Espada' Costume)
(Mrs H. O. Havemeyer) Metropolitan Museum, New York
Victorine (see 45) is shown in the bold elegance of the costume, appropriately flapping the *muleta* (the bullfighter's red cloth) 'miming the gestures of a toreador with the mischievousness of a courtesan' (Douglas Cooper).

52 ⊞ ◒ 43×40 / *1862*

Jeune Femme en Costume de Toréador (Young Woman in Toreador's Costume) Carleton Mitchell Collection, New York

53 ⊞ ◒ 95×113 / 1862

Jeune Dame Couchée en Costume Espagnol (Young Woman in Spanish Dress Lying Down) Yale University

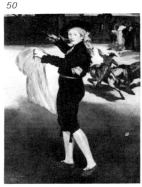

51 (Plate VII)

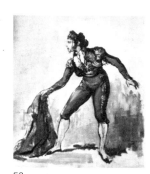

52

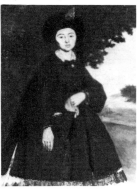

53

54

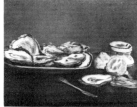

55 (Plate VI A)

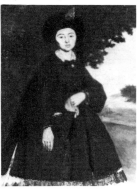

56

Art Gallery, New Haven
Portrait of a friend of Nadar, the photographer, who lent his premises for the first show by the Impressionists in 1874. There is an inscription at the bottom on the right, 'To my friend Nadar, Manet'. The hypothesis has sometimes been put forward that this painting should be thought of as a pendant to *Olympia* (62), rather like the two *Maja* by Goya (Prado, Madrid). The comparison does not hold water, however, since the two works are of different dimensions. The picturesque nature of the costume, which interested Nadar, Baudelaire and their friends, gives the work an illustrative importance.

91

54 ⊞ ◉ 38×46 1862 ▤ ⦂

Huîtres (Oysters) (Adele R. Levy) National Gallery, Washington

This is thought to be the first known still-life by Manet. It hung on the wall in the dining room of Suzanne, the sister of Ferdinand Leenhoff (see 59) in the Rue de l'Hôtel de Ville at Batignolles. After her marriage to Manet it went with her to all their subsequent homes.

55 ⊞ ◉ 77,5×121,5 1862 ▤ ⦂

Nature Morte, Guitare et Chapeau (Still-life, Guitar and Sombrero) Musée Calvet, Avignon

Manet painted this for his own atelier.

56 ⊞ ◉ 132,5×100 1862 ▤ ⦂

La Dame au Gant (Portrait de Mme Brunet) (The Woman with a Glove) Private Collection, New York

This did not please the sitter. ('She wept to see herself looking so ugly', reported Duret [T.]) and it remained in the painter's studio.

57 ⊞ ◉ 116×72 1862 ▤ ⦂

Le Petit Lange (Little Lange) Staatliche Kunsthalle, Karlsruhe

58 ⊞ ◉ 43×43 1862 ▤ ⦂

Portrait de Victorine Meurent (Portrait of Victorine Meurent) Museum of Fine Arts, Boston

The model for Manet's most famous paintings of the period (see 45).

59 ⊞ ◉ 208×264,5 1863 ▤ ⦂

Déjeuner sur l'Herbe (The Picnic) Jeu de Paume, Paris.

A A. Proust (Souvenirs)

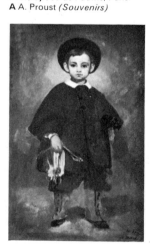
57

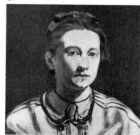
58

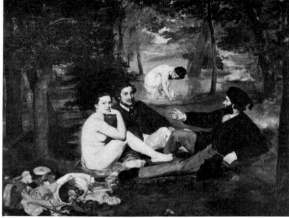
59A (Plates IV-V)

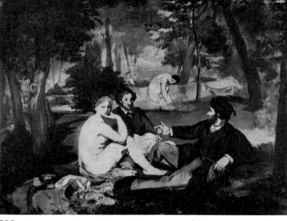
59B

59C

M. A. Raimondi, The Judgment of Paris (after Raphael; 29,5 × 44,5), related to no. 59.

recounts that when Manet was by the Seine near Argenteuil one day, he noticed some ladies bathing and said: 'It seems I must do a nude. All right, I'll do one for them . . . in the transparent air, with people like those we can see over there. They'll slay me for it but let them say what they like.' This was the origin of the London canvas (see below). It was soon noticed that the presentation of the characters — Gustave, the painter's brother, the Dutch sculptor, Ferdinand Leenhoff, Suzanne's brother, and a woman, wrongly thought to be Suzanne herself — bore a close affinity to the right-hand group (the personification of a river) in an engraving by Marc Antonio Raimondi taken from a Raphael drawing, The Judgment of Paris. Another source soon identified was the famous canvas in the Louvre, Concert Champêtre, believed to be by Giorgione or Titian. When the large sketch was finished, Manet changed the composition, substituting for the nude female figure that of Victorine Meurent (see 45). He considered the work to be worthy of the Salon which was to open its doors on 1 May 1863. However, it was rejected by the hanging committee (among whom were Meissonier, Ingres and Delacroix, though the two latter were absent). It then appeared in the Salon des Refusés. The reactions of the critics to Le Bain, as it was then called, in reference to its origin, was varied but excited. Astruc

(SQ 1868) saw in it 'éclat, inspiration, piquancy and wonder'. Monselet thought its creator was 'a pupil of Goya and Charles Baudelaire' and showed 'that he had already overcome the bourgeois disgust, which was a great stride forward'. Lockroy (CA 1863) and Desnoyers (Salon des Refusés) considered Manet to have great promise while others, such as Thoré-Bürger, the discoverer of Vermeer (IB 1863) and one Pelloquet (GF 1863) sought to discover the reasons why, as Lockroy once noted, 'the public cannot appreciate' the quality of the work. 'Le Bain is in very doubtful taste . . . I cannot imagine what made an intelligent and distinguished artist choose such an absurd composition. But there are qualities of color and light in the landscape and some very real passages of modeling in the body of the woman . . . M. Manet adores Spain and the chief object of his affections would seem to be Goya, whose sharp clashing colors and free, impetuous brushwork he

imitates,' wrote Thoré-Bürger. And Pelloquet clinched the argument with 'M. Manet has the qualities needed to make him be refused unanimously by every hanging committee in the world. His shrill colors penetrate the eye like a steel saw; his characters are sharply punched out with a crudity which no compromise can soften. He has all the sourness of a green fruit that will never ripen'. Rewald suggests that more important than the disillusionment of the public, which was forced to recognize itself in this 'unseemly' bourgeois idyll, were the 'emphatic contrast of tone and tendency to simplification' Manet's 'vulgarity' in the eyes of the beholder, consisted more in the execution than in the theme. However, the most hurtful indictments, from Manet's point of view, were expressed by Chesneau (CH 1863): 'M. Manet will show talent on the day when he learns drawing and perspective; he will show taste on the day when he abandons these subjects which have been chosen with scandal in mind. . . . M. Manet wishes to achieve

fame by shocking the bourgeois. **B** The oil sketch in London (98·5 cm. × 115 cm.; signed; Home House Trustees). This was the first sketch for the Déjeuner and it was kept by Commandant Lejosne during Manet's lifetime. When the heirs wanted to sell it in 1920, serious problems arose because the work was judged to be a fake, a copy made either by Bazille or Eva Gonzalès. Its authenticity was later proved and was confirmed by some of the most eminent Manet scholars. **C** Another oil painting on canvas (46 × 56 cm., signed; Museum van der Heydt,

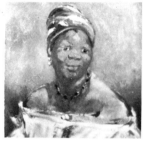
61

Wuppertal) sometimes entitled La Pêche, which was painted at Saint-Ouen as a study for the background of the Déjeuner.

60 ⊞ ◉ 49,5×86,5 1863? ▤ ⦂

Repos (Toreadors at Rest) (also known as Posada, from the Spanish word for a tavern) Hill-Stead Museum, Farmington, Connecticut

This is ascribed by Jamot and Wildenstein to 1866 but it would seem more likely to date from the year given above, if only because this would coincide with a series of bull-fights put on in Paris. A gift from Manet's widow to Alfred Stevens (T.).

61 ⊞ ◉ 59×49 1863 ▤ ⦂

Négresse au Madras et au Collier (Negress in Madras Headdress with Necklace) Private Collection

Painted while Manet was working on details for Olympia (62) The model's name (Laure, très belle negresse) is known from the painter's own notes (T.).

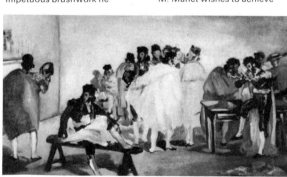
60

62 (Plates IX-X)

92

62 ⊞ ◍ 130,5×190 / 1863 ▤ ⦂
Olympia Jeu de Paume, Louvre, Paris
Only two or three sittings were needed for Manet's most famous work to be completed with consummate sureness and no second thoughts. He based it on a preparatory watercolor now in the Niarchos Collection in Paris. The variations from this sketch are few: a pearl at the woman's throat, a heavy bracelet with a medallion on her right arm, while 'the pillows and the flowered stole make a play of nuances which enliven the foreground, and the luminous background is darkened to form a contrast . . .' (T. 1947). Richardson points out the possible pictorial sources: first of all, the *Venus of Urbino*, which Manet had copied in his youth (10) 'which has a similar vertical division of the background; cf. the portrait of Zacharie Astruc (70) (Milneu); then the *Maja desnuda* by Goya (Prado, Madrid), the *Odalisque et son esclave* by Ingres and the *Odalisque* by Jalabert. 'But', he declares, '*Olympia* entirely transcends earlier models and must be seen as one of the key-paintings of the nineteenth century'. Compared with the *Déjeuner sur l'Herbe* (59, painted a few months earlier, it speaks in a new and daring language. The shapes are simplified to the utmost by areas of a frontal light and a dark background. However, in spite of the apparent flatness, it gives a feeling of volume in the shrewd counterpoise of light and dark and in the subtly suggested outlines which lend to the body of the model, Victorine Meurent, (45) 'a marvelous tactile quality and fleshy density'. The title of *Olympia* came to be attached to it fifteen months later, because of some lines written by Astruc in a mediocre little poem, *La Fille des Isles*. The work was entered for the 1865 Salon, causing much tumult and shouting. Indeed, towards the last few days, it had to be re-positioned at a height where it would escape both notice and attack (Bazire). The critics lashed out at Manet, and the words of Paul de Saint Victor (PR 1865) seem to sum up the reactions of the visitors: 'The mob crowds around M. Manet's rotting *Olympia* as if they were at the morgue. Art which has sunk so low is not worthy even of censure.' The painter complained about all the insults in a letter to Baudelaire, who replied sharply, trying to instil some new courage into him by instancing other artists who had suffered a similar fate. A few days later, writing to Champfleury, the poet said: 'Manet has a powerful talent, one that will last. But his is a weak character. He seems to be desolate and dizzy with shock. What also strikes me is the imbecile joy of those who think he is finished'. When *Olympia* was put up for sale after the painter's death, it remained unsold and reappeared in 1889 (T.) in the Palais des

Beaux-Arts at the Exposition Universelle. There it was admired by an American collector who expressed the desire to buy it. The painter Sargent, however, convinced that the work should, by rights, go to the Louvre, warned Monet of the offer and the latter started a subscription list to present it to the nation. The list was opened in July 1889 and declared closed in January 1890. A ministerial

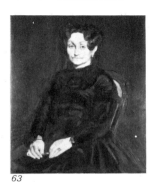
63

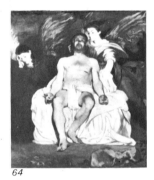
64

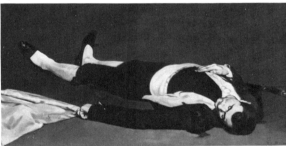
65 (Plates XII-XIII)

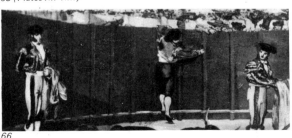
66

decree ordained that *Olympia* should be placed in the Musée de Luxembourg, where it remained until January 1907, when finally, on the orders of the Prime Minister, Clémenceau, it was transferred to the Louvre where it was hung as a pendant to Ingres' *Odalisque*.

63 ⊞ ◍ 105×80 / 1863 ▤ ⦂
Portrait de Mme la Mère de Manet (Portrait of Manet's Mother) Isabella Stewart Gardner Museum, Boston

Mme Manet is shown in mourning for the death of her husband and her hair is dressed in bandeaux, after the fashion of 1830, the year of her marriage.

64 ⊞ ◍ 179,5×150 / 1864 ▤ ⦂
Christ aux Anges (Christ with Angels) (H. O. Havemeyer) Metropolitan Museum, New York
As early as 1863, Manet confided to the Abbé Hurel: 'I am going to do a dead Christ with angels' and prepared the composition for the 1864 Salon. (He may have been inspired by the *Pietà* by Mantegna in the Statens Museum in Copenhagen (*The Complete Paintings of Mantegna* 69).

65 ⊞ ◍ 75×154 / 1864 ▤ ⦂
Combat de Taureaux (Le Toréador Mort) (Bullfight) (The Dead Toreador) (Widener) National Gallery, Washington
When the 1864 Salon closed, Manet gave considerable thought to the criticisms directed at his pictures, particularly at the *Corrida (Combat de Taureaux)* which had been condemned for its 'errors' of perspective ('A wooden toreador killed by a rat') and made up his mind to cut the work into two pieces, of which this is the larger (see also 66). As sources for this work, Miss Coffin-Hanson and Richardson point to *Orlando muerto*, attributed to Velasquez, which was then in the Galerie Pourtalès. This was denied from

the first, however, by Baudelaire in his famous letter to Thoré-Bürger: 'M. Manet has never seen the Galerie Pourtalès. That may seem incredible to you, but it is true.' (see also Critical Outline).

66 ⊞ ◍ 48×108 / 1864 ▤ ⦂
Combat de Taureaux (Corrida) (Bullfight) Frick Collection, New York
The other piece taken from the *Corrida* (see 65)

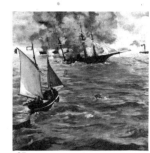
67

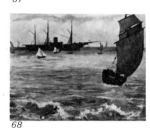
68

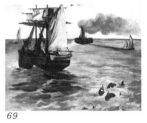
69

70

67 ⊞ ◍ 134×127 / 1864 ▤ ⦂
Combat entre le 'Keasarge' et l' 'Alabame' (The Battle of the 'Keasarge' and 'Alabama') John G. Johnson Collection, Philadelphia
On 19 June 1864, the North American corvette, *Keasarge*, sank the Southern Confederalist ship *Alabama* off Cherbourg. Since the encounter had been foreseen for days, the inns on the coast were flooded with sightseers. According to A. Proust, Manet was actually present when this event took place, but a letter from Manet himself to Burty (to thank him for having 'noticed' the showing of the picture by Cadart, in *La Presse* of 18 July) would seem to rule this out: 'On Sunday *Keasarge* was at anchor at Boulogne. I went to see it. It was much as I had imagined. Anyway, I painted it as it would be at sea. You'll see what you think.' The sea is portrayed with that excited interest which, as a result of his youthful travels, stayed with him for the whole of his life. It was put on show by Cadart in July 1864 and exhibited at the 1872 Salon.

68 ⊞ ◍ 91×100 / 1864 ▤ ⦂
Steamboat (Le 'Keasarge' au large de Boulogne-sur-Mer) ('Keasarge' off Boulogne-sur-Mer) Peter H. M.

Frelinghuysen Collection, Washington
Often erroneously shown as *L' 'Alabame' au large de Cherbourg* (see 67)

69 ⊞ ◍ 81×100,3 / 1864? ▤ ⦂
Navires en Mer (Ships at Sea) (Anne Thomson) Museum of Art, Philadelphia
In the Thomson Collection, Philadelphia since 1893. This may be the picture referred to as *Porpoises* (title referred to the sea creatures to be seen on the right) which was exhibited in London in 1872, and may also be one of the seascapes praised by Zola in the one-man show of 1867. It was omitted from the more 'classic' catalogues of Manet's work but was accepted by Rey (1938) and then by Miss Coffin-Hanson (AB 1962) and by others. In spite of some weaknesses it should be considered authentic.

70 ⊞ ◍ 90×116 / 1864 ▤ ⦂
Portrait de Zacharie Astruc (Portrait of Zacharie Astruc) Kunsthalle, Bremen
This strange character, Astruc (1835–1907), who was critic, painter, sculptor, composer and poet, was one of Manet's most faithful defenders. The influence of Venetian painting is particularly noticeable in the background which recalls the arrangement of the *Venus of Urbino* by Titian, which Manet knew (see 10), with the figure of Mme Astruc, seen from behind reflected in the mirror. The Astrucs did not like the work and it remained in the painter's studio.

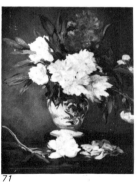
71

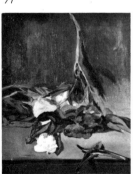
72

73 (Plate XI)

71 ⊞ ◕ 93,2×70,2 1864

Vase de Pivoines sur un Piédestal (Vase of Peonies on a Pedestal) Jeu de Paume, Louvre, Paris

72 ⊞ ◕ 56,8×46 1864

Nature Morte, Tiges de Pivoines et Sécateur (Still-life, Peony Stems and Secaters) Jeu de Paume, Louvre, Paris

73 ⊞ ◕ 31×46,5 1864

Nature Morte, Branche de Pivoines et Sécateur (Vase de Pivoines et Sécateur) Still-life, Peony Branch and Secateurs (Vase of Peonies and Secateurs) Jeu de Paume, Louvre, Paris

74 ⊞ ◕ 59×34 1864

Vase de Pivoines sur un Plateau Laqué (Vase of Peonies on a lacquered Tray) Payson Collection, New York

78

79

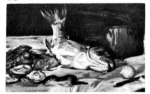
80 (Plate VI B)

75 ⊞ ◕ 63,5×53,5 1864

Pivoines dans une Bouteille (Peonies in a Chianti Bottle) Private Collection, New York

76 ⊞ ◕ 30×46 1864?

Pivoines (Peonies)
Given by Manet to Champfleury after whose death it passed from one collection to another.

74

75

94

77 ⊞ ◕ 28×23 1864

Pivoines, Fleur et Bouton (Peonies, Flower and Bud) Formerly in the Stettiner Collection, Paris

78 ⊞ ◕ 45×71 1864

Nature Morte, Saumon, Brochet, Crevettes (Still-life, Salmon, Pike and Shrimps) Norton Simon Collection, Los Angeles

79 ⊞ ◕ 38×46 1864

Nature Morte, Rouget et Anguille (Still-life, Red Mullet and Eel) Jeu de Paume, Louvre, Paris

80 ⊞ ◕ 73,5×92 1864

Nature Morte, Huîtres, Anguilles et Rouget (Still-life, Oysters, Eels and Red Mullet) (Ann Swan Coburn) Art Institute, Chicago (In the USA called Still-life with Carp)
This is one of the still-lifes painted by the artist for the exhibition at Martinet's in February 1865.
A copy (71 cm. × 100 cm.) is in the National museum in Stockholm. It was not known to Duret and was catalogued as dubious by Jamot and Wildenstein. Tabarant declared it to be a fake. It is a far too carefully detailed replica and an offer to lend it for the Centenary Exhibition in 1932 at the Orangerie was turned down.

81 ⊞ ◕ 45×73,5 1864

Fruits sur une Table (Fruit on a Table) Jeu de Paume, Louvre, Paris

82 ⊞ ◕ 37×44 1864?

Panier de Fruits (Basket of Fruit) (John T. Spaulding) Museum of Fine Arts, Boston
Omitted by Duret. Forbes Watson (A 1925) dates it 1880.

83 ⊞ ◕ 21×26 1864

Nature Morte, Raisins et Figues, (Still-life, Grapes and Figs) Mrs F. J. Gould Collection, Cannes

84 ⊞ ◕ 17×22 1864

Nature Morte, Amandes, Groseilles, Pêches (Still-life, Almonds, Redcurrants, Peaches) Private Collection, New York

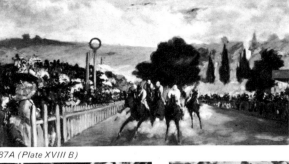
87A (Plate XVIII B)

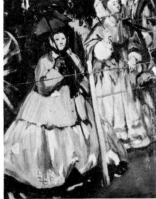
87B

87C

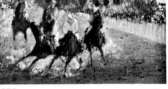
87D

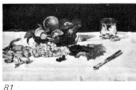
87E

85 ⊞ ◕ 1864

Nature Morte, Deux Poires, (Still-life, Two Pears)

86 ⊞ ◕ 13,5×16 1864

Nature Morte, Deux Pommes (Still-life, Two Apples) Musée Magnin, Dijon

87 ⊞ ◕ 43,9×84,5 1864?

Champ de Course à Longchamp (Longchamp Racecourse)
(Potter Palmer) Art Institute, Chicago
A A combination of earlier experiments (see below) about life on a racecourse.
Particular reference should be made to the watercolor in the Fogg Art Museum, Cambridge, Massachusetts. There is also a view of the course near Paris below the hill of Saint-Cloud, which is more in close-up, with the details on the left-hand side eliminated, so that the race is seen at a moment of dynamic tension, a somewhat unusual aspect for Manet, who preferred static subjects. Tabarant notes that, although Degas had painted his first racing pictures as early as 1862, these do not display the same desire for a new mode of expression as do those by Manet, who had been seeking such a new language for five years. Jamot and Wildenstein relate the painting to 1872.
B Oils on canvas (41 cm. × 31 cm.; signed and dated 1864;

Art Museum, Cincinnati). It may be part of a large work, together with the painting mentioned below.
C Oils on canvas, seemingly dating from the end of 1864, but dated 1865 (38 cm. × 23·4 cm.; formerly in the G. Cognacq Collection, Paris) showing a turn in the course at

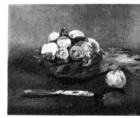
81

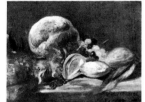
83

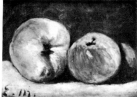
85

Longchamps. Harris has put forward the theory that it may be related to the preceding picture (q.v.) forming part of a whole composition which was dismembered by the painter himself.
D A small study in oils on canvas (12·5 cm.× 21·5 cm.; signed; from the Widener Collection, National Gallery, Washington). It would appear to be contemporary with the preceding ones and shows five jockeys in light-colored silks. The crowd and the trees are briefly indicated at the sides. Duret dates it between 1875 and 1877, while Jamot and Wildenstein assign it to 1872.
E Four galloping jockeys can be seen in a study, also in oils, (34 cm.× 41 cm.; signed; whereabouts unknown) largely accepted as authentic, although not mentioned by Duret.

88 ⊞ ◕ 72×93 1864-65

Sortie du Port de Boulogne (Vue de Mer, Temps Calme) Leaving Boulogne Harbor (Sea View in Calm Weather) (Potter Palmer), Art Institute, Chicago
Exhibited at Martinet's in 1865 and in the 1867 one-man show under the title Vue de mer, temps calme. Begun during the summer holiday at Boulogne and finished in the studio during the January of 1865 (T. 1947).

89 ⊞ ◕ 191×147,5 1865

Jésus Insulté par les Soldats (Jesus Mocked by the Soldiers) (J. Deering) Art Institute of Chicago
A Painted for the 1865 Salon, where it appeared with Olympia (62) and received a disastrous reception. The non-professional model for the figure of Our Lord was a locksmith, Janvier, who had undertaken some little jobs for Manet. As for the stylistic sources, De Leiris notices echoes of Titian's Christ Derided in the Louvre in

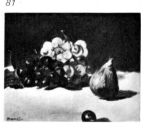
82

84

86

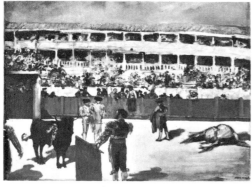

99

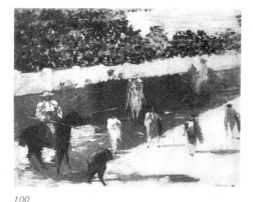

100

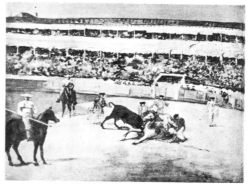

101

Paris. Miss Coffin-Hanson, on the other hand, sees a relationship with the same theme by Terbruggen at Lille (Musée), while the kneeling soldier would seem to derive from Velasquez' *Epiphany*, and the one holding

88

89A

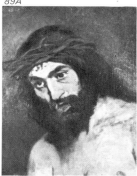

89B

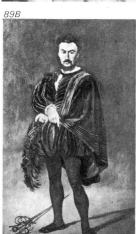

90

the robe from *Vulcan's Forge* by the same artist.
B An oil-painting on canvas exists of the head and shoulders only of Christ (46 cm. × 38 cm.; Edward Hanlet Collection, Bradford). It is a fragment of an early complete version of the theme with which the painter was not satisfied and from which he cut this section to give to his friend the Abbé Hurel (as the latter recorded in an inscription on the back).

90 ⊞ ◑ 185×110
1865

Acteur Tragique (L'acteur Philibert Rouvière comme Hamlet) The Tragic Actor (The actor Philibert Rouvière as Hamlet) (E. Stuyvesant Gerry) National Gallery, Washington
This actor was a painter and a pupil of Gros before devoting his life to the stage, and it was his performance as Hamlet which made him famous in the Dumas and Meurice adaptation of the play. He posed in the studio in the Rue Guyot, but died in October before the picture was finished. Manet used Roudier and A. Proust to pose for the final sittings, the former for the legs and the latter for the hands.

91 ⊞ ◑ 146×114
1865

Religieux en Prière (Monk at Prayer) Museum of Fine Arts, Boston
Mathey is not certain whether this was painted before or after the trip to Spain (August–September 1865). He observes, however, that the style is close to that 'of the aging Franz Hals, of the maturing Goya and of the Rembrandt of the "negro-head" period'.

92 ⊞ ◑ 21×26
1865?

Marine (Seascape) Private Collection, New York
Jamot and Wildenstein assign it to 1869. The above-mentioned date, given by Tabarant and others, would seem, however, to be more likely.

93 ⊞ ◑ 92×72
1865

Angélina (Femme à la fenêtre) Angelina (Woman at the Window) Jeu de Paume, Louvre, Paris
It owes its usual title of *Angelina* to the name of the model, who may have been of Spanish origin. For some unknown reason, Duret dates it 1859–60. It is certainly connected with the painter's

stay in Spain, in the sense that it was painted after his return to Paris, but was certainly not, as Moreau-Nélaton would have it, painted during his stay in Madrid. It is rich in overtones of Iberian art.

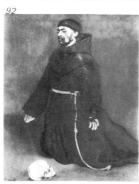

92

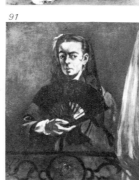

91

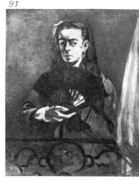

93

94 ⊞ ◑ 61×50
1865?

Espagnole à la Croix Noire (Spanish Woman with a Black Cross) Emery Reeve Collection, Saint-Jean-Cap-Ferrat

95 ⊞ ◑ 185×110
1865

Le Philosophe (Philosophe Drapé) The Philosopher (Cloaked Philosopher) (Arthur Jerome Eddy) Art Institute, Chicago
By analogy with the two following paintings, the character should be seen as a mendicant philosopher, after a concept that had come back into fashion around the middle of the nineteenth century as a result of the *études des moeurs*, which showed men in their various roles in life (C–H). Actually, it would seem that the painter's brother Eugène was the model. Manet reveals direct inspiration from Velasquez, whose works he had studied not long before in Spain, and particularly from his *Aesop* and *Menippus* in the Prado in Madrid. In this, as in 96 and 97, Richardson sees an almost literal transcription from the Spanish master.

96 ⊞ ◑ 188,5×109
1865

Mendiant (Philosophe; Philosophe à la main tendue) Beggar (Philosopher; Philosopher with Outstretched Hand) (A. A. Munger) Art Institute, Chicago
(See 95).

97 ⊞ ◑ 195×130
1865

Le Chiffonier (Mendiant; Philosophe) Rag-and-Bone Man (Beggar; Philisopher) Private Collection, Switzerland
The obvious thematic

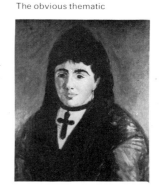

94

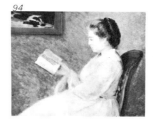

98

similarities to the two preceding works (see 95) do not justify the frequent confusions which have arisen regarding it. Apart from anything else, in comparison with the others the darkness of the background is less marked, with a vaguer delineation between light and shade, and it lacks the distinction between the ground plan and the background (C–H).

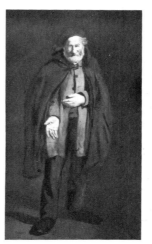

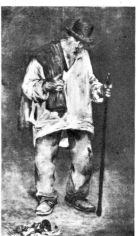

95

96

97

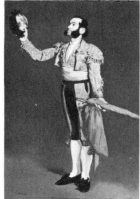
102

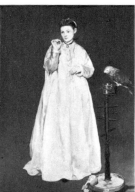
103

104

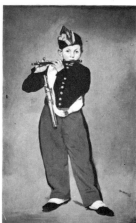
105 (Plate XVI)

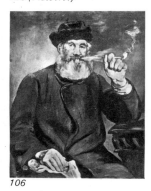
106

98 ⊞ ◑ 64×80 1865?

Liseuse (Woman Reading)
Private Collection, New York
Jamot and Wildenstein date this 1862, but the date 1865 has been adopted, perhaps with more justification, by Tabarant and others.

99 ⊞ ◑ 48×60,5 1865-66

Combat de Taureaux (Le Mort du Taureau; Corrida) Bullfight (Death of a Bull) (Martin A. Ryerson) Art Institute, Chicago
In spite of the casualness of the setting, one's attention is still drawn by the intense black bulk of the bull, like a cut-out, with no sense of modeling (C–H.). The colors of the background are vivid in the extreme, briefly indicating the spectators and the stands around the arena against the backdrop of the sky. (See also 101).

100 ⊞ ◑ 67×78 *1866

Corrida (Les 'Picadores') Bullfight (The Picadors)
Formerly in the Matsukata Collection, Tokyo
(See 101).

101 ⊞ ◑ 90×110 *1866

Combat de Taureaux (Bull-fight) Private Collection, Paris
This is the most important of the related themes (see 99, 100 and 102) painted on Manet's return from Spain, while the memory of things he had seen there was fresh in his mind, particularly the Goya engravings. It reflects in a vivid manner his impressions and the plans which Manet mentioned in a letter to Z. Astruc, to render in paint the dramatic feeling of the bullfights witnessed by him.

102 ⊞ ◑ 171×113 *1866*

Matador Saluant (Matador Waving) (Mrs H. O. Havemeyer) Metropolitan Museum, New York

103 ⊞ ◑ 185×132 1866

Femme au Perroquet (Woman with a Parrot) also called Young Lady in 1866 (J. & W.) (E. Davis) Metropolitan Museum, New York
The model was Mlle Meurent (see 45). Exhibited in the 1868 Salon, it received mostly sharp criticism. Théophile Gautier, among others, wrote (MU 1868): 'When, in a canvas, there is neither composition, drama nor poetry, its execution must be perfect, which is not the case here . . . The head which M. Manet shows us is surely an exaltation of ugliness. Upon ordinary and badly-drawn features spreads an earthy color which does not represent the flesh tints of a fair young woman.' And Mantz (ILL 1868): 'The artist shows us a young woman in a *peignoir* standing by a gray parrot's perch; on the floor lies an orange peel . . . he does not know how to paint flesh; nature interests him but little;

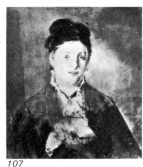
107

108

scenes from life do not move him. This indifference will be his punishment.' But, apart from the appreciative remarks made by Zola, who had admired the painting during his first visit to the painter (saying that it showed 'the native elegance which that man of the world, Edouard Manet, had in the depths of his being') there were also those of Castagnary and Thoré-Bürger (IB 1868): 'That impalpable air is also in the portrait of the young woman in a pink dress standing by a fine grey parrot on its perch. Pink and grey, and a little touch of lemon at the bottom of the perch. That is all. . . .'

104 ⊞ ◑ 63,5×80 1866

Joueuse de Guitare (Portrait de Victorine Meurent) Woman playing a Guitar (Portrait of Victorine Meurent) Hill-Stead Museum, Farmington, Connecticut
(See 45)

105 ⊞ ◑ 160×97 1866

Le Fifre (The Fifer) Jeu de Paume, Louvre, Paris
One of Manet's masterpieces, particularly admired by Zola. The model was a young military bandsman who was taken to Manet's atelier by Commandant Lejosne, a friend both of the painter and of Baudelaire. The work combines interest in Japanese painting in the stylization and the flat rendering, and in Velasquez, in the rendering of no other background than air (a quality which Manet had admired in the Spanish painter [R.]). It was offered to the 1866 Salon and was refused: it was in these circumstances that Zola, charged with writing some pieces for *L'Evénement*, went to visit Manet and came away deeply impressed (Rewald). He put this impression into words in an article which brought upon him the protests of the readers and, later, the loss of the job.

109

110

106 ⊞ ◑ 100×80 1866

Le Fumeur (Man Smoking a Pipe) Tribune Gallery, New York
The model was the painter Joseph Gall (see 36). The picture was shown in Manet's Exhibition of 1867.

107 ⊞ ◑ 65×50 1866

Portrait de la Femme de Manet, de face (Full-face Portrait of Manet's Wife) Norton Simon Collection, Los Angeles
The dating given above is deduced from the article by Zola of January 1867 (R XIX). It is often, however, attributed to about 1868 (J–W : M–N etc)

108 ⊞ ◑ 100×76 1866

Portrait de Mme Manet, en Profil (Profile Portrait of Mme Manet) (Miss Adelaide Milton de Croot Collection) Metropolitan Museum, New York
In the rough sketch stage: Susanne Manet is wearing a black hat and a light gray dress: the hands are barely sketched in.

109 ⊞ ◑ 62×48 1866

Nature Morte, Lapin (Still-life, Rabbit) Private Collection, Paris
Bazin (AA 1932) relates it to *Lièvre* by Chardin (Louvre, Paris), while Miss Coffin-Hanson is more precise, claiming that it combines and synthesizes three paintings on the same theme by Chardin.

110 ⊞ ◑ 73,5×94 1866?

Nature Morte, Saumon (Still-life, Salmon) (E. Havemeyer Webb) Shelburne Museum, Shelburne, Vermont

111 ⊞ ◑ 69×92 1866

Fruits et Melon sur un Buffet (Fruit and Melon on a Side-board) (Eugene Mayer) National Gallery, Washington
Not mentioned by Duret; dated 1870 by Meier-Graefe.

112 ⊞ ◑ 65×54 1866?

Chardons (Thistles)
Formerly Tannhauser Property, Berlin-Lucerne
According to Jamot and Wildenstein, prior to 1860. The date given above is supported by Tabarant.

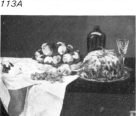
113A

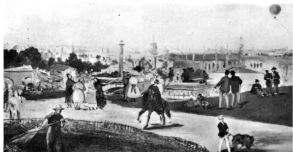

112

114 (Plate XVIII A)

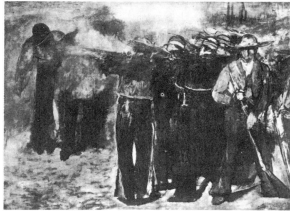

115

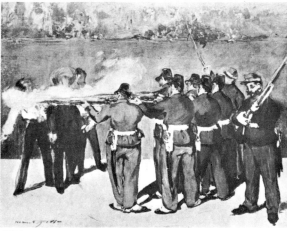

116A

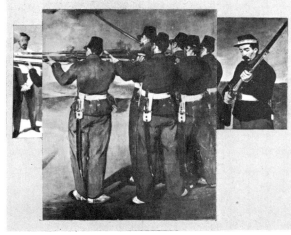

116B

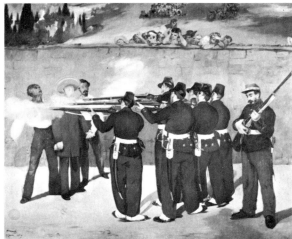

116C (Plate XVII)

113 $\frac{47 \times 37}{1866}$

Chien Epagneul (Spaniel)
Mrs Mellon Bruce Collection,
New York
A Was exhibited in 1867 in the
atelier along with other works
refused by the Salon.
B A study (oils [?] 26 cm. ×
18 cm.) was noticed (T) in the
J. Hessel Collection in Paris.

114 $\frac{108 \times 196}{1867}$

**Vue de l'Exposition
Universelle de Paris 1867
(View of the International
Exhibition 1867)**
Nasjonalgalleriet, Oslo
Inspired by *Vue de Paris du
Trocadéro* by Berthe Morisot,
exhibited in the 1867 Salon.

115 $\frac{195 \times 259}{1867}$

**l'Exécution de
Maximilien de Mexique
(The Execution of
Maximilian of Mexico)**
(Macomber) Museum of Fine
Arts, Boston
As is well-known, on 19 June
1867, Maximilian, Emperor of
Mexico since 1863 (April
1864 [T.]) was shot at
Queretaro, along with Generals
Mejia and Miramón. Manet
heard of the event and –
possibly in the early days of
August – painted this kind of
large rough sketch. The
political climate made it
impossible for him to present the
picture in the show at the Place
de l'Alma, because it might risk a
breach of the peace. It is only
in this version (see 116) that the
soldiers are wearing Mexican
uniform. Obvious echoes of
Goya's *Shooting of 3 May 1808*
(Prado, Madrid) appear in the
way it is set out.

116 $\frac{50 \times 61}{1867}$

**l'Exécution de Maximilien
de Mexique (The Execution
of Maximilian of Mexico)**
Ny Carlsberg Glyptothek,
Copenhagen
A It was probably not until after
painting the preceding work
that Manet managed to obtain
certain details of the episode
(see 115) from the illustrations
in *Le Figaro* (11 August 1867),
in particular the fact that the
soldiers in the firing-squad were
wearing French-style uniforms.
His friend Commandant
Lejosne brought to the studio a
group of soldiers from the
Pepinière barracks to pose as the
firing squad. The Emperor
Maximilian, who is holding the
hands of his two companions, is
shown here wearing a
sombrero. The head of Maxim-
ilian was taken from a photo-
graph.
B In the same year, Manet took
up the theme again in a large
canvas, the original dimensions
of which are unknown because
it was cut up by the painter
himself, no one knows when or
why. The pieces (National
Gallery, London), apart from a
tiny strip of blue which may
have come from the back-
ground, comprise two parts of
the figure of General Miramón
(89 cm. × 30 cm.), the firing-
squad group (190 cm. ×

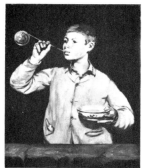

117 (Plate XIX)

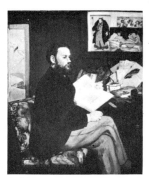

118 (Plates XXIII-XXIV)

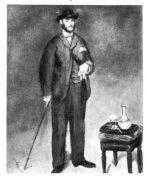

119

160 cm.) and the figure of the
soldier loading a rifle (99 cm. ×
59 cm.). Examination of the
central part shows that the
event seems to have been set
out in the open, as in the Boston
painting (115) that is, without
the wall in the background,
visible in the Copenhagen and
Mannheim versions (for the
latter, see below).
C The other version (oils on
canvas, 252 cm. × 305 cm.) is
signed and dated with the day of
the shooting (Manet, 19 June
1867) although it was
presumably not begun until
September. It belongs to the
Kunsthalle in Mannheim and has
various elements in common
with the Boston sketch (115). It
was lent by Manet to the singer
Emilie Ambre, who was going on
tour in the United States, and
the work was successfully
exhibited in New York and Boston.

117 $\frac{100 \times 81.4}{1867}$

**Garçon aux Bulles de Savon
(Boy Blowing Soap
Bubbles)** Fundacao Calouste
Gulbenkian, Oeiras
Léon Koëlla posed for this in
September at the studio in the
Rue Guyot.

118 $\frac{146 \times 114}{1867-68}$

Portrait d'Emile Zola Jeu
de Paume, Louvre, Paris
Between November 1867 and
February 1868, Zola went to
Manet's studio seven or eight
times to pose for this portrait
which his friend dedicated to
him as a mark of gratitude for
the comments Zola had made
on his work (see *Manet, Man
and Artist*, 1866 and 1867). As
Richardson notes 'the
characterization has been
sacrificed to stylistic
consideration'. The figure is
two-dimensional and comes
out in clear flat zones of color.
Manet's interest in Japanese
art is revealed, not only in the
flatness of the shapes but also
in other elements, such as the
silk screen with the flowering
branch pattern on the left, and
the Utamaro print on the wall.
Near the latter are two even
more significant things: a
photograph of *Olympia* (62)
and the upper part of an
engraving of Velasquez's
Topero. The picture was
submitted to the 1868 Salon
where, for the most part, it
received unfavorable criticism,
though it is possible to catch a
glimpse, from time to time, of
just how much attention and
curiosity the work aroused.
P. Mantz, for example, notes
(ILL 1868): 'M. Manet is quite
successful with his still-life
subjects; he is less happy as a
portrait painter. In the portrait of
Emile Zola, the main interest
belongs not to the sitter, but to
certain Japanese drawings
which cover the walls. The
head is inert and vague, and as
for those blacks which M.
Manet professes to love, they
are cloudy and lacking in
audacity.'

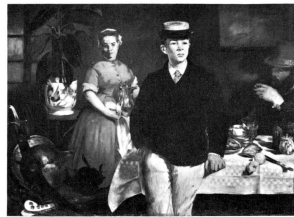

120 (Plates XX-XXI)

119 ⊞ ◉ 43×35 1868 ▤ ⦂

Portrait de Théodore Duret
Petit Palais, Paris
The writer who published *Les Peintres français en 1867*, in which Manet was harshly dealt with, must have had a change of heart, since he agreed to pose for this portrait, which postulates friendship between himself and Manet whom he had come to know by chance in Madrid (1865). When the figure work was finished, Manet added a still-life which, as in the Zola portrait (118), gave the composition balance. It was completed on the eve of Manet's departure for Boulogne-sur-Mer and he sent it to Duret who expressed his thanks with a case of cognac. Earlier, the sitter had asked Manet by letter whether he could remove the signature which had been placed in a patch of light. This was so that his visitors should not be able to read such a contentious name on it before passing judgment.

120 ⊞ ◉ 120×154 1868 ▤ ⦂

Déjeuner dans le Studio (Luncheon in the Studio)
Bayerische Staatsgemalde-sammlungen, Munich
In the summer of 1868, Manet spent six weeks at Boulogne-sur-Mer. When he returned to Paris, he took up the idea again in the picture which he called *Le Déjeuner* and which therefore erroneously came to be known later by the title above. Richardson remarks upon the 'unusually elaborate detail' which is reminiscent of the *Famille Belleli* by Degas (Louvre, Paris). It was submitted to the 1869 Salon and Castagnary wrote (SI 1869): 'M. Edouard Manet is a real painter.... Up till now, he has been more whimsical than observant, more bizarre than powerful. His *oeuvre* is poor, if one leaves aside the still-lifes and the flower paintings which he handles with the touch of a master.'

121 ⊞ ◉ 170×124,5 1868 ▤ ⦂

Le Balcon (The Balcony)
Jeu de Paume, Louvre, Paris
A The three people in the foreground are the landscape artist Antoine Guillemet, the violinist Fanny Claus and, seated, Berthe Morisot. Behind them stands Léon Koëlla with a tray.

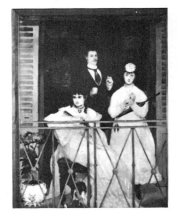

121A (Plates XXV-XXVI)

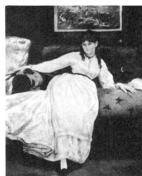

131

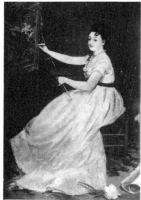

133

Richardson sums up the opinion of most informed criticism when he observes that 'the group is charming and each figure masterly' but that nevertheless there exists no thematic link between the figures, each stares fixedly out at something different'. He adds, moreover, that more of the 'stimulus of the thing seen – in this case ... at Boulogne-sur-Mer' comes through than the recollection of *Women on the Balcony* by Goya (Prado,

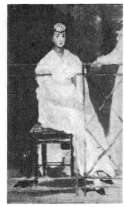

121C

Madrid) the intensity of which it does not rival. The painting was submitted to the 1869 Salon and P. Mantz (GB) saw in it: 'extremely delicate flesh tones, and if he (Manet) has not solved the problem, we must be thankful to him for having posed it.' Chesneau was more severe (CL 1869) 'Manet: the same qualities, the same faults. As he gets used to this painting, the visitor finds it better now than he did earlier. He is wrong : it is not the painter who has changed, it is the public.'
B A copy is known (37 cm. × 30 cm.) which was considered authentic by Duret, dubious by Jamot and Wildenstein and rejected by Tabarant.
C Oils on canvas (71 cm. × 43 cm., Pitman Collection, London).

122 ⊞ ◉ 38×46,5 1868 ▤

Mme Edouard Manet au Piano, de profil (Mme Edouard Manet at the Piano, profile) Jeu de Paume, Louvre, Paris
In 1867 Degas painted a portrait of the Manets. The portrait of Mme Manet in particular did not please the sitters and they removed her figure from the canvas. Degas was offended and took the picture back. Manet then re-drew his wife in the same pose but in a more flattering way.

123 ⊞ ◉ 60,5×73,5 1868 ▤ ⦂

La Lecture (Reading) (Léon Koëlla and Mme Manet) Jeu de Paume, Louvre, Paris

124 ⊞ ◉ 73×60 1868–69 ▤ ⦂

Berthe Morisot au Manchon (Berthe Morisot with a Muff) (C. Hanna

jnr) Museum of Art, Cleveland
Painted on a winter's day between the end of 1868 and the beginning of 1869. It is one of the most beautiful portraits of Berthe Morisot by Manet. The canvas can be seen through the rapid, self-confident brush strokes of the cloak.

125 ⊞ ◉ 41×32 1869 ▤ ⦂

Berthe Morisot au Chapeau à Plumes (Berthe Morisot in a Feathered Hat) Private Collection, Paris

126 ⊞ ◉ 60×73,5 1869 ▤ ⦂

Départ du Vapeur de Folkestone (The Departure of the Folkestone Boat) (Carrol S. Tyson) Museum of Art, Philadelphia
A Of the two works on the same theme, this is certainly the happier and more coherent. The two figures on the left, sheltering under a parasol, are Suzanne Manet and Léon Koëlla. In some parts, for example in the crowd on the mole, an impressionistic treatment is used, and this may be due to the artist's friendship with Morisot and Monet (R.).
B The first version (oils on canvas; 63 × 100 cm., O. Reinhard Collection, Winterthur) was certainly painted at Boulogne-sur-Mer during the summer.

127 ⊞ ◉ 33×45 1869 ▤ ⦂

Jetée de Boulogne (Boulogne Jetty) Formerly in Paris, owned by Durand-Ruel
A This is the more lively and better organized of the two versions of the theme.
B The other version (oils on canvas ; 71 cm. × 92 cm. ; signed ; Private Collection, Paris), probably the earlier of the two.

128 ⊞ ◉ 82×101 1869 ▤ ⦂

Le port de Boulogne-sur-Mer au Clair de Lune (Boulogne Harbor by Moonlight) Jeu de Paume, Louvre, Paris

129 ⊞ ◉ 43×96 1869? ▤ ⦂

Bateaux en mer au Soleil Couchant (Ships at Sea, Sunset) Musée du Havre, Le Havre
Since this would once again seem to be a theme suggested by something seen at Boulogne-sur-Mer, the date 1870 advanced by Jamot and Wildenstein would appear to be wrong. In that year, while Manet was preparing to set off for Boulogne, the Franco-Prussian war broke out.

130 ⊞ ◉ 32,5×65,5 1869 ▤ ⦂

Sur la Plage de Boulogne (On Boulogne Beach) Paul Mellon Collection, Upperville, Virginia
This is a somewhat disjointed work, but the individual groups and figures have some fresh-ness. Manet sold it in 1873, along with various other works, to Durand-Ruel for 600 francs.

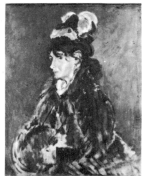

124

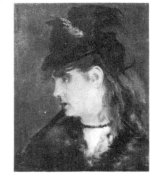

125

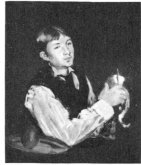

132

135

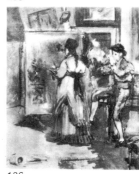

136

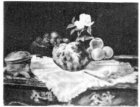

137

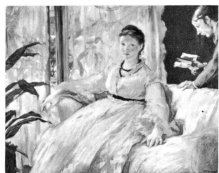

122

123 (Plate XXII)

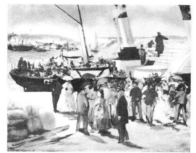

126A 126B

127A 127B

129

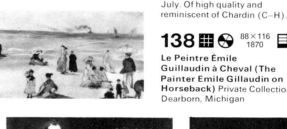

128 130

139

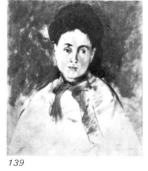

141

143

it would be a good idea to combine the two since she, too, was a musician. Originally the work measured 120 cm. × 107 cm. and perhaps included the whole figure.

135 🔲 ◐ 73×92 1870 ▤ ⁝
Enterrement (The Funeral)
Metropolitan Museum, New York
Tabarant has shown that this scene took place on the edge of the Mouffetard quarter of Paris. The domes of the Observatoire, the Val-de-Grâce and the Panthéon can be identified.

136 🔲 ◐ 56×46 1870 ▤ ○⁝
Eva Gonzalès en train de peindre dans le Studio de Manet (Eva Gonzalès painting in Manet's Studio)
Formerly in Paris, Alphonse Kann Collection
The painting on the easel is the one with which Mlle Gonzalès obtained admission to the Salon for the first time, *Enfant de Troupe.* Léon Koëlla is seen once more, as the boy on the right in Spanish costume.

137 🔲 ◐ 65×81 1870 ▤ ○⁝
Nature Morte, Brioche, Fleurs et Fruits (La Brioche Fleurie) (Still-life, Brioche, Flowers and Fruit) Private Collection, New York
Painted between June and July. Of high quality and reminiscent of Chardin (C–H).

138 🔲 ◐ 88×116 1870 ▤ ○⁝
Le Peintre Émile Guillaudin à Cheval (The Painter Emile Gillaudin on Horseback) Private Collection, Dearborn, Michigan

131 🔲 ◐ 148×111 1869 ▤ ⁝
Repos (Berthe Morisot) (Resting) Rhode Island School of Design, Providence, Rhode Island
Tabarant and Davidson do not consider the usual title of *Le Repos* very suitable because of the position of the sitter. Théodore de Banville found it unconditionally pleasing and saw a powerful modernity in it. George Moore also liked it and was impressed by the magnificent rendering of the white garments which make a rich contrast to the wine-colored sofa and the wall, on which hangs a *kakémono* in the form of a triptych. It may have been started in September 1869.

132 🔲 ◐ 85×71 1869 ▤ ⁝
Jeune Homme à la Poire (Léon Koëlla) (Le Peleur) (Young Man with a Pear) Nationalmuseum, Stockholm

133 🔲 ◐ 198×135 1869-70 ▤ ⁝
Portrait d'Eva Gonzalès
National Gallery, London
This was begun in February 1869, a few days after this sensitive pupil first came to the atelier, and she posed countless times. Berthe

Morisot was jealous and wrote to her sister, Edma, about this portrait which 'was still no further forward'. She added 'He (Manet) tells me that they have reached the fortieth sitting and the canvas has once again been wiped clean'. It was not completed until 12 March 1870, the last possible day for sending it to the Salon. Of the reviews it received, the painter was especially pleased with what Duranty, and, particularly, Duret (EL 1870) had to say: 'M. Manet . . . is an inventor, one of the rare few who have a proper way of looking at things and who, for that reason, are fully alive.'

134 🔲 ◐ 140×173 1870 ▤ ○⁝
Leçon de Musique (Zacharie Astruc) (The Music Lesson) Private Collection, Boston
A Definitely painted in the first weeks of 1870.
B The above-mentioned canvas was preceded by another (97 cm. × 82 cm.; J. Charron Collection, Paris) depicting only the female figure. The model, a young Parisienne, whose acquaintance Manet had made at Boulogne, arrived in the studio while Astruc was posing with his guitar and the painter thought

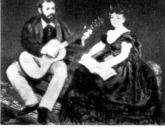
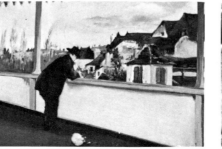

134A 134B

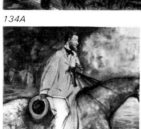
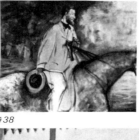

138 140

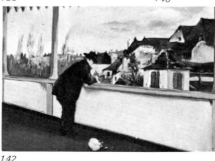

142 144

139 🔲 ◐ 57×46,5 1870 ▤ ?⁝
Femme en Buste (Tête de Femme) (Mme Bourdin) (Bust/Head of a Woman) (Staechelin) Kunstmuseum, Basle

140 🔲 ◐ 45×55 1870 ▤ ○⁝
Jardin (The Garden) Private Collection, New York
At the beginning of the summer, Manet went to spend several days as the guest of the De Nittis family at Saint-Germain-en-Laye painting this canvas among others.

141 🔲 ◐ 61×50 1870 ▤ ⁝
Petit-Montrouge pendant la Guerre (Petit-Montrouge in Wartime) National Museum of Wales, Cardiff
Dated 28 December 1870. At this time Manet was under arms, but succeeded in painting this, and perhaps other canvases, all trace of which has been lost (see, however, 427).

142 🔲 ◐ 42×62 1871 ▤ ⁝
Oloron-Sainte-Marie (Léon Koëlla) Bührle Collection, Zurich

143 🔲 ◐ 62×46,5 1871 ▤ ⁝
Oloron-Sainte-Marie Staatsgalerie, Stuttgart

99

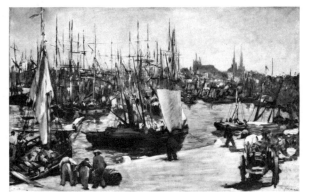

146 (Plates XXVIII-XXIX)

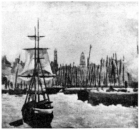

152

153

154

144 ⊞ ◗ 53×20
1871
**Vélocipède (The Bicycle)
(Léon Koëlla)** Private
Collection, Paris
Originally this was part of a
large composition, the
dimensions of which are not
known. (see 145)

145 ⊞ ◗ 19,5×24,5
1871
**Biche (?) Levrier (?) (Doe
[?] Greyhound [?])** Formerly
in Paris, Makeev Collection
Originally this formed part of
the same composition which
included 144. Other fragments
of the work have not been
traced with any certainty.
However, according to Jamot
and Wildenstein, it must have
been little more than a large
rough sketch.

146 ⊞ ◗ 63×100
1871
**Le Port de Bordeaux (The
Harbor of Bordeaux)**
Bührle Collection, Zurich
On 21 February 1871, Manet
left Oloron for Bordeaux,
where, according to Richardson,
he painted this picture from
the window of a café on the
Quai des Chartrons. It recalls
the view of the harbor at Le
Havre by Boudin and similar
ones by Jongkind. It is one of
Manet's most distinguished
and ambitious seascapes.

147 ⊞ ◗ 25×30
1871
**Le Bassin d'Arcachon
(Arcachon Dock)** Rudolph
Staechelin Collection, Basle
A similar view (oils on board;
35 cm. x 55 cm. ; signed) seen
from the Villa Servanti, belongs
to Emil G. Bührle of Zurich.

148 ⊞ ◗ 34×49
1871
**Arcachon, Temps d'Orage
(Arcachon, Stormy
Weather)** Formerly in Berlin,
owned by Alfred Cassirer

149 ⊞ ◗ 25×42
1871
**Arcachon, Beau Temps
(Arcachon, Fine Weather)**
Private Collection, New York

150 ⊞ ◗ 39×54
1871
**Intérieur à Arcachon (Mme
Manet and Léon Koëlla)
(Interior at Arcachon)** Clark Art
Institute, Williamstown, Mass.
Painted at Arcachon; through
the open window can be seen
the sea with a sailing boat.

151 ⊞ ◗ 46×73
1871
**Partie de Croquet à
Boulogne-Sur-Mer (The
Game of Croquet at
Boulogne-sur-Mer)** Private
Collection, Paris
Done in the garden of the
Casino at Boulogne-sur-Mer.
Léon Koëlla, Eva Gonzalès'
sister, Jeanne, and Roudier, a
friend of Manet, can be
recognized on the left.

152 ⊞ ◗ ___ 1871
**Bateaux dans le Port de
Calais (Boats in Calais
Harbor)** Formerly in New
York, owned by Havemeyer

153 ⊞ ◗ 21×26
1871
**Nature Morte, Amandes
Vertes (Still-life, Green
Almonds)** Formerly in Paris,
owned by Bernheim-Jeune

154 ⊞ ◗ 40×24
1871?
**Vue prise près de la Place
Clichy (Rue) (View from
near Place Clichy) (A
Street)**
The designation of 'near Place
Clichy' was given by Duret, who
assigns it to 1875–7. Jamot and
Wildenstein date it 1877.

155 ⊞ ◗ 61×47
1872
**Jeune Femme à la Voilette
(Berthe Morisot) (Young
Woman with a Veil)** Private
Collection, Basle
This is the first of four portraits
(156–158 also) of Berthe
Morisot, painted in the new
studio in the Rue Saint-
Pétersbourg, perhaps between
July and September. The veil
gives the face a strange
expression. Renoir called it:
'A veiled woman – very ugly'.

156 ⊞ ◗ 46,5×32
1872
**Berthe Morisot au Soulier
Rose et Paysage avec
Campanile (Berthe
Morisot with a Pink Slipper
and Landscape with
Campanile)** Hunt Henderson
Collection, New Orleans

157 ⊞ ◗ 60×45
1872
**Berthe Morisot à l'Eventail
(Berthe Morisot with a Fan)**
Jeu de Paume, Louvre, Paris

158 ⊞ ◗ 55×38
1872
**Berthe Morisot au Chapeau
Noir et Violettes (Berthe
Morisot with a Black Hat
and Violets)** Rouart Collection,
Paris

159 ⊞ ◗ 21×27
1872
**Nature Morte, Bouquet de
Violettes et Eventail (Still-**

155

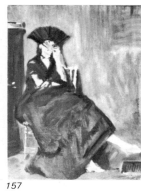

157

156

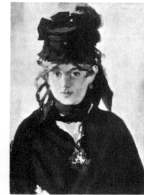

158 (Plate XXVII)

life, a Bunch of Violets and a
Fan)** Bears a signed
dedication to Berthe Morisot:
'A Mlle Berthe – E. Manet)

160 ⊞ ◗ 52×32
1872
**Femme à l'Ombrelle
(Woman with a Sunshade)**
William Goetz Collection, Los
Angeles

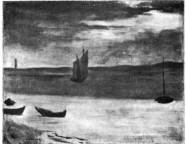

147A

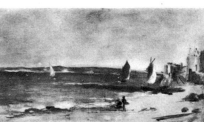

147B

148

149

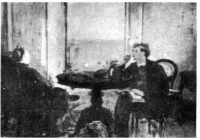

150

151

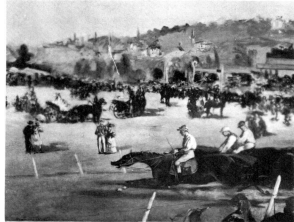

164

This is the same non-professional model who posed for the following picture, 161.

161 60×49 1872

Buste de Femme Nue (Portrait Bust of Nude Woman) Louvre, Paris Certainly dating from 1872.

162 38×42 1872

Femme au Lorgnon (Woman with Pince-nez) Formerly in Dublin, Christian Kilternan Collection Particular attention is given to the light values in the floral drapery in the background and in the carafe and glass. A head and shoulders only (oils on board; 24 cm. × 24·5 cm.; Private Collection, Paris) bears a false signature and has justifiably been rejected by Duret, Jamot and Wildenstein.

163 50×60,6 1872

Vue de Hollande (Dutch Landscape) (Wilstach) Museum of Art, Philadelphia Tabarant gives the dimensions 80 cm. × 64 cm. Painted in August during the trip to Amsterdam.

164 72,5×92,5 1872

Courses au Bois de Boulogne (Racing at the Bois de Boulogne) John Hay Whitney Collection, New York Commissioned by M. Barret, the sportsman and collector, on Manet's return from Holland. The man with the top hat, seen from the back, is possibly Degas. Richardson emphasizes the obvious difference between the sharp focus of the central part of the picture, with the horses which are typical of English prints (even to the 'incorrect' rendering of the horses' legs) and the impressionistic style of the hill of Saint-Cloud in the background, with a glimpse of the houses through the trees.

165 94×83 1873

Bon Bock (Good Beer) (Carrol S. Tyson, Jr.) Museum of Art, Philadelphia
A The model, the lithographer Bellot, is blissfully sitting at a table in the Café Guerbois in Paris. Rewald recalls that Manet's friends had some misgivings about this portrait. They did not find his usual

whimsy and vulgarity and the more he is reproached for a weakness, the more he seems to assert it'. In spite of the praise, Manet did not have the success he had enjoyed in 1861. When the exhibition at the Salon closed, a *brasserie* in the Latin Quarter put up *Bon Bock* on its sign-board; there were tableaux given of it in the intervals in the revue theatres and shortly afterwards, Bellot himself founded and presided over an association called *'du Bon Bock'* which even published a weekly paper, *Echo des brasseries françaises*. The painting was snapped up by Faure for 6,000 francs.
B A *Bon Bock* is known to exist (oils [?]; 22 cm. × 18 cm.; private collection) which is perhaps restricted to the beer-mug alone and which is supposed to be a preliminary sketch. Tabarant, however, rejects this idea as the actual canvas was done 'from scratch'.

166 50×38 1873

Palette au Bock (Palette with a Beer-mug) Formerly in Paris, owned by Pierre. Painted on the palette used for *Bon Bock* and in honor of that painting.

ardor and vigor in it and, for the most part, were distressed that the way in which it was rendered gave it almost the character of an Old Master. However, the painting required much work, infinite pains and a good seventy (T), or maybe even eighty sittings. All this was amply rewarded by the extraordinary success it achieved at the 1873 Salon. Albert Wolff wrote (F 1873): 'M. Manet has watered down his beer *(Bon bock* or *Good beer* being its original title); he has given up the violent and the noisy in favor of a pleasanter harmony. We shall have to wait a year or two before passing a final judgment on the artist. It is impossible that so gifted a painter should stand still'. On 13 July, however, there was an attack by Charles Garnier, the architect of the new Opera House (MU): 'Here I am in front of M. Manet's pictures. Everyone knows them, for the public is always fond of anything remotely scandalous and these two canvases are an artistic scandal. M. Manet has offered up a sacrifice to

167 57×72 1873

Sur la Plage (On the Beach) Jeu de Paume, Louvre, Paris

168 38×44 1873?

Baigneuses sur la Plage à Berck-sur-Mer (?) (Bathers on the Beach at Berck-sur-Mer) Robert H. Tannahill Collection, Detroit

169 65×81 1873

Hirondelles (Swallows) (Manet's Mother and Wife) Bührle Collection, Zurich The title refers to the birds which are flying close to the ground on the right.

170 12×21 1873?

Vaches au Pâturage (Cows Grazing) Formerly in Paris, Donop de Monchy Collection Some scholars (D; J–W etc) refer this unusual theme to 1871, though they consider it to have been painted at Berck-sur-Mer. At the Hoschedi sale in 1878 it made 155 francs.

171 63×80 1873

Travailleurs de la Mer (Fishermen) Formerly in Berlin, the Franz von

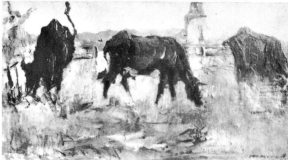

170

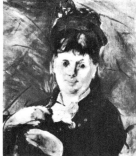

160

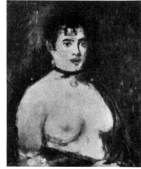

161

159

162

163

165A

166

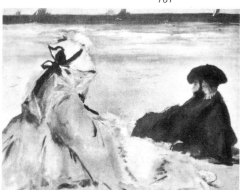

167

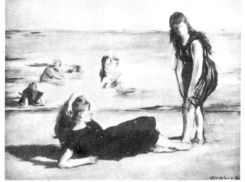

168

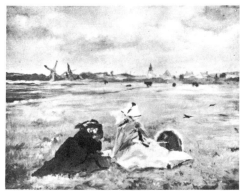

169

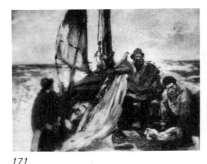

171

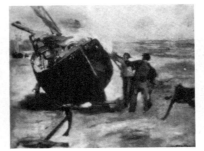

172

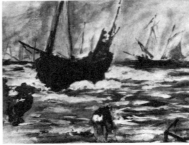

173

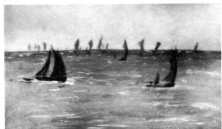

174

175

176

183 ⊞ ◷ 56×46 / 1873 ▤ ⦂

Jeune Fille en Blanc (Marguerite de Conflans au Capuchon) Girl in White (Marguerite de Conflans wearing a Hood) O. Reinhart Collection, Winterthur

184 ⊞ ◷ 54×35,5 / 1873 ▤ ⦂

Marguerite de Conflans en Robe de Bal (Marguerite de Conflans in a Ball Gown) Formerly in Paris, Le Meilleur Collection

185 ⊞ ◷ 65×50 / 1873 ▤ °°°

Marguerite de Conflans aux Cheveux Défaits (Marguerite de Conflans with her Hair Loose) Private Collection, New York Belonged to the Havemeyer Collection in New York. When the collection was sold in 1930, this was listed as a work of the 'French Modern School'.

Mendelsohn Collection
From a photograph taken by Manet himself, a scarcely legible signature emerges, followed by a date which can be seen more clearly. Later, the painter signed it again in the center. It was sold to the singer Faure, for 2,000 francs in 1873. The title is perhaps a reference to the novel of the same name by Victor Hugo, published in 1866. It was painted at Berck-sur-Mer.

172 ⊞ ◷ 59×60 / 1873 ▤ ⦂

Bateau Goudronné (Tarring a Boat) Barnes Foundation, Merion, Pennsylvania

173 ⊞ ◷ 50×61 / 1873 ▤ °

Bateaux Abordant (Marine) Boats coming Ashore (Seascape) Formerly in New York, Carroll Carstairs Collection

174 ⊞ ◷ 34×53 / 1873 ▤ ⦂

Bateaux en Mer (Golfe de Gascogne ; Baie d'Arcachon) Boats at Sea (Gulf of Gascony ; Arcachon Bay) (J. H. Wade) Museum of Art, Cleveland

175 ⊞ ◷ 47×58 / 1873 ▤ °°

Marée Montante (Incoming Tide) Bührle Collection, Zurich

176 ⊞ ◷ 55×72 / 1873 ▤ °°

Marine, Temps d'Orage (Seascape, Stormy Weather) Formerly in Tokyo, the Matsukata Collection

177 ⊞ ◷ 55×72 / 1873 ▤ *°°

Marine, Temps Calme (Plage de Berck à Marée Basse) Seascape, Fine Weather (Beach at Berck at Low Tide) Formerly in Paris, H. Bernstein Collection

178 ⊞ ◷ 39×47 / 1873? ▤ °°

Barques de Pêche, Temps Calme (Marine) Fishing Boats in Fine Weather (Seascape) Formerly in Paris,

Chausson Collection
Sometimes (J—W etc) dated 1869. Rejected by Duret.

179 ⊞ ◷ 46×50 / 1873 ▤ °°

Mme Edouard Manet et Paysage à Berck-sur-Mer (Manet's Wife and Landscape at Berck-sur-Mer) Private Collection, New York

180 ⊞ ◷ 93×112 / 1873 ▤ ⦂

Chemin de Fer (The Railway) (H. O. Havemeyer) National Gallery, Washington A modern at heart, Manet considered the railway a magnificent spectacle and thought the train-crews were endowed with amazing *sang-froid*. Only the details of the work were painted in the studio, the rest was carried out in a small garden belonging to the painter Hirsch, situated at the intersection of the Rue de Rome and the Rue de Constantinople. In the background, on the left, there is a corner of a house in the Rue de Rome; on the right is a glimpse of the Pont de l'Europe through the steam, rails and signals. Godet soon photographed this work and the singer, Faure, hardly looked at it before taking an option on it. Manet reserved the right to submit it to the 1874 Salon where it was accepted, though 169 was turned down.

181 ⊞ ◷ 72,5×106 / 1873 ▤ ⦂

Partie de Croquet (The Croquet Game) Städelsches Kunstinstitut, Frankfurt Endless games of croquet were played in the Stevens' garden, and Manet took up once again the theme which he had already used at Boulogne-sur-Mer (151), this time with the figures arranged diagonally to evoke distance. The woman on the left is Victorine Meurent, the one on the right, Alice Lecouvé, Stevens' model. The man in the background is Paul Roudier, who also appeared in *Partie de Croquet à Boulogne,*

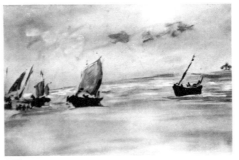

177

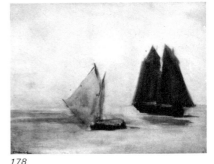

178

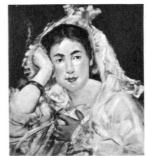

180 (Plate XXX)

182

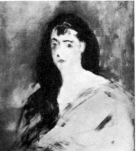

184

while the other is possibly Stevens himself. Richardson notes that Manet returns here to 'an impressionist manner, but the color is not broken up prismatically, as in comparable pictures by Renoir or Monet'.

182 ⊞ ◷ 53,5×45 / 1873 ▤ ⦂

Jeune Femme Accoudée (Marguerite de Conflans) Young Woman with her Head in her Hand Smith College, Northampton, Mass. Among those who took part in the musical afternoons *chez* Manet were Mme de Conflans and her daughter Marguerite, who was a ravishing beauty. Manet asked her permission to paint some portraits. There are four authenticated ones (see also 183–185) which, with the exception of this one, Duret and Jamot and Wildenstein assign to between 1875 and 1877.

186 ⊞ ◷ 37×19,5 / 1873 ▤ °°

Intérieur (Jeune Femme dans un Intérieur) Indoor Scene (Indoor Scene with Young Woman) Formerly in Stockholm, Private Collection

187 ⊞ ◷ 46,5×38,5 / 1873 ▤ ⦂

Bal Masqué à l'Opéra (Masked Ball at the Opéra) Bridgestone Gallery, Tokyo A See below. B Another similar painting, contemporary with the last, (35 cm. × 27 cm. ; signed ; Halfdan Mustad Collection, Oslo) with the crowd briefly indicated.

188 ⊞ ◷ 60×73 / 1873 ▤ °°

Bal Masqué à l'Opéra et Polichinelle (Masked Ball at the Opera with Punchinello) Mrs Horace Havemeyer Collection, New York A Manet had made many studies and try-outs of this

182

183

185

theme, (187) especially water-colors, before the event that spurred him into realizing the project. A little after midnight on 28 October 1873, the Paris Opéra was destroyed by fire. The painter set to work on the subject with such zeal that, by the beginning of November, Godet was able to photograph the painting which contained an elaboration of themes and features used in previous works. It was submitted to the 1874 Salon and was rejected. On 18 November 1873, Manet received a visit from the singer Faure, who bought the picture while the paint was still wet.
B The jester (Punchinello), on the left, may be seen on his own in an oil painting of similar date (50 cm. × 32 cm.; signed; René Lecomte Collection, Paris) for which the model was Edmond André, the painter. Manet seems to be following tradition, notes Bazin (AA 1932); he may have been

186

190

191

179

189

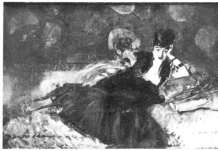

181

192 (Plate XXXVI)

inspired by *L'Indifférent* by Watteau (Louvre, Paris).
C Another, almost identical (oils on canvas; 53 cm. × 35 cm.; owned by Durand Ruel, Paris), where the head and legs are most clearly defined.

189 ⊞ ❂ 26×34 1873 目 ⁚

Berthe Morisot, Étendue (Berthe Morisot, reclining) Private Collection, Paris
In November, Berthe Morisot revisited Manet in his studio and he expressed his pleasure at the visit with this portrait. He was not, however, satisfied with the perspective, or so it would appear from some remarks in Berthe's *carnet*, and he removed the lower part of the canvas.

190 ⊞ ❂ 62×50 1873 目 ⁚

Berthe Morisot en Chapeau de Deuil et Voile (Berthe Morisot in Mourning Hat and Long Veil) Hans Hahnloser Collection, Berne
The painter was in mourning for the death of her father. Her face appears extraordinarily luminous beneath the veil.

191 ⊞ ❂ 61×49 1873 目 ⁚

Mme Edouard Manet, de Profil (Manet's Wife, in Profile) Museum of Art, Toledo, Ohio
According to Duret, this dates from 1874; Moreau-Nélaton and Jamot and Wildenstein date it 1878. However, the sitter herself refers the painting to 1873 and this is confirmed by Tabarant.

192 ⊞ ❂ 113,5×166,5 1874 目 ⁚

Dame aux Éventails (Nina de Callias) (Woman with Fans) Jeu de Paume, Louvre, Paris
Finished in January. The sitter was Marie-Anne de Callias, known as Nina, a painter and friend of intellectuals and artists, whom Manet had probably known since 1873.

The sittings took place in the studio, although the sitter appears in an oriental-style atmosphere. Nina is wearing a bolero, has oriental slippers on her feet and is decked in jewels. In the background is a Japanese wallpaper with flowers and ibis, its decorative effect enriched by a number of Japanese fans hung on it. The heightening of the colors also adds to the exotic effect. Charles Cros, a friend of Nina who was present at the sittings, published in *Revue du Monde Nouveau* (15 February 1874) the second version of the wood-engraving by Prunaire from Manet's drawing, with the title 'Une Parisienne, by Manet' and, on the following page, a sonnet he had written. In the same year a letter reached Manet from Nina's husband, Hector de Callias, art critic and publisher of *Le Figaro*, from whom she had been separated for some time. Callias asked that the picture, which had been spoken of as a portrait of Nina de Callias, should not be exhibited under that name or else that it should not be shown in public at all. The artist replied assuring Callias that he would keep the picture himself. So he did, and the work appeared in the inventory drawn up after Manet's death. It was sold in 1884 to Jacob and then passed into the hands first of Berthe Morisot and then the Rouarts.

193 ⊞ ❂ 149×131 1874 目 ⁚

Argenteuil Musée des Beaux-Arts, Tournai
Painted at Gennevilliers on the Seine opposite Argenteuil, where Manet spent the summer of 1874 as the guest of his cousin, Jules de Jouy. The models were Rudolph Leenhoff, Manet's brother-in-law, and an unknown woman who often went boating with them. Richardson says that the painting 'vibrates with summer light' and that it was 'a serious attempt to depict contemporary

life'. It had a stormy reception at the 1875 Salon, though a few had the courage to praise it openly. In 1884 it was sold for 12,500 francs; in 1889 for 14,000.

194 ⊞ ❂ 96×130 1874 目 ⁚

En Bateau (Boating) (H. O. Havemeyer) Metropolitan Museum, New York
According to various scholars (T; J–W etc), the man at the tiller may be the painter Rudolph Leenhoff, Manet's brother-in-law, but J. E. Blanche, on the other hand, suggests the name of Baron Barbier, an enthusiastic yachtsman and a close friend of Guy de Maupassant. The identity of the lady is not known. Richardson notes that, in general, the stippled parts of the painting, made up of massed color, are consistent with the concept of Impressionism, but that there are touches of black present, which would have been considered a heresy by the instigators of the movement. The bold line of the composition is more typical of Degas than of Manet, while the fact that the subject is viewed from above, and the vast expanse is given over to the turqoise water, is reminiscent of Japanese painting (C–H).

195 ⊞ ❂ 61×100 1874 目 ⁚

Bords de la Seine à Argenteuil (The River at Argenteuil) Lady Aberconway Collection, London
A The woman is possibly Camille, the wife of the painter Monet, with their son.
B The boats, which are grounded in the London painting, are seen again, this time on the waters of the river at Argenteuil, in a canvas of the same date as the previous one (60 cm. × 81 cm.; National Museum of Wales, Cardiff) which is countersigned with initials, perhaps by Manet's widow.

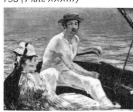

193 (Plate XXXIII)

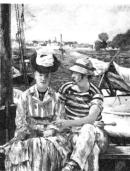

194 (Plate XXXII)

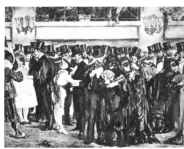

187A

187B

188A

188B

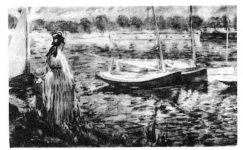

195A

195B

197A (Plate XXXI)

197B

196

199

196 ⊞ ⊘ 132×98 1874? 🔲 ⁑ ⁝

Baigneuses en Seine (Bathers in the Seine) Museu de Arte, São Paolo
Sometimes taken to be simply a study and therefore entitled *Académie*. Jamot and Wildenstein relate it to 1876.

197 ⊞ ⊘ 80×98 1874 🔲 ⁝

Claude Monet et sa Femme dans son Studio Flottant (Claude Monet and his Wife in his Floating Studio) Neue Pinakothek, Munich
A Monet, had taken a small boat

at Argenteuil and transformed it into an atelier for himself. Manet took a fancy to the subject and painted a picture of his friend, together with his wife, Camille. Miss Coffin-Hanson points out that this painting is a fine example of Manet's methods of work during these years: the vibrant, rapid brush-strokes succeed in catching vividly the essence of the shapes and the personality of the sitters. Manet kept the work for himself, but it was sold to Chocquet in 1884 for 1,150 francs and in 1899 for 10,000.
B In another oil painting of the same date (106 cm. × 134·6 cm.; Hammer Gallery, New York) the theme appears sparingly, but astonishingly well, caught in close-up, with some variants, particularly in the figure of Monet. It was given by the painter to Monet, who kept it all his life.

198 ⊞ ⊘ 48×95 1874 🔲 ⁝

Claude Monet, sa Femme et son Fils au Jardin (Claude Monet, his Wife and Son in the Garden) Private Collection, New York
The painting was given by Manet to Monet who, however, gave it back to him in a fit of bad temper.

199 ⊞ ⊘ 41×33 1874 🔲 ⁝

Jeune Femme dans un Jardin (Young Woman in a Garden) Private Collection, Frankfurt
Known to have belonged to the painter Pissarro. Dated 1878 by Jamot and Wildenstein, but this is belied by the fashion of the clothes (T 1947), not to mention Pissarro's own annotations.

200 ⊞ ⊘ 61×50 1874 🔲 ⁝

Berthe Morisot à l'Eventail (Berthe Morisot with a Fan) Private Collection, Paris
Of unusual freshness in the combined use of blacks and

browns. This was the last Manet portrait of Berthe, who married Eugène Manet a few months later (22 December 1874) and did not pose for her brother-in-law again.

201 ⊞ ⊘ 193×130 1875 🔲 ⁝

Artiste (Portrait de Gilbert-Marcellin Desboutin) (The Artist) Museu de Arte, São Paolo
According to the 'artist' himself, Manet was particularly interested in portraying an exceptional personality. The subject — poet, painter and sculptor — was, indeed, a bizarre bohemian. After the Franco-Prussian war, he settled himself with his dog in a decrepit old atelier in Paris. He was reduced to this situation by

having spent a long period living as a grand *signore* in Florence. The painting is faithful to the concept of this vivid, restless character.

202 ⊞ ⊘ 61×49,5 1875 🔲 ⁝

Tama, Chien Japonais (Tama, a Japanese Dog) Paul Mellon Collection, Upperville, Virginia
The model was brought back by Cernuschi and Duret from their travels in Japan *(tama* in Japanese means 'jewel') and the doll in the foreground also comes from that country.

203 ⊞ ⊘ 27,5×21,5 1875 🔲 ⁝

'Bob', Chien Griffon ('Bob', a Rough-haired Terrier) J. Cheever Cowdin Collection, New York
The dog belonged to the baritone Faure, who commissioned the work.

204 ⊞ ⊘ 32,5×25,5 1875 🔲 ⁝

'Douki', Chien Griffon ('Douki', Yorkshire Terrier) Private Collection, Paris
Signed with an M by the painter and a different hand has added 'anet'. The inscription at the top refers to the dog.

205 ⊞ ⊘ 42×30 1875 🔲 ⁝

Portrait de l'Abbé Hurel (Portrait of Abbé Hurel) Museo Nacional de Arte Decorativo. Buenos Aires

206 ⊞ ⊘ 58,7×71,5 1875 🔲 ⁝

Gondole sur le Grand Canal, Venise (Gondola on the Grand Canal, Venice) (E. Havemeyer Webb) Shelburne Museum, Shelburne, Vermont
This is one of two similar themes painted by Manet in Venice. In connection with this one, Richardson draws

attention not only to the impressionistic brushwork of the shapes and open areas — which can be seen in both the works — but also to a similar painting by Monet (1908) which was painted, as perhaps was this one by Manet, from the Palazzo Barbaro.

207 ⊞ ⊘ 57×48 1875 🔲 ⁝

Le Grand Canal à Venise (The Grand Canal, Venice) Provident Securities Company, San Francisco

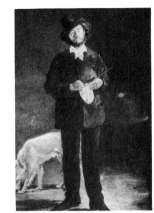

201

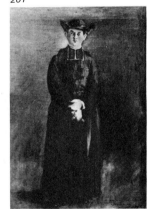

205

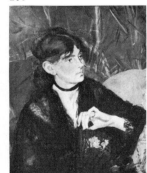

200

198

202

203

204

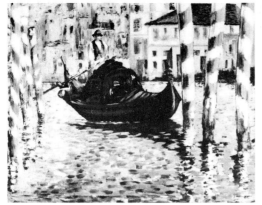

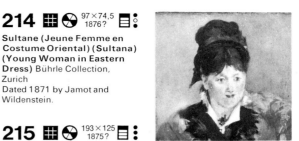

206

207 (Plate XXXIV)

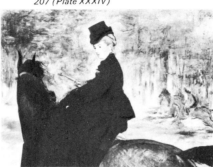

210

213

208 ⊞ ◐ 145×115 1875

Le Linge (Washing)
Barnes Foundation, Merion, Pennsylvania
Richardson defines this work, painted in the garden belonging to the painter Hirsch, as a delicate idyll. Alice Lecouvé (see 181) posed as the woman, and the child is the son of their hosts' concierge. A. Proust and Desboutin praised it highly, but it was turned down at the 1876 Salon and was exhibited in the artist's studio.

209 ⊞ ◐ 73,5×60 1875

Modèle du 'Linge' (Académie) The Model from 'Washing' (Académie) Owned by Bernheim-Jeune, formerly in Paris
A The model is Alice Lecouvé (see 208)
B A similar painting, but in the sketch stage (oils 71 cm. × 57 cm.). Was acquired by Shriver at Sotheby's in London on 7 December 1966.

210 ⊞ ◐ 24×32 1875

Jeune Femme au Livre (Young Woman with a Book) Private Collection, Paris

211 ⊞ ◐ 26×28 1875?

Portrait d'Alice Lecouvé dans un Fauteuil (Portrait of Alice Lecouvé in an Armchair) Bührle Collection, Zurich
Jamot and Wildenstein date it 1879.

212 ⊞ ◐ 222×157 1875

Cavalier (Portrait équestre de M. Arnaud) Horseman (Equestrian portrait of M. Arnaud) (Grassi Collection) Galleria d'Arte Moderna, Milan
This was one of the painter's friends (T). When compared

with the photograph by Lochard taken in 1883, it reveals some re-painting, especially in the background and in the shadows thrown by the horse's hooves.

213 ⊞ ◐ 90×116,5 1875

Portrait de Marie Lafébure à Cheval (Portrait of Marie Lafébure on Horseback) Museu de Arte, São Paolo

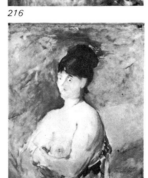

208

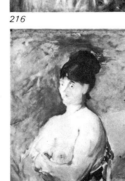

216

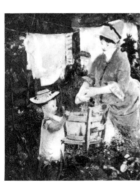

209 A

209B

214 ⊞ ◐ 97×74,5 1876?

Sultane (Jeune Femme en Costume Oriental) (Sultana) (Young Woman in Eastern Dress) Bührle Collection, Zurich
Dated 1871 by Jamot and Wildenstein.

215 ⊞ ◐ 193×125 1875?

Parisienne (Robe à Traine) Parisienne (Dress with a Train) Nationalmuseum, Stockholm
It is known that Ellen Andrée posed for this. She was a professional model before becoming an actress. Tabarant assigns this to 1876, but the date shown above comes from information given to the museum by Léon Koëlla.

216 ⊞ ◐ 92×74,5 1876

Devant la Glace (In Front of the Mirror) S. R. Guggenheim Museum, New York

217 ⊞ ◐ 97×130 1876

Portrait d'Ernest Hoschedé et son fils (Tabarant refers to 'sa fille') (Portrait of Ernest Hoschedé and his son) Private Collection, Caracas
Not dating from the summer of 1875 (M–N; J–W) but from the following summer when the Manets spent a couple of weeks at Montgeron as the guest of the Hoschedé family. It was never taken beyond the sketch stage.

218 ⊞ ◐ 60×98 1876

Enfant dans les Fleurs (Jacques Hoschedé) (Child among the Flowers) Formerly in Paris, owned by Durand-Ruel
A This is another of the six children of the Manets' hosts in the summer of 1876 (see 217). The work was intended for the Hoschedé family, but the painter took it back to Paris with him to complete, and it was never finished. At the sale organized by his widow in 1884 it was acquired by Dr Robin for 400 francs. (In the inventory drawn up after the artist's death it was only valued at about 300.)
B A small sketch in oils is known, showing the garden vase in the picture mentioned above. It is dated 1880 by Jamot and Wildenstein.

211

212

214

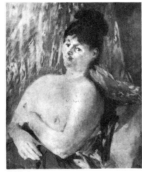

215

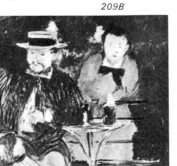

217

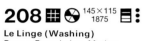

218A

218B

219 ⊞ ◐ 65,5×81 / 1876 ▤ ? ⦂

Jeune Femme dans les Fleurs (Young Woman among the Flowers) Paul Steiner Collection, Berlin
Certainly painted at Montgeron, which would seem immediately to refute the Jamot and Wildenstein dating of 1879.

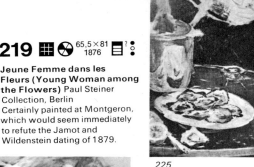
225

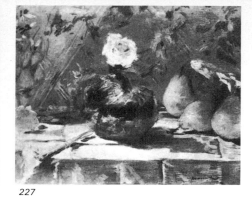
226

220

220 ⊞ ◐ 113×80 / 1876 ▤ ⦂

Jeune Fille dans les Fleurs (Girl among the Flowers) Formerly in Paris, Private Collection
This was reduced from its original dimensions of 114 cm. × 95 cm. to its present size by Durand-Ruel in order to get rid of the unpainted strips of canvas.

221 ⊞ ◐ 126×175 / 1876? ▤ ⦂

Femme au Jardin (Woman in a Garden) Formerly in Berlin, Liebermann Collection

For stylistic reasons this must belong to the short but intense period of activity at Montgeron. It is omitted by Duret and dated 1881 by Jamot and Wildenstein.

222 ⊞ ◐ 61,5×46,6 / 1876? ▤ ⦂

Femme à Mi-corps (Half-length Portrait of a Woman) H. Golding Collection, USA
Work in the sketch stage. Jamot and Wildenstein date it 1880. The present owner acquired it in New York, in 1960 for $29,000.

223 ⊞ ◐ 190×171 / 1876 ▤ ⦂

Portrait de Carolus Duran (Portrait of Carolus Duran) Barber Institute of Fine Arts, Birmingham
A The painter Carolus Duran was one of Manet's closest friends, and often met him during his stay at Montgeron (see 217). Manet mentioned working on this picture in a letter to Mlle Gonzalès.
B A small oil painting (canvas, 35 cm. × 27 cm.) exists, which seems to be a preparatory study for the above portrait which, although it came from Duran's own studio is not considered authentic (T1947).

224 ⊞ ◐ 27,5×36 / 1876 ▤ ⦂

Portrait de Stéphane Mallarmé (Portrait of Stéphane Mallarmé) Jeu de Paume, Louvre, Paris
One of the most felicitous and penetrating of Manet's portraits. After his stay at Montgeron and a brief period at the seaside, at Fécamp, the painter returned to Paris and, by 2 September, the door of his studio was once again open to his friends, among whom Mallarmé was one of the most frequent visitors. The poet is shown reclining on a divan, the same one that appears in 211. The walls are covered with Japanese wallpaper with flowers and ibis, as in 192 and, later, in Nana, 229. When it was finished, Manet added on to the right-hand side of it a five-centimeter strip which he painted with the colors of the wallpaper. The date was put on a few days later when the painter gave the picture to his friend, so the date of 1877, which is so often given, cannot be accepted.

225 ⊞ ◐ 55×35 / 1876? ▤ ⦂

Nature Morte, Huîtres et Seau à Champagne (Still-life, Oysters and Champagne Bucket) Private Collection, Paris
Often dated 1878.

226 ⊞ ◐ 38×46 / 1876 ▤ ⦂

Nature Morte, Huîtres, Citron, Brioche (Still-life, Oysters, Lemon and Brioche) Private Collection, Zurich
The date 1874 (J–W) cannot be upheld on stylistic grounds, and is, in any case, belied by what is said in connection with 1876 by the painter Guillemet, who received it from Manet himself.

227 ⊞ ◐ 46×54 / 1876 ▤ ⦂

Nature Morte, Brioche, Fleurs, Poires (Still-life, Brioche, Flowers, Pears) Private Collection, New York

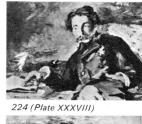
224 (Plate XXXVIII)

228

228 ⊞ ◐ 81×65,5 / 1876? ▤ ⦂

Chanteuse du Café-Concert (Singer in a Café-Concert) Private Collection, New York
Jamot and Wildenstein date this 1878.

229 ⊞ ◐ 150×116 / 1877 ▤ ⦂

Nana (Nana) Kunsthalle, Hamburg
The model for this picture, Henriette Hauser, shared with her sister, Victorine, the reputation of a *demoiselle de galanterie* and was a soubrette. She was the mistress of the Prince of Orange and a frequent and assiduous visitor to the *Tortons* of Paris. The sittings were started in the autumn of 1876 and went on into the winter, which compelled Manet to have his studio heated so that Henriette could pose *en déshabillé*. In addition, he transformed a corner of the atelier into a boudoir, with a Louis Quinze console-table with a vase of flowers on it. Sitting on the Louis Quinze divan is the unknown admirer who did not begin posing until January. In the background is the Japanese wallpaper with flowers and ibis already seen in other paintings (see 224). It would appear that the name, Nana, rather common among the aforementioned *demoiselles*, was not inspired by Zola. However, *L'Assommoir* by Zola was published in installments between July 1876 and January 1877, in the weekly *République des lettres* and the chapters concerning Nana first saw the light of day in November, just at the time when Manet was painting the picture. It is therefore possible to assume that it was a coincidence or that there was some mutual outside inspiration for the two. The novel, *Nana*, by Zola began to appear in *Voltaire* on 16 October 1879. The painting, which was submitted to the 1877 Salon, was turned down as an outrage against morals and was exhibited instead at Giroux on the Boulevard des Capucines, where it provoked such protest that it was feared that the police would intervene.

230 ⊞ ◐ 196×130 / 1877 ▤ ? ⦂

Jean-Baptiste Faure comme 'Hamlet' (Jean-Baptiste Faure as Hamlet) Kunsthalle, Hamburg
A The baritone Faure had achieved great success in Ambroise Thomas' *Hamlet*, and Manet painted a portrait of him in the role. The sittings, which may have begun towards the end of 1876, were enlivened

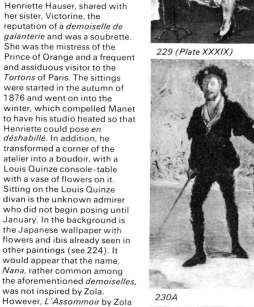
229 (Plate XXXIX)

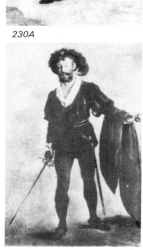
230A

230C

219

221

231

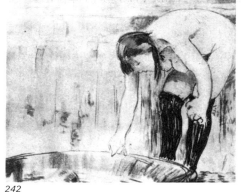

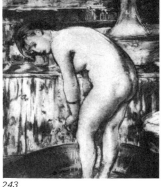

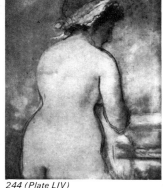

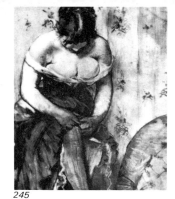

242

243

244 (Plate LIV)

245

by discussions on the way in which the figure should be interpreted. The singer wanted a flattering portrait where he would appear as the personification of the Shakespearian hero. Manet, on the other hand, was aiming to reveal the man beneath the stage paraphernalia. Faure himself recounts (GA 1884): 'We got annoyed with each other one day and this lasted for some time. . . . After posing twenty times, I was obliged to go off and sing somewhere or other. Manet continued his work in my absence and when I returned I found the portrait entirely changed, with supernatural glittering blues and with legs which were not mine.' (Indeed, the figure appears more slender and elegant than in the preparatory work.) The baritone rejected the picture, though his friendship with Manet remained unchanged, and the painter exhibited it in the 1877 Salon.
B *Hamlet and the Ghost* (probably a pastel) was the first of the preparatory works (board, 46 cm. × 56 cm.; 1877 or 1888; Marcus Wickham Boynton Collection, Burton Agnes Hall).

J. Mathey (1966) reproduces, as a first sketch, immediately following the above-mentioned pastel, a canvas (61 cm. × 50 cm.) which was supposed to have been owned by A. Proust and which re-emerged in 1947 in private ownership in France.
C The search for more realistic motifs which is documented in drawings and watercolors, found its focus in an oil on canvas (196 cm. × 131 cm.; signed and dated 1877; Folkwang Museum, Essen) where the figure of the baritone, in the foreground, occupies the entire height of the work.

231 ⊞ ◓ 89×71 1877 ▤ ⦂

Portrait d'Albert Wolff (Portrait of Albert Wolff) (Tannhauser) S. R. Guggenheim Museum, New York
Wolff was always somewhat more ambiguous in his criticisms of Manet, though not really unfavorable towards him. Hirsch tried to bring the two together, but the cordiality was completely superficial. However, Manet invited him to pose for a portrait because 'that anthropoid face interested him as a beautiful monstrosity' (T. 1947). In July the critić went to the studio for the sittings, which took place in silence. He showed no interest in the picture, although Duret believed that he 'must have admired the work which made his ugliness into

something artistic'. Actually, Wolff went so far as to say that Manet was not an accomplished artist, and that after many sittings the portrait was still only in the sketch stage. Also, the painter was himself somewhat unhappy and the sittings were discontinued. The critic thought so little of this work that he did not catalogue it among the pieces in his own collection.

232 ⊞ ◓ 183×110 1877 ▤ ⦂

Portrait d'Antonin Proust (Portrait of Antonin Proust)
Musée Fabre, Montpellier
This was preceded by at least four or five studies, but none of the sketches which have been associated with this present work, including an oil painting (65 cm. × 53cm.) at the Pushkin Museum in Moscow, have been accepted by recent scholars.

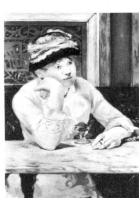

234A (Plate XXXVII)

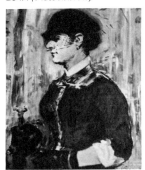

235

233 ⊞ ◓ 74×49 1877 ▤ ⦂

La Prune (The Plum)
Paul Mellon Collection, Upperville, Virginia
This was a non-professional model who has not been identified, but who was a frequent customer of the *Brasserie Nouvelle-Athènes*, which was one of those patronized by Manet and his friends. The similarity to *L'Absinthe* by Degas, painted in the previous year, is obvious. The decoration of the panel in the background is interesting since 'art nouveau' decoration is used to convey period feeling' (R).

234 ⊞ ◓ 92,5×72 1877 ▤ ⦂

Skating Fogg Art Museum, Cambridge, Mass.
A A scene of contemporary life

233

236

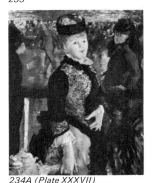

237

238 (Plate XXXV)

taken at the skating rink in the Rue Blanche, where Manet often went.
B A pastel on this theme was exhibited on the gallery of the *Vie Moderne* in 1880, but is now lost.

235 ⊞ ◓ 55×46 1877 ▤ ⦂

Jeune Femme au Chapeau Rond (Young Woman in a Round Hat) H. Pearlman Collection, New York

236 ⊞ ◓ 98×61 1877? ▤ ⦂

Vase de Fleurs (Vase of Flowers) Formerly in Ottawa, G. C. Edwards Collection
Decorative panel painted in the apartment in the Rue de Saint-Pétersbourg.

237 ⊞ ◓ 41,5×53 1877 ▤ ⦂

Tête de Caniche (Head of a Poodle) Formerly in Paris, owned by Bernheim-Jeune

238 ⊞ ◓ 50,5×61 1878? ▤ ⦂

Mme Edouard Manet sur un Divan (Manet's Wife on a Divan) Jeu de Paume, Louvre, Paris
One of the best-known of Manet's pastels. Jamot and Wildenstein date it 1878 for stylistic reasons as well as for reasons of fashion. According to Tabarant, however (1947), it is more likely to date from 1874.

239 ⊞ ◓ 62,5×52 *1878* ▤ ⦂

Blonde aux seins Nus (Nude)
Jeu de Paume, Louvre, Paris
One of the most famous of Manet's works, and rightly so. The model for this was known only by her Christian name, Marguerite. In her diary Mme Manet, who in any case was not always very well informed, confuses her with a girl called Amélie-Jeanne who frequented the ateliers in about 1878–80 (Bazire).

240 ⊞ ◓ 81,5×65,5 1878? ▤ ⦂

Nu se Coiffant (Nude combing her Hair) Private Collection, Paris
This is the second of the oil-paintings for which Marguerite posed (see 239) and she was perhaps also the model for five pastels of the same period (241–245). The woman, who is combing her blonde hair into a fringe, is sitting on the edge of a bed. Jamot and Wildenstein date it 1880.

241 ⊞ ◓ 54×44 1878 ▤ ⦂

Jeune fille se Coiffant (Young Woman combing her Hair) Private Collection, USA
Known also as *Petite Fille se*

239 (Plate XLIII)

240

241

coiffant and *Fillette à sa Toilette*, although the person shown hardly justifies the designation of 'young girl'. The initials of the atelier mark have been added to the authenticated signature. This is the first of the pastels for which Marguerite posed (see 239–245). Richardson puts forward the theory that the same model did not figure in all five because the heads only slightly resemble one another and he considers that for some, for example 243, the model may have been Amélie-Jeanne, quoted by Mme Manet (239). According to Jamot and Wildenstein, the whole series belongs to 1880, but it would seem certain that Manet was no longer painting true nudes after 1878.

242 ⊞ ◓ 45×54 1878 ▤ ⦂

Le Tub (The Bath) Schocken Collection, Scarsdale, New York

107

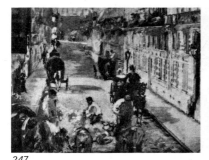

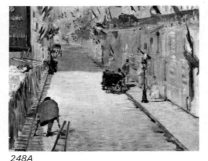

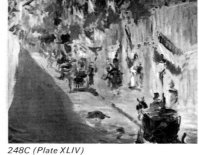

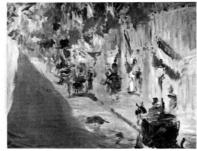

247 248A 248C (Plate XLIV) 248D

243 55×45 1878

Dans le Tub (Femme au Tub) In the Bath (Woman in the Bath) Private Collection, Paris

244 56×46 1878

Nu de Dos (Nude) Private Collection, Zurich

245 53×44 1878

Femme à la Jarretière (Woman fastening her Garter) (W. Hansen) Ordrupgaardsammlingen, Copenhagen

246 180×85 1878

Femme en Robe de Soirée (Woman in Evening Dress) Formerly in New York, owned by Tannhauser
A Possibly a portrait of Suzanne Reichenberg. Manet made up his mind in order to reduce the size of the canvas considerably (45 cm. at the bottom, 5 cm. at the top, 20 cm. on the left and 5 cm. on the right) and the white lines which he had drawn can still be seen in the photograph by Lochard. These later disappeared and the canvas was only reduced a little at the top, on the right and on the left.
B A detail of a basket of flowers on the Louis Quinze table gave the painter the idea for another oil (65 cm. × 81 cm.; Bergaud Collection, Paris).

247 63×79 1878

Paveurs de la Rue de Berne (Road-menders in the Rue de Berne) (From the Mrs Butler Collection) National Gallery, London
The Rue Mosnier, now called Rue de Berne, could be seen from the window of the atelier in the Rue de Saint-Pétersbourg, which Manet was preparing to leave, and he decided to record it in five canvases (see 248). The view is given life, not only by the road-menders, but also by a carriage, a removals cart and by the sign-board of a large shop, *Le Coin de rue, Vêtements sur mesure.* In addition to the lively rendering of the sign and the colors, which reveal a personal interpretation of impressionism, Richardson notes Manet's ability to make the atmosphere 'more tangibly Parisian' than in certain pictures painted by Claude Monet in the same period.

248 65×80 1878

Rue Mosnier Pavoisée (Rue Mosnier decked with Flags) Paul Mellon Collection, Upperville, Virginia
A The government had decided to celebrate the success of the Exhibition of 1878 with a national holiday, and on 30 June all the streets were decked with flags. Manet decided to preserve this on canvas. The Rue Mosnier (see 247) is brightly sunlit, with a few passers-by, a brougham on the right and a man with crutches in the left-hand corner.
B The motif of the brougham is the subject of an earlier study sketch *Rue Mosnier avec*

246A

246B

carrosse (oils on canvas, 65 cm. × 80 cm.; whereabouts unknown).
C An evocative view of the street may be seen in *Rue Mosnier Pavoisée* (oils on canvas, 65 cm. × 81 cm.; authenticated by Mme Manet; Bührle Collection, Zurich) which shows, on the left in the foreground, a large tricolor blowing in the wind. The authenticity of this picture has occasionally been doubted.
D An oil sketch on the motif of the *Rue Mosnier au Rémouleur* (Rue Mosnier with Knife-grinder) (40·5 cm. × 32·5 cm.; W. Coxe Wright Collection, Philadelphia) is known also as *Le Bec de Gaz.*

249 73×91 1878

Cabaret en Plein Air (La Guinguette) Open-air Cabaret ('Guinguette') Pushkin Museum, Moscow
According to Tabarant the theme of this picture was not suggested by a part of Place Moncey in Paris, as was thought by Jamot and Wildenstein, but a spot near the Porte *(barrière)* de Clichy. The man, in fact, portrayed as 'A sturdy fellow, a real *type de barrière'.*

250 27×35 1878

Journaliste (Journalist) Isabella Stewart Gardner Museum, Boston. Study of the interior of a café, perhaps the *Nouvelle-Athènes*, which takes its title from the man sitting at the table.

251 64,5×81,5 1878

Buveur au Café (George Moore) Man drinking in a Café (Ralph J. Hines) Metropolitan Museum, New York
This is in oils, and not a drawing, as it is sometimes catalogued. The model — poet, dramatist, novelist and art critic, a friend of Rimbaud, Verlaine, Banville, Duranty, Zola, Mallarmé and

others — was known as the *Anglais de Montmartre.* Here he is shown at the *Nouvelle-Athènes.* It is not catalogued by Duret, but otherwise there are no reservations about it.

252 24×20 1878

Promeneur (Man walking in the Street) Private Collection, Paris

253 61,5×50,5 1878

Femme au Fichu Noir (Femme en Buste) Woman with a Black Fichu (Bust-portrait of a Woman) (L. Coburn) Art Institute, Chicago
Supposedly a portrait of the sister of Murer (J–W).

254 90×71 1878

Femme (Mme Guillemet [?]) Assise sur un Divan Woman (Mme Guillemet [?]) seated on a Divan Formerly in Paris, G. Menier Collection
Authenticated by Manet's widow.

255 56×47 1878

Fillette à Mi-Corps (Line Campineau) (Half-length Portrait of a Little Girl) Nelson-Atkins Gallery of Art, Kansas City, Missouri.
A Line Campineau was seven years old when she posed for this painting, which was done on the occasion of a visit of the Campineau family to Paris to go to the Exposition Universelle. It is also known as *Line de Bellio,* from the name of her great-uncle who brought her to Manet's studio.
B Another oils on canvas of the same date (*Fillette dans un Fauteuil* [Small Girl in an Armchair]; 55 cm. × 47 cm.; [C. Curry] University of Kansas, Lawrence, Kansas) has been considered (T 1947) as a preparatory sketch, though Miss Coffin-Hanson thinks that this presents a different conception of the portrait of Line Campineau which remained unfinished.

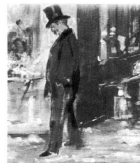

248B

252

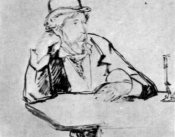

253

254

249 250 251

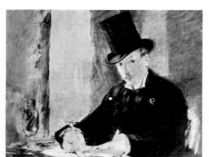

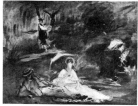

256

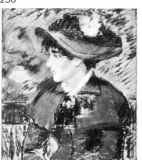

257A

257B

261

256 65×81 1878

Arroseur (Sous le Arbres) Watering the Plants (Under the Trees) Private Collection, Paris
The title was given by Camille Pissarro, to whose collection the painting belonged for an uncertain period of time. In the photograph by Lochard, however, it is called *Une Partie de Campagne*.

257 61×50,5 1878

Sur le Banc (On the Bench) Marshall Field Collection, New York
A An unknown little girl is sitting on a garden bench which, according to Tabarant, was to be found in Manet's studio in the Rue de Saint-Pétersbourg.
B This picture was perhaps preceded by another in pastels in which the same girl is represented (56 cm. × 35·5 cm.; formerly in London, Lefèvre Gallery).

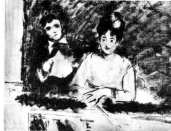

258 61,5×50,5 1878

Tête de Jeune Femme (Tête de Jeune Fille) (Ellen Andrée) Head of a Young Woman (Head of a Girl) Mrs H. O. Havemeyer Collection, New York
A On the photograph by Lochard, Léon Koëlla put a note *Portrait d'une Inconnue* (Portrait of an unknown Girl) which is surprising, because he himself had identified the model of the pastel, dealt with below, as being the same as in this one. On the same photograph, Léon has also added *Portrait très effacé* (Very faded portrait), but this observation would also seem unacceptable, since the subject emerges with great sensitivity and mellowness.
B The pastel just mentioned (60·5 cm. × 50 cm.; Louvre, Paris), should be regarded as unfinished.

259 60×73 1878

Dans la Loge (Loge aux Italiens) In the Box (Box at the Théâtre des Italiens, Paris) Formerly in Paris, Private Collection
A This is a sketch note given by Manet to his pupil Eva Gonzalès (see 133) for a picture called *La loge aux Italiens* that the latter was preparing to paint, and which she exhibited at the 1879 Salon and which is now in the Louvre.
B Of the same date is another pastel (42 cm. × 33 cm.; signed; owned by Alfred Daber, Paris) which contains only the face of Mlle Gonzalès.

260 56×46,5 1878

Jeune Homme à la Barbe Blonde (Young Man with a Fair Beard) (Portrait of Dr Materne [?]) Formerly in Paris, De la Narde Collection
The color is limited to the head and the top of the shoulders.

259A

259B

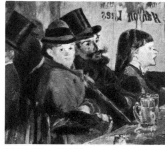

264A (Plate XLVII)

264B

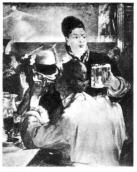

266A

261 61×50 1878

Lecture de 'l'Illustré' (Liseuse à la Brasserie) Reading the 'Illustré' (Woman reading in a Bar) (Coburn) Art Institute, Chicago
The model, in a black felt hat and with her hair in a fringe, was nicknamed Trognette and was often at the *Nouvelle-Athènes*.

262 55×46 1878

Buveuse de Bocks (Woman drinking Beer) (W. Burrell) National Gallery, London
This appeared in the 1880 exhibition at the gallery *Vie Moderne*.

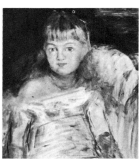

255A

225B

258A

258B

266B (Plate XLII)

263 1878

Le Buveur (Man Drinking)
Exhibited at the same time as number 262, this painting was destroyed before it was photographed.

264 77×83 1878

Au Café (At the Café) O. Reinhard Collection, Winterthur
A The identified models are the engraver Guérard (see 234) and Ellen Andrée. The name of the woman in profile is unknown. Tabarant observes that the title *A la Brasserie* might be more suitable, since the setting is the Brasserie Reichshoffen (see also 266A and B).
B The work was almost certainly preceded by an oils on board (*Au café*; 9 cm. × 7 cm.; owned by Bernheim-Jeune).

265 56×46 1878-79

Homme au Chapeau Rond (Alphonse Maureau) (Man in a Round Hat) Art Institute, Chicago
The painter Maureau (and not Moreau, as given by Duret and others), a friend of Degas and an *habitué* of the *Nouvelle-Athènes* had taken part in the third show by the Impressionists in 1877. While Tabarant dates this picture 1878, Jamot and Wildenstein consider it to be not earlier than 1882. Miss Coffin-Hanson suggests 1880 because the halfway dating seems more fitting, for reasons of style and technique which show Manet to have adopted some of the devices used by Degas, such as the alternation of pencil work with *gouache*.

266 98×79 1878-79

Serveuse de Bock (The Waitress) National Gallery, London
A Begun in 1878 and finished in the following year. In the background can be seen a double-bass player and the stage with a *chanteuse*. According to Tabarant, Manet made two pieces, this one and 264, from a single picture. It is possible that he had prepared a large canvas, *Café-concert de Reischshoffen*, and that, before finishing it, he cut it into two parts, restarting, modifying and finishing each at different times. Richardson, however, considers the question still unsettled, since 'the scale and position of the various figures are hardly reconcilable'.
B A variant of the same date (oils on canvas, 77·5 cm. × 65 cm.; Louvre, Paris) was called by Manet *Servante de Bocks* (Waitress serving Beer) and by Durand-Ruel *L'Assommoir* (The Pub') — a clear reference to Zola. This is often confused with the other, but the waitress here has a rounder face, the whole scene is more in close-up and the table is cut off at the base of the canvas. According to Richardson, 'the waitress at the *Brasserie Reischshoffen*... insisted that

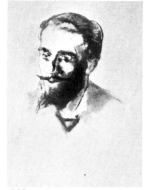

260

262

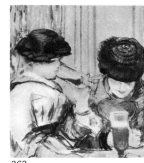

265

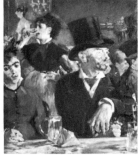

her *galant* — the man in the blue blouse — accompany her when she posed'. The same writer invites us to compare the composition with a Daumier lithograph, *Les Chinois de Paris*, no. 1 (1863).

267 47,5×39 1878

Buveurs de Bocks (Beer Drinkers) Walters Art Gallery, Baltimore
The setting must once again be the *brasserie-concert* Reischshoffen (264 and 266). The models are not identified, the detail of the *chanteuse* reflected in the mirror, in the background, is of interest. (see 266 and 357A.)
A supposed study for this exists (oils on canvas, 46 × 33 cm.; signed; W. Hansen Collection, Copenhagen) in which the old man in a top hat is cut off midway and the woman appears more coarse. It is justifiably omitted by Duret and by Jamot and Wildenstein.

267

269

268 15×150 1879

Dans la Serre (In the Conservatory) Staatliche Museen, Berlin
A The painter's two friends, the Guillemets, were painted, in fact in the studio lent to Manet by Rosen, which was much more like a conservatory than an atelier. The painting was submitted to the 1879 Salon and the criticisms were not altogether encouraging. Wolff went so far as to call Manet 'this gypsy of painting'. Among the most acceptable were the appreciations by Huysmans (V 1879): 'This year, M. Manet has had two canvases accepted (this and 231)... The woman, somewhat squat and dreamy, in a gown which seems to have been painted in great strokes, at the gallop — yes, go and see for yourselves! — and which is superb in execution; the man, bare-headed, with the light playing on his forehead and touching him here and there. ... this is a very attractive modern work, a battle under-taken and against the accepted convention of sunlight which is never observed by nature.' Castagnary's criticism was also welcome (SI 1879): 'Nothing is more simple than the composi-tion, nor more natural than the attitudes. One thing, however, is worthy of greater praise, namely the freshness of the tones and the general harmony of the color.'
B A sketch exists of the garden vase on the left (oils on canvas; 78 cm. × 60 cm.; formerly in Berlin, Liebermann Collection) executed with the tip of a brush.

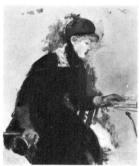

270A

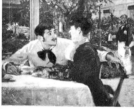

271 (Plates XL-XLI)

272

269 81,5×100 1879

Mme Edouard Manet dans la Serre (Mme Manet in the Conservatory) Nasjonalgalleriet, Oslo
Although Suzanne Manet rarely went to her husband's studio for fear of disturbing him, when M. and Mme Guillemet,

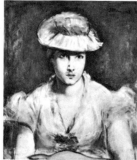

273

I 10

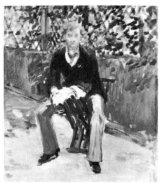

278A

her friends, posed in Rosen's studio (268) it was easier for her to be present. Manet's contemporaries complained, as usual, that he was incapable of finishing a painting. The sitter kept it in her room, only letting it go in 1895 for lack of money, to Marcel Joyant (but Duret claims that it was only sold in 1906 after Suzanne's death). Duret catalogues (252 bis) a similar portrait of the lady (Bonford Collection, London) which Jamot and Wildenstein list as dubious, maintaining that Suzanne Manet, displeased with the first which showed her with 'a very red face, which she did, in fact, have', had begged her husband to paint another with a somewhat paler face. Tabarant judges it to be quite improbable that Manet would have acceded to such a request. Besides, he thinks that it was actually this one, and not the previous one — as Duret asserts — which was sold after the death of the sitter (1906). He believes that, all things considered, this was another instance (see 34) where, when she had to part with the original (1895) she had a copy made — the work in question — by the altogether too skilful imitator Edouard Vibert, her nephew.

270 1879?

Liseuse (Portrait de Mme Guillemet) (Woman reading) Private Collection, New York
A Omitted by Duret and formerly dated 1882 (T 1931 ; J—W). The identity of the sitter was recognized by Tabarant and the theory is confirmed by an annotation placed on the back of the photograph by Lochard.
B Tabarant refers to a similar painting, this time complete, which is known to scholars through a photograph.

271 93×112 1879

Chez le Père Lathuille (At Père Lathuille's) Musée des Beaux-Arts, Tournai

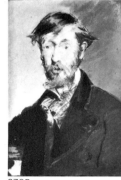

276A (Plate XLV)

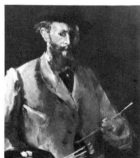

278B

Père Lathuille was a famous restaurant near the Café Guerbois, where the *bande à Manet* used to gather. There he met the proprietor's son, Louis Gauthier-Lathuille, in his dragoon's uniform, and had him pose with Ellen Andrée. The sittings proceeded and 'the picture was coming on very well' when Mlle Andrée's

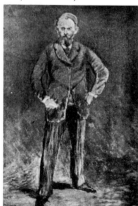

274 (Plate XLVIII)

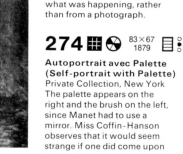

275

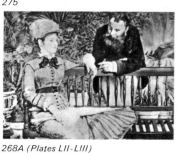

268A (Plates LII-LIII)

268B

sittings were interrupted because of her theatrical commitments. Manet called in Judith French, a relation of Offenbach, but the composition, which was already quite far advanced, went no further until the painter insisted that the young man should substitute for his uniform the common *blouse*. Thus was born the picture that we know, 'one of Manet's most brilliant and Maupassant-like vignettes of contemporary life' (R). It was exhibited at the 1880 Salon and received mostly hostile criticism. However, Zola (1880 V) wrote: 'There is in the Salon. ... a *plein-air* scene, *Chez le Père Lathuille*, which has astonishing gaiety and delicacy of tone. I have been one of the first to defend M. Manet against the imbecile attacks of press and public for fourteen years. During that time he has worked a great deal, always fighting, making an impression on men of intellect by his rare qualities as an artist, by the sincerity of his efforts, as well as by the originality of his color which is so clear and so distinguished . . .'

272 35×27 1879

Minnay, Chien Griffon (Minnay, Terrier Dog) Formerly in Paris, Lathuille-Joliot Collection
This was Louis Gauthier-Lathuille's dog (see 271). One day Manet came upon the young man trying to draw the animal. He grabbed the brush, repainted and finished the work and added his signature to it.

273 61×50 1879

Mlle Gauthier-Lathuille (Jeune Fille en Blanc) (Girl in White) Musée des Beaux-Arts, Lyon
Mlle Gauthier-Lathuille, the daughter of the proprietor of the restaurant in 271, has repeatedly said that she never posed for the painting. Therefore we must suppose that the work was taken from a drawing made when the girl was not aware of what was happening, rather than from a photograph.

274 83×67 1879

Autoportrait avec Palette (Self-portrait with Palette) Private Collection, New York
The palette appears on the right and the brush on the left, since Manet had to use a mirror. Miss Coffin-Hanson observes that it would seem strange if one did come upon

him painting when he was dressed in street clothes with his hat on, and it is true that here Manet appears in the guise of a dandy rather than as an artist. For a copy, see 275.

275 ▦ ◉ 94×63 1879 ▤ :
Autoportrait (Self-portrait)
Formerly in Hamburg, Behrens Collection
This is to some extent still in the sketch stage, and was known only to his intimates. Manet does not show himself here as an elegant *boulevardier* as in the previous work (274) but in a somewhat weary and forced attitude. The right leg is not in a natural position (it had been hurting him for several years) ànd the whole weight of the body is on the left one.

276 ▦ ◉ 94,5×74 1879 ▤ :
Portrait de Georges-Benhamin Clémenceau Jeu

277

287

279

de Paume, Louvre, Paris
A Originally it measured 114 cm. × 94 cm. and perhaps was reduced to its present size by Clémenceau himself so that he could frame it when he received it as a gift from Manet's widow in 1883.
B A portrait of the same date exists (oils on canvas, 114 cm. × 94 cm.; Mrs G. K. Tannhauser Collection, New York) in which the clothes and the position of

the subject are similar to the painting in the Louvre, while the podium is much more visible in this one.

277 ▦ ◉ 79×65 1879 ▤ :
Portrait de Jules de Jouy
Private Collection, London
This portrays the painter's cousin, a lawyer who owned a house and land at Gennevilliers. De Jouy kept the portrait until his death in the house where Manet had so often been his guest. Manet asked De Jouy to be his executor.

278 ▦ ◉ 55×46 1879 ▤ :
Portrait de Georges Moore
Paul Mellon Collection, Upperville, Virginia
A See 251 and *Apollo Magazine*, June 1966.
B There exists a pastel of the same date of the head and shoulders alone, slightly turned

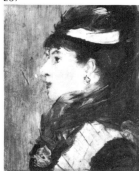

288

to the left (55 cm. × 33·5 cm.; signed; [H. O. Havemeyer] Metropolitan Museum, New York) which the sitter used in his autobiography.

279 ▦ ◉ 82×66 1879 ▤ :
Jeune Femme en Rose (Anita Mauri) (Young Woman in Pink)
Tannhauser Property, formerly in Berlin/Lucerne

Antoine Proust accompanied the young Spanish dancer Anita Mauri, his friend who was working at the Opéra, to Manet's studio. Because of her theatrical commitments the sittings were few and the portrait was not altogether completed. The various other dates put forward for the painting – 1875–7 (D), 1876 (M–G), 1877 (J–W) – seem to be belied by the fact that in those years Anita was still unknown.

280 ▦ ◉ 91×71 1879 ▤ :
Femma à l'Epingle d'Or (Isabelle Lemonnier) (The Woman with the Golden Pin) Private Collection, Geneva
Tabarant states that this is in the Rijksmuseum in Amsterdam, but this information is wrong. The sitter, who belonged to one of the families of great jewellers in Paris on the Boulevard des Italiens, was one of Manet's favorite models during these years (see also 281–285).

281 ▦ ◉ 96,5×63,5 1879 ▤ :
Jeune Fille à la Cravate Blanche (Isabelle Lemonnier) (Girl with a White Scarf) Ny Carlsberg Glyptothek, Copenhagen

282 ▦ ◉ 101×81 1879 ▤ :
Isabelle Lemonnier le Chapeau à la Main (Isabelle Lemonnier holding her Hat) Formerly at Weimar,

283 ▦ ◉ 81,5×74 1879 ▤ :
Isabelle Lemonnier au Manchon (Portrait de Femme) Isabelle Lemonnier with a Muff (Portrait of a Woman)
Antonio Santamarina Collection, Buenos Aires

284 ▦ ◉ 101×81 1879 ▤ :
Isabelle Lemonnier en Robe de Soirée (Jeune Femme en Robe de Bal) Isabelle Lemonnier in Evening Dress (Young Woman in Ball Gown)
Private Collection, Paris

285 ▦ ◉ 32,5×41 1879 ▤ :
Isabelle Lemonnier Assise (Isabelle Lemonnier, seated)
F. Coxe Wright Collection, Philadelphia

286 ▦ ◉ 196×116 1879 ▤ :
Portrait d'Armand Brun
Bridgestone Gallery, Tokyo
The subject was a friend of

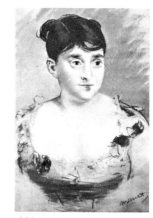

286

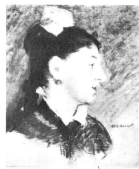

292A

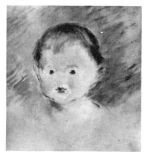

289

290

Emilie Ambre (see 301). The painting may have been done at Bellevue. Degas was one of the many people who have owned it.

287 ▦ ◉ 65×47 1879 ▤ :
Jeune Fille à Mi-Corps (Half-length Portrait of a Girl)
Art Institute, Chicago
Originally the dimensions were 65 cm. × 81 cm. The present

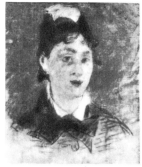

291

292B

ones were obtained by cutting off the two unpainted side edges of the canvas. The oils, which are diluted, are laid on with such complete freedom as to make the coloring almost like that of a watercolor. The model has not been identified.

288 ▦ ◉ 14×12 1879 ▤ :
Tête de Femme (Woman's Head) (C. S. Carstairs)
National Gallery, Washington

289 ▦ ◉ 36×33 1879 ▤ :
Tête d'Enfant (Julie Manet) (Child's Head)
Formerly thought (T) to have been a pastel. The subject, the daughter of Berthe Morisot and Eugène Manet, shown here at the age of fifteen months, was to become the wife of Ernest Rouart.

290 ▦ ◉ 56×46 1879 ▤ :
Espagnole à la Mantille (Spanish Woman with a Mantilla) Formerly at Nancy, Meixmoron de Dombasle Collection
The identity of the model is unknown. She was possibly a Spanish woman passing through Paris (T). According to Jamot and Wildenstein, this was Eva Gonzalès (see 133, 139 etc) but a comparison of the portraits would seem to rule out this hypothesis.

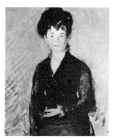

280

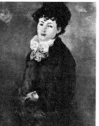

281

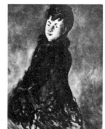

282

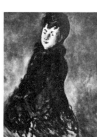

283

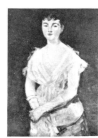

284

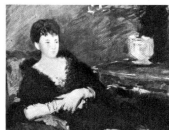

285

304

305

306

307

291 ⊞ ⊗ 55×35 1879 **291**
Portrait de Mme du Paty (Portrait of Mme du Paty)
Formerly in USA, Mrs H. Payne-Whitney Collection

292 ⊞ ⊗ 48×39 1879
Profil de Femme (Woman's Profile) Private Collection, Paris
A The model has not been identified. This picture is omitted by Duret, but later scholars have agreed on its authenticity.

B The same person posed for another pastel (46·5 cm. × 38·5 cm.; in the 1884 sale, present whereabouts unknown) where she is shown full face with an ornament in her hair similar to that seen in the previous work.

293 ⊞ ⊗ 55×35,5 1879
Portrait de Louise Valtesse de la Bigne (Portrait of Louise Valtesse de la Bigne) Metropolitan Museum, New York
The beauty and wit of this *galante demoiselle*, an 'opera singer', led to her becoming the Comtesse de la Bigne. Manet offered to paint a portrait of her, and, when it was finished, the Valtesses wrote him a letter full of enthusiasm, not only because the painter had 'flattered' his sitter, but also because she was proud to have posed for an artist such as he.

294 ⊞ ⊗ 54×45 1879
Jeune Fille à la Rose (Isabelle Lemonnier) (Girl with a Rose) (H. O. Havemeyer) Metropolitan Museum, New York See also 280.

295 ⊞ ⊗ 56×46 1879?
Femme en Manteau de Fourrure (Au Théâtre) Woman in a Fur Coat (At the Theater) Private Collection, New York
Wrongly held to be a portrait of Méry Laurent. For a similar theme, see 329.

296 ⊞ ⊗ 55×34 1879
Portrait de Constantin Guys (Un Vieillard) Portrait of Constantin Guys (An Old Man) (H. O. Havemeyer) Shelburne Museum, Shelburne, Vermont
Guys was a very sprightly seventy-four year-old when this portrait was painted. As Miss Coffin-Hanson observes, the color is laid directly on the canvas.

297 ⊞ ⊗ 54×45,7 1879
Portrait de Louis Gauthier-Lathuille (Portrait of Louis Gauthier-Lathuille) M. Heyman Collection, New York
For the sitter, see 271.

298 ⊞ ⊗ 56×46 1879
Tricot (Knitting) Private Collection, Paris
Executed during the stay at Bellevue. Gauguin is recorded as being one of the various owners of the painting.

299 ⊞ ⊗ 27×11 1879
Toréador Formerly in Paris, A. Vollard Collection
Emile Bergerat organized a display in the gallery *Vie Moderne* of tambourines painted by noted artists in aid of the flood victims in the Spanish city of Murcia. Manet was among those who participated.

On the parchment of one of them, shaped into a rectangle, he took up once more the motif which he had already used more than ten years before (102). Similar works are also known which were made – it would seem – for Bergerat (with Spanish dancers and similar themes), for the dancer-guitarist, Pagans, (with the purchaser shown dancing with a Spanish woman) and for A. Proust (one with a Spanish woman, a second with a *chanteuse* and musicians). However, it is true that although these references seem somewhat dubious, the works connected with them reveal a quality not unworthy of the master.

300 ⊞ ⊗ 55,5×46 1879*
Portrait de Mme Zola (Portrait of Mme Zola) Jeu de Paume, Louvre, Paris

301 ⊞ ⊗ 91,5×73,5 1879-80
Portrait d'Emilie Ambre comme Carmen (Portrait of Emilie Ambre as Carmen) (E. Scott) Museum of Art, Philadelphia

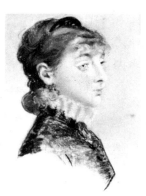
293

294

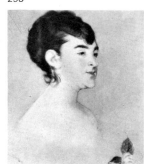
295

297

299

296

298

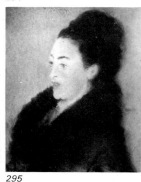
300 (Plate LI)

301

302

303

Begun during Manet's stay at Bellevue and completed in the following year at the same place.

302 ⊞ ◓ 53×34 1879-80 ▤ ⦂
Portrait de Marie Colombier (Portrait of Marie Colombier) (Burrell) Art Gallery, Glasgow

303 ⊞ ◓ 129,5×96 1880 ▤ ⦂
Portrait d'Antonin Proust (Portrait of Antonin Proust) (Edward Drummond Libbey) Museum of Art, Toledo, Ohio
This bears the dedication *A mon ami Antonin Proust, 1880, Manet* ('To my friend Antonin Proust, 1880, Manet'). It was prepared from various drawings dating from the last months of 1879 and, in the January of 1880, Manet set resolutely to work. It was submitted to the 1880 Salon.

304 ⊞ ◓ 151×115 1880 ▤ ⦂
Jeune Fille au Seuil du Jardin de Bellevue (Marguerite) (Girl going into the Garden at Bellevue) Private Collection, Paris
The girl was the sister of Mme Guillemet.

305 ⊞ ◓ 92×70 1880 ▤ ⦂
Jeune Fille au Milieu du Jardin de Bellevue (Marguerite) (Girl in the Middle of the Garden at Bellevue) Bührle Collection, Zurich
The girl (see 304) is seen once again, dressed in the same clothes as in the previous painting.

306 ⊞ ◓ 65×77 1880 ▤ ⦂
Jeune Fille dans le Jardin de Bellevue (Marguerite) (Girl in the Garden at Bellevue) Howard B. White Collection, USA
The girl and the setting (see 304) are beautifully rendered, in impressionistic style.

307 ⊞ ◓ 61×51 1880 ▤ ⦂
Jeune Fille et Enfant dans le Jardin de Bellevue (Marguerite) (Girl and Child in the Garden at Bellevue) Formerly in Paris, A. Vollard Collection
A rapid sketch accepted by Tabarant (1931 and 1947) with incorrect dimensions (65 cm. × 51 cm.) and with the above-mentioned dating. Jamot and Wildenstein assign it to the less likely year of 1879.

308

309

311A

311B

308 ⊞ ◓ 151×116 1880 ▤ ⦂
Jeune Femme dans la Verdure (Young Woman among the Plants) Private Collection, New York

309 ⊞ ◓ 86,5×66 1880 ▤ ⦂
Mme Edouard Manet dans le Jardin de Bellevue (Manet's Wife in the Garden at Bellevue) V. Horowitz Collection, New York

310 ⊞ ◓ 82×65 1880 ▤ ⦂
La Mère de Manet dans le Jardin de Bellevue (Manet's Mother in the Garden at Bellevue) Private Collection, Paris
Believed by Duret to have been a portrait of Berthe Morisot.

311 ⊞ ◓ 74×61 1880 ▤ ⦂
Fillette sur un Banc (Young Girl on a Bench) A. L. Hillman Collection, New York
A The subject, a friend of Emilie Ambre, posed in the singer's garden (see 304). The green background is only briefly indicated, as are the head and figure of the girl, but the painting is complete, and Manet has captured the character of his young model without drawing in the outlines and without the emphasis given by definite passages of brush-work, thus allowing the back-

312

ground of the canvas to appear in several places (C–H). B Another portrait of the young sitter exists (oils on canvas, 60·5 cm. × 50·5 cm.; Barnes Foundation, Merion, Pennsylvania) where she is seen in a similar pose, though the bench on which she is sitting is not visible. The signature ('E. Manet') was placed on it by the painter's widow.

312 ⊞ ◓ 33×25 1880 ▤ ⦂
Jeune Fille Assise (Profil de Jeune Fille) Seated Girl (Profile of a Girl) Private Collection, Paris
Portrait of the young actress Ellen Andrée, daughter of the painter Edmond. Vouched for by Manet's widow.

313 ⊞ ◓ 97×60 1880 ▤ ⦂
Arrosoir (Watering-can) Hirschland Collection, New York
The watering-can is placed in a setting of trees, perhaps in the garden at Bellevue (see 304).

314 ⊞ ◓ 54×65 1880 ▤ ⦂
Jardin de Bellevue (The Garden at Bellevue) Private Collection, Paris
This painting is omitted by Duret, but is referred to in Berthe Morisot's notebook: 'A little landscape of the garden at Bellevue in 1880 (see 304). Sold at the Magasins du Louvre, or rather exchanged for a Turkish carpet; was re-sold to my husband during the Beaux-Arts exhibition.'

315 ⊞ ◓ 81×65,5 1880 ▤ ⦂
Arbres et Banc dans le Jardin de Bellevue (Trees and a Bench in the Garden at Bellevue)
Tabarant maintains, that the surrounding wall in the background of the view is the one at Bellevue (see 304).

316 ⊞ ◓ 46×55 1880 ▤ ⦂
Asperges (Bundle of Asparagus) Kunstgewerbemuseum, Cologne
This is a still-life acquired by Charles Ephrussi, who, instead of paying 800 francs, as agreed, raised the price to 1,000 francs (see 317).
Another similar oil-painting (Private Collection, Paris), accepted by previous cataloguers, has rightly been rejected as spurious by Tabarant.

317 ⊞ ◓ 16,5×21,5 1880 ▤ ⦂
Nature Morte, Asperge (Still-life, Asparagus Stem) Jeu de Paume, Louvre, Paris
Manet, amused by Ephrussi's action with regard to the previous work (see 316), painted the present picture shortly afterwards and sent it to Ephrussi with a note: 'There was one missing from your bundle.' It should be considered as among the finest still-lifes painted by Manet,

318 ⊞ ◓ 46,5×56,5 1880 ▤ ⦂
Nature Morte, Melon (Still-life, Melon) Paul Mellon Collection, Upperville, Virginia
Sold by Manet to the 'hunter' Pertuiset (see 341).
A version exists of it with the

melon upright on a white cloth (32·7 cm. × 44 cm.; National Gallery, Melbourne) which some scholars (J–W; T 1947) rightly consider spurious. In 1914 it was authenticated by Duret, but he did not mention it in the editions of his book. It was shown at the exhibition in Chicago and Philadelphia in 1966–7 and was ascribed to approximately 1868.

319 ⊞ ◓ 29,5×40,5 1880 ▤ ⦂
Nature Morte, Pêches (Still-life, Peaches) Mrs Charles Dewey, Jr. Collection, USA

320 ⊞ ◓ 32×42 1880 ▤ ⦂
Nature Morte, Jambon (Still-life, Ham) (Burrell) Art Gallery, Glasgow
Once belonged to Pertuiset (see 341) and, later, to Degas. It received enthusiastic approbation when in 1929 it was shown in the Gallerie Etienne Bignou in Paris.

321 ⊞ ◓ 35×46 1880 ▤ ⦂
Corbeille de Poires (Basket of Pears) Ordrupgaardsamlingen,

316

317

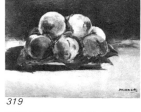
318

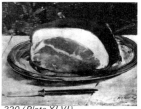
319

313

314

315

320 (Plate XLVI)

113

321A

321B

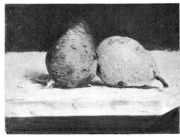

322

323

324

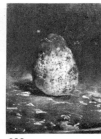

325

Copenhagen
A Estimated at 50 francs in the inventory drawn up after the painter's death.
B Another oil-painting, with a similar composition, but with a foreshortened view of a garden in the background (49 cm. × 45 cm.; whereabouts unknown) was bought for 100 francs by Vollard in 1894. Rejected by Duret.

322 ⊞ ◐ 17×24 1880

Nature Morte, Deux Poires (Still-life, Two Pears) Private Collection, Zurich

323 ⊞ ◐ 22×16 1880

Nature Morte, Poire (Still-life, Pear) Private Collection, Zurich
Bought by Degas at the sale of the Pertuiset Collection (see 341).

324 ⊞ ◐ 1880

Nature Morte, Grappe de Raisins (Still-life, Bunch of Grapes)

325 ⊞ ◐ 14×22 1880

Nature Morte, Citron (Still-life, Lemon) Jeu de Paume, Louvre, Paris
This is the same painting which the catalogue of the Gérard sale (1905, Paris; 500 francs) listed as *Un citron sur une assiette de faïence* (Lemon on a Faience Plate).

326 ⊞ ◐ 55,5×35 1880

Portrait du Docteur Materne Jeu de Paume, Louvre, Paris
The subject, formerly doctor to Prince Napoléon, took care of Manet at Bellevue.

327 ⊞ ◐ 93×70 1880

Promenade (Mme Gamby) Walking (in the Garden at Bellevue?) Paul Mellon Collection, Upperville, Virginia

328 ⊞ ◐ 93×74,5 1880

Chanteuse du Café-Concert (Singer in a Café-Concert) Private Collection, Paris

328A (Plate XLIX)

328B

A Painted in the autumn at the *Folies-Bergère* or at an open-air *café-concert*.
B A detail of the *chanteuse* was taken up again in a smaller canvas (53 cm. × 35 cm.; signed; Mrs Mark C. Steinberg Collection, Saint Louis).

329 ⊞ ◐ 57×45 1880?

Femme en Manteau de Fourrure, de Face (Portrait de Marie Colombier [?]) Woman in a Fur Coat, Full-face (Portrait of Marie Colombier [?]) Formerly in Adolph Lewisohn Collection, New York
This would appear to be the same model as for 295. It would seem to be identical with the painting offered in 1881 by the painter in the sale organized on behalf of the mistress of Duranty, who died in April 1880.

330 ⊞ ◐ 55×35 1880

Portrait de Mme Clémenceau (Portrait of Mme Clémenceau)

331 ⊞ ◐ 55×35 1880

Portrait de Mme Guillemet (Portrait of Mme Guillemet) City Art Museum, Saint Louis

332 ⊞ ◐ 46,5×55,5 1880

Mme Loubens Assise (Mme Loubens, seated)
The lady, already portrayed in 32, is sitting on the red divan in Manet's atelier. An annotation by Léon Koëlla informs us: *Pastel fait en une heure* (Pastel done in an hour). It was presented as a gift to the sitter by Manet's widow.

333 ⊞ ◐ 46×56 1880

Mme Loubens au Lit (La Convalescente; Femme Couchée) Mme Loubens in Bed (The Convalescent; Woman lying down) Formerly in T. A. Scott Collection, Philadelphia
Manet painted the portrait of his old friend (see 332) when she was ill in bed.

334 ⊞ ◐ 60,5×50,5 1880

Femme à l'Ombrelle (Woman with a Sunshade)

335 ⊞ ◐ 53,5×46,5 1880

Buste nu de Jeune Femme (Portrait de Mme Jacob) (Nude) Jeu de Paume, Louvre, Paris
The beautiful wife of the art expert appears in perfect *décolleté* just veiled in a light garment.

336 ⊞ ◐ 56×46 1880

Fillette au Grand Chapeau (Le Chapeau Jaune) Little Girl in a Large Hat (The Yellow Hat) Private Collection, New York

337 ⊞ ◐ 55×35 1880

Portrait de Jean de Cabanes, dit Cabaner (Portrait of Jean de Cabanes, called Cabaner) Jeu de Paume, Louvre, Paris
The subject was an eccentric musician who often went to the *Guerbois* and the *Nouvelle-Athènes*.

338 ⊞ ◐ 55×35 1880

Portrait d'Emmanuel Chabrier Ordrupgaardsamlingen,

329

327

330

331

326

337

338

339

Copenhagen
The composer portrayed here was Manet's close friend until the last.

339 ⊞ ◐ 54×34 1880

Homme Blond (Fair Man) Fogg Art Museum, Cambridge, Massachusetts

340 ⊞ ◐ 56×46 1880-81

Portrait de Léontine Massin (Portrait of Léontine Massin) Formerly in Charles Oulmont Collection, Paris
The sitter, a beautiful woman but a mediocre actress, posed between the end of 1880 and the January of 1881.

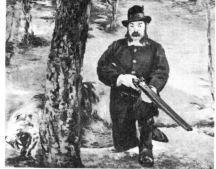

341 (Plate LVI)

344

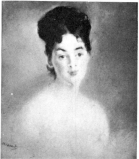

335 (Plate L)

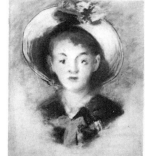

336

340

341 ⊞ ◑ 150×170 1880-81 ▤ ⦂

Pertuiset, Chasseur de Lions (Pertuiset, Lion-hunter) Museu de Arte, São Paolo
For some time Manet had wanted to paint a portrait of Pertuiset, an odd fellow who was an explorer, hunter and, in his leisure time, a painter. In November 1880 Manet was able to start the painting, but it was not completed until the February of 1881 because of various delays and Pertuiset's commitments. The hunter is seen

in a far from exotic setting – in fact in the garden of his own house, at 14 Passage de l'Elysée-des-Beaux-Arts (Montmartre). The sittings for the figure work, however, took place in Manet's studio. The painting was submitted to the 1881 Salon where it did not receive very favorable criticism, but where it eventually won Manet the Salon medal for second place and with this the right to exhibit *hors concours* at any future Salon, thus by-passing the judgment of the hanging committee.

342 ⊞ ◑ 80×73 1881* ▤ ⦂

L'Evasion de Rochefort (The Escape of Rochefort) Mrs F. J. Gould Collection, Cannes
A Marquis Henri de Rochefort-Luçay, who had earlier opposed Napoléon III and who was also against the Commune, had been exiled in 1874 to New Caledonia. He escaped with some companions, and a boat took them offshore. From there they were picked up by an English schooner and were able to reach the United States. Finally they returned to Paris after the amnesty of 21 July 1880. Manet kept himself fully appraised of the circumstances of the flight from the island, intending to send a painting to the Salon.
B The same theme suggested an oil-painting of the same name (146 cm. x 116 cm.; Kunsthaus, Zurich) in which the boat is seen from not so far away and the English schooner is more clearly defined. It has been considered (J–W ; T 1947) as a preliminary study for the preceding canvas. The man at the prow may be Rochefort (T) or, more probably, Olivier Pain (C–H).
C Another oils on canvas of the same date (50 cm. x 48 cm.; with signature put on by Manet's widow ; Crocker Collection, San Francisco) in fact shows in sketch form the figure of Pain at the prow of the same boat.
D A study is known of the above-mentioned figure (oils

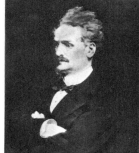

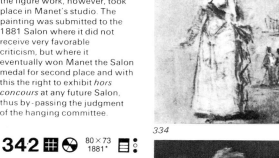

334

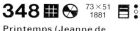

343 (Plate LVIII)

on canvas ; 41 cm. x 33 cm. ; with false signature; formerly in the Vitta Collection, Paris) which shows merely the head and shoulders. Given to Manet by A. Proust.

343 ⊞ ◑ 81,5×66,5 1881 ▤ ⦂

Portrait d'Henri Rochefort (Portrait of Henri Rochefort) Kunsthalle, Hamburg
Rochefort (see 342) posed on very few occasions for this portrait which succeeds in capturing the unruly hair and the highly-strung aristocratic face (C–H). Manet wanted to give it to him but the sitter refused, saying that it had been an honor to sit for an artist of such fame (actually Rochefort was somewhat mystified by the painting of Manet and the Impressionists). It was shown at the 1881 Salon and sold by Manet to the baritone Faure.

344 ⊞ ◑ 36×45 1881 ▤ ⦂

Suicide Bührle Collection, Zurich
The unusual theme which, according to Tabarant, was only 'a sort of artistic pot-boiler', was painted by Manet for the show-cum-sale in aid of Cabaner (see 337), who had been sent to a sanatorium. Duret, as well as Jamot and Wildenstein, date t between 1875 and 1877.

345 ⊞ ◑ 55×45 1881 ▤ ⦂

Portrait de Jeanne Martin (Jeanne Martin au Chapeau Capote) Portrait of Jeanne Martin (Jeanne Martin in a Bonnet) Formerly in Berlin, owned by Tannhauser
The subject, a vivacious frienc of Forain, was a regular model for Manet for some time.

346 ⊞ ◑ 54×44 1881 ▤ ⦂

Portrait de Jeanne Martin au Chapeau orné d'une Rose (Portrait of Jeanne Martin in a Hat with a Rose) Formerly in the Vogal Collection, USA
Executed a few days after the previous one (345), it appears more detailed. The features are more accentuated and great importance is given to the hat and the quiff of black hair on the forehead.

347 ⊞ ◑ 91×72 1881 ▤ ⦂

Dame en Rose (Jeanne Martin) (Woman in Pink) Gemäldegalerie, Dresden
This would seem to be the last of the portraits of Mlle Martin (see 345)

348 ⊞ ◑ 73×51 1881 ▤ ⦂

Printemps (Jeanne de Marsy) (Spring) H. Payne Bingham Collection, New York
Throughout the year Manet had had in mind the idea of portraying the seasons by using four beautiful female figures and he may have been decided in this (R) by the fact that the painter Alfred Stevens had carried out a similar commission for the king of the Belgians. However, only half the project was ever realized (see also 372), since Summer and Winter were never painted. The model for this work was a young actress, Jeanne de Marsy. Manet chose her clothes and also advised her in the purchase of a hat (A. Proust). Manet threw himself enthusiastically into this work and the result was magnificent. It was presented at the 1882 Salon and received an unprecedented enthusiastic reception. Even Wolff wrote (F 1882) that 'the young woman walking in a spring landscape gives an enchanting impression'. A. Silvestre for his part (VM 1882) noted 'His figure of Jeanne has the charm of the most attractive Japanese pictures with an altogether intoxicating Parisian flavor'.

332

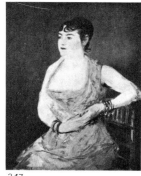

333

345

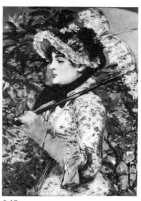

346

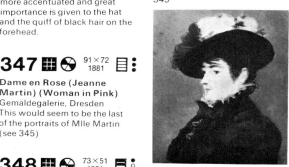

347

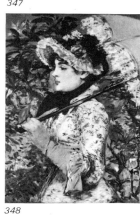

348

342A

342B

342C

115

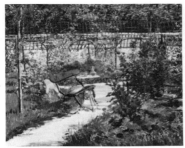

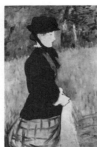

349

349 ⊞ ◔ 87×105 1881 ▤ :
Banc (The Garden Seat)
Mrs John Barry Ryan Collection,
New York
This is a corner of the garden of
the villa at Versailles which was
rented by the Manets for the
summer of 1881. Manet's illness
was making it more and more
difficult for the painter to move
about and he wrote to Mlle
Gonzalès: 'Went away to make
some studies in the garden
designed by Lenôtre, but had to
make do with simply painting
my own garden, a most
frightful one.'

350 ⊞ ◔ 110×72 1881? ▤ :
**Femme se Promenant dans
le Jardin (Woman walking in
the Garden)** Barnes Foun-
dation, Merion, Pennsylvania
The date given above is
suggested by a comparison
with a similar watercolor (A.
L. Hillman Collection, New
York) which certainly dates
from 1881. Duret dates this
1875–7 and Jamot and
Wildenstein 1879.

351 ⊞ ◔ 131×79 1881 ▤ :
**Henry Bernstein, Enfant
(Henry Bernstein as a
Child)** Cécile Rothschild
Collection, Paris
Marcel Bernstein often went to
his own villa at Versailles and,
on those occasions, never
missed the chance of visiting
Manet, taking with him his son
Henry who was to become a
famous dramatist. The painter
took a fancy to the little boy with
his scampish ways and was
happy to give the portrait to the
boy's father.

Decorative Works
A series of three still-lifes and a
landscape for which there was
no commission and which
therefore remained in the
atelier until the painter's death.

352 ⊞ ◔ 97,5×60 1881 ▤ :
A Lièvre (Hare) National
Museum of Wales, Cardiff

352 ⊞ ◔ 97×57,5 1881 ▤ :
B Grand-duc (Eagle-owl)
Bührle Collection, Zurich

352 ⊞ ◔ 98×58 1881 ▤ :
**C Liserons et Capucines
(Convolvulus and
Nasturtiums)** Mrs Edgar
Tobin Collection, San Antonio,
Texas

350

352 ⊞ ◔ 97×60 1881 ▤ :
**D Coin de Jardin (Corner of
the Garden)** Formerly in the
M. Liebermann Collection, Berlin

353 ⊞ ◔ 79×99 1881 ▤ :
**Taureau dans un Pré (Bull in
a Meadow)** Private Collection,
London

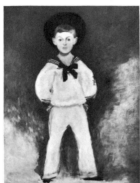

351

353

354

354 ⊞ ◔ 65×45 1881 ▤ :
**Portrait d'Emmanuel
Chabrier (Portrait of
Emmanuel Chabrier)**
(Grenville L. Winthrop) Fogg
Art Museum, Cambridge, Mass.

355 ⊞ ◔ 55×36 1881 ▤ :
**Jeune Fille à la Pèlerine
(Jeanne de Marsy) (Girl in a
Tippet)** Private Collection, Paris
For information see 348.

356 ⊞ ◔ 85×74 1881 ?▤ :
**Modiste (Portrait de Mme
Virot [?]) (Milliner)**
Palace of the Legion of Honor,
San Francisco
The usual French title of *Modiste*
supports the theory that the sitter
was the milliner from whom
Jeanne de Marsy bought
the hat for *Printemps* (348)

357 ⊞ ◔ 96×130 1881 ▤ :
**Le Bar aux Folies- Bergère
(The Bar at the Folies-
Bergère)** Home House
Trustees, London
A This was the last great
composition devoted to the
contemporary scene and is
painted with a freshness and
freedom which is unknown in
the earlier paintings of a similar
kind. One of the two barmaids,
Suzon, went to the studio for
Manet to complete the figure.
On the counter is one of the
finest still-lifes that he ever
painted. Behind Suzon, who is
reflected in it from behind, is a
large mirror, a motif which he
had often tried out earlier. Also
reflected in it are the
customers, among whom
appears Méry Laurent (see 360),
dressed in white, and, beside
her, the painter Gaston
Latouche and, possibly, Henry
Dupray, also a painter. It was
exhibited at the 1882 Salon and
was a tremendous success.
B Perhaps dating from a few
days earlier than the above is a
sketch (oils on canvas, 47 cm.
× 56 cm.; deposited from the
F. F. R. Koenigs Collection,
Gemeentemusea, Amsterdam)
which is a similar composition.
The model is another *serveuse*,
also blonde but less attractive.
The painter Henry Dupray is
standing nearby. The picture has
been 'hideously' violated
(T 1947; R) with repainting.

358 ⊞ ◔ 54×34 1881 ▤ :
**Modèle du 'Bar aux
Folies-Bergère' (Suzon)
(Model from the 'Bar aux
Folies-Bergère')** Musée des
Beaux-Arts, Dijon

352A

352B

352C

352D

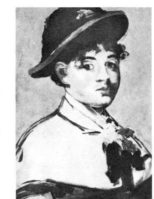

355

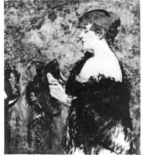

356

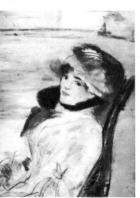

359

This is the *serveuse* who
figures in 357.
Another painting (oils on
canvas, 54 cm. × 38 cm.;
Private Collection, Paris [?])
shows her full-face in a straw
hat. Rightly omitted by Duret
and by Jamot and Wildenstein.

359 ⊞ ◔ 72×50 1881 ▤ :
**Jeune Femme (Jeanne de
Marsy [?]) au bord de la
Mer Young Woman
(Jeanne de Marsy [?]) by
the Sea** Formerly in the M.
Monet Collection, Giverny

358 (Plate LV)

360

361

360 ⊞ ◔ 65×50 1881 ▤ :
**Jeune Femme Accoudée
(Méry Laurent) (Young
Woman with her Head in
her Hand)** Formerly in the
Hecht Collection, Paris
This is the young woman in
white reflected in the mirror in
357, a gay and spirited friend of
artists and poets, including
Mallarmé.

361 ⊞ ◔ 55×46 1881 ▤ :
**Portrait de la Comtesse
'Iza' Kwiatowska Albazzi
(Portrait of the Comtesse
'Iza' Kwiatowska Albazzi)**
Mrs G. K. Thannhauser
Collection, New York

362 ⊞ ◔ 32,5×50,5 1881 ▤ :
**Repos (Femme en Bleu;
Portrait de Mme Guillemet
en Bleu) Resting (Woman in
Blue; Portrait of Mme
Guillemet in Blue)** Private
Collection, Paris
A Over a period of a few days,
Manet made three pastel
portraits of the beautiful and
elegant American wife of Jules

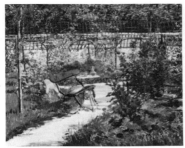

116

363A

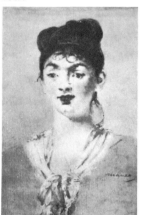

363B

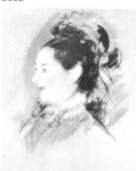

364

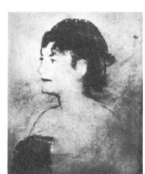

367

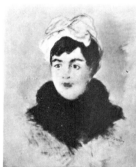

366

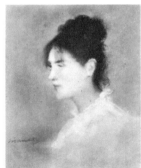

368

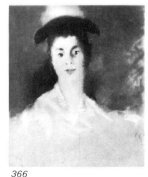

366

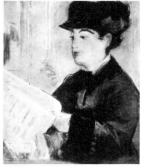

370

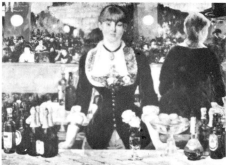

357A (Plates LX-LXI)

357B

362A

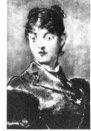

362B

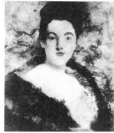

362C

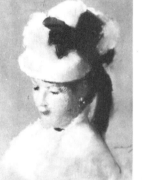

369

371

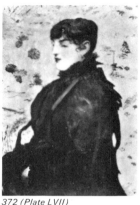

372 (Plate LVII)

373

Guillemet (see 268). Here the lady's face stands out in rich contrast with the blue dress (which gives the better-known title to the painting) and the black-gloved hands.
B The first of the other two pastels, which almost certainly preceded the above, seems to be the one known also as *La Parisienne* (56 cm. × 36 cm., Ordrupgaardsamlingen, Copenhagen).
C The other pastel — although the identification of the sitter is certain — has oddly become known as *L'Inconnue* (The unknown Woman) (53 cm. × 44 cm., Kunsthistorisches Museum, Vienna).

363 ▦ ✪ 53×45 1881 ▤ ⦂
Suzette Lemaire, de Profil (Suzette Lemaire, Profile) Mrs Watson Webb Collection, Vermont
A Madeleine Lemaire, who was thirty-six at the time, was brought to Manet's studio with her daughter Suzette, by her friend and admirer Charles Ephrussi so that the girl could pose for her portrait. Manet did two pastels of her. This one pleased Mme Lemaire very much and she wrote an enthusiastic letter to the painter to thank him.
B The second pastel (53 cm. × 33 cm.; signed; Private

Collection, London) shows Suzette Lemaire full face.

364 ▦ ✪ 61×51 1881 ▤ ⦂
Femme au Chapeau à Brides (Woman with a Hat tied with Strings) (Cone) Museum of Art, Baltimore
According to the photograph by Lochard, the subject was Jeanne Martin but, by comparison with the known portraits of her (345–7), this would seem to be unlikely.

365 ▦ ✪ 55×46 1881 ▤ ⦂
Tête de Femme (Femme au Noeud Bleu; Parisienne) Head of a Woman (Woman with a Blue Bow; Parisienne) Lazarus Phillips Collection, Montreal
The last two titles derive from its being incorrectly confused with the portrait of Mme Guillemet (362). According to Jamot and Wildenstein this is a portrait of Mme Monchot.

366 ▦ ✪ 61×50 1881 ▤ ⦂
Tête de Femme (Femme au Chapeau Garni de Gaze) Head of a Woman (Woman with a Hat trimmed with Veiling) Formerly in the G. Menier Collection, Paris

367 ▦ ✪ 56×46,5 1881 ▤ ⦂
Jeune Femme Décolletée (Young Woman en décolleté)

368 ▦ ✪ 53×44 1881 ▤ ⦂
Tête de Jeune Fille (Ouvrière) Head of a Girl (Servant) Museum of Fine Arts, Montreal
This portrays a seamstress who went daily to Mlle Laurent's (360). Manet painted this in the latter's house and gave it to her. Because of its second title it is sometimes confused with 383.

369 ▦ ✪ 56×46 1881 ▤ ⦂
Jeune Femme au Chapeau Blanc (Young Woman in a White Hat) D'Albis Collection, Limoges

370 ▦ ✪ 55×46 1881 ▤ ⦂
Liseuse à la Brasserie Nouvelle-Athènes (Woman

reading at the Nouvelle-Athènes) Formerly in the Tanner Collection, Berlin. Similar in subject matter to 261, but the fashion of the woman's clothing, in the masculine styles of 1881, confirms the dating given above.

371 ▦ ✪ 32×45 1881 ▤ ⦂
Café, Place du Théâtre Français (Intérieur de Café) (Café in the Place du Théâtre Français) (Café Interior) (Burrell) Art Gallery, Glasgow

372 ▦ ✪ 73×51 1881 ▤ ⦂
Automne (Méry Laurent) (Autumn) Musée des Beaux-Arts, Nancy
This is the second representation in the cycle of the seasons which was begun with *Printemps* (348). The beautiful Méry Laurent (see 360), although only thirty years old, did not mind being 'associated with the age of dead leaves' (T). So the sad season was happily and opulently portrayed, vividly set against a background of floral wallpaper.

373 ▦ ✪ 23×31 1881? ▤ ⦂
Coin de Jardin (Corner of a Garden) Formerly in the Max Liebermann Collection, Berlin
Identified by Jamot and Wildenstein as a corner of the garden at Rueil (see 391) where Manet spent the summer of 1882.

374 ▦ ✪ 33×25 1882? ▤ ⦂
Nature Morte, Bocal de Condiments (Still-life, Pickle-jar) Formerly in Paris, owned by Bernheim-Jeune
The stylistic quality seems to take us back to 1880. This is upheld by Tabarant who, however, did not definitely rule out the attribution to 1882 which was given by Duret and others.

375 ▦ ✪ 56×46,5 1882 ▤ ⦂
Méry Laurent au Carlin (Méry Laurent with a Pug-dog) Formerly in the De Hatvany Collection, Budapest

376 ▦ ✪ 56×35,5 1882 ▤ ⦂
Méry Laurent à la Voilette (Femme à la Voilette) Méry Laurent with a Veil (Woman with a Veil) Mrs Albert D. Lasker Collection, New York

117

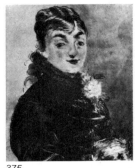

375

376

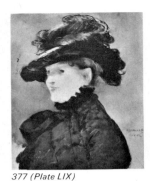

377 (Plate LIX)

378

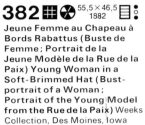

379

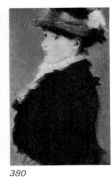

380

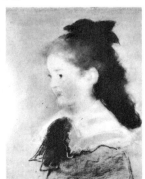

374

377 ⊞ ✪ 54×44 1882 ▤ ⦂

Méry Laurent au Chapeau Noir (Méry Laurent in a Black Hat) Musée des Beaux-Arts, Dijon

378 ⊞ ✪ 54×34 1882 ▤ ⦂

Méry Laurent au Chapeau de Loutre (Méry Laurent in a Sealskin Hat) (H. Ittleson Jr.) Metropolitan Museum, New York

379 ⊞ ✪ 54×34 1882 ▤ ⦂

Méry Laurent au Petit Chapeau (Méry Laurent in a Small Hat) Clark Art Institute, Williamstown, Mass.

380 ⊞ ✪ 54×34 1882 ▤ ⦂

Méry Laurent au Chapeau Garni de Fleurs (Buste de Femme; Femme au Chapeau garni d'une Plume Grise) Méry Laurent in a Flowered Hat (Bust-portrait of a Woman; Woman in a Hat with a Gray Feather) Formerly in the Montgomery Sears Collection, New York

381 ⊞ ✪ 41×37 1882 ▤ ⦂

Tête de Jeune Fille, de Profil (Méry Laurent [?]) (Head of a Girl, Profile) Museum of Fine Arts, Montreal

382 ⊞ ✪ 55,5×46,5 1882 ▤ ⦂

Jeune Femme au Chapeau à Bords Rabattus (Buste de Femme; Portrait de la Jeune Modèle de la Rue de la Paix) Young Woman in a Soft-Brimmed Hat (Bust-portrait of a Woman; Portrait of the Young Model from the Rue de la Paix) Weeks Collection, Des Moines, Iowa

383 ⊞ ✪ 56×35,5 1882 ▤ ⦂

Ouvrière (Servant) Formerly in the Henry Ittleson Collection, New York

384 ⊞ ✪ 50,8×44,2 1882? ▤ ⦂

Tête de Femme au Chapeau Noir (Head of a Woman in a Black Hat) L. M. Rogers Collection, New York

385 ⊞ ✪ 57×36,5 1882 ▤ ⦂

Irma Brunner à la Voilette (Irma Brunner with a Veil) Bührle Collection, Zurich Irma Brunner, known in Paris by the nickname of *La Viennoise*, was a friend of Méry Laurent (see also 386).

386 ⊞ ✪ 55,5×46 1882 ▤ ⦂

La Viennoise (Dame au Chapeau Noir; Irma Brunner) The Viennese (Lady in a Black Hat) Jeu de Paume, Louvre, Paris This is one of Manet's most famous pastels, although it was only catalogued by Duret in the later edition of his book. In various catalogues the surname of the model (see 385) is wrongly given as 'Blumer'.

387 ⊞ ✪ 74,5×51 1882 ▤ ⦂

Portrait de Mme Lévy (Portrait of Mme Lévy) (Chester Dale) National Gallery of Art, Washington A In June Mme Lévy wrote to Manet asking him to paint her portrait. He actually did two, this one and another pastel (see below). The lady chose the first. B The other (65 cm. × 54 cm.; marked with the seal of the atelier), formerly in the C. S. Carstairs Collection in London.

388 ⊞ ✪ 56×35 1882 ▤ ⦂

Buste de Jeune Femme (Jeune Fille Déshabillée) Bust-portrait of a Young Woman (Girl en déshabillé) E. Scott Collection, Villanova, Pasadena, California The model has not been

386 (Plate LXIII)

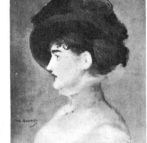

387 (Plate LXIV)

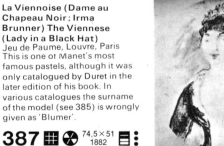

387B

identified. Here, in place of a punctilious severity of line, there is the freedom and elegance which is associated with eighteenth-century French works of the same kind (C–H).

389 ⊞ ✪ 49×39 1882 ▤ ⦂

La Petite Hecht, de Profil (The Little Hecht Girl in Profile) Jeu de Paume, Louvre, Paris A The little girl, who was brought to Manet's studio by her father, a faithful admirer of his, was also portrayed in the two other pastels listed below, which are also in the Louvre. B La Petite Hecht, de Face (The Little Hecht Girl, full-

381

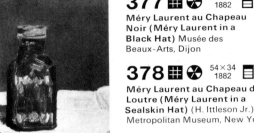

382

384

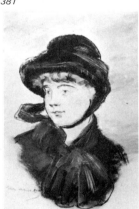

383

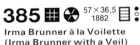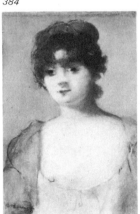

385

388

389A

389B

389C

390

393

out by Tabarant on the basis of comparison with the landscapes of Rueil (391 and others).

391 73×92 1882

Maison de Rueil (The House at Rueil) Staatliche Museen, Berlin

A This is the house which Manet rented from Labiche and where he spent the last summer of his life. It was not very convenient, nor very pleasant, with a small garden in the front, which irritated the artist very much. It is a work of similar quality to those of Monet and Renoir, but '... the brilliance of sunlight, which the Impressionists conjured up ... is lacking'. (R)
B The same theme was repeated in a vertical version (oils on canvas; 92 cm. × 73 cm.; signed and dated; National Art Gallery of Victoria, Melbourne).

392 82×66 1882

Coin du Jardin de Rueil (Allée du Jardin de Rueil) Corner of the Garden at Rueil (Path in the Garden at Rueil) Kunstmuseum, Berne

392A

392C

392B

392D

391A (Plate LXII)

A This is the garden adjoining the house in 391.
B The same theme with little variation is encountered again in another oils on canvas (*Coin du Jardin de Rueil* or *Allée dans le Jardin de Rueil*; 82 cm. × 51 cm.; Musée des Beaux-Arts, Dijon).
C A similar picture is known by the same title (56·5 cm. × 46·5 cm.; Bizot Collection, Lyon)
D Another, similar to 392 C (oils on canvas, 81 cm. × 65·5 cm.).

393 100×81 1882

Sur l'Arrosoir (Julie Manet) (Sitting on the Watering-can) Private Collection, Paris

394 33,5×40,5 1882

Nature Morte, Pêches (Still-life, Peaches) Private Collection, London
Painted in the dining room in the house at Rueil. Manet was by now almost completely immobile, but he became acutely aware of the beauty of the things which he could see around him.
Tabarant recognizes also two similar compositions (23·5 cm. × 34·5 cm.; and 22 cm. × 33·5 cm., with forged signatures) which were justifiably not mentioned by Jamot and Wildenstein and other cataloguers.

395 21×26 1882

Corbeille de Fraises (Basket of Strawberries) Metropolitan Museum, New York

391B

396 38×46 1882

Corbeille de Fruits (Basket of Fruit) Tyson Collection, Philadelphia

397 18,5×24 1882

Nature Morte, Cinq Prunes (Still-life, Five Plums) Formerly owned by Tannhauser in New York

398 17×23 1882

Nature Morte, Trois Pommes (Still-life, Three Apples) Donald S. Stralem Collection, New York
A Bears the dedication: *A mon amie Méry L, Manet*. It was a gift from the artist to Mlle Laurent, who had cheered a lonely day during his stay at Rueil.
B Similar subject (but with four apples; oils on canvas, 18 cm. × 24 cm.; signed) Private Collection, New York (at an earlier date it had been passed from Bernheim-Jeune in Paris to Knoedler in New York and Cassirer of Berlin).

399 21×26 1882

Nature Morte, Pomme (Still-life, Apple) Formerly in the Malherbe Collection

400 19×24 1882

Nature Morte, Quatre Mandarines (ou Pommes ou Grenades) Still-life, Four Mandarin Oranges (or Apples or Pomegranates) Nathan Cummings Collection, Chicago

401

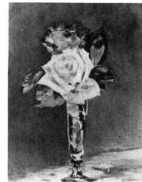
402

403

401 22×40 1882

Nature Morte, Grenade (Still-life, Pomegranate) Formerly owned by Durand-Ruel, Paris

402 31×24 1882

Nature Morte, Roses Rouges dans un Verre à

face) (65 cm. × 35 cm.).
C La Petite Hecht au Chapeau, de Profil (The Little Hecht Girl in a Hat, in Profile) (34 cm. × 44 cm.).

390 46×38 1882?

Arbres (Arbres dans le Jardin de Rueil; Troncs d'arbres) Trees (Trees in the Garden at Rueil; Tree-trunks)
Jamot and Wildenstein date this as early as 1863, but it would seem difficult to see a direct stylistic relationship with the Saint-Ouen landscapes (34 and 59C) or with the *Déjeuner sur l'Herbe* in the Louvre (59A). Besides, the photograph by Lochard bears the annotation: 'Done either at Rueil or at Bellevue'. This latter place was ruled

394

398A

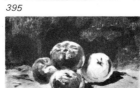
395

398B

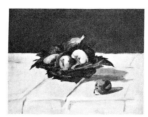
396

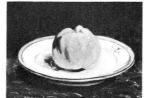
399

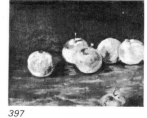
397

400

Champagne (Still-life, Red Roses in a Champagne Glass) (Burrell) Art Gallery, Glasgow

403 ⊞ ◒ 19×24 1882 📇⦂

Nature Morte, Deux Roses (Still-life, Two Roses) W. S. Paley Collection, New York

404 ⊞ ◒ 16×21 1882 📇⦂

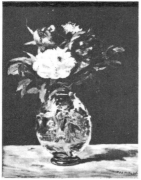
404

Nature Morte, Roses et Pétales (Still-life, Roses and Petals) Formerly owned by Bernheim-Jeune, Paris

405 ⊞ ◒ 58×36 1882 📇⦂

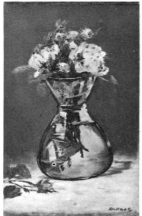
405

Nature Morte, Roses Mousseuses dans un Vase (Still-life, Moss-roses in a Vase) Clark Art Institute, Williamstown, Mass.

406 ⊞ ◒ 55×44 1882 📇⦂

Nature Morte, Bouquet de Pivoines (Still-life, Bunch of Peonies) Private Collection, New York

407 ⊞ ◒ 100×81 1882 📇⦂

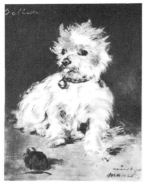
406

Clairon (Bugler) Contareanu Collection, Paris
A sick and weary Manet returned to Paris six months before the opening of the Salon. He had in mind a large military composition which had been suggested to him by the painter Henry Dupray, who sent a model to the atelier, a former infantryman who had been a bugler. Soon, however, Manet tired of the idea and abandoned the sketch. It appeared in the inventory after his death but was not photographed by Lochard. A few years later it was seen in George Moore's collection.

408 ⊞ ◒ 74×52 1882 📇⦂

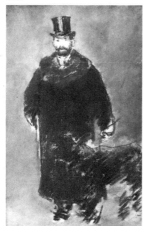
412

Amazone, de Face (Full-face Portrait of a Horse-woman) K. Koerfer Collection, Berne
A The identity of the model is in dispute. According to J. E. Blanche, it was Mlle Henriette Chabot but, from Manet's notes and the annotation by Léon Koëlla on the photograph by Lochard, it would seem to be the daughter of the bookseller in the Rue de Moscou,
B Two oil studies preceded, or accompanied, this painting. One (115 cm. × 90 cm.; Hahnloser Collection, Berne) was ripped from top to bottom by Manet himself. The two parts were found in the atelier after his death and the picture was inventoried as *Amazone déchirée* (Torn Horsewoman).
C The other, which was not finished (73 cm. × 53 cm.; formerly owned by Tannhauser in New York) shows the model seen from the back.

409 ⊞ ◒ 91×75 1882 📇⦂

Femme au Chat (Mme Edouard Manet) (Woman with a Cat) Tate Gallery, London
According to Léon Koëlla, this was painted in the apartment in the Rue de Saint-Pétersbourg. In the color relationships, the pink dress, the red sofa, the black cat with its white mask,

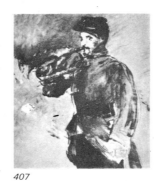

and in the broad brush strokes which go to make up the gown, and which are more broken, especially in the upper part, can be seen once more the artist's ability to use a variety of different techniques and, at the same time, his affectionate penetration of his subject.

410 ⊞ ◒ 54×44 1882? 📇⦂

Portrait de Claire Campbell Museum of Art, Cleveland
The sitter was the daughter of the editor of the London *Daily Telegraph*. Tabarant assigns it to 1875, but the dating given above, which has been confirmed by Jamot and Wildenstein, would seem more likely.

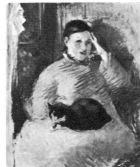
407

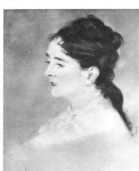
409

411 ⊞ ◒ 55×35 1882 o '83 📇⦂

Roses et Lilas dans un Vase (Roses and Lilacs in a Vase) E. C. Vogel Collection, New York
A One of the many flower-paintings executed by Manet in the last period of his working life and for which a definite dating is often difficult to establish.
B A similar motif, but the vase has feet instead of a square base as in the previous work (oil on canvas; 32 cm. × 24·5 cm.; signed; Private Collection, USA).
C The vase from 411A reappears, but with different flowers, in another oil on canvas (54 cm. × 34·5 cm.; with the atelier mark; O. Reinhart Collection, Winterthur).
D The container in 411B is seen again, with lilacs, in another oil on canvas (27 cm. × 21·5 cm.; signed; Private Collection, USA).
E One white lilac bloom in the base from 411A (oil on canvas; 55 cm. × 34 cm.; signed; Private Collection, Paris).
F The same vase, with roses and tulips, appears in another oil (on canvas; 54 cm. × 33 cm.; signed; Bührle Collection, Zurich).
G The same container, with roses, tulips and lilacs, is in another oil on canvas (32 cm. × 25 cm.; signed; Private Collection, New York). Sometimes (J–W etc) dated 1880.
H The container from 411B. with different flowers, is found again in another oil on canvas; 32 cm. × 25 cm.; Mrs Mellon Bruce Collection, USA). It seems that this was given by Manet to a lady as a New Year present in 1883 (J–W). Omitted by Duret.

410

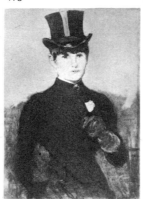
415

414A

414B

414C

416

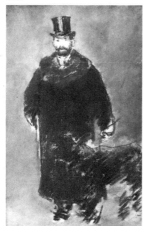
413

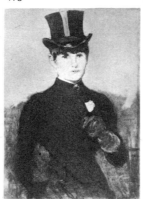
408A

408B

408C

I20

412 ⊞ ◕ 37×32 1882

Follette, Chienne (The Bitch Follette) Formerly in the Santamarina Collection, Buenos Aires
The dog belonged to A. Proust's secretary, E. Cante, to whom the painter dedicated the picture : 'To my friend, E. Cante, Manet'.

413 ⊞ ◕ 56×35,5 1882*

Homme au Chien (René Maizeroy) (Man with a Dog) Private Collection, Chicago
The subject, Baron Toussaint, formerly a naval officer, was about to become a reporter for *Vie Parisienne*.

414 ⊞ ◕ 92×73,5 1882-83

Portrait de Jean-Baptiste Faure (Portrait of Jean-Baptiste Faure)
A The baritone Faure, (see 230) posed once again in the last days of December 1882 and the first days of January 1883. Manet made three oil-sketches

which are little-known and often confused with one another. In the first — this one — the body, which is rather more than half-length, is outlined with brush-strokes and only the head with the eyes apparently closed, has been fully worked.
B In the second (oils on canvas; 81 cm. × 63 cm.) which shows the model as far as the waist, the eyes still seem to be closed.
C The third (46 cm. × 38 cm. ; [Ralph J. Hines] Metropolitan Museum, New York) shows the identical head to the previous one, with the eyes open.

415 ⊞ ◕ 55×34 1882-83

Portrait de Jules de la Rochenoire (Portrait of Jules de la Rochenoire) Private Collection, Paris
The subject was a noted painter with an equal reputation as a drinker.

416 ⊞ ◕ 56,5×35,5 1883?

Portrait de René Maizeroy (Portrait of René Maizeroy) Museum of Fine Arts, Boston

417 ⊞ ◕ 55,5×34,5 1883

Oeillets et Clématites (Pinks and Clematis) Jeu de Paume, Louvre, Paris
A This painting marks the opening of the last series of floral subjects painted by Manet 'in the great French tradition of Chardin and Fragonard' (R). The vase is that shown in 411A and it recurs in some of the following works.
B **Roses et Lilas (Roses and Lilacs)** (oil on canvas ; 54 cm. × 41 cm. ; signed; E. Reeves Collection, Roquebrune).
C **Lilas Blanc (White Lilac)** (oils on canvas, 54 cm. × 41 cm.; signed; Staatliche Museen, Berlin). Perhaps painted on 28 February 1883.
D **Roses dans un Verre à Pied (Roses in a Goblet)** (oils on canvas; formerly in Mrs H. O. Havemeyer Collection, New York). Inexplicably ascribed by Duret to 1870.
Further similar paintings: *Roses et Iris (Roses and Irises)* (canvas; 60 cm. × 50 cm.) ; *Fleurs (Flowers)* (canvas; 31

cm. × 23 cm.) ; *Roses* (Roses) (board, 33 cm. × 26 cm.) ; *Id.* (canvas ; 56 cm. × 35 cm. ; Private Collection, New York); *Id.* (canvas ; 22 cm. × 23 cm. with false signature; formerly in A. Lindon Collection, Paris); *Deux Roses (Two Roses)* (canvas ; 35 cm. × 23 cm. ; Private Collection, New York); *Pivoines (Peonies)* (canvas; 61 cm. × 38 cm.) which are accepted only by Tabarant, should be rejected.

418 ⊞ ◕ 25×20 1883

Portrait d'Elisa (Portrait of Elisa)
This was the maid who worked for Méry Laurent (see 360). She came — as on almost every other day — on the day before Easter (which in 1883 fell on 25 March) to bring flowers from her mistress to Manet's studio, and he asked her to pose. Later the painter was not able to return to the atelier to complete the picture and after his death it was found by his widow still on the easel.

Other Attributed Works

The works included in this list follow the most plausible chronological order, though it is not possible to prove their authenticity. In the case of works which could not be examined, their authenticity did not seem sufficiently demonstrated simply on the basis of the documentation available.

419 ⊞ ◕ 61×72

Femme nue Couchée (Reclining Nude) Formerly in the T. Duret Collection, Paris
Tabarant claims that this may have been executed at the end of Manet's period of studies with Couture (c. 1856). Earlier considered dubious by Jamot and Wildenstein.

420 ⊞ ◕ 23,5×19

Autoportrait Caricatural (Self-portrait, a Caricature)
On the left is an inscription 'A friend ! !'. Accepted by Tabarant only, who ascribes it to 1856–7 and claims that Manet always kept this caricature for himself.

421 ⊞ ◕ 47×37

Gamin à la Toque Rouge (Boy in a Red Cap) Private Collection, Paris (?)
Sometimes the model is identified as Alexandre (see 19) which would seem to be immediately refutable. Similarly, the authenticity is called in question by Jamot and Wildenstein, although Duret (1902) always claimed that he saw the painting in Manet's studio.

422 ⊞ ◕ 55×46

Vase de Pivoines Roses (Vase of Pink Peonies)
Accepted by Tabarant, who ascribes it to 1864. Not mentioned by Duret or by Jamot and Wildenstein.

423 ⊞ ◕ 65×80

Fleurs Devant la Fenêtre (Flowers in front of the Window)
Apparently this remained for many years at Gennevilliers in the house of Jules de Jouy, Manet's cousin, and was brought to the painter's studio after the latter's death.

424 ⊞ ◕ 21×24

Dame Assise sur la Plage (Woman sitting on the Beach) Formerly in the Alfred Gold Collection, Berlin
This would relate (T) to the summer of 1865, when Manet went to Boulogne-sur-Mer after the Salon closed. At the bottom on the left, in fact, is written 'July' and on the back 'Edouard Manet to his friend Leclerc, July 1865'.

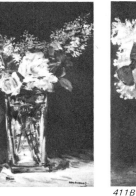
411A

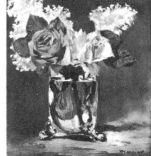
411B

411C

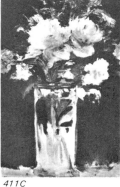
411D

411E

411F

411G

411H

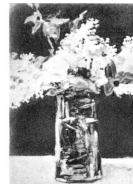
417A

417B

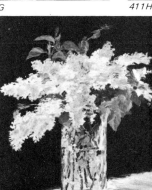
417C

417D

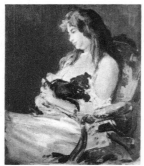

425

425 ⊞ ◒ 41×33,5 ▤ :
Jeune Rousse au Chiot Noir (Red-headed Girl with a Black Puppy) Mme T. Gaulin Collection, Bordeaux
Exhibited at Bordeaux in 1964 (*La Femme et l'Artiste*, 125). Accepted as authentic by various scholars, including J. Mathey (1966) who considers that the initial 'M' at the top on the left is also genuine.

426 ⊞ ◒ ▤ :
Sur la Plage (Boulogne-sur-Mer [?]) (On the Beach) Accepted only by Tabarant (1947), who ascribes it to 1869, but does not show a reproduction of it.

433

427 ⊞ ◒ 50×61 ▤ ? :
La Gare de Sceaux (Sceaux Station) Formerly in a Private Collection, Paris

428 ⊞ ◒ 26×37 ▤ ? :
Faubourg Sainte-Croix à Oloron (?) Private Collection, Paris (?)
Reproduced by Tabarant (1947) with reference to 1871. Omitted by other cataloguers.

429 ⊞ ◒ 28×49 ▤ ? :
Faubourg Sainte-Croix à Oloron (?) Private Collection, Paris (?)
Published by Tabarant (1947) who ascribed it to 1871. Not mentioned by other cataloguers.

434

430 ⊞ ◒ 24,5×38,5 ▤ :
Sous les Pins à Arcachon (Manet's Mother and his Sister, Marthe [?]) (Beneath the Pines at Arcachon) On paper backed with canvas. Duret noticed the influence of Corot and ascribed this painting to 1857.

431 ⊞ ◒ 30×46 ▤ ? :
Paysage (Arcachon [?]) (Landscape) Private Collection, London (?)
The uncertainties on the part of the most recent critics are particularly concerned with the identification of the place. In any case, Jamot and Wildenstein omit it and Tabarant considers it an authentic work dated 1871.

437

432 ⊞ ◒ 39×44,5 ▤ ? :
Enfants sur la Plage (Children on the Beach) Formerly in the G. Viau Collection, Paris
Accepted only by Tabarant (1947), though he gives the dimensions as 28 cm. × 35 cm. It is regarded with great suspicion by later scholars.

444

433 ⊞ ◒ 53,5×64,5 ▤ :
Marguerite de Conflans (?) près d'un Miroir (Marguerite de Conflans [?] by a Mirror) Jeu de Paume, Louvre, Paris
Bequeathed to the Louvre in 1945 by Mlle d'Angély,

450

daughter of the sitter, who was supposed to have been given it by Manet himself. Tabarant (1947) recognizes it as an authentic work from 1873, in spite of the repainting and mutilations.

434 ⊞ ◒ 180×127 ▤ :
Mme Claude Monet en-train de Lire (Mme Claude Monet reading)
This has been mentioned as authentic by F. Wisinger (*Die Kunst und das schöne Heim, 1965*). J. Mathey (1966) agrees on the attribution and the identification of the model and is only uncertain about the date: before 1870 or 1874.

435 ⊞ ◒ 46,5×56 ▤ :
Bateaux de Bains sur la Seine (Bathing Boats on the Seine)
A Brief sketch, accepted as authentic only by Tabarant (1947) who ascribes it to 1874.
B Another similar one, which has been lost, was photographed by Lochard. However, it is omitted by Duret and by Jamot and Wildenstein.

436 ⊞ ◒ — ▤ :
Saules au bord de la Seine (Willows by the Seine)
Known only through the photograph formerly in the possession of Moreau-Nélaton and now in the Bibliothèque Nationale in Paris.

437 ⊞ ◒ 55×45 ▤ ? :
Buste de Femme en Habit de Soirée (Bust-portrait of a Woman in Evening Dress)
This only became known in about 1930. Some think it to be a portrait of the actress Jeanne de Marsy, but this would seem rather unlikely as the model appears older than the supposed subject would have been in 1881 when she posed for *Printemps* (see 348) and in this case the dating must be about 1875.

438 ⊞ ◒ 30,5×22 ▤ :
Portrait d'Ernest Hoschedé (?)
Accepted by Tabarant (1947) with a reservation only about the identity of the subject. He dates it 1876.

439 ⊞ ◒ 46×38 ▤ :
Pivoines dans un Grand Verre (Peonies in a Large Glass) Catalogued only by Tabarant (1947) as an authentic work from 1877.

440 ⊞ ◒ 61×40 ▤ :
Iris dans un Vase (Irises in a Vase)
Sketch accepted as authentic only by Tabarant (1947), with reference to 1877.

441 ⊞ ◒ 32×24 ▤ :
Femme aux Bras Croisés (Woman with Folded Arms)
Private Collection, USA
Reputed to be a portrait of the wife of the landscape artist

Stanislaus Lépine. Accepted by Tabarant (1947) with reference to 1878. It was catalogued, but with reservations, by Jamot and Wildenstein.

442 ⊞ ◒ 72×83 ▤ :
Femme en Noir à l'Eventail (Woman in Black with a Fan) Formerly in a Private Collection, Berlin
According to Duret, who had this in his collection, the unknown sitter was painted in Rosen's studio-conservatory. It would therefore date from 1879, a date which is accepted by Tabarant, who is also in agreement on its authenticity.

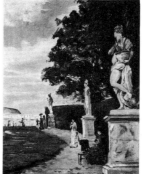

446

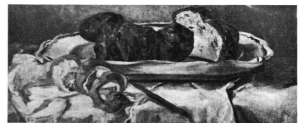

443

443 ⊞ ◒ 41×24 ▤ ? :
Coin Fleuri du Jardin de Bellevue (Corner of the Garden at Bellevue, with Flowers)
A Tabarant, who accepts it as an authentic work dating from 1880, thinks that this is a scene captured at Bellevue (see 304). Tabarant throws doubt upon the authenticity of the signature (initials) believing that they were put on by Manet's widow.
B A similar sketch is also mentioned by Tabarant (1947) as being left to Léon Koëlla after the death of Manet's widow.

444 ⊞ ◒ 33×46 ▤ :
Chemin entre les Arbres (Roadway between Trees)
Mentioned by Mathey (1966) as an authentic work from 1880, which is supported by the fact that on the back there is a seal, showing that it had been left to Manet's widow.

445 ⊞ ◒ 22×27 ▤ :
Nature Morte, Pêches (Still-life, Peaches)
Accepted only by Tabarant (1947), who ascribes it to 1880.

446 ⊞ ◒ 25,5×54,5 ▤ :
**Nature Morte, Brioche et Citron (Still-life, Brioche

and Lemon)** Musée des Beaux-Arts, Strasbourg
The old attribution to Manet, which had since been rejected by many authorities, has recently been taken up again by R. Rey (*Manet*, Paris, 1938).

447 ⊞ ◒ 29,5×61 ▤ :
Faisan sur une Serviette (Pheasant on a Table-napkin)
Tabarant (1947) cites this work, but makes no pronouncement on its authenticity, since he knew it only through an unsatisfactory photographic reproduction by Camentron. According to the latter, it was painted at Versailles in 1881.

448 ⊞ ◒ 61×46 ▤ :
Deux Perdrix Accrochées à un Mur de Bois (Two Partridges hanging up on a Wooden Wall)
The remarks made for 447 apply to this also.

449 ⊞ ◒ 61,5×46,5 ▤ ? :
Coin du Parc de Versailles (Corner of the Park at Versailles) H. Carre Collection, Paris
On the left is the top part of the château. On the back is the stamp of the dealer, Latouche of Paris, from whom Manet was in the habit of getting his painting materials. The work was privately authenticated by P. Courthion. J. Mathey (1966) guarantees its authenticity as well as that of the monogram 'M'.

450 ⊞ ◒ 33×19 ▤ :
Fenêtre de Méry Laurent (Fenêtre aux Plantes Rampantes ; Fenêtre de la Villa 'des Taulus')
Méry Laurent's Window (Window with Climbing Plants ; Window of the Villa 'des Taulus')
On the back there is written: 'Window of the room of Méry Laurent, known as *le Gros Oiseau* (the Large Bird), a friend of François Coppée'. This suggests (T 1947) a connection with Méry Laurent's (see 372) summer residence and the possibility that Manet stayed there in 1881. Authenticated also by Jamot and Wildenstein.

451 ⊞ ◒ 42×32 ▤ :
Pivoines dans un Verre à Champagne (Peonies in a Champagne Glass)
Accepted only by Tabarant (1947) with one doubt — whether it was painted at Rueil in 1882 or at Versailles the year before.

Concordance

For every entry in this volume (CA) the corresponding numbers are provided for the catalogues by Jamot and Wildenstein (JW) and Tabarant 1947 (Tab), as listed on page 82. Such a comparison with the two earlier authoritative catalogues provides not only easy identification of the works listed in all three volumes, but also immediate access to opinions as to autograph works, whether these are rejected, or whether they have been added in the course of the last twenty years. From 419 onwards are listed the works whose attribution has been called in question.

CA	JW	Tab	CA	JW	Tab	CA	JW	Tab	CA	JW	Tab	CA	JW	Tab	CA	JW	Tab	CA	JW	Tab
1	3	1	73	105	81	139	180	163	209 A	262	245	268 B	402	316	339	428	499	397	405	414
2	6	2	74	104	83	140	179	164	209 B	263	246	269	297	313	340	474	500	398 A	414	415
3	5	3	75	108	84	141	185	165	210	248	248	270 A	503	314	341	454	373	398 B	491	416
4 A	2	6	76	170	85	142	188	167	211	315	247	270 B	—	314	342 A	458	374	399	489	417
4 B	1	7	77	—	86	143	187	168	212	266	251	271	325	317	342 B	456	375	400	492	418
5	7	4	78	99	88	144	194	171	213	267	252	272	327	318	342 C	455	376	401	488	419
6	12	18	79	98	89	145	—	171	214	200	253	273	326	319	342 D	457	377	402	515	420
7	11	8	80	96	90	146	196	172	215	256	254	274	294	320	343	459	378	403	393	421
8	14	15	81	100	91	147 A	190	177	216	278	255	275	295	321	344	271	379	404	512	422
9	8	9	82	130	92	147 B	191	173	217	251	256	276 A	372	322	345	477	501–502	405	514	423
10	4	10	83	102	93	148	189	174	218 A	253	257	276 B	371	323	346	478	503	406	542	425
11	13	14	84	171	94	149	192	175	218 B	403	258	277	341	324	347	323	381	407	516	426
12 A	69	16	85	91	95	150	193	179	219	319	259	278 A	338	325	348	470	380	408 A	484	427
12 B	70	17	86	490	96	151	197	180	220	320	260	278 B	—	475	349	460	382	408 B	481	428
13	90	11	87 A	202	101	152	199	181	221	452	261	279	272	326	350	321	384	408	483	429
14	31	23	87 B	80	97	153	169	182	222	381	262	280	274	327	351	468	385	409	395	430
15	22	5	87 C	115	98	154	301	183	223 A	252	264	281	269	328	352 A	462	386	410	527	456
16	24	27	87 D	205	99	155	207	184	223 B	—	264	282	373	329	352 B	463	387	411 A	505	431
17	25	12	87 E	204	100	156	206	185	224	265	265	283	375	330	352 C	465	388	411 B	543	432
18	76	25	88	92	76	157	210	186	225	300	266	284	374	331	352 D	464	389	411 C	510	433
19	33	20	89 A	113	105	158	208	187	226	109	267	285	317	332	353	461	391	411 D	392	434
20	32	26	89 B	114	106	159	209	188	227	261	268	286	369	334	354	453	392	411 E	511	435
21	23	24	90	125	103	160	201	189	228	302	269	287	329	335	355	469	393	411 F	504	436
22	26	22	91	117	104	161	258	190	229	275	270	288	330	336	356	322	394	411 G	391	438
23	29	28	92	164	107	162	211	191	230 A	277	273	289	339	337	357 A	467	396	411 H	508	437
24	9	30	93	118	109	163	212	193	230 B	276	272	290	352	476	357 B	466	397	412	328	442
25	10	31	94	27	110	164	203	194	230 C	—	271	291	445	478	358	476	504	413	529	539
26	28	35	95	111	111	165 A	213	195	231	273	274	292 A	439	480	359	438	505	414 A	517	439
27	38	36	96	112	112	165 B	213	195	232	377–379	275–278	292 B	440	479	360	432	506	414 B	519	440
28	37	37	97	153	113	166	214	196	233	293	279	293	359	481	361	441	507	414 C	518	441
29	—	550	98	71	114	167	224	197	234 A	279	280	294	358	482	362 A	475	510	415	520	538
30	73	32	99	121	118	168	220	198	234 B	279	280	295	362	483	362 B	431	508	416	—	539 bis
31	35	34	100	122	119	169	230	199	235	340	281	296	426	485	362 C	420	509	417 A	506	444
32	36	33	101	120	120	170	198	200	236	280	282	297	364	486	363 A	446	511	417 B	544	448
33	40	38	102	124	121	171	221	201	237	270	285	298	357	487	363 B	447	512	417 C	545	449
34	30	29	103	132	115	172	222	202	238	311	455	299	346	339	364	472	513	417 D	541	452
35 A	55	42	104	136	116	173	223	203	239	257	286	300	448	477	365	349	514	418	540	540
35 B	53	39	105	126	117	174	227	204	240	370	287	301	383	333	366	350	515	419	19	13
35 C	54	40	106	133	122	175	225	205	241	425	460	302	419	489	367	534	515 bis	420	—	19
35 D	—	41	107	144	123	176	226	206	242	423	461	303	376	340	368	355	516	421	34	21
36	41	43	108	135	124	177	228	207	243	424	462	304	399	342	369	521	517	422	—	82
37	42	44	109	129	125	178	165	208	244	421	463	305	400	343	370	473	518	423	—	87
38	106	78	110	168	126	179	229	209	245	22	464	306	398	344	371	443	519	424	—	108
39	—	—	111	131	127	180	231	210	246 A	331	288	307	318	345	372	480	399	425	—	—
40	110	59	112	21	128	181	232	211	246 B	401	289	308	502	346	373	499	390	426	—	153
41	304	50	113 A	128	129	182	236	212	247	291	290	309	397	347	374	410	443	427	—	166
42	61	48	113 B	—	130	183	237	213	248 A	289	293	310	396	348	375	536	520	428	—	169
43	60	49	114	137	131	184	250	214	248 B	254	291	311 A	384	349	376	433	521	429	—	170
44	44	45	115	138	132	185	268	215	248 C	290	294	311 B	385	350	377	538	522	430	—	176
45	45	46	116 A	141	133	186	235	216	248 D	288	292	312	342	351	378	537	523	431	—	178
46	59	47	116 B	139	134	187 A	218	217	249	292	302	313	382	358	379	539	524	432	—	pag. 220
47	48	51	116 C	140	135	187 B	217	218	250	367	303	314	394	353	380	449	525	433	—	215 bis
48	46	52	117	148	136	188 A	219	219	251	337	304	315	498	357	381	355	526	434	—	—
49	47	53	118	146	137	188 B	216	220	252	305	305	316	389	359	382	535	527	435 A	—	230
50	52	54	119	147	138	188 C	215	221	253	284	306	317	388	360	383	522	528	435 B	—	230
51	51	55	120	149	139	189	234	222	254	380	308	318	386	361	384	450	529	436	—	—
52	49	56	121 A	150	141	190	233	223	255 A	286	309	319	406	362	385	530	530	437	—	250
53	63	57	121 B	151	—	191	312	454	255 B	285	310	320	387	364	386	531	531	438	—	457
54	57	63	121 C	152	140	192	237 bis	224	256	287	311	321 A	413	365	387 A	533	532	439	—	283
55	58	58	122	142	142	193	241	225	257 A	361	467	321 B	412	366	387 B	532	533	440	—	284
56	39	60	123	167	143	194	244	226	257 B	360	468	322	404	367	388	523	534	441	310	307
57	72	61	124	154	144	195 A	242	227	258 A	353	469	323	407	368	389 A	525	536	442	283	315
58	50	62	125	155	145	195 B	243	228	258 B	354	470	324	411	369	389 B	524	535	443 A	—	355
59 A	79	66	126 A	163	147	196	264	229	259 A	356	471	325	409	370	389 C	526	537	443 B	—	356
59 B	78	65	126 B	162	146	197 A	240	231	259 B	351	472	326	479	488	390	77	407	444	—	—
59 C	74	64	127 A	160	149	197 B	239	232	260	471	474	327	324	352	391 A	493	401	445	—	363
60	123	67	127 B	161	148	198	245	233	261	334	297	328 A	333	371	391 B	494	402	446	—	—
61	81	69	128	159	150	199	306	234	262	444	465	328 B	332	372	392 A	495	403	447	—	—
62	82	68	129	178	152	200	238	235	263	366	466	329	363	489	392 B	496	404	448	—	—
63	134	70	130	166	151	201	259	236	264 A	314	295	330	442	490	392 C	497 bis	405	449	—	—
64	85	71	131	183	154	202	260	237	264 B	313	296	331	430	491	392 D	497	406	450	490 bis	400
65	83	73	132	145	155	203	267 bis	239	265	528	473	332	435	492	393	500	408	451	—	424
66	84	72	133	174	159	204	308	238	266 A	355	298	333	436	493	394	509	409			
67	87	74	134 A	177	157	205	255	241	266 B	336	299	334	437	494	395	485	412			
68	88	75	134 B	176	156	206	247	242	267	303	300–301	335	418	495	396	486	413			
69	—	—	135	184	158	207	246	243	268 A	296	312	336	451	496						
70	103	77	136	173	160	208	249	244				337	429	497						
71	101	79	137	181	161							338	427	498						
72	143	80	138	182	162															

Indexes

Index of subjects and titles

As well as the English titles adopted here, the most usual French titles are also given for ease of reference.

Index of locations